# POST CITY

## Habitats for the 21$^{st}$ Century

Edited by Gerfried Stocker / Christine Schöpf / Hannes Leopoldseder

**Ars Electronica 2015**
Festival for Art, Technology, and Society

September 3 – 7, 2015
Ars Electronica, Linz

**Editors:** Gerfried Stocker, Christine Schöpf, Hannes Leopoldseder

**Editing:** Jutta Schmiederer

**Translations:** German – English, all texts
(unless otherwise indicated): Mel Greenwald

**Copyediting:** Catherine M. Lewis, Jutta Schmiederer,
Ingrid Fischer Schreiber

**Graphic design and production:** Gerhard Kirchschläger

**Typeface:** Klavika

**Printed by:** Gutenberg Werbering GmbH, Linz

**Paper:** Claro Bulk 150 g/m², 300 g/m²

**Published by**
Hatje Cantz Verlag
Zeppelinstrasse 32
73760 Ostfildern
Germany
Tel. +49 711 4405-200
Fax +49 711 4405-220
www.hatjecantz.com
A Ganske Publishing Group company

Hatje Cantz books are available internationally at
selected bookstores. For more information about our
distribution partners please visit our homepage at
www.hatjecantz.com.

ISBN 978-3-7757-4021-0

Printed in Austria

Cover illustration: Pablo Scapinachis Armstrong, Stefan Eibelwimmer

**PEFC**
PEFC/06-39-27

This product is from
sustainably managed
forests and controlled sources.

**printed climate-neutrally** ⁰
CP IKS-Nr.: 53401-1508-1002

ARS ELECTRONICA

HATJE
CANTZ

## Ars Electronica 2015

Festival for Art, Technology and Society

**Organization**
Ars Electronica Linz GmbH

**Managing Directors**
Gerfried Stocker, Diethard Schwarzmair
Ars-Electronica-Straße 1, 4040 Linz, Austria
Tel: +4373272720
Fax: +4373272722
info@aec.at

**Co-organizers**

**ORF Oberösterreich**
**Director:** Kurt Rammerstorfer

**LIVA – Veranstaltungsgesellschaft m.b.H.**
**Directors:** Hans-Joachim Frey, Wolfgang Lehner

**OK Offenes Kulturhaus im OÖ Kulturquartier**
Directors: Martin Sturm, Gabriele Daghofer

**Partners**
Kunstuniversität Linz – Universität für künstlerische
und industrielle Gestaltung
Lentos Kunstmuseum Linz
Mariendom Linz
Österreichische Post AG

Akademie der bildenden Künste Wien
Backlab Collective
Bugnplay - Multimedianetzwerk
C3 - Multimedianetzwerk
Campus Genius Award
Central Linz
CPN Centre for the Promotion of Science
CERN
Connected Intelligence Atelier
Deutscher Multimediapreis – Multimedianetzwerk
DIG gallery
Empowerment Informatics
European Space Agency
European Southern Observatory
Etopia
FAB Verein zur Förderung von Arbeit und Beschäftigung
GV Art
ifva
Ingenieure ohne Grenzen Austria
Interface Cultures
Internationales Teletext Art Festival ITAF
International Students Creative Award
Internet Yami-Ichi and Body Paint
Japan Media Arts Festival
Kammer der Architekten und Ingenieurkonsulenten
für Oberösterreich und Salzburg
Kapelica Gallery / Kersnikova
LABoral
Mons 2015
ORF Teletext
QUT Queensland University of Technology
Science Gallery
Stadtwerkstatt
Tourismusverband Linz
University of Tsukuba
V2 Institute for the Unstable Media
Zaragoza City of Knowledge Foundation

**Directors Ars Electronica:** Gerfried Stocker, Christine Schöpf
**Head of Festival:** Martin Honzik
**Technical Head:** Karl Julian Schmidinger
**Finance & Organization:** Veronika Liebl

**Production Team:** Katharina Bienert, Sigrid Blauensteiner,
Florina Costamoling, Roman Dachsberger, Katharina Edlmair,
Hannes Franks, Marion Friedl, Rosi Grillmair, Alexander
Hinterlassnig, Georg Holzmann, Andrea Kohut, Sofie
Kronberger, Theresa Lackner, Kristina Maurer, Hans Christian
Merten, Manuela Naveau, Emiko Ogawa, Hideaki Ogawa,
Elvis Pavic, Felix Pöchhacker, Christina Radner, Tina Reinthaler,
Susanne Rosenlechner, Jutta Schmiederer, Mike Sarsteiner,
Florian Sedmak, Tobias Tahler, Anna Titovets, Jochen Tuch,
Joschi Viteka, Susi Windischbauer, Nina Wenhart, Michaela
Wimplinger, Viktoria Wöß, Johanna Zauner, Jochen Zeirzer,
Patrick Zorn

**Co-curators**
**Ars Electronica Animation Festival:** Christine Schöpf,
Jürgen Hagler
**Big Concert Night:** Dennis Russell Davies, Heribert Schröder
**Campus Exhibition:** Jean-Luc Soret, Chu-Yin Chen
**Connected Intelligence Atelier:** Derrick de Kerckhove,
Maria Pia Rossignaud
**Spaceship Earth:** Robert Meisner
**Expanded Animation:** Jürgen Hagler, Wilhelm Alexander
**Interface Cultures Exhibition:** Christa Sommerer, Laurent
Mignonneau, Martin Kaltenbrunner, Michaela Ortner, Marlene
Brandstätter, Reinhard Gupfinger
**Knowledge Capital Curatorial Team**
**Music Monday:** Werner Jauk
**Naked Veriti:** Javier Galán
**Post City Nightline:** Salon 2000

## Prix Ars Electronica 2015

**Co-organizers**

**ORF Oberösterreich**
**Director:** Kurt Rammerstorfer

**LIVA – Veranstaltungsgesellschaft m.b.H.**
**Directors:** Hans-Joachim Frey, Wolfgang Lehner

**OK Offenes Kulturhaus im OÖ Kulturquartier**
**Directors:** Martin Sturm, Gabriele Daghofer

**Idea:** Hannes Leopoldseder
**Conception:** Christine Schöpf, Gerfried Stocker
**Coordination:** Martin Honzik, Emiko Ogawa
**Technical Management:** Karl Julian Schmidinger

**Production Team:** Katharina Bienert, Bernhard Böhm, Viktor
Delev, Christoph Einfalt, Theresa Lackner, Veronika Liebl,
Kristina Maurer, Hans Christian Merten, Elvis Pavic, Johannes
Poell, Christina Radner, Tina Reinthaler, Jutta Schmiederer,
Claudia Schnugg, Joschi Viteka, Florian Voggeneder

**Press**
Christopher Sonnleitner, Robert Bauernhansl,
Martin Hieslmair, Magdalena Leitner

**Marketing**
Isabella Ematinger, Manuela Seethaler, Eva Tsackmaktsian

## ORGANIZER

 **ARS ELECTRONICA**

Ars Electronica Linz GmbH is a company of the city of Linz.

---

## COOPERATION PARTNERS

Akademie der bildenden Künste Wien
Anton Bruckner Privatuniversität
any:time Architekten mit Clemens Bauder, Felix Ganzer
Aquaponic-Austria
Art Council Tokyo
BRP ROTAX
bug`n`play
c3
Campus Genius Award
CDDV Centre for digital Documentation
and Visualisation
Central Linz
Centre for the promotion of science
CERN
COMMOD-Haus
Crossing Europe
CTi – Culture and Technology International
(Connected Intelligence Atelier)
CTIA – Chungnam Culture Technology Industry Agency
CUBUS
DIG gallery
Empowerment Informatics
Etopia
European Southern Observatory
European Space Agency
FAB Verein zur Förderung von Arbeit und Beschäftigung
FH Hagenberg - FH OÖ Studienbetriebs GmbH
Gelbes Krokodil
GV Art London
Hard-Chor Linz
holis market
ifva incubator for film & visual media in asia
Ingenieure ohne Grenzen Österreich
Integrationsbüro der Stadt Linz
Interface Cultures
Interio AG
International Students Creative Award
Internationales Teletext Art Festival ITAF

Japan Media Arts Festival
Kammer der Architekten und Ingenieurkonsulenten für
Oberösterreich und Salzburg
Kapelica Gallery / Kersnikova
Kepler Salon - Verein zur Förderung
von Wissensvermittlung
Kinderfreunde OÖ
KI-I - Kompetenznetzwerk Informationstechnologie zur
Förderung der Integration von Menschen mit Behinderungen
KinderUni OÖ
Klimabündnis Oberösterreich
Kunst- und Kulturverein Backlab
Kunstuniversität Linz - Universität für künstlerische und
industrielle Gestaltung
laboral - Centro de Arte y Creación Industrial
Lammerhuber KG
LENTOS Kunstmuseum Linz
maiz - Autonomes Zentrum von & für Migrantinnen
Mariendom Linz
mb21
Mons 2015
OPEN COMMONS LINZ
ORF Teletext
OTELO Linz und Vorchdorf
PANGEA | Werkstatt der Kulturen der Welt
QUT-Queensland University of Technology
Science Gallery
Sibelius AVID
Stadtwerkstatt
[tp3] architekten ZT Gmbh
The Alfred Fried Photography Award
The PELARS Project
Tourismusverband Linz
University of Tsukuba
V2 - Institute for the Unstable Media
WhatAVenture
Wirtschaftskammer OÖ
Zaragoza City of Knowledge Foundation

ARS ELECTRONICA RECEIVES SUPPORT FROM

Land Oberösterreich

Bundeskanzleramt

Bundesministerium für
Wissenschaft, Forschung
und Wirtschaft

Bundesministerium für Europe,
Integration und Äusseres

KulturKontakt
Austria

Creative Europe

EU Kultur

EU Council of Europe

Europäische Kommission

Erasmus+

DG Near

Japan Foundation

EU-Japan Fest
Japan Commitee

Gobierno de Espana -
Ministerio de education,
cultura y deporte

Spain arts + culture

AC/E – Accion cultural
Espanola

ARCADI

Ferderation Wallo-
nie-Bruxelles

Institut Francais
en Autriche

Ministry of Culture &
Communication France

creative
industries
fund NL

Creativ Industries Fund NL
(CIFNL)

ARCUB

RKI Wien - Rumänisches
Kulturinstitut Wien

Romanian Cultural
Institute

SRE AMEXCID

# SPONSORS

Linz AG

Hakuhodo

voestalpine

Hutchison 3

Mercedes-Benz

Liwest

ÖBB-Personenverkehr AG

Österreichische Post AG

LIVA

KNOWLEDGE CAPITAL

Greiner Holding AG

Industriellenvereinigung OÖ

netidee

SSI Schäfer Shop GmbH

Schäfer Shop GmbH

SilberHolz

NTS

Messe Linz

Rotary Club Linz-Altstadt

Ton + Bild

Sparkasse OÖ

FESTO

Quanta Arts Foundation

Casino Linz

Ableton

Smurfit Kappa

trotec

Rotes Kreuz

Cordial

Carl Zeiss GmbH

Hilti Austria Ges.m.b.H.

Kuka

Creative Region OÖ

PH Oberösterreich

Landestheater Linz

art:phalanx

JP IMMOBILIEN

Paris 8 University
Vincennes-Saint-Denis

Université 8.0
Le pari numérique

Laboratoire d'Excel-
lence Arts-H2H

Investissements
d'Avenir

Initiative d'Excellence en for-
mations innovantes, CreaTIC

École nationale supérieure
des Arts Décoratifs

Yllisu

fuRo

MATULA Gartengestaltung
GmbH

Otto Bock HealthCare
Deutschland GmbH

Screenteam

ÖAMTC Oberösterreich

Vöslauer
Mineralwasser AG

COMMOD-Haus GmbH

Siteco Österreich GmbH
AN OSRAM BUSINESS

BIO AUSTRIA

AURO Naturfarben

Weinhaus Wakolbinger

Triple A

Donau Metall

Baumschule Ökoplant
GmbH

STS Consulting &
Trading GmbH

Johammer e-mobility GmbH

NTRY Ticketing OG

Marchfelder Bio-Edelpilze
GmbH

Das Fraunhofer-Institut für
Bildgestützte Medizin MEVIS

XI Machines GmbH

Red Bull GmbH

Future Catalysts

Rauch Recycling

TBF-PyroTec GmbH

Connecting Cities

art&science

## MEDIA PARTNERS

OÖ Nachrichten

Ö1

FM4

Radio Fro

der Standard

Wired

# CONTENTS

Gerfried Stocker

# POST CITY
## Habitats for the 21st Century

Much of what constitutes our cities today has been handed down to us from the Industrial Age. But what about designing cities for the times to come? How will cities of the future have to be configured when there are more robots than people working in factories, everything is intelligently interlinked, autos drive autonomously and drones deliver the mail? And what does it mean for future megacities—above all, those on seacoasts—when climate change really does shift into high gear? The rethinking of urban living spaces has already begun—all over the world, people are coming up with exciting ideas for new architectures and forms of social organization that are able to keep up with the changes the next few decades will bring.

Dovetailing art, technology and society in the inimitable way Ars Electronica has done ever since 1979, experts from all over the world will be convening at an extraordinary think tank in Linz in September. And they'll do so at an extraordinary place. Set amidst the railroad yard of Linz's main train station, a 100,000 m² facility that used to be the postal service's letter and parcel distribution center will serve as the festival venue and a publically accessible lab for the city of the future.

> The city, it would appear, is humankind's most successful survival strategy, and still our greatest social experiment. The Digital Revolution has imparted a new dimension to this experiment.

Around 1900, 165 million people—approximately 10% of the world population—lived in cities. In 2015, the number of city dwellers is 3.4 billion, 54% of Earth's inhabitants (and it's already up to two-thirds in Europe), and they use 80% of all energy resources. And their numbers are steadily rising—human beings spurred by hope to survive, to find a better way of life, and to live a lifestyle of their own choosing. According to the UN, 200,000 people a day relocate from rural areas to urban centers.

But cities haven't only been places that promised security and prosperity; they are also symbols of freedom and progress. And they have always been flashpoints of all the social conflicts that human-

kind has had to manage in every epoch. The buildings we are erecting now and the traffic arteries we are laying out constitute the cityscape of the 21st century, and also determine coming generations' quality of life. How we now implement architectural measures to configure the public sphere, participatory models to bring about transparency and integration and, above all, to whom we actively entrust or passively cede the responsibility to do so—these are decisive determinants of which opportunities and which conflicts and crises the 21st century will bring.

So what will it look like, this city capable of dealing with what the 21st century dishes out? In other words, what will our habitats look like after we've gone through the Digital Revolution, when the global shift of political and economic power has taken hold, and climate change really gets down to business? POST CITY is the urban sphere afterwards—the city in the wake of all those changes that will perhaps constitute the greatest and most momentous upheaval in recent centuries. This is a development that some call a looming crisis and others see as the dawn of a better day.

Ars Electronica 2015 is focusing on four thematic clusters in order to consider, from both local and global perspectives, how developments—those already in progress and prognosticated shifts—will be changing how our cities look and function:
**Future Mobility**—The city as transportation hub;
**Future Work**—The city as workplace & marketplace;
**Future Citizens**—The city as community; and
**Future Resilience**—The city as stronghold.

### Future Mobility—Mobility of People, Things and Data

The self-driving car is simply a logical consequence of the Digital Revolution. From the mainframe dinosaurs to the PCs and mobile devices to ubiquitous computing—the huge scale of omnipresent devices and things interlinked in networks will create a reality in which motorists behind the wheel will be about as exotic as horse and buggies in midtown traffic today. Engineers already have a pretty good idea of how such robotic cars and trucks will function; still

among the big unknowns are how they will be integrated into our lives and our living spaces, and how they will communicate with us and we with them. Now, the focus is mostly on the technical aspects of convenient, carefree mobility-on-demand, but what will probably be making the most powerful impact on cities is the mobility of human beings who have no other choice but to make a move. The primary destinations of the 21st century's mass migrations are metropolises, and national borders can't hold these people back.

### Future Work—Work and Joblessness in the 21st Century

Will the city of tomorrow be able to provide work for people? What will be their occupations after the big economic crisis? Will we simply have to accept that there is no afterwards because the crisis isn't a temporary illness but rather chronic suffering due to the incapacity to adapt to these new realities? Or maybe, just maybe, we will rise from the ashes like a phoenix as the creative, innovative driving forces of a future with a humanistic sense of proportion. One thing is sure—the much-vaunted re-industrialization of Europe will provide more work for robots and automatons than for laborers. The city as a place for science and R&D, as an educational campus, will play a decisive role in bringing forth the competence and cultural techniques we need to counteract social polarization and segregation.

### Future Citizens—Open Society or Global Domination by the Internet?

Cities are characterized by their capacity to foster social integration, by their infrastructure and networks, by their scientific facilities and cultural institutions, and, above all, by the diverse array of competence, knowledge and initiative of their inhabitants. How do we go about organizing societal coexistence after the birth pangs of Digital Society with its new economies, with its reordering of private and public spheres, with all the collateral damage and lifestyle diseases that we still have no high-tech means to prevent?

The Industrial Revolution brought with it republics and democracies. What political models will be the outgrowth of the Digital Revolution? Which governance systems can satisfactorily facilitate the capacity of digitally networked citizens to get involved effectively and thus maximize the social capital of the future?

### Future Resilience—Refuge and Resistance

The city was always a place of refuge, of safety. The "peace of the city" in the Middle Ages was an essential element that went into making cities an economic success. The architectural and administrative manifestations of this security had manifold effects on the appearance of cities and the coexistence of their inhabitants. Cyber-crime, total surveillance, climate change—what do the cities of tomorrow have to protect us from? What must they defend themselves against? And which means are available? And since cities will inevitably be the first places where these challenges and problems rear their ugly heads, they're also where the solutions are to be sought.

Upon considering these questions, it quickly becomes clear that answering them calls for wide-ranging cooperation among people in all social strata and walks of life. After all, the challenges are greater than the capabilities of individual groups of experts. New skills that cut across the boundaries of discrete fields, new job descriptions and new educational models are desperately needed.

It has already been a quarter of a century since the development of the WWW triggered the internet's evolution from strictly technical computer infrastructure to a network of human beings, to a socio-cultural Plural Universe with a current population of over 2.6 billion. The epithet Digital City has been superseded by Smart City, but the question of how to fabricate the digital equivalent of a city remains unanswered.

Perhaps we have to call into question our previous conception of a city as a geographic conglomeration of resources, and consider the internet itself as the megacity of the future.

*http://www.aec.at/postcity*

# POST CITY
## A City within the City

Last year's Ars Electronica was a festival *in* the city. The 2015 conclave is *about* the city—the way cities of tomorrow will look, how we'd like them to be, and what we can do to make that happen. But, like every year, in addition to the festival theme we're staging encounters with several other focal-point topics at an interesting array of venues. Accordingly, this year's festival divides up, geographically and thematically, into three sectors.

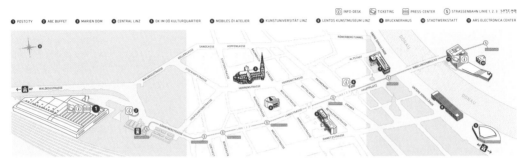

### POST CITY

Post City is the Festival hub—the location of all conferences, summits, the symposia & exhibitions dealing with the Festival theme, and CREATE YOUR WORLD—The Future Festival of the Next Generation.

### DOWNTOWN

The OK Center, Central cinema, and the New Cathedral (Mariendom) are hosting events connected with the Prix Ars Electronica, including the CyberArts exhibition, Prix Forums, and the Animation Festival.

### ALONG THE DANUBE

In the triangle formed by the Ars Electronica Center, Linz Art University, and the Brucknerhaus, the focus is on Digital Art and Science. Here, you'll find the Spaceship Earth exhibition and this year's Campus show.

Our encounter with Art and Science will take place on both banks of the Danube: at the Ars Electronica Center and in the Campus exhibition on Linz's main square, Hauptplatz. Downtown, the accent is on the Prix Ars Electronica. Prizewinning works will be showcased by the Cyberarts exhibition in the OK Center for Contemporary Art, and the Animation Festival in the former Central cinema.

And then there's Post City. The spectacular setting for dealings with this year's festival theme is a 100,000-m² former postal logistics facility at Linz's main train station. This will be the venue of symposia and theme exhibitions, as well as the festival's main concert hall.

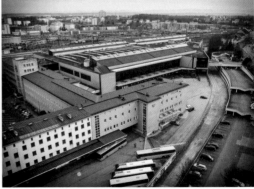

From its landscaped roof to the sprawling civil defense bunkers in the basement, this huge building complex with its unique ambience set amidst the tracks and infrastructure of a major railroad hub will itself be one of the featured attractions on exhibit—a city within the city. Directly in front of the train station, festivalgoers will be picked up by a shuttle bus and transported up the main entry ramp right into the middle of the exhibitions arrayed throughout the Upper Level of Post City. From there, they can explore the enormous halls by bicycle or via electro-scooter, and experience the amazing stuff on display for their edification and enjoyment throughout the premises.

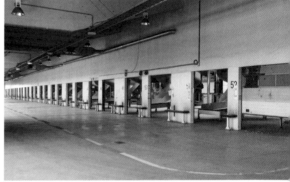

The former mail sorting facility, multi-story spiral packet chutes, and conveyor belt systems will be reactivated for performances and art projects. The transportation infrastructure and loading docks will serve as a space for the public to congregate and socialize. The spacious office suites and storerooms are being converted into galleries and exhibition halls.

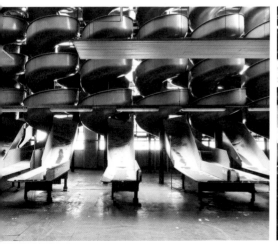

Future Mobility, Habitat 21, Post City Kit, Future Fashion, Future Food, hundreds of architectural models, an internet flea market, u19–CREATE YOUR WORLD, and a 1,000-m² prototype of a Kids' R&D Park are the major neighborhoods that make up the festival village on Post City's 1st Upper Level.

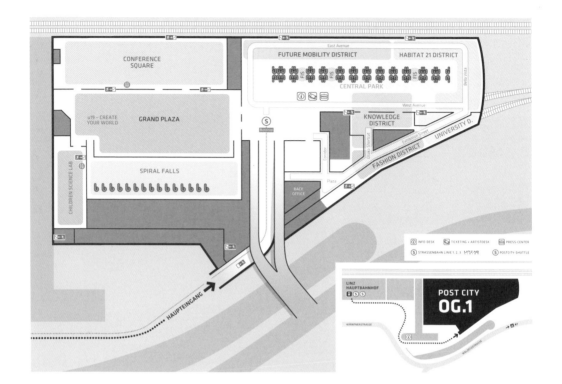

Where lines of boxcars used to pick up and deliver packages and letters, right on the platforms situated amongst the tracks and conveyor belts, the Train Hall is now being relaunched as a Concert Hall to host the Festival's performances and sound art installations designed especially to take maximum advantage, both acoustically and visually, of this venue's spatial dimensions. A program will be staged here every evening–audio-visual installations customized to this setting; musical pieces for orchestra and piano; industrial noise.

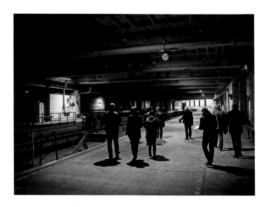

Underground shelters for thousands of civilians were built into this building complex that went into service in 1993. Now, these basement spaces–that, thankfully, were never put to use–will constitute an appropriate setting for art & documentation projects having to do with the huge refugee city in Zaatari, Jordan, and thus take a highly topical look at urban habitats of the future.

# Day-by-Day Overview

**Thursday is Opening Day** at the festival. Exhibitions kick off across the board. The program of symposia and lectures in Post City gets a bright-and-early start. The AE Animation Festival lights up the screen in the Central, the former cinema on Landstraße. u19 – CREATE YOUR WORLD, the festival-within-a-festival for young people, opens its doors in Post City, where the opening event will be held Thursday evening.

**Friday is Symposium Day,** and mobility—its many facets and modes—will be the first order of business: a spectacular R&D prototype of a self-driving car; high-tech prostheses; the mobility of data; and the mobility of millions of people leaving the land for life in the big city.
The afternoon theme is the Smart City. Festivalgoers will critically scrutinize the current hot topic of all futuristic urban scenarios.
The evening highlight is the awards ceremony honoring this year's Prix Ars Electronica winners. The after-party will be a concert nightline in Post City.

**Saturday is Market Day** at Ars Electronica. Two markets will open for business in Post City. The big symposium hall will host a Yami-Ichi, an internet flea market for transacting ideas and wishes having to do with the internet, and thus way beyond big corporations' inventories of the usual gadgets. And an organic farmers' market is an effort by urban raise-it-yourselfers to erect a bridge to digital modernism and thus nurture people's consideration of our food supply's future.
A marketplace of the best-and-brightest projects is the Prix Forum in the OK Center for Contemporary Art. Those singled out for recognition in the various categories will discuss their work.
The Sky lounge atop the Ars Electronica Center will host the 2nd Council of Europe Platform for Exchange on Culture and Digitization, at which a group of Council of Europe experts will join festivalgoers to discuss Policy Guidelines for the Digital Society.
Calling all fans of the Linzer Klangwolke! This year's cloud of sound is the third lollapalooza to be produced by Hubert Lepka/Lawine Torrèn (of 2005 and 2010 fame). Those seeking a rather more out-of-the-ordinary way to call it a day should definitely consider attending OK Night.

**Sunday is Citizen Day** at Post City. The centerpiece: citizen involvement projects designed to get locals to rethink Linz and to discover and develop new perspectives. And Part 3 of the theme symposium deals with the role of public spaces—both real and virtual ones—and their outgrowths that pose challenges to city planners and architects.
Sunday's highlight is Big Concert Night: electronic and digital music, audiovisual performances and installations throughout Post City and a big orchestra on the Rail Hall stage.

**Monday is Music Day** and a don't-miss opportunity for all those interested in digital music and sound art to partake of up-close-and-personal encounters with artists and musicians on the festival lineup.

# POST CITY

## Habitats for the 21st Century

Geeta Mehta
# Building Future Resilience with Social Capital

Future historians may scoff at the last four decades as the time when the world's highest paid financial and corporate leaders used shareholder value to justify running roughshod over the sustainability of the planet and the wellbeing of its inhabitants. A system that allows Earth's non-renewable resources to be plundered, and denies nearly half of the world's population the dignity of reasonable shelter, livelihood, and health, is not smart. It is time for us to recognize and nurture natural capital as well as social capital as important aspects of our wealth. This article deals with social capital, and a methodology to use market mechanisms to nurture and leverage it for common good and happiness.

## What is Social Capital?

Social capital consists of the networks amongst people and the resultant propensity of people to undertake actions for the broader good of their community and beyond. It implies that people take ownership and responsibility for their communities and the global commons, rather than simply being consumers who demand that their problems are solved and their desires met by the government, with minimum obligations on their part. Being a consumer instead of a citizen leads to dissatisfaction, as no government has the resources to fulfill increasing citizen demands. Developing social capital counters this trend. Community festivals, carnivals, theaters, songs and public art through history have been clear illustrations of community creativity and social capital. These are not just one-time events; they bring the community together in a manner that also enables it to solve difficult problems together when they arise. Social capital is what makes certain areas of a city come alive with entrepreneurship and ideas, makes a group of houses become a lively neighborhood, or makes certain streets abuzz with economic activity and 'street life'. Social capital has not received as much attention as it should have, mainly because the elements of civic trust, happiness, and community good inherent in it are hard to measure and are context-dependent. The fact that social capital grows over a long period of time further complicates things, but should not deter us from understanding that social capital is one of their most important assets of communities.

## Social Capital Credits (SoCCs)

My academic, professional, and non-profit work over the past twenty-five years in twelve countries in Asia, Africa, North and South America has been about designing to build social capital. Everywhere my teams and I have worked, we found that the social capital of communities was being ignored under the current and emerging financial systems that seek to measure everything in terms of money. Most of the solutions to problems on the ground being considered were top down, and communities often had marginal inputs in the programs. This is when I developed the concept of SoCCs (Social Capital Credits), based upon my work with the two non-profit organizations I have co-founded: URBZ –User Generated Cities *(www.urbz.net)*, and Asia Initiatives *(www.asiainitiatives.org)*. SoCCs is a system for fostering grassroots development by incentivizing communities to leverage their own social capital. It is a community currency for social good that combines the best practices of carbon credits and loyalty programs. SoCCs is currently being used in eight pilot sites in India, Ghana, Kenya and Costa Rica.

SoCCs leads to an increase in the overall wellbeing of the community while also nurturing its social capital. SoCCs acts as a catalyst for development without the sole reliance on money, and multiplies the impact of every development dollar. SoCCs gives back power and freedom of choice to communities, helping them become the main stakeholders in their success. The SoCCs system entails working with individual communities to customize SoCCs Earning and SoCCs Redeeming menus to their specific needs and capabilities. As shown in the diagram, SoCCs Earning menus may include items such as waste management, providing childcare or senior care, planting trees, or becoming custodians of the natural environment. SoCCs Redemption menus may include items such as telephone talk time, skill training classes, home repairs, childcare or senior care. The philosophical basis of SoCCs is the Theory of Positive Psychology, in which SoCCs acts as a form of social

therapy, enhancing interpersonal connections and instilling a sense of larger meaning or purpose.

SoCC Managers are trained by Asia Initiatives to hold SoCCratic dialogues with communities to develop SoCC Earning and SoCC Redeeming menus. In communities where governments are unable to provide these services, SoCCs can be earned for waste management, micro infrastructure building, paving or maintaining streets, improving neighborhood safety, getting children vaccinated, tutoring, etc. Earned SoCCs can then be redeemed for products and services such as telephone talk time, skill building courses, home improvements, healthcare, school scholarships and so on. SoCCs is particularly relevant for unemployed youth and senior citizens who have much to contribute but are hampered if money is the only medium of exchange. SoCCs enable services and products to be generated within a community, using SoCCs as a medium of barter. Just as carbon credits encourage and reward environmental responsibility using market mechanisms, SoCCs encourage social responsibility using market mechanisms and help price community values into the economy at a premium to values of consumerism. In an effort to expand SoCCs, *SoCCmarket. org*, an online platform that enables trades has been created. It also helps communities to learn about initiatives other communities are taking to improve their homes and neighborhoods, fostering

P2P learning. Some of the SoCC projects currently in operation are described below.

### SoCCs in Kumasi, Ghana

The SoCC System was first piloted in 2013 in Kumasi, the second largest city of Ghana, in partnership with Columbia University's Earth Institute and Women Strong International. In order to participate in the SoCCs program, women vendors in the Bantama Market were required to get health checks offered free at a local clinic, which simultaneously helped many women identify treatable diseases and improve their health. At the Kumasi site, the most popular items on the SoCCs Earnings Menu include maintaining a savings account, keeping the market and the produce clean, and using long-term family planning methods. Redeeming Menu items include getting business skills training and access to the small loans scheme. Currently, many of the 130 members have used the small loans to expand their businesses. Impressively, no borrower has defaulted in payments to date. Based upon the success of the SoCC program, the local partner Women's Health for Wealth has also expanded the SoCC program to Adwumakaase-Kese and Krobo in the Afigya Kwabre and Kwabre east districts respectively. The two communities are using the program to address insanitary conditions, teenage pregnancy and nutrition issues in their communities.

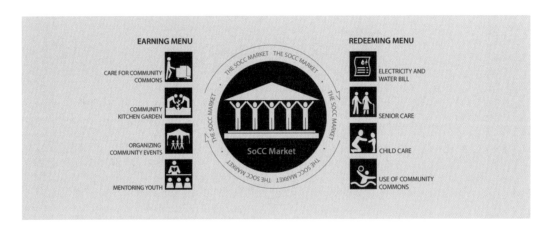

25

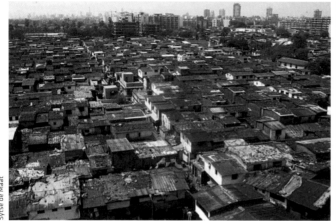

Sytse de Maat

Dhravi, Mumbai

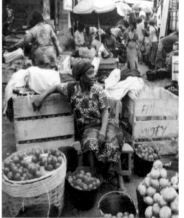

Geeta Mehta

Bantama Market, Kumasi

## SoCCs in Mumbai, India

How one can build or destroy social capital in a city is well illustrated in the case of Dharavi, Mumbai. Often referred to as the largest slum in Asia, Dharavi is in fact a craft village of approximately 700,000 people who live in 80 distinct "nagars" or neighborhoods. The communities have been incrementally developed and crowd-sourced through generations of residents that have upgraded their shelters and businesses according to their needs and means, while contributing nearly a billion dollars per year to Mumbai's economy. Some enterprises manufacture leather and fashion goods for well-known stores in Paris and New York, while there is also a plant where sutures for Johnson and Johnson are manufactured. However, the authorities now deem most residents of Dharavi as illegal occupants of this public land, which the government is now very keen to bulldoze and redevelop for higher income housing and offices. However, recent government projects to re-house slum dwellers in poorly designed tall buildings in Mumbai have proved to be disastrous for the livelihoods and social capital of poor communities. According to UN-Habitat's *Quick Guide for Policy Makers: Housing the poor in Asian Cities*, the argument for the highest and best use of land often has political and business support due to the liquid profits available, but pales when you consider that moving poorer populations farther from the city center develops distance between the rich and the poor that eventually results in social distance and loss of civic trust, urban security, and a lower quality of life for the rich and poor alike.

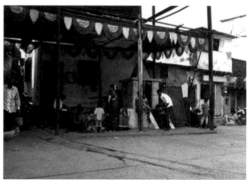

Geeta Mehta

Celebration underway in a Dharavi street

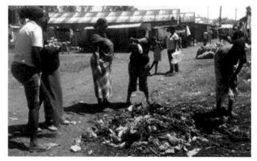

Beldina Opiyo

SoCCs project for street cleaning in Manyatta neighborhood

URBZ launched *dharavi.org* in 2008, the first ever website developed with and for the people of Dharavi, which changed the perception of Dharavi from that of a place of despair to a place of vibrant hope. In its first year, it had 100,000 visits, 250 registered users, and hundreds of comments by residents,

visitors and researchers. URBZ's experimental urban research and activism has provided empirical evidence that self-upgrading settlements like Dharavi are socially and economically superior to any top down redevelopment schemes that governments or developer have built so far. If given secure tenure and basic infrastructure, places like Dharavi can develop themselves by improving their homes and neighborhoods through strong community networks. Asia Initiatives and URBZ are also incubating SoCCpreneurs in Dharavi, who start for-profit businesses with a commitment that a percentage of their profits go back into Dharavi through the SoCC Redemption menus.

### SoCCs for Restoring a River in Madurai, India

In partnership with a local NGO, the Dhan Foundation and a New York based NGO, Earth Celebrations, we are using SoCCs at our Madurai site to incentivize riverside communities to become custodians of the highly polluted Vaigai River, restoring the people–nature symbiosis that had existed in Madurai for nearly 2,000 years. Communities earn SoCCs for ensuring that there is no dumping of garbage, sewage, or industrial pollutants into the river, and for building and managing riverside public spaces. SoCCs are redeemable for telephone talk time, skill training classes, water harvesting installations, and school fees. The SoCC process involves SoCCratic stakeholder meetings, educational workshops, and a public social action art project.

### SoCCs in Kisumu, Kenya

The SoCCs program was started in 2015 in the Manyatta informal settlement in Kisumu, Kenya's third largest city, in partnership with Women Strong International and the local partner Alice Visionary Foundation. Members of the Group Savings and Loan program started the SoCCs program to meet the urgent need of keeping their neighborhood clean, and their children, especially daughters, safe as they walk to and from school. The program will later be expanded to meet nutritional, health, educational, and business development needs for the members, most of whom are petty traders dealing in fish or food processing.

### SoCCs in Curridabat, Costa Rica

The SoCCs project in La Europa neighborhood in Curridabat is sponsored by the local Mayor's office. People are earning SoCCs for joining neighborhood watch groups to enhance safety, for maintaining the public spaces, and for tutoring children. SoCCs are redeemed for Internet service and telephone talk time. The program will later be expanded to include home improvements. SoCCs can help cash-strapped governments enlist people as partners instead of consumers in the provision of essential services.

### Conclusion

As evident from our SoCC pilots described above, there is an increasingly urgent need to create workable alternatives to the top down "planner knows all" Modernist model, as well as the neo-liberal "greed is good" model that has destroyed many significant communities and urban fabrics in the past three decades. Most governments today do not have the resources or deep local knowledge about informal or other lower income communities, so resource and solution mobilization from within the communities is not only possible, but also more desirable. The role of the governments, architects, and planners, then is to be facilitators and consultants to the communities. This approach acknowledges the fact that the local people are the 'experts' in their communities, and can be powerful agents of development rather then helpless recipients of government benevolence when and if it comes.

The only thing certain about the future is that we cannot yet visualize it. Climate change, volatile and often irresponsible financial markets and politics, and unsustainable life styles are coming together to create challenges that are going to require much innovation, holistic technologies, and resilience in our lives, our cities and our regions. These are qualities that no government, no matter how wealthy and well-run, can manage without participation from the people. Resilience depends not only upon financial capital, but also upon social capital, a form of capital that springs from the understanding of global interdependence among people. For this reason, understanding and developing systems to leverage the social capital are of critical importance.

Kristien Ring

# Self Made City
## Qualities for Future Urban Living

The housing markets of our major cities are determined today mainly by profit-driven developments. New alternatives, however, have been tested that offer the increase of choice and reduction of costs at the same time—projects that are also helping to foster neighborhoods and to enable affordable, adaptable, customized living solutions. The self-determined design of space, be it in the form of co-housing, co-working or other project forms, has produced an architectural quality and diversity in recent years that is exemplary.

The most significant and innovative built examples, particularly in Berlin, have been initiated by architects for a specific group of clients who were all looking to live in the buildings personally. On the surface, we see practical solutions where single-family homes are stacked and combined to optimize the use of an urban site. But the closer we look, the more we can observe how the intense collaboration between the architects and the group of clients has packed these projects with special features and spaces that foster interaction. In this way, new processes in architectural production are leading to better and more sustainable solutions, and collective is being re-defined.

Sustainable development involves not only high-quality, resource saving, and flexible design, but must also add to urban vitality by considering social issues of inclusion and community as well as hybrid uses that fuel urban interaction. It is through active engagement and participation that future users develop a vested interest in the building, house-community and neighborhood that goes beyond their own personal needs and surroundings—active users being the key in determining the success of sustainable concepts.

So, what can we achieve collectively? Somewhere between pragmatism and idealism, collectives are forging future-oriented solutions:

Green, open and community-shared spaces have proven to become vital parts of good neighborhoods.

Common spaces such as rooftop terraces, or party rooms, children's playrooms and guest rooms, or even a sauna can create better living situations and bring people together. Every collective project in Berlin has a shared garden, often even open to the public, and a high percentage share built common spaces. The connections created between the green and surrounding urban space is a resource for the city from which the entire neighborhood profits—helping people to have a sense of identity and inviting neighbors to take on responsibility for the place they live. For example, a shared rooftop terrace with a guest apartment or a public pocket park, created on private land and cared for by the owners, or the projects Anklammer Str. 52, Berlin, by Roedig. Schop Architects, and Schönholzer Str. 10A, Berlin, by Zanderroth Architects.

Long-term affordability helps to create stable neighborhoods. In collective projects, the future users decide what to invest in and where money can be best saved, redefining the price-quality relationship. Alternative models for financing and ownership have offered a new level of long-term affordability within a non-profit ideology, such as in the co-op association Spreefeld, presented in this publication. A land-grant or a leasehold contract guarantees the long-term use of land in return for rent, but also ensures that what is built and established there meets certain criteria and ideologies—for example, the low-rent policy and socially oriented programming of the Ex-Rotaprint and Holzmarkt eG projects. Quality of life can be improved by having choice in planning. By enabling personalized solutions, and spaces that can be adapted to suit changing needs over time, people with special needs can find a place in the city—for families, multi-generation living, barrier-free standards or ecological ways of life. For example, architect Florian Koehl worked closely together with the Strelitzer Str. 53 group throughout, orchestrating the design in shared authorship. Fold-out balconies were created because the city

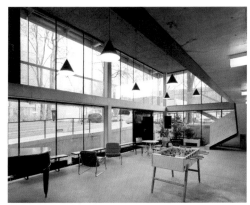

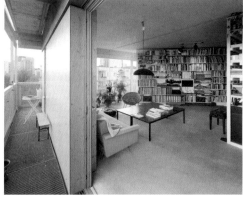

Ritterstrasse 50: The architectural and design concept accommodated an intensive participatory process, which can serve as a transferable model. The project explores spatial translation of private and common needs and has a high potential for fostering urban interaction and spatial variety.
Architects: Ifau und Jesko Fezer + HEIDE VON BECKERATH, Berlin

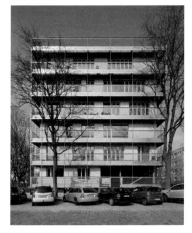

Andrea Kroth

Spreefeld: A built manifesto that strategically uses new solutions to achieve complex goals through collaborative processes—a new collective and model for the mixed-city
Program, Project, Process: Die Zusammenarbeiter, Gesellschaft von Architekten mbH
Architecture: carpaneto, fatkoehl, BAR architekten, Berlin

planning commission prohibited real ones, inspiring many other collectives to try new ideas.

Hybrid typologies contribute to sustainable urbanity with a functional mix that supports interaction with the surrounding urban community. Whereas investors normally deal in either housing or commercial real estate, collective projects are based on and developed out of existing needs. Groups who create their own niches and oases are helping to make mixed urban quarters possible. For example, August Str. 51, Berlin, by Gruentuch-Ernst Architects, or FRIZZ23 by Deadline Architects.

Collective projects are leading the way in ecology by realizing ecological living ideologies and construction standards such as high-rise timber construction or passive houses. The willingness to experiment and invest in new technologies is expressed by the users and owners themselves, who are best able to balance their merits and vices. For example, several different types of multi-story wooden construction solutions are now certified in Germany—the clients for these projects are collective groups—such as the Christburger Str. 13, Berlin project by Kaden Architects, or the Linienstr. 23, Berlin project by BCO Architects.

Future-oriented architectural solutions find new ways to create quality living spaces whilst improving the urban fabric and open spaces at the same time. Often, culturally and architecturally valuable buildings that would otherwise be unattractive for investors have been re-activated and converted by collectives who can utilize existing resources with specific, creative solutions (as self-users). And finally, through experiments, alternative solutions are tested and models for the future are developed. For example, in the Hegemonietempel by Heberle. Mayer Architects in Berlin, only a "core" space is air-conditioned; the project makes us reconsider how much space we use, and need to continually heat or cool.

By going from consumers to pioneers, many collectives have succeeded in developing projects that generate a high quality of life, added value for the community and provide long-term affordability.

The role of the architect is expanding from designer to that of an initiator, a developer, a moderator of engagement processes and project manager. It is a great challenge to organize a project in a way that ensures real involvement of the future residents on many levels and, at the same time, develops a harmoniously built architectural solution. The processes are different in every group and need to be adjusted for each specific project. Nevertheless, many architects have gathered experience and have developed exemplary strategies in which important parameters and processes are defined.

The success of our cities in the future will hinge upon how we utilize further development to improve urbanity—with an adequate amount of suitable, affordable housing and planning that meets our growing ecological challenges. Collectives can help to meet this challenge. But, in order to do so, whether ownership-based or associations, they need to be considered more highly as a strategy—within the architectural profession as well as on a political level. Most often, the largest challenge for groups is buying a site. Specifically, in getting the needed loan together quickly enough to beat other investors to the table. By designating public land for development in the form of a leasehold or a land-trust, social, cultural and urban planning goals of the city can be realized in private initiative and within long-term self-administration. Goals such as social mix, mixed use, ecological standards or non-profit constraints can all be regulated within land-lease policies. England, Finland and many other countries are reestablishing policy in order to facilitate collective building. It is time that our cities are determined by the people who live there—and that profit takes a back seat to high-quality solutions that contribute positively to the surrounding urban communities.

Friedrich Schwarz
# Urban Ecology
## How the City's Ecosystem Works

Cities are places essentially characterized by human beings—without them, the phenomenon "city" wouldn't exist. Cities differ from the open spaces of the countryside, obviously—on one hand, heavier traffic, more noise, greater architectural density, sealing of the soil surface, less nature; on the other hand, jobs, good infrastructure, better consumer services, cultural offerings. Good points; bad points. But what essentially sets cities apart from their outlying areas?

### The Trend towards Urbanization

The global trend towards urbanization is one of the most striking of the last century. The number of city dwellers increased tenfold during the 40 years up to 1990! Today, half of humankind lives in cities and the rate is accelerating. One of the most vehement critics of excessive urban development is Richard Rogers, a prominent British architect who was involved in the planning of Solar City in Linz. As an advocate of sustainable urban planning, he warns of the dangerous influence that modern megacities can exert on our environment. A city with a viable future should take into account social needs as well as environmental considerations. It should feature public transit systems that protect life on the streets, and energy systems that reduce our dependency on finite natural resources.

### How do the City and the Countryside differ?

For starters, let's take a quantitative look at city life. For this purpose, ecologists have coined the term biomass, defined as the weight of all plants and animals in a particular area at a particular time. This mass can be specified as fresh weight or dry weight. If, in addition, you compute the amount of biomass that's produced (grows) over the course of a year, then what you get is an ecologically and, often, economically meaningful indicator of an ecosystem's productivity.

Corresponding computations were made for the City of Brussels. According to them, its biomass (including 66,000 trees lining the streets) amounts to 1.5 million tons (fresh weight). In contrast to ecosystems though, only a minimal animal mass lives off this plant mass. One of the main reasons for this is that the leaves that fall from street-side trees don't naturally decompose in the soil; they're raked up and carted away. So it's no wonder that in the census of so-called consumers—the ecologists' term for living creatures who live off live foodstuffs—the slightly over a million inhabitants of Brussels make up the largest proportion of biomass: 59,000 tons. They're joined by dogs (1,000 tons) and cats (750 tons). This biomass depends on a high intake of energy in the form of fuel and foodstuffs from beyond the city limits. Despite the unnatural facts and circumstances on the ground, the city is also the site of soil life that's usually underestimated but is critical for material cycles. The population of earthworms alone is conservatively estimated at one million per hectare (= 1 ton). The biomass of Brussels earthworms is estimated at 8,000 tons, which puts them in second place behind human beings.

In comparison to natural or semi-natural ecosystems, the urban ecosystem differs above all with respect to the large external inputs of additional energy in the form of fossil fuels and petroleum-based materials. That leads to a correspondingly high output of so-called waste products: heat emissions that warm the urban climate, garbage and sewage that have to be disposed of. And the technical infrastructure for these inflows and outflows is correspondingly elaborate. To satisfy the average daily per capita demand for clean water of 130 liters (including industrial and commercial users), Linz AG pipes in approximately 53,000 m³ of water per day and delivers it to customers. The total length of all water pipes within the city limits is 594 km. At 551 km, the sewer network is almost exactly as long as all city streets put together.

### The Urban Climate

The climate too differs significantly from the surrounding region. The main causes of an urban climate's formation are the profound modifications produced by the local heat balance (thermal economy). The city can be seen as a so-called heat island

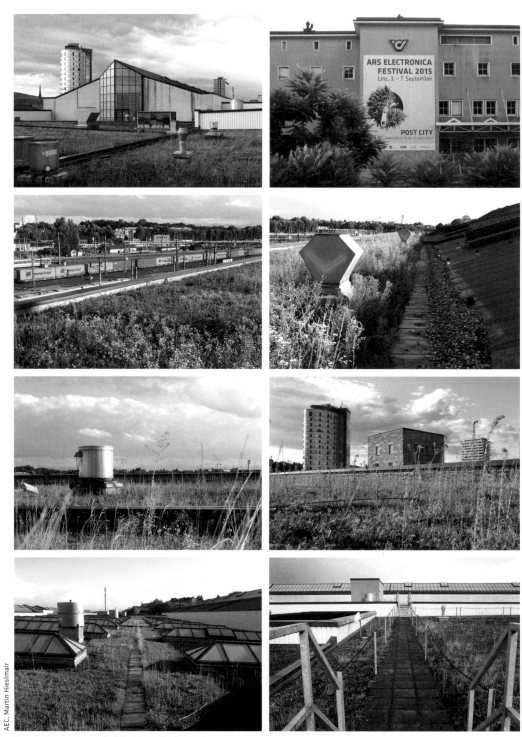

ARS ELECTRONICA
FESTIVAL 2015
Linz, 3. – 7. September

POST CITY

Vegetation on the roof of the Post City festival venue

as the result of waste heat emitted by factories and buildings, the greenhouse effect, and the heightened warming capacity of huge masses of concrete.

## The City isn't so devoid of Nature after all

Although cities increasingly resemble modern metropolises all over the world, every city is unique nevertheless. Accordingly, there are major differences from city to city with respect to the quantity and diversity of its flora and fauna. But all inner cities are where nature is most radically suppressed. Be that as it may, an inventory conducted in downtown West Berlin counted 380 higher plant species per square kilometer—though this is partially attributable to bombing during World War II (Sukopp, 1990). In West Berlin neighborhoods with lower building density and up to 55% green spaces, more plant species occur than in suburbs where the city segues into the countryside. This is due to the particularly high diversity of land use there: nurseries & garden centers, landscaped homes, allotment gardens and parks mean tremendous variety.

Special flora and fauna have gotten established on the inner city periphery where landfills, waste disposal sites, water treatment plants and fields irrigated with sewage take in and process the city's refuse. Out on the edge of town, plant diversity declines but the animal species diversity here is often higher than in the countryside where land is used exclusively for agriculture and forestry. It's strange but true: more species of birds are sometimes found in city gardens than in their counterparts in the loveliest, most idyllic village. This is simply due to the fact that cities are the nexus of a broad spectrum of biotopes: Parks rich in trees as woods and meadows; gardens as bushy scrubland; towers and walls as rock cliffs; plus, various bodies of water.

The flora and fauna that have made the city their home react to various environmental conditions. Today we know that a city's inventory of species can have undergone substantial modification, and might not have done so in ways that would have been expected—by importing exotic species, cultivating them in nurseries and propagating them in parks. The other city dwellers too—wild plants and animals that have moved into town as humankind's entourage—display significant differences. What have emerged are special urban flora and fauna, characteristic communities that precisely reflect the particular facts and circumstances with respect to land use and architecture.

What's most interesting about city-dwelling fauna is the phenomenon of urbanization (whereby birds have been the subjects of the most intensive research). This can manifest itself in the following ways:

- The city becomes a particular species' optimal biotope, above all with respect to nutrition. Therefore, the species breeds exclusively or with great regularity in the city, and typical cityscape elements (niches in walls, traffic lights, steeples) serve as brood spaces.
- There occurs an expansion of the so-called ecological amplitude—i.e. the species becomes more flexible with regard to its habitat demands.
- The urban populations are relatively stable; they reproduce, and minimal exchange with their surroundings takes place.
- Among some species, gamete development begins earlier and individuals exhibit longer life expectancy.
- Behavior modification can even occur—e.g. blackbirds that sing and breed in winter.
- The city can be the setting for the formation of new symbiotic communities that don't occur elsewhere—e.g. jackdaw-kestrel symbiosis.

## Urban Nature: What's the Point?

All this nature amidst the cityscape raises a justifiable question: Why do we even need this? There are two diametrically opposed points of view on this issue. On one hand, there's the frequently maintained position that nature with its flora and fauna is all well and good, but cities are for people! Nature belongs out in the wide-open spaces. On the other hand, there are the feelings of many city dwellers—people who relate to animals and plants and protest vociferously when trees are cut down or green spaces are rezoned for construction. For them, urban nature plays an essential role in wellbeing and daily rest and relaxation.

Nature in the city introduces variety to a mostly paved and constructed environment, brings change to the monotony of asphalt, concrete, metal and glass, of cotoneaster ground cover, blue spruce trees and expanses of lawn. Diversified urban nature

View of Linz from Freinberg: Cities are manmade ecosystems that display considerable differences based on ecological framework conditions (climate, water, air, soil) in comparison to the surrounding countryside.

The highest concentrations of species in cities are found in city-countryside transition zones.

enriches and vivifies the senses: smells, sounds, and tastes, the change of seasons. "Nature" can still be experienced, and a person's immediate environment has a distinctive character. In addition to architecture suited to human beings and city planning that has the human touch and puts people's needs atop the priority list, nature in the city makes a major contribution to endowing identity and a sense of wellbeing to everyday life in residential neighborhoods. Among other plusses, this assures that people can feel at home, that a sense of security emerges. And where people feel well and identify with the physical setting of their life is where a sense of responsibility for the common good and willingness to act in ways that are environmentally friendly and socially just can emerge.

In addition to maintaining natural diversity for its own sake—and thus as a matter of ethics—there also exists, from the human perspective, a series of "egotistical" reasons to nurture nature in general and urban nature in particular:

• The presence or absence of a particular plant or animal species is an indicator of certain natural conditions such as soil nutrient balance, air pollution and changes in the water supply. Taking an inventory on a regular basis documents how the environment is changing and whether certain measures were successful.

• Every species has its special function in the natural equilibrium. Ecosystems with high biodiversity are usually also stable systems since they can react flexibly to changes.

• Maintenance of the genetic reservoir is important for evolutionary adaptation and the emergence of new varieties. The special facts and circumstances to which urban pioneers among the plant and animal kingdoms are subjected are precisely what are conducive to the origination of genetically distinct types.

• Nature in the city is also important in conjunction with maintaining cultural-historical diversity. Old parks, village centers, millstreams and cultivated landscapes attest to historical development and endow neighborhoods with a distinct identity.

• Urban nature also has aesthetic functions. The diversity of colors, forms, sounds, and scents are very important for allowing people daily contact with nature and thus refreshment right in their own backyard. Especially for children, the elderly and people with impaired mobility, nature makes an essential contribution to their wellbeing in their residential environment.

Two prominent advocates of urban ecology have provided cogent responses to the question "Urban Nature: What's the point?"

Sukopp and Wittig (1993): "One of the most urgent tasks that conserving nature in the city entails is seeing to it that these organisms are maintained as the basis for city dwellers' immediate contact with the natural elements of their environment."

Hermann Seiberth: "Urban biotopes are also important as settings for encounters with pixies and fairies, giants and dwarves, elemental spirits, gnomes, undines and salamanders, with the Frog Prince and Mother Goose. In the wake of life's rationalization, humankind's image of nature changed. Nature became an available, lifeless, inanimate object. The starry sky is outshone by storefronts' neon lighting; Little Red Riding Hood can no longer go astray in a well-laid-out city park, but it doesn't even matter 'cause Granny's in the old-age home safe from the wolf anyway. The encounter with natural elements, with spontaneous vegetation on meadows full of flowers, in gardens, parks and debris-strewn lots can help rebuild bridges to remembrance of what's been forgotten."

## Nature Conservation in the City

Coexistence at close quarters of human beings and nature is not necessarily an incompatible arrangement, even if nature, due to its tight confinement, is more in jeopardy downtown than in spacious natural landscapes. Thus, in urban settings, our plant and animal neighbors are particularly dependent on our help.

Needless to say, we can't plan our cities primarily to accommodate the needs of frogs, dragonflies and warblers. But it's a rewarding task—not only for urban planners and parks department officials, but for private citizens too—to give some thought to how to conserve the nature that exists within the city and to nurture as much natural diversity there as possible. There's a wealth of possibilities. Biotopes in gardens provide a habitat for many different creatures. A little pond, a sunny rock pile, a stack of dead wood in a shady corner of the yard, nesting boxes, a meadow that's mowed only twice a year—give free rein to your imagination!

The aim of all these endeavors should be to maintain the city's livability for all its inhabitants—humans, animals and plants. Only in this way can we do what Seiberth told us to: "rebuild bridges to remembrance of what's been forgotten."

**Literature:**

Ambach, J. (1999). Verbreitung der Ameisenarten in den unterschiedlichen Lebensraumtypen von Linz. *ÖKO.L 21/4*, 21–32.

Kutzenberger, H. (2000). "Zirpzirp", es lebt – Artenschutzprogramm Heuschrecken Linz. *ÖKO.L 22/4*, 3–13

Laister, G. (1994). Bestand, Gefährdung und Ökologie der Libellenfauna der Großstadt Linz. Naturk. *Naturkundliches Jahrbuch der Stadt Linz*, 9–305.

Lenglachner, F. & Schanda, F. (2001). Biotopkartierung Stadt Linz, Teilbereich VOEST-Gelände 2000. Unpublished study commissioned by Magistrat Linz, Naturkundliche Station, Linz, 27 pages.

Mitter, H. (1997). Untersuchungen der Linzer Käferfauna. *ÖKO.L 19/4*, 3-8.

Moser, J. (1999). Die Reptilien der Linzer Augebiete. *ÖKO.L 21/3*, 16-22.

Reiter, G. & Jerabek, M. (2002). Kleinsäuger in der Stadt Linz. Unpublished study commissioned by Magistrat Linz, Naturkundliche Station, Linz.

Reiter, G. (in preparation). Fledermausfauna von Linz. Unpublished study commissioned by Magistrat Linz, Naturkundliche Station.

Rogers, R. (1997). *Cities for a Small Planet*. London.

Schanda, F. & Lenglachner, F. (1990). Biotopkartierung Traun-Donau-Auen Linz 1987. *ÖKO.L 12/4*, 3-20.

Schwarz, F. & Sokoloff, S. (2002). Naturkundlicher Wanderführer durch die Stadt Linz. 1. Teil: Von Mauerblümchen, Schluchtwäldern und Grillenwiesen. *ÖKO.L 24/1*, 3-10.

Schwarz, M. (2000). Linz, eine wespenreiche Stadt. *ÖKO.L 22/3*, 3-20.

Sokoloff, S. & Schwarz, F. (2002). Naturkundlicher Wanderführer durch die Stadt Linz. 2. Teil: Begegnungen mit Bibern, Eisvögeln und Fledermäusen im „Linzer Urwald". *ÖKO.L 24/2*, 20-27.

Sokoloff, S. & Schwarz, F. (2002). Naturkundlicher Wanderführer durch die Stadt Linz. 3. Teil: Edelkastanien, Obstwiesen und Trockenrasen auf dem „Linzer Hausberg". *ÖKO.L 24/3*, 3-10.

Sokoloff, S. & Schwarz, F. (2002). Naturkundlicher Wanderführer durch die Stadt Linz. 4. Teil: Unverhofft kommt oft! Seltsamkeiten im Linzer Industriegebiet. *ÖKO.L 24/4*, 3-8.

Sukopp, H. (Hrsg.) (1990). *Stadtökologie: das Beispiel Berlin*. Berlin: Reimer.

Sukopp, H. & Wittig, R. (Eds.). (1993). *Stadtökologie*. Stuttgart: Fischer.

Weissmair, W., Rubenser, H., Brader, M. & Schauberger, R. (2002). Linzer Brutvogelatlas. *Naturkundliches Jahrbuch der Stadt Linz*, 46–47.

Weissmair, W. (2001). Scherenritter in Linz. Aktuelle Verbreitung, Schutz und Management der Flusskrebse. *ÖKO.L 23/4*, 3-11.

Weissmair, W. (2001): Feuerkröten, „Schlammgeher" und andere Lurche in den Augebieten im Süden von Linz. *ÖKO.L 21/2*, 3-10.

Zechmeister, H., Tribsch, A. (2002): "Ohne Moos nix los!" Die Moosflora von Linz. *ÖKO.L 24/1*, 24-32.

Addie Wagenknecht
# Silk Road

Like many people of my generation of heavy net users, I have an origin story.

Growing up, I was a sorta-artist kid, never really good at sports—which is to say, not good enough to make varsity in a town where football and running was religion. I was clever and capable, but not, in my mind, sufficiently acknowledged. I was both bitter and sensitive, both friendless and a serial monogamist. I became hooked on the web somewhere between German class and Pre-Calculus; as my then-boyfriend discovered endless porn, I discovered War and Peace, IRC channels with anonymous people I called friends, and BB forums.

Before long, the web became my everyday lunch date. We fell in love more with each passing day. My appetite for discovery was dwarfed only by my desire for new experience: any experience, all experiences, so desperately did I want to ditch my lonely life. The web brought me total freedom. Somewhere in the early 1990s, my lifelong love affair with the web began. I transformed into this new space. Online, I could be anyone, and I could find anything. It is 2015 and I'm constantly experiencing insomnia. My friend told me my lack of jetlag is a sign that my body is in some sort of state of constant survivalism. I installed redshift on every screen I look at. In the meantime, my tablet is constantly alerting me to appointments, at retweets or Slack messages. I open Slack, 15 times a day, for part work (open hardware summit), part community (Deeb Lab), I rely on email lists for the latest trending news (F.A.T. lab, ListServ), and I use Twitter to maintain my careers pulse with collectors all over the world (bitforms). We are creating a world where the obsession for material goods and Twitter followers have left us all within an environment of chronic habitual work. Where life is lived between LAX, CDG and forgetting which airport you are departing from and which one you are going to (yes, this has happened to me more than once). We are placeless in the sense that we are homeless. We are homeless in the sense that we do not identify with a geopolitically defined space but rather with the network. I am a citizen of the net.

The hyper-real disenchantment with physical culture has become a habit of our everyday routine. We chronically check our phones. We are addicted to the refresh button. We trust companies more than the individual. We have invested in machines our ultimate desires and secrets. We have become a culture that is confessional, where our cellular providers know more about us than our families. To look at the world, we look at our screens. We look at screens more than we look at what is around us. Every Google maps search is an artifact of the privilege of the overhead view and a comment on the monopolies used to produce it: In Google We Trust. Perhaps I'd reached some sort of transcendent state fueled by coffee and lack of sleep, but when I first discovered the deep web, I felt the excitement of discovering the web of those Netscape days all over again. It was the first time since the early days of the net, I felt the transformation of public to private. I no longer had to navigate and perform as myself on a daily basis though credit card charges and e-mails. The mundane slogging of the details of the "real" world dissolved. I was safe in a web of VPN exit nodes.

As theorist Mark Hansen explains, the notion of identity extends into different planes of reality as we experience "smart" technologies—or what he calls "mixed reality". This mixed reality is a recent phenomenon, "what is singular about our histortechnical moment, is precisely the becoming-empirical, the manifestation of mixed reality as the transcendental technical, the condition of the empirical as such". Even though the "smart" technologies and digital technologies may have not just yet completely transcended our physical space, the potential for deeply profound, real exchanges and experiences becomes naturalized and normalized within the network. I realized while exploring the deep web's labyrinthine, intricate barriers and unknowns it was not so far from the same rush I felt getting lost in the markets in Istanbul or Goa. I fell in love with the unknown and being unknown just the same. Perhaps because the most interesting thing to happen in my life these days is the arrival of the FedEx truck. The nomadic gypsy life I lived for

so long has dissolved into a family, an address, and some state of normality. The deep web, however, reflects the nature of my other long-lost loves: this dark uncertainty and some escape, for which I fell those years ago, now rebooted.

It reminds me of the internet of my youth—the lost Wild West. The deep web offers anything you ever wanted and more, at your fingertips. Its endless possibilities felt just as anonymous as my early days and late nights online in the 1990s. So much adventure and discovery. The dark felt safe and familiar again. I found it, it found me—and perhaps we'd fall together.

Michael Fischer once called hacking an "endlessly repeatable collusion of freedom and determinism—the warp and woof of fixed rules and free play." The deep web, in a contemporary culture—which thanks to Chelsea Manning and Snowden we have learned is so heavily controlled—embodies this dichotomy of freedom and constraint. It was as though it exists only to turn against itself. Its existence seems impossible in such a conservative, dried-up world. I was absorbed by its freedom to exist. I was in love with it, and, like everything I've loved, it was just a matter of time until it destroyed itself.

As Marshall McLuhan once pointed out—authorship must be attributed. The last time in history authorship was not valued was prior to the printing press. It was that invention which did away with anonymity and gave value to fame and property. Culture became consumed with what was 'authentic' and so, in order to be authentic, it had to be attributed, but with attribution we lost innocents and unrestricted freedom. In my memory, the Internet of my teens was as innocent as I was. It was a free and an unrestricted place. Just how one night in the 1990s, from the middle of a small town in Oregon, I TCP/IP'ed onto the web, in all my 14.4k glory, and became a citizen of the world. And now, on the deep web, almost 20 years later, I discovered that curious place again. It was wild, yet contained within itself, paths erased and untraced. While systems create parameters for control, at the same time they create methods of how that control can be defied. Tools can be used to make things as much as they can be used to break things down. *Authorship is gone with the deepness.*

Silk Road was a bazaar for those who could find it. It looked a little like eBay in the late 1990s, only instead of a short URL, it had a long, cryptic address that could only be accessed through Tor—a decentralized network of servers that encrypt and relay traffic in order to obfuscate a user's online activity. Silk Road represented a desire to connect while, simultaneously, being isolated—untracked and anonymous, without cookies or caches or even names. Like all relationships, we formed our history on trust and secrets. It illustrated how many of us can live a blurred existence between online and offline. We want it all, and so we can have it all. The Silk Road functioned like an enemy of the state: although it was seized and taken down by the FBI, it was quickly replaced by a hundred other marketplaces. At some point in its short life, the space occupied by the Silk Road began to embody a generation that has become and is becoming a large, anonymous, singular identity. We do not take credit for an entire work; instead, we live with many, by git pulls and repositories. When you cannot put boundaries on something or trace its shadow, the movement and motions become much more pronounced. In quantum theory, it's said that the world is simply a potential, and that whatever happens is nothing compared to what *didn't*. According to some economists, capitalism thrives on destroying the past, on deleting previous economic orders and the current value of existing products, in order to create new wealth and new systems.

This is where we are now. Perhaps we're no longer the creators. As individuals, we're simply signal filters. We receive signals, and filter them according to the taste of ourselves, manifesting a new culture. If the current version doesn't make sense, it gets debugged and reversioned to something smarter, cleaner and more parsable. This is the beauty of what we lost—and what will replace it. We succeed more with every take-down and take-up. The future we hold cannot be stopped. Not without stopping us.

Carlo Ratti

# Towards a New Conception of Working Spaces

The modernist city of Le Corbusier—the one outlined by the Athens Charter—was divided into siloed areas for working, living and leisure. Today, the digital revolution allows for the creation of new types of mixed spaces, offering new possibilities for the hybridization of working spaces.

Here in Boston, in the basement of MIT, there are still some "mainframe" computers, dating back to the Sixties and Seventies of the previous century. What strikes us about these dinosaurs of the information age today is not so much their computing power—often less than what each of us carries in our pocket thanks to smartphones—but the fact that they forced us to work in inhuman conditions. Forty years ago, in fact, operating a computer required a large room, usually in a dark and sealed atmosphere, and many hours to handle punch cards. The characteristics of the work environment were dictated by the needs of the machine.

By the beginning of the new millennium, the computer had been reduced to a desktop tower, complete with keyboard and a monitor. Users enjoyed a more pleasant computer-based work environment, though they remained tied to a fixed location. Working space had become slightly more human. Finally, today we work on tablets or laptops, and the network of wireless connectivity allows for far greater mobility. Moving from room to room, we can connect to different screens or keyboards, appropriating different interfaces in the workplace. All of this is part of what was predicted by Mark Weiser, a visionary computer scientist working at Xerox Park: "First were mainframes, each shared by lots of people. Now we are in the personal computing era, person and machine staring uneasily at each other across the desktop. Next comes ubiquitous computing, or the age of calm technology, when technology recedes into the background of our lives."

Technology "in the background" opens up unprecedented possibilities for architects and designers: it allows us to put the needs of the human ahead of the machine. And this is revolutionizing both the design of workplaces and their social dynamics. Offices are becoming more flexible, with fewer areas for individual work and more informal areas for interaction. Francis Duffy, one of the pioneers of "new office" design, once told me: "When I started practicing, a few decades ago, the common areas in office buildings rarely exceeded 10 percent of the total. Today we are at over 50 percent", a configuration that promotes interaction and exchange of ideas within an organization as well as making better use of buildings. Today, the dynamics of co-working are becoming ever more fluid: rather than working from home, self-employed profession-

als favor common areas to share services and ideas. We are currently working with TAG, a concept born in Italy that is popping up all over the world. TAG, short for Talent Garden, is an international network that provides spaces for co-working, young startups and freelancers who work on innovation. It is not only about shared offices. It is a laboratory of ideas: a place to establish new partnerships and become part of professional networks.

Rejecting isolation doesn't necessarily mean being tied to a specific place. Both "space" and "time" are becoming more flexible, and can be spent in several places with places for work being diffused across the whole city. Since the American coffee chain Starbucks started to provide wireless Internet connections, many of its rooms have been converted into neighborhood work hangouts. From the perspective of urban dynamics, this becomes very interesting, as it allows a better use of public spaces through the superposition of different activities: the areas that were once used only in limited periods of the day (such as the lunch interval), now become active all day.

We can even use outdoor spaces as "offices". For the city of Guadalajara in Mexico we have been working on the masterplan for a large redevelopment project of an urban area based on the concept of the outdoor office—benefiting from Guadalajara's year-round pleasant climate and the native courtyard architecture to create spaces to work in the open air. Because of our site's location next to the Parque Morelos—and its beautiful historical fabric built around outdoor courtyards—it's possible to imagine people working in a new way, in indoor-outdoor working environments, liberated by increased mobility and new technologies.

Today's visionaries predict a utopian era where work time is reconciled with leisure time, where country and cities are connected. But this is nothing new; it is not so different, for instance, from Élisée Reclus' dream at the end of the 19th century. He supported the virtues of democratic urbanism and the interest he took in cities makes him, in fact, an active town-geographer, although more from the political "polis" angle than the "urbs" angle. In one of his seminal works he wrote: "Man must have the double advantage of access to the delights of the town, with its solidarity of thought and interest, its opportunities of study and the pursuit of art, and, with this, the liberty that lives in the liberty of nature and finds scope in the range of her ample horizon." We will soon see if our future will be so generous—but in the meantime, we can rejoice in working in better spaces, no longer chained to the cold and dark MIT basements.

Madeleine O'Dea
# Polymath's Paradise
## Ou Ning Reimagines Rural China

When I ask Ou Ning how he would answer that perennial dinner party question, *What do you do?*, he laughs. It's not easy for one of China's true poly-maths, but he gives it a try. "I'm a cultural worker," he offers modestly, before teasing out the twists and turns of a career that has taken him from under-ground poet to concert promoter to star designer to documentary film-maker to curator to biennial director to think-tank animator to literary editor and, finally, to where he finds himself presently, plotting how to revivify his country's rural life, which has been denuded by 30 years of runaway economic reform.

Ou was born in 1969 in Suixi, a small fishing village on the western tip of Guangdong Province, to a poor family who normally would never have been able to send their son to university. But when he was 10 years old, China's government made a decision that would transform his family, his village, their home province of Guangdong, and the country as a whole. For the first time in the history of the Peo-ple's Republic of China, the door was opened to for-eign investment, initially through a series of special economic zones. The first of these, a coastal hamlet called Shenzhen, would play a special role in the Ou family's fortune. Situated just over the border from Hong Kong, Shenzhen's economy exploded once its new status was established, and the government was soon dispatching recruitment trucks deep into the countryside in search of labor for the city's bur-geoning factories. One day a truck rolled into Ou's village, and his sister decided to take the chance and jump aboard. It would be her factory wages that would ultimately pay for Ou to attend university.

His sister still lives in Shenzhen, but, she is no urbanite and has never felt at home there. But there is nothing for her back home. Like thousands of other villages across the country, Suixi has long been hollowed out from years of development. Meanwhile, the cities are submerged under waves of workers seeking a better life. Thirty years ago, 70 percent of China's population lived on the land; less than 50 percent do so today. Ou believes there is an urgent need to rebalance the country and the city, to find a way to reconstruct the countryside so it can draw people home again.

It's not an idea one might expect from someone who started his career as the quintessential urban-ite. Fresh out of university, Ou worked as a concert promoter, and in 1999 he grabbed public attention with *New Sound of Beijing*, his study of underground music in the city. The book was a marriage of gritty reportage and freewheeling design, and a chance for the self-taught designer/writer to play with a riot of visual ideas to express the energy of the capital's exploding music scene. The chutzpah of *New Sound of Beijing* attracted the attention of the acclaimed artist Fang Lijun, who needed a designer for the first serious book on his own work. Ou got the gig—and through it got to know the curator Hou Hanru.

At the time, Hou was working on a theme for the 2003 Venice Biennale: an exploration of urban spaces as "zones of urgency" created out of "urgent demands rather than planning." Ou, a Guangdong native who had watched the Pearl River Delta be swallowed by industrial sprawl, knew what this story was about. He teamed up with video maker and rising art star Cao Fei, to make *San Yuan Li,* an experimental documentary film about a village situ-ated on the fast-advancing frontier of urbanization. As the city engulfs it, the traditional farmland of San Yuan Li village is eaten away until all that's left are the farmers' homes. Trapped within the city with no land to sustain them, the villagers find them-selves renting out rooms to displaced farmers from other parts of China who are coming to the city to work. Cao and Ou captured this strange world of lost souls on video in stark black and white, revealing a teeming community existing within, but still apart from, its host.

It was around this time that Ou first came across Rem Koolhaas's 2002 book *The Great Leap Forward.* "Koolhaas," says Ou, "could find the power and energy behind the city. He was not only interested in architecture but in politics and economics, too—his method was totally new to me." Soon Ou was "read-ing more about urbanism, about urban geography and how the process of urbanization in Asia was producing conflict." In 2009 he curated the Hong Kong & Shenzhen Bi-City Biennale of Urbanism and Architecture. In one section, he explored the contrasting histories of his declining hometown of

Suixi and the rising city of Shenzhen; in doing so, he thought more about how problems in the cities were connected to the decline of the countryside, and how the husklike villages might be just as important to consider as the teeming, overcrowded cities.

Looking to rural life for inspiration and spiritual strength has deep cultural roots in China, but over the past hundred years some intellectuals have also felt a duty to serve the countryside in return, finding ways to support and reinvigorate rural culture in the face of industrialization. In this group could be counted the educator Y.C. James Yen (1890–1990)—who promoted mass literacy campaigns in China's countryside in the 1920s and '30s and set up the first peasants' newspaper—and even, in some senses, Mao Zedong.

Ou believes the notion of rural reconstruction has become critical and is helping to coalesce a movement of thinkers and artists who are responding to displacements resulting from the last 30 years of development. "If we can create more job opportunities in the countryside, people who are in a bad situation in the city can come back," Ou posits. He reflects on the situation of his sister: "She can't find herself in the city," he says simply. "I want to do something to help balance the countryside and urban life, to help people whether they live in the country or in the city. That's why I want to do something for the rural reconstruction movement."

Anhui province is situated in China's rural heartland and is now one of the country's greatest sources of urban labor. Women flock to the cities to work as maids or factory workers, while the province's men are the muscle on construction sites all over China. Anhui had become a byword for poverty over the last century, but today it is buoyed by remittances—and tourism.

Huangshan ("Yellow Mountain") is a place fabled for its natural beauty, its jagged granite peaks wreathed in clouds. Monks built temples on its slopes in the 13th century; in the 16th century, the region inspired a school of landscape painting, of mountaintops, pines, and clouds, defining elements of Chinese art. Poets, too, have eulogized Huangshan, from Li Bai in the Tang Dynasty onward. It has retained its allure: Contemporary poets gather here to party on the peaks, and some have chosen to settle nearby. One of those poets is Han Yu.

Her move—and that of the writer Zuo Jing—to set-tle in Anhui inspired Ou to take a closer look. The area is also famous for its rural village architecture, which has all but disappeared elsewhere in China. This is the architecture of what were once thriving trade centers that grew in the Tang Dynasty and prospered for more than a thousand years. On the granite-paved streets of towns like Xidi (a World Heritage site), Hongcun, and nearby Bishan, where Han has settled, are houses and public halls with carved stone façades and elaborately ornamented wooden interiors built with techniques that have survived the vicissitudes of the past 60 years. Sensing that places like this could endure not just as tourist sites but as places to make a new start, Ou bought a home in Bishan in 2010.

Ou sketches out his vision. A town like Bishan shouldn't depend on tourism or weekending urbanites. He wants the villagers to thrive by using the skills they have always possessed. He pictures local carpenters busy at home rather than on distant construction sites, and women weaving traditional fabrics in the village rather than being lost to factories in the cities.

Over the last couple of years, Ou has built up a database of all the traditional local skills—food production, fabric making, interior decoration, architecture, and carpentry—and the people who still possess them. His idea is to create an economic base for these villages by helping them make products that urban people will want to buy. That's where his friends come in. Ou has spent the last 20 years working with artists, writers, designers, and architects; now he has a vision of city-based designers working with rural carpenters to create furniture that fuses urban style with real craftsmanship, and handwoven fabrics that will strike a chord with fashion houses looking for something new.

With a lot of help from friends like Han and Zuo, as well as a slightly bemused local government, Ou threw the first Bishan Harvestival, which featured music, dance, a mini documentary festival, academic panels on rural reconstruction with local and Taiwanese intellectual heavyweights in attendance, and, most importantly, the chance for outside designers and artists to interact with local tradespeople and artisans.

Text published by courtesy of the author.
First published in *Modern Painters*, June 2012

Ou Ning

# The Bishan Project
## Restarting the Rural Reconstruction Movement

During World War I, the leader of China's mass education and rural reconstruction movements Y. C. James Yen (1893–1900) was a student at Yale University majoring in political science and economics. In 1917, the Beiyang government (a series of military regimes that ruled from Beijing from 1912 to 1928) joined the Entente Powers of World War I, declaring war on Germany and the Austro-Hungarian Empire, and nearly 200,000 Chinese laborers entered the battlefields of Europe. After graduating from Yale in 1918, Yen volunteered his services in France to members of the Chinese Labor Corps, mostly writing letters for illiterate workers wanting to communicate with their families back home. It was here on the battlefields of Europe that Yen first had the idea of teaching laborers how to read and write, and also where he established the first ever Chinese-language labor publication *zhonghua*

*laogong zhoubao* (China Workers' Weekly). Moved by Yen's teaching and assistance, one member of the labor corps sent Yen the wages he received for three years of service in Europe, which amounted to 365 French Francs. From this experience, Yen realized the potential for learning among the common people, and was inspired to return to China and start the mass education and rural reconstruction movements that ultimately gave shape to his lifelong dedication to developing the strength and knowledge of the people.

After enduring the slaughter of two world wars and the hardships posed by the Cold War, the countries of Europe sought to make real a European Union. Notions of mass education and rural reconstruction forged in the conflagration of Europe's battlefields swept mainland China during its Republican Era, but were not enough to dislodge entrenched

political and social realities, and even today, more than a century later, China's leaders continue to seek improvements along these lines. During the Republican Era, the chaos and power struggles of warlordism gave rise to frequent changes in political power, as well as the proliferation of countless ideologies and social movements. Quests for industrialization and urbanization repeatedly washed over the country, but agrarianism was too deeply rooted in society, and the vast population of uneducated, closely-knit residents was unable to adapt to these changes touted as modernization. And even today, despite the rhetoric of a rising China, chronic backwardness plagues the nation.

At first China's leaders introduced communist political solutions from Europe, and more recently neoliberal economic ones from the United States, but both have resulted in endless problems. These modes of political administration and economic development have merely established a stage for party struggles or benefited society's upper strata, but never enabled the poor and working classes to guide history. Nonetheless, developing the strength and knowledge of the people is still an important talking point in today's China. After the turn of the new millennium, pressure on rural areas, agricultural industries and farmers to industrialize and urbanize has steadily increased, prompting some intellectuals to rethink the direction of China's development. Returning to the mass education and rural reconstruction movements of the Republican Era for ideas, they have launched new reconstruction campaigns in various parts of the country that make use of the political, economic and cultural resources of rural areas, and in doing so, have rejected globalization and excessive urbanization in favor of local issues.

The Bishan Project is one such project resulting from the history outlined above. In 2011, Zuo Jing and I chose Bishan Village in Anhui Province's Yixian County as the site for Bishan Commune, which is our experiment in rural reconstruction and living. In the first year we invited artists, architects, designers, musician, film directors, writers and student volunteers from around China to visit the Bishan area and survey local society. Based on this foundation, we started planning for the first Bishan Harvestival in cooperation with the villagers. Festival activities centered on the presentation of village history, protection and revitalization of housing, design of traditional crafts, staging of traditional regional opera and music performances, production and screening of documentaries about the villages, and conducting forums where rural reconstruction workers who advocate different schools of thought and practice in various areas can share their experiences. For our second festival held in 2012, the Yixian County government entrusted us with the planning of the seventh Yixian International Photo Festival, which included participants from Asia, Europe and North America and focused on themes of environmental protection, community-supported agriculture, rural economic cooperatives and community colleges.

Another practitioner of rural reconstruction, Wen Tiejun, uses the School of Agricultural Economics and Rural Development as his knowledge base. His approach differs from Bishan's emphasis on art and culture as entry points into village life, in that he directly applies political and economic strategies to develop community organizing, operate community colleges, further agricultural technology training, help farmers establish economic cooperatives, and promote Community Supported Agriculture. Fundraising for the Bishan project relies solely on large-scale art events, such as my decision to incorporate my work as curator for the International Design Exhibition at the Chengdu Biennale into the Bishan Project in order to share the budget. Furthermore, our networks and working experiences lie mostly in the art world, and because Bishan is located in the Huizhou region, celebrated for its rich cultural heritage and humanities, we have chosen to use artistic production as our primary starting point for reconstruction practice.

Art production in the Bishan Project is rooted in rural culture, and has arisen from reflection on local art institutions and practices. Art in China today is an extremely lively and flourishing field of endeavor, yet has been increasingly stifled by the public authorities and commercialism. Institutional mech-

anisms such as biennales, galleries, auctions and art expositions, which are outgrowths of European and North American museum systems, while vast in their global reach, have already been reduced to urban and national brands for the purpose of marketing, or even carnivalesque forums for commercial trading and financial investment. Art production has been relegated to the assembly line to meet the needs of supply and demand, while the power of creativity and social critique are further diluted on a daily basis. Art production and circulation are concentrated in urban areas associated with economic development and high population densities, leading to production values that by no means favor border regions or rural areas and ultimately the injustice of regional imbalance. Cities possess a surfeit of cultural resources and opportunities while cultural famine ravages border regions and rural areas, which is a pattern duplicated on a macro scale by the globalized political economy.

Before and after starting the Bishan Project, we researched rural experiments by artists and intellectuals in different parts of Asia, including Rirkrit Tiravanija and Kamin Lertchaiprasert's Land Project in Chiang Mai, Thailand; the Echigo-Tsumari Art Triennale held in the mountain villages of Niigata Prefecture, Japan; and Indian author Arundhati Roy's opposition to the Narmada dam project and support for Maoist farmers. Focusing on collisions between globalization and local politics, economies, culture or traditional lifestyles, these practices explore alternative art systems and culture-based strategies to promote social movements and the revitalization of overlooked agricultural regions of Asia where rice is grown for food. We have sought inspiration from like-minded artists and intellectuals such as these when designing our Bishan programming.

The Bishan Project is not just art programming, however. We started out from wanting to address those imbalances between cities and the countryside that have manifested grim realities such as the deterioration of agricultural industries, rural villages, and farm laborer empowerment, and are the direct result of excessive urbanization. The project relies on the accumulated experience of the rural reconstruction movement led by Chinese intellectuals since the Republican Era, as well as the cultural practices of various rural regions in Asia. Adopting the intellectual resources of China's traditional agricultural industry and rural philosophies, as well as leftist or even anarchist ideas, Bishan aims to combat the encroachments of globalization and neoliberalism, and by using art and culture as our first point of entry, we ultimately hope to influence politics and economics with our work in rural areas. Our interests lie in exploring the economics of rural life, establishing relationships between the city and countryside based on mutual sustenance, promoting labor practices based on mutual aid and exchange, establishing a social structure based on horizontal power, adopting consensus-based decision making, applying direct action, reviving the tradition of autonomy in China's rural areas, and transforming Utopian ideals into Realpolitik.

Most people in China imagine Europe and the United States as successful representatives of a certain kind of modernity, which has led to countless waves of wild-eyed advocates over the last 100 years. But unfortunately westernization has left China in the awkward position of being neither here nor there. An obvious example would be the lure of individualism, which has undermined China's traditional patriarchal society and threatened the once stable relationship between the city and countryside that

was based on mutual sustenance. Before so-called modernization, China's countryside provided the cities with children who would grow into the next generation of elites, and form associations in the cities with others from the same hometowns. Longing for their hometowns, these city dwellers would often send money back to the countryside, and thus supported rural areas with the construction of ancestral temples and schools, or aid for the poor and orphans. Today, however, along with the popularity of individualism, feelings for rural hometowns have faded, and been replaced with the concept of discarding the old, leading to grave consequences. Those from the countryside who move to cities for work or school are proud to have gotten away and do not send money back home, and the urban-rural relationship has become antagonistic.

Reasons for these problems also lie in deeper levels of social institutions. Historically, contemporary land use and the household registry systems in China have always seen the relationship between the city and country as binary-based, but misunderstandings between the two cultures are also a significant factor. As the pioneering researcher and professor of sociology and anthropology Fei Xiaotong (1910–2005) has said, traditional Chinese society in both the countryside and city was unified based on the notion of one's native soil. Fei goes on to claim, with respect to familial relationships, social organization followed a "differential mode of association," and with respect to politics, started at the top with politically centralized power and moved down to power at the county level. From the county level down, social organization and stability relied on the autonomy of landowners in small villages. Since the May Fourth Movement (1919), this traditional social structure has been continu-

ally criticized and transformed leading to chronic disorder. Since the end of the Cold War, China has actively embraced globalization and, guided by GDP and the urbanization movement, has reallocated human resources even more intensely than under the Cultural Revolution. The majority of rural land resources have been reallocated to urban commercial development, which has resulted in continual reduction of acreage under tillage. Agricultural businesses move closer to bankruptcy on a daily basis and the population is increasingly reliant on imports for food and energy, which has in turn reduced the country's ability to resist global disasters.

Traditional rural society in China has always had the ability to resist outside forces based on its economic self-sufficiency and political autonomy. Re-evaluation here is not intended as a reactionary call for a return to the past, as all countries today are compelled to form some relationship with globalization. The "small states with few residents" that Laozi claimed were ideally suited to good governance cannot possibly exist in today's world, much less in a country as vast as China with its overflowing population. Revisiting rural society means preserving those features which still hold advantages under new historical conditions, and to pursue with open minds new paths that emphasize the unique offerings of China that are different from those pursued by other Asian countries or by Europe and the United States thus far. The Bishan Project, as an experiment conducted in a rural area of China, has purposely chosen this kind of path, and hopes to retain a broad vision and open mind, yet a practice focused on local regions.

March 18, 2013, Beijing. Commissioned by the *Europe (to the power of) n* project. The Chinese version was published in *ARTCO* Magazine, April issue, 2013, Taiwan.

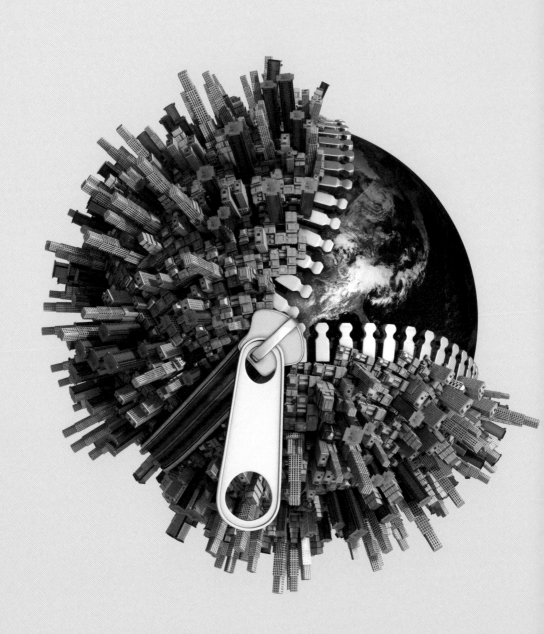

# HABITAT 21

Michael Badics

# Habitat 21
## Solutions-related Projects in Urban Space

The development of habitats in the context of urbanization is as diverse as the definitions of "habitat" to be found in a dictionary. The urbanization process of the 21$^{st}$ century—as well as natural and environmental conditions—is bringing about significant changes in how habitats come into existence and evolve in different places. Consequently, human beings need to find new solutions to deal with this dynamic process of habitat evolution.

*Habitat 21* exemplifies the variety of habitats on different levels. It shows how strategies are employed to cope with challenges caused by a framework of cultural, religious, political, historical, and natural parameters. In this context, social, economic and ecological sustainability of a habitat is one of the central aims. Improving this sustainability also leads to an improvement of living conditions in general. Cities and their citizens need to be ready to face the ever-changing framework conditions and to deal with the challenges in a constructive, positive way. Consequently, city planners (and citizens) look for new ways of approaching the problems related to habitat development.

The analysis of specific examples such as Nepal reveals the diversity of habitats and shows that each habitat is a unique space with distinctive features. This individual character of each habitat is reflected in the way the parameters are interconnected. On the one hand, each habitat's network of parameters differs, which means that the approach that works for one habitat may not work for another. On the other hand, living spaces with a similar set of parameters may share similar problems—and they may share the same kinds of solutions. Therefore, it is necessary to look at each habitat's specific features and dynamics, in order to find the best strategies to solve existing problems.

To sum up, it is important to understand the habitat itself and its individual conditions and processes. And to have wide-ranging cooperations and networks among people in all social strata and walks of life. Additionally Big Data, Open Data, and a different way of thinking paired with new innovative use of technology will all play an important role to foster better understanding of cities as a living space—and to develop future perspectives.

Ars Electronica Solutions, The Grameen Creative Lab,
Engineers without Borders Austria

# After the Disaster
## Crisis as an opportunity

The earthquakes that shook Nepal in April and May 2015 have affected an estimated 8 million people in Nepal—almost 1/3 of Nepal's population—across 39 of the country's 75 districts. Entire villages were flattened, while others were severely damaged. In the aftermath of the earthquake, aid and hopes for reconstruction are directed towards the city rather than rural areas, which are difficult to access. The prospect of higher living standards in the city therefore incentivizes the rural population to flee to the cities. Ars Electronica Solutions and the Grameen Creative Lab initiated first steps to support the reconstruction of villages, starting with Katunje Benshi in the district Kavre Palanchowk. Engineers

Kathmandu, after the earthquake

Kathmandu, after the earthquake

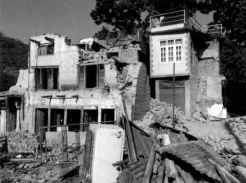

Raghuchour village, after the earthquake

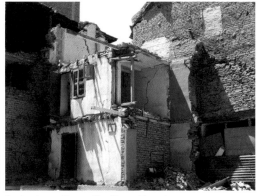

Raghuchour village, after the earthquake

Raghuchour village, after the earthquake

without Borders support the project, creating a concept to construct buildings more resistant to earthquake damage with local materials and resources. The aim of the project is to reconstruct rural areas in a sustainable manner and to improve livelihood opportunities. Based on an ecovillage approach, the rebuilt villages are more socially, economically and ecologically sustainable. This approach leverages technology to enable communities to operate with minimal ecological impact while creating a richer and more efficient way of life.

Text: Michael Badics, Klaus Dieterstorfer, Marie Masson

A cooperative project by Ars Electronica Solutions, The Grameen Creative Lab, Engineers without Borders Austria

Lukas Maximilian Hüller, Hannes Seebacher,
Kilian Kleinschmidt, Robert Pöcksteiner

# Post Refugee City

Photographer Lukas Maximilian Hüller and artist Hannes Seebacher jointly launched the *Let the Children Play* initiative. *Let the Children Play* is an effort to visualize ethnic values—in keeping with the United Nations' guidelines for the protection and promotion of fundamental human rights and the rights of children. In cooperation with numerous artists worldwide, this initiative has produced several projects having to do with games and playing. The point of departure was *Children's Games*, a 1560 painting by Pieter Bruegel the Elder, which Lukas M. Hüller updated by means of elaborately staged photographic settings in various countries throughout the world.

*Let the Children Play at Zaatari Refugee Camp* took this initiative to the next level. Here the aim was to observe people in extreme situations and to really work together with them: The refugee camp as the end of the line. As the crisis in Syria goes on with no end in sight, a whole generation of children is being scarred by violence and displacement and beset by hopelessness. A desert that was devoid of human beings not so long ago is now the site of Al Zaatari, the world's third-largest refugee camp. This small city in the middle of nowhere has a population of 100,000, of which 60,000 are children and young people. The mission of Kilian Kleinschmidt, the former UN commissioner responsible for organization and coordination at Al Zaatari, is to set an example: the Post Refugee City that addresses the possible economic and logistic future of the refugee city and seeks an effective way to deal with the consequences of modern mass migration. Kleinschmidt tirelessly preaches Beyond Survival, a term

he coined to refer to the impossibility of satisfying people's need to preserve their dignity and identity with only a tent, water and bread. And this is where an extraordinary form of cooperation comes in: this seemingly unrealistic photography project undertaken by artists Lukas M. Hüller and Hannes Seebacher. Their initiative is an attempt to create a positive, iconographic symbol and get hundreds of refugees—children, youngsters, and grown-ups—actively involved. This isn't just "playing" with kids in a refugee camp; this is art as necessity, a means of acknowledging and maintaining the dignity of the individual amidst extreme circumstances. This is an attempt to get inside the cage that, for many, is precisely what enables them to survive. *Snapshots in Time*, a documentary by filmmaker Robert Pöcksteiner, goes inside the cage. Instead of encountering refugees, he meets human beings. Mortally afraid, they fled from Syria, leaving behind all they had. Attorneys, physicians, gardeners, housewives, school kids, mechanics and nurses—they're all in a refugee camp now, seeking something to do while waiting for peace to return to their homeland. How they deal with their fate and pass the time each day is recorded by Pöcksteiner and reported without commentary.

*Let the Children Play* project, realized at Zaatari Refugee Camp, Jordan, by Hüller / Seebacher, 2014 / produced by playfoundation.org. Featured in Robert Pöcksteiner's documentary film project *Snapshots in Time*, Zaatari Camp. Project and photo compositions realized with the substantial support of Kilian Kleinschmidt, former camp manager Zaatari Refugee Camp.
*http://www.letthechildrenplay.info*
*http://www.dontpanicproduction.com*

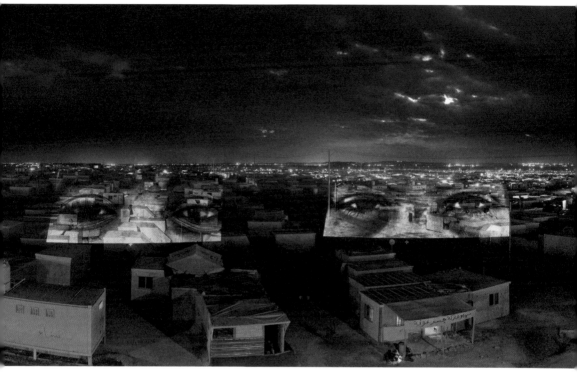

*Zaatari Twilights*, refugee children projected onto Zaatari Camp, by Seebacher / Hüller, 2014

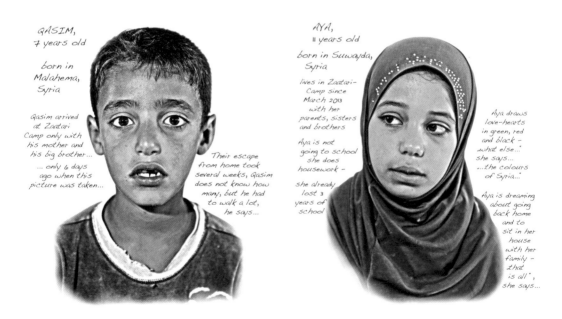

QASIM,
7 years old

born in
Malahema,
Syria

Qasim arrived
at Zaatari
Camp only with
his mother and
his big brother...
... only 6 days
ago when this
picture was taken...

Their escape
from home took
several weeks, Qasim
does not know how
many, but he had
to walk a lot,
he says...

AYA,
11 years old

born in Suwayda,
Syria

lives in Zaatari-
Camp since
March 2013
with her
parents, sisters
and brothers

Aya is not
going to school
she does
housework -

she already
lost 3
years of
school

Aya draws
love-hearts
in green, red
and black -
what else..."
she says...
...the colours
of Syria..."

Aya is dreaming
about going
back home
and to
sit in her
house
with her
family -
that
is all",
she says...

*Children of Zaatari*, portraited by Lukas Maximilian Hüller, 2014

# What Does Peace Look Like?

Curated by Lois Lammerhuber

*HEAL* by Davide Tremolada is above all a personal expression about war. In each image a wild animal is put into a war zone, in places affected by bombardments and prolonged fighting. The presence of the animal points to the potential for healing these places. No animal can stand calmly in a place if it senses imminent and actual danger to its life. The suffering that fades away is not forgotten but internalized and overcome, for people eventually to be at peace with others.

*HEAL* is only one example of the works of the six winners of The Alfred Fried Photography Award 2014—Pierre Adenis, Emil Gataullin, Heidi & Hans-Jürgen Koch, Max Kratzer, David Tremolada and Ann-Christine Woehrl. The winners' works and an edited version of the shortlist will be exhibited at Post City. All these works plus a special jury edition of 320 images will be shown on a 12-screen-installation in the Ars Electronica Center lobby.

But The Alfred Fried Photography Award is much more than just a photography competition. It is the only photography award worldwide that reaches out to people, encouraging them to express through their images how they think of peace and to create a visual answer to the question: *"What Does Peace Look Like?"* The annual award ceremony takes place at the Austrian Parliament in Vienna and will also serve to commemorate the journalists killed on duty and will include a keynote speech on peace—this year by Kailash Satyarthi, 2014 Nobel Peace Prize laureate. The "Peace Image of the Year" will be released to the international media on September 21, 2015, the United Nations International Day of Peace. The Alfred Fried Photography Award 2015 attracted a total of 14,115 photo entries from 121 countries on all five continents.

*http://www.friedaward.com*

Organized by UNESCO, Austrian Parliament, The Austrian Parliamentary Reporting Association, International Press Institute, Photographische Gesellschaft and Edition Lammerhuber. Curated by Lois Lammerhuber. *HEAL* by Davide Tremolada is one of the 6 award winning works.

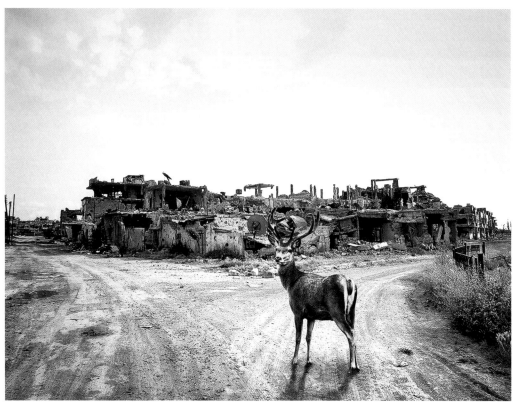

*HEAL*, Davide Tremolada

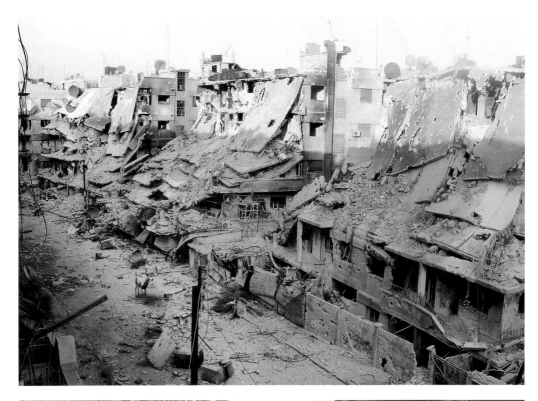

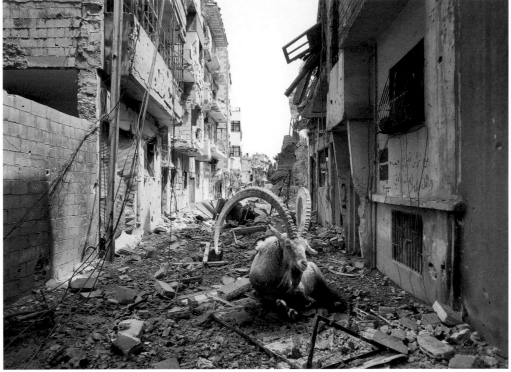

*HEAL*, Davide Tremolada

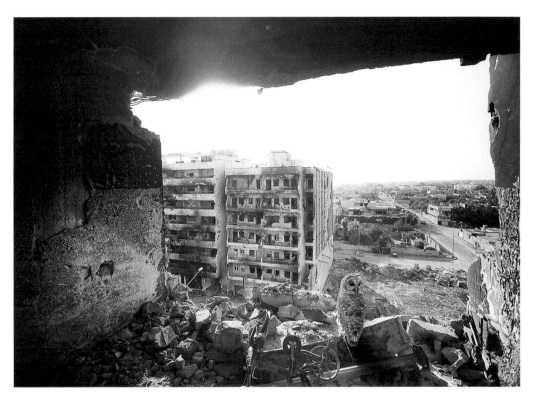

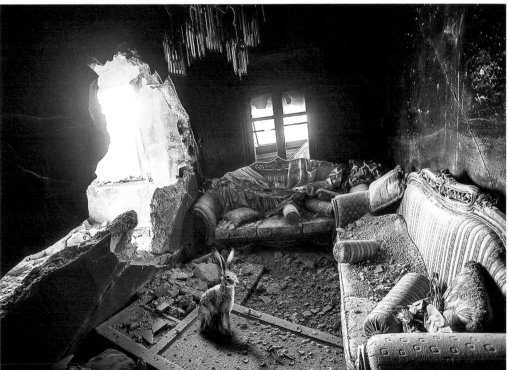

*HEAL*, Davide Tremolada

Ianina Prudenko

# Mythogenesis

This project embodies my observations as a new media researcher. Its purpose is a visual analysis of propaganda videos that have become a source of the mythogenesis process of the new Ukrainian hero. Critical analysis reveals various aspects of this process and points out inconsistencies regarding the objective processes. It will facilitate the development of alternative hero images and fix a polynarrative of heroics in the emerging cultural memory. Seven videos were selected for visual analysis. Some of them were broadcast on TV, others are on the Internet. All videos are characterized by a high degree of pathos created by archetypes of Ukrainian culture, national symbols, exalted music, and even Soviet poetry from WWII. Three parameters were selected for the mythogenesis analysis of the modern Ukrainian hero: gender, language, and the comparison of soldiers and volunteers as heroes. The analysis data are presented as visualization in the exhibition space. There are 3 pairs of graphs (female/male, soldiers/volunteers, Russian/Ukrainian) on which the image size of the hero depends on the timing of her/his appearance in a shot. Lev Manovich's cultural analytics was an inspiration for the visualization of the analysis. Along with the graphs, there is the device in which museum visitors can view the analysis source material.

According to the general results it can be concluded that the mass media-created image of a modern ATO (anti-terrorist operation) zone hero is predominantly male, mostly speaks Ukrainian, and is an exceptional soldier. The project was presented at the National Art Museum of Ukraine during the exhibition *Heroes. An Inventory in Progress*, curated by Michael Fehr (Berlin) and the curatorial group of the NAMU. Discussion of *Mythogenesis* during the opening in the museum gave rise to a heated debate, which proved that the process of the myth's deconstruction—even during its formation—is a very painful process for the national community.

Visualization: Iryna Kostyshyna, Kateryna Mokriak, Alina Iakimenko

Ian Banerjee

# Educational Urbanism
## Rise of the Learning Intensive City

Biblioteca España

Educational Urbanism Tours in Medellin

From over 150 international references, collected between 2009 and 2015, the author infers the convergence of three globally emerging trends of social practices: a) In the domain of educational planning he sees a growing trend towards an "urbanization" of educational planning; b) in the domain of urban planning he sees a trend towards "educationalization of urban planning" and c) in the domain of civic engagement and the bottom-up making of cities ("tactical urbanism") he sees a rapid diversification of collective learning of citizens. Researching these trends has been an ongoing project of the author since 2009. In 2010 he coined the term "educational urbanism" to draw attention to the emergence of a new paradigm of urban planning at the converging ground between the above-mentioned domains. The city Medellin in Colombia has explicitly started to use this term. Medellin has gained international acclaim

for its remarkable transformation in the last ten years. Beside "social urbanism", which is the umbrella term it uses to define its overall planning philosophy, it speaks of "pedagogical urbanism" interchangeably with "educational urbanism" to describe how it connects education, urban planning and civic engagement to set in motion a multi-dimensional process of social and urban transformation.

The author's research is based on the assumption that the 21st century city will be shaped by Learning Intensive Societies of various kinds. The creation of "ecologies of learning" as relational pools of local knowledge (as "open source" and "topographies of knowledge") will a) create more "dispersed intelligence" among the sectors of society, b) enhance the capacity of individuals, organizations, communities and cities to respond more adequately to their needs, and c) help citizens develop new forms of urbanism.

Habidatum & Mathrioshka
# Semantic Landscapes

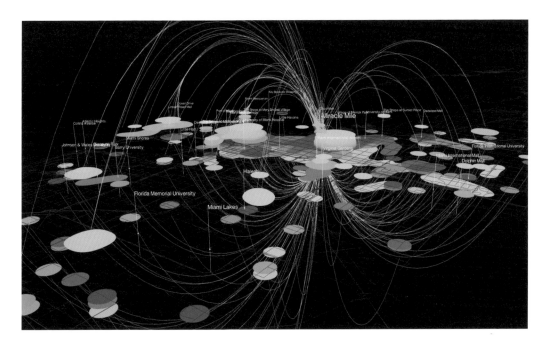

The city is not only the conglomerate of buildings and roads, jobs and homes and people moving in between—it is an interconnected environment constructed by the interactions of people with people and with physical objects. It is also a set of images evolving through space and time and navigating the communities in urban environment. Virtual city is an extension of the "actual" one. Enforced by digital technologies, this city of interactions, thoughts and images is dramatically changing the urban way of life. But it still remains invisible, unexplored and disregarded. What if we could unveil the invisible virtual city? What if we could explore its relation with the "actual" one we got used to seeing and dealing with? What if we could challenge our views on the city, both in its "actual" and in the virtual dimension? Habidatum presents a set of projects that approaches these questions in different fields, regions and scales. Explore the mental geography of Moscow, the emotions of tourists and locals in Barcelona, and the connections of Miracle Mile (south Miami) with other urban areas via Twitter discussions!

Text: Alexei Novikov, Katya Serova (Habidatum)
Vadim Smakhtin, Eduard Haiman (Mathrioshka)

Habidatum develops analytical visualization tools for urban decision-making. Mathrioshka works in the fields of digital design and data visualization.
Project management and urban analysis: Habidatum
Data analysis and visualization: Mathrioshka
Acknowledgements: Moscow Urban Forum; Barcelona Urban Lab / Barkeno, Cooper, Robertson & Partners

Katja Schechtner, Dietmar Offenhuber

# sensing place / placing sense 3
## improvising infrastructure

This year's instance of the *sensing place / placing sense* series investigates the pockets of informality inside the formal urban systems that structure our daily lives. Not only in the megacities of the Global South, life is characterized by a constant struggle with infrastructure. The electricity grid, logistics and supply chains, transportation—every system that is centrally planned and managed from above always requires some level of improvisation and tinkering from below in order to make the system work for its users. These creative appropriations are, however, never part of the official representations of infrastructure; they are marginalized and difficult to observe. As a result, there is a misbalance between what we know about formal structures and what we can only infer about informal practices.

In this hybrid between a workshop/panel/exhibition, we bring together people who deal with urban informality from different angles. The project *Manila Improstructure* investigates and documents the creative practices around the electricity grid and the street lighting system of Manila, Philippines, in collaboration with the Urban Planning Institute of the Technical University Vienna and Julia Nebrija, VivaManila.

60

The Grameen Creative Lab
# Social Business

GrameenDanoneFoods

Yoghurt enriched with crucial nutrients

GrameenCreativeLab

Six Principles of Grameen
Social Business

1. Business objective will be to overcome poverty, or one or more problems (such as, education, health, technology access, environment, etc) which threaten people and society; not profit maximization.

2. Financial and economic sustainability.

3. Investors gets back the investment amount only. No dividend is given beyond investment money.

4. When investment amount is paid back, company profit stays with the company for expansion and improvement.

5. Environmentally conscious

6. Workforce get market wage with better working condition.

7. do it with Joy

"I believe that we can create a world without poverty because it is not the poor that create poverty."
Nobel Laureate, Muhammad Yunus, Grameen Creative Lab

Unlike traditional business, a social business operates for the benefit of addressing social needs that enable societies to function more efficiently. Social business provides a necessary framework for tackling social issues by combining business know-how with the desire to improve quality of life. Muhammad Yunus has already shown the effectiveness of this new type of business: his clear focus on eradicating extreme poverty combined with his condition of economic sustainability has created numerous models with incredible growth potential. With the idea of social business, he has introduced a new dimension for capitalism: a business model that does not strive to maximize profits but rather to serve humanity's most pressing needs. Social business will not replace traditional business. It will coexist with it—and expand our idea of what it can mean to "do business". We believe that social business is capitalism at its best: creating, innovating and expanding.

The Grameen Creative Lab GmbH,
*http://www.grameencreativelab.com*
Executive Director: Hans Reitz

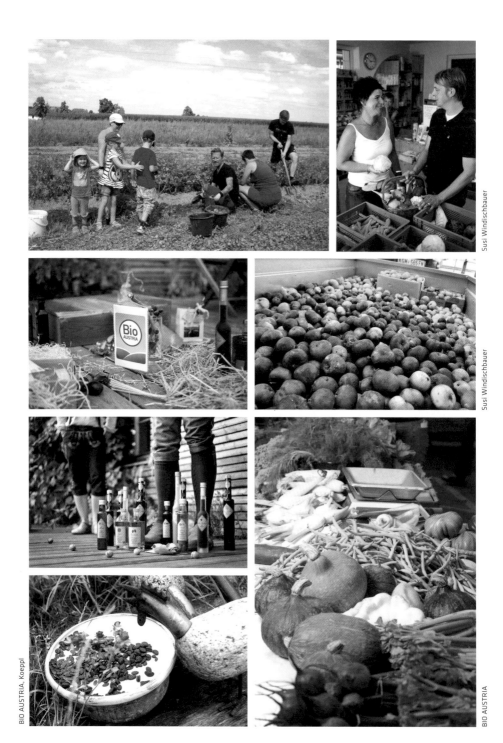

BIO AUSTRIA
# Farmers' Market of the Future
Organic farmers are securing the future of healthy nutrition

The 2015 Ars Electronica Festival will scrutinize emerging developments in urban living and life in the 21ˢᵗ century. We at BIO AUSTRIA, this country's largest association of organic farmers, are focusing on the future of nutrition and the production & distribution of foodstuffs. The way we see it, the answer is clear: Our food has to be organic!

How about a future in which chemical pesticides and herbicides are no longer used? In which farmers do without fertilizers fabricated from petroleum? In which we put a stop to the exploitation and degradation of the soil? In which livestock are kept in ways that are respectful and appropriate to their species? In which nutritious, nutrient-rich foodstuffs containing no chemical residues or additives were abundantly available for all?

Ars Electronica is making a loud-and-clear statement with great future promise by endeavoring to serve organic food at this year's festival. Plus, on Saturday during Festival week, there'll be a *Farmers' Market of the Future* at which the wide array of products produced by Upper Austrian organic farmers will be presented and offered for sale. At public discussions, panelists will talk about their experiences with trendsetting approaches like organic production per se, agriculture in which solidarity is an utmost principle, and food distribution via co-ops. In the Province of Upper Austria, there are already about 15 volunteer-staffed organic food co-ops that are pioneering new modes of local food and short food supply chains for rural and urban areas, and the *Kochtopf statt Mistkübel* (Into the pot, not into the garbage) initiative, where people can directly experience wastecooking—how garbage is removed from our throwaway society and turned into delicious meals, turning consumerism on its head.

Supported by BIO AUSTRIA Upper Austria

TU WIEN and Inter-American Development Bank (IDB)

# Urban Design Laboratory

Peter Scheibstock

Panama Lab, 2015

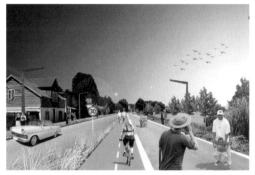

Tamara Egger

Valdivia proposal result Costanera

Sebastian Sattlegger

Valdivia

Tamara Egger

Santiago Dominican Republic Chile, 2014

The Urban Design Laboratory (UDL) is an experimental design methodology combining people-centered planning, participatory planning tools, urban strategies and urban design. The UDL is calling for a shift—away from rigid, conventional planning approaches towards more complex and flexible ones, developing collaborative and multisectorial design solutions in the context of rapid urban growth in Latin America and the Caribbean. The leading elements of UDL are the people and the information they have about a specific, complex and local situation. We as planners moderate and design sustainable new neighborhoods, revive abandoned areas, extend cites and design urban regeneration projects. In local workshops, local key actors and the community elaborate together planning visions, scenarios and urban strategies, which are developed further by the UDL designers. A collaborative feedback process is shaping the proposals and pilot projects. The UDL was successfully tested in over ten partner cities in Latin America and the Caribbean and is a constantly improving tool-kit.

*urbandesignlab.org*
*www.facebook.com/UrbanDesignLaboratory*

Text: Roland Krebs

Roland Krebs: Emerging and Sustainable Cities Initiative, Inter-American Development Bank, Washington, DC, USA, and Institute for Urban Design, University of Technology Vienna, Austria
Andreas Hofer: Institute for Urban Design, University of Technology Vienna, Austria

Lisa Mittelberger

Xalapa Mexico Emerging Topics

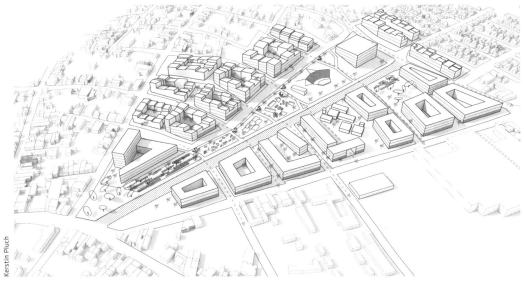

Kerstin Pluch

Campeche Mexico long-term urban vision

Roland Krebs

The Panama LAB–workshops in Panama City

Roland Krebs

The Panama LAB–the community workshops

CityIF

# Urbanization as Disaster

Beijing Ponding Map

CHU Yan

Distribution of Unusual Behaviors

Mao Min

||| Unusual Behaviors
Number
— Ring Road
▬ Slum

Urban disaster, born of rapid urbanization and resulting from the inter-reaction between the built environment (buildings, roads) and grown environment (climate, ecology and society), is generating new and mixed urban landscapes. This is exemplified in Beijing, which, despite the rain and water deficiency, is frequently flooded due to the city's faulty, antiquated water infrastructure and microclimate change in the region, and in the evolution of habitats due to the many urban migrant workers, who survive by living in neighborhoods between urban and rural areas and working unofficially. How can we "capture" and include them in passive/active participatory data mapping? On the bright side, will it inspire the idea of future urban habitats? Two of CityIF's works call for debate.

Text: YANG Lei

Beijing Municipal Institute of City Planning & Design,
CITYIF Urban Planning Cloud Platform

Beijing Ponding Map

CHENG

[tp3] architects and Eddea Arquitectura y Urbanismo
# Citythinking—WHY IS MORE

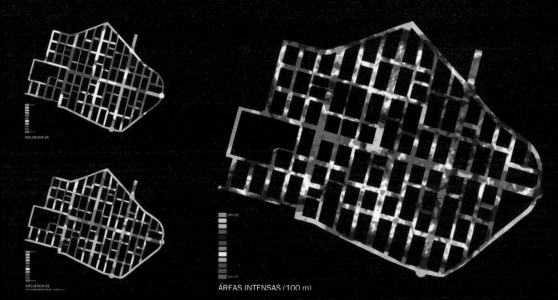

INFLUENCIA DE

INFLUENCIA DE
EQUIPAMIENTOS (100 m)

MENOR

MAYOR

ÁREAS INTENSAS (100 m)

Citythinking is an open organization to display, rethink and adapt territorial organizations, linking economy, society and environment. For us, the city is a superposition of simultaneous events, a strained network that links these three areas. We work to create the conditions for a new dialog between them through a Holistic Development Strategy. Questions are formulated, spatial structures visualized, reconsidered and adapted. In the era of the Post City, and in contrast to the mythical "Less is More", the excessive "More is not Enough", or the latest Nordic "Big is more", our motto "WHY IS MORE" reflects a new attitude towards the huge contemporary challenges facing us.

"WHY IS MORE" is the question that is linked directly to the theme of development processes. Each adaptive change is accompanied by a categorical "why". In nature, development tends towards perfection in order to be more efficient. But nothing is bigger, better or higher without a reason!

By questioning our territorial reality, decoding it through mapping different flows as energy, communication, information, we can generate more rich and creative proposals, to help to improve our closest environment. This perspective will be linked with the idea of Post City and will be visualized with a presentation of the creative process.

For the Ars Electronica Festival 2015, the Linz-based architect team [tp3] and the Seville Urbanism and Architecture consultancy, Eddea Arquitectura y Urbanismo, deal with strategic development processes of cities to present a creative approach for the future urban development during the festival. The way through the exhibition contribution also reflects the representation of this strategic process operation. What this strategic development process is all about, we want to clarify in this post.

*http://www.eddea.es*
*http://www.tp3.at*

Original Idea: Citythinking by Eddea
Concept Design and Production: Citythinking by Eddea and [tp3] architekten
Graphic Design: Citythinking by Eddea.+ Conacento SL
Organization, Translation: [tp3] architekten

# 1,001 Models of Habitats for the 21ˢᵗ Century

Austria's largest architectural exhibition, created by architects and urban planners: This year's Ars Electronica Festival showcases visible manifestations of their inventiveness, visionary power and planning competence in the form of an amazingly diverse array of architectural models.

What will the cities of the future look like? Naturally, this will depend on the way architects and urban planners are designing them today. Whatever is built now will shape the cityscape for decades to come, and decisively impact the next generation's quality of life. The infrastructure that we don't implement now will be sorely missed tomorrow. The city is a long-term project, and the "gravity of buildings" entails totally different lifetime cycles to those of the disposable smartphone electronics. So how can we connect these two developments—cre-

ating smart cities that, instead of causing anxiety, can actually enhance our lives? What should habitats for smart city citizens be like?

Ars Electronica is especially intent on localization—relating these big issues to the specific facts and circumstances prevailing in Linz and Upper Austria, and implementing a point of departure that is as simple as it is effective: a gigantic model city set up in the huge halls of Post City. We want to create a visible manifestation of architects' visionary power, planning competence and inventiveness, one that features as many architectural models as possible—regardless of whether they were actually built or only proposed, from a DIY prefab house to a futuristic high-rise, from houseboats to row houses, from a kindergarten to a factory ...

*http://www.aec.at/postcity/1001modell/*

grüne Mitte, Projekt der Familie, Linz, 2013
Architects Gärtner+Neururer ZT GmbH

Neue Mittelschule, Schörfling am Attersee, 2012
Architects Christian Sumereder, Reinhold Wetschko

Bezirksalten- und Pflegeheim Haid, 2014
Gsottbauer architektur.werkstatt

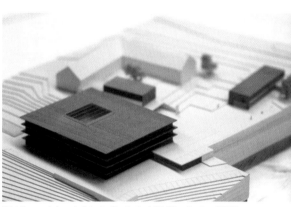

Wettbewerb Landwirtschaftschule ASS Altmünster, 2006
Architects Mayer+Seidl

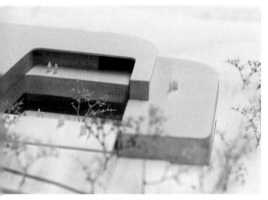

Hospizhaus Tirol, Hall in Tirol, 2015
Gsottbauer architektur.werkstatt

*LINZ HUB*, Neues Institut für Raum und Designstrategien, Linz, 2006
waax architects

EUROPAN 11, Stadtteil der Zukunft, Tabakfabrik Linz, 2011
[tp3] architekten, ZT. GmbH Henter I Rabengruber

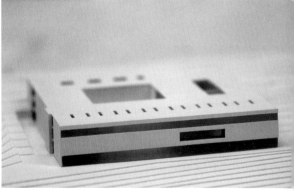

AgrarBildungsZentrum Salzkammergut, Altmünster, 2007
Fink Thurnher architects

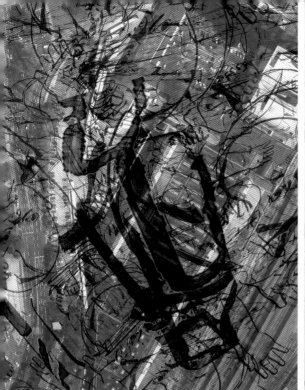
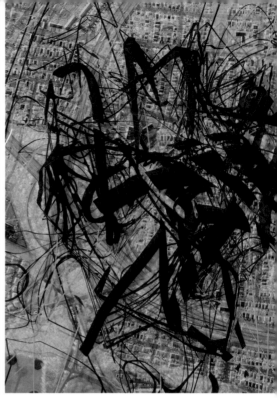

Markus Riebe, *Form/Code/Maps: Linz, Post 2, Kanal Q*, 2015
3D Lenticular Image, 81 x 107 cm, unique print

Markus Riebe, *Form/Code/Maps: New York, Kanal Q*, 2015
3D Lenticular Image, 81 x 107 cm, unique print

Markus Riebe

# Form/Code/Maps: Air Corridors

The series *Form/Code/Maps: Air Corridors* consists of twenty 81x107 cm lenticular images from 2015, which allow you to experience areas such as landscapes, forms, space, atmosphere all in computer-generated 3D images. (The three dimensional impression is produced using optical ton lenses. This illusion can be seen without 3D glasses however only in the original exhibition, as you can not reproduce this illusion on photographs or on screen.) Arial plans of cities provide a real frame for orientation from which floating, fluctuating shapes emerge. These creations are based on virtual wireframe models that serve as containers and projection surfaces for graphical trails, drawings, and textures. As semi-transparent texture maps they are coded by their positions in space. The conflicting forces of virtuality and reality invite the viewer to choose between the two worlds, while simultaneously discovering that this is impossible. The image morphs according to the viewer's position, providing an ever-changing experience. Stereoscopic depth-perception allows the image to 'interact' with the user. The computer is used only as a tool on the sidelines, for example, when slicing the 3D levels for the lenticular images on the final product. Essentially the computer provides the matrix for the alignment of the models, the order of patterns and the islands of consciousness. Floating artifacts, remnants of code dissolve the established views computer users have on city plans. Concentrating on the space above the plans removes the original function of them for your orientation. In previously empty areas of land, structures and interferences appear before your eyes, which help redefine what is meant by "City". The visual and spatial structures irritate in their effect. Questions are raised about one's own position and general state of consciousness using pictures of the city.

Jess Ching-wa Lau

# The Fading Piece

*The Fading Piece* is a duo stop-motion animation with sound. In this installation two side-by-side screens simultaneously project a diminishing pastel on the right, while the screen on the left reveals the line-by-line development of the fading district of Kwun Tong in Hong Kong. It is based on a photo titled *Kwun Tong Town Centre* from Wikipedia, which no longer looks the same due to an urban renewal program. The role of the animator is restricted, as the length of the animation is determined solely by the diminishing pastel. The installation reveals the artist's preoccupation with time, symbolized by the process of consumption of the pastel.

*http://cargocollective.com/jesslau/The-Fading-Piece*

Artistic advisers: Kaho Yu, Tamás Waliczky, Kinchoi Lam
Silver Award Winner and the Best Local Work of 20th ifva Media Art Category. *www.ifva.com*

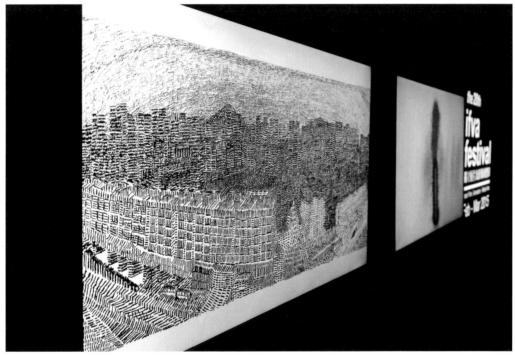

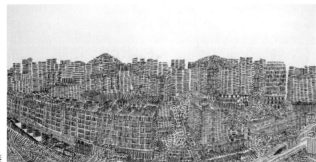

Andreas J. Hirsch

# Re-Reading the City
## Views of the Post-Urban Condition

Reassuming the role of the photographer as a kind of post-flaneur, Andreas J. Hirsch casts personal views on the city reflecting the post-urban condition as such. Using the photographic image as the raw material of memory as well as of vision leads to detecting shifts in the fractal body of collective images of "the city after the city". Photography is applied here in its ambiguity as one of the most personal and at the same time the most ubiquitous of media. *Re-Reading the City* follows hidden traces of the inner city behind the obvious city, the different cultural cities and their specific codes embedded in

the same places. It uses strategies of psychogeography and situationist practices. Following pathways and losing your way are both part of the concept, as are unexpected encounters with the obvious as rediscovered in emerging views.

For *Re-Reading the City* photographer Andreas J. Hirsch reflects the cracks in the public image of a city, looks at the periphery of urban space in transition and at the lost dimensions of the center while exploring and commenting on the Post City.

Norbert Artner
in cooperation with Thomas Macho and Ingrid Fischer-Schreiber

# Hallstatt Revisited

Since 2012, Hallstatt hasn't only been a town in the Salzkammergut region of Austria. There's also a place of that name in the southern Chinese Province of Guangdong, in the vicinity of Huizhou, a city of 4.5 million inhabitants in a logistically favorable location, a one-hour drive from Hong Kong, Shenzhen and Guangzhou. The Chinese version is called "Hallstatt See" 哈施塔特.

The word is that the wife of one of the men on the Board of Directors of China Minmetals Corporation, the state-owned company operating this project, is an Austria fan, and the replica was her idea. Hallstatt is a UNESCO World Cultural Heritage site; the air quality is fine, the landscape intact; it epitomizes respect for tradition—all factors meant to attract the prosperous Chinese middle class and to set the *Hallstatt See* project apart from other knock-offs of European towns in China. To produce it, Austrian Hallstatt was meticulously photographed—right down to the last detail. These photographs then served as a "template" for a Peking architectural firm. Nevertheless, they only copied the core zone of Hallstatt: the Marketplace including the Trinity Column (mirror-inverted!), the quaint old homes packed together along the *Badergraben*, and the Protestant Church. On the surrounding hills and beside a lake—a former reservoir—are villas and row houses in what you might call Bavarian style. The amazing thing is the comparatively high quality of the craftsmanship that went into the copy. *Hallstatt See* was originally planned to contain 6,666 residential units; in the meantime, the project has been scaled back considerably due to a slump in the real estate market.

The *Hallstatt Revisited* project documents this process of transcultural reflection and the practice of citation. It examines the question of what possibilities of innovation are introduced by this form of imitation. It asks: What is the relationship between the model and the copy, the original and the quotation? It scrutinizes imagination and globalization, function and appearance, inclusion and exclusion, ideal and cliché. Its subject is not only the "original copies" of the architecture, but also the "images in the picture" that can be perceived in the photographs taken in both Hallstatts. The boundaries become blurred so that the original as well dissolves. Ultimately, it gets hard to tell which Hallstatt actually inspired the other.

The large-format photographs taken by Norbert Artner in the Chinese reproduction of Hallstatt don't come across as—and this is the source of their great strength—satirical or supercilious cultural critique. They open up a new narrative that raises questions rather than providing closed answers. These works make it clear that the global cultures of the future will not emerge from conflict and competition, disputation over original versus copy, but rather from a multiplicity of novel practices of participation, interest and the experience of diversity.

The photographs of Hallstatt and Hallstatt See were taken between 2010 and 2014.

Norbert Artner, Hallstatt (Upper Austria) and Hallstatt See (Boluo, China), 2010–2014

Norbert Artner, Hallstatt (Upper Austria) and Hallstatt See (Boluo, China), 2010–2014

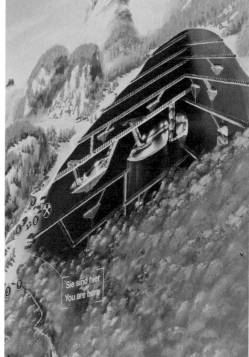

Norbert Artner, Hallstatt (Upper Austria) and Hallstatt See (Boluo, China), 2010–2014

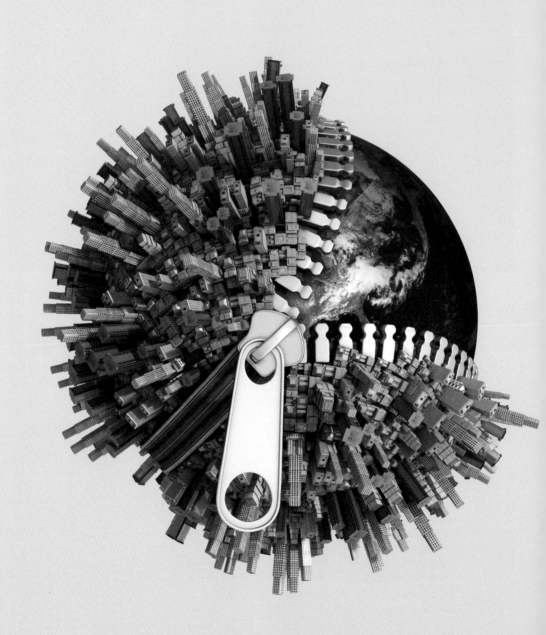

# THE FUTURE CATALYST PROGRAM

Alexander Mankowsky

# Futures Studies & Ideation
## Autonomous Cars: The Introduction of Automation into Society

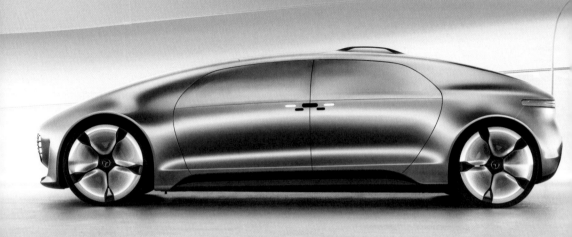

*Futures Studies* are widely done as a process which ends up in scenarios about possible futures. There are two quality gates for these scenarios. The people who assemble these futures should have expert status, and every scenario should be free of contradictions. The finished reports then are most often presented to politicians or executives with a more or less alarmist request to take action. These procedures originated before the Internet age, before Google democratized expertise for everybody.

*Ideation* on the other hand is often seen as a follow-up of customer research: the researcher has to observe people for unsatisfied needs, and then somebody has to come up with a service or product to satisfy the unsatisfied. In effect, people in all their diversity are reduced into segments of needy beings, lacking consumer goods to feel better.

For Daimler, a company with a proven capability to innovate against the mainstream[1], I will show a different approach. It is intended to be vital and open, fitting to today's way of fast, collaborative innovation. It is a three-step process, simple and flexible. I will use these steps to illuminate a path into a desirable future.

The automobile has formed our civilization for a century. Now, transformative change through automation has targeted the automobile itself, which will recursively touch every artifact and every habit shaped through the automobile in the 20th century. My thesis is that the introduction of automated cars into the open wilderness of public streets will play out its potential only as a collaborative invention. So, what can we do about the future of the car, and of our society?

### 1. Learn: Driving Forces—Get a Sense of Time

"The past is never dead. It's not even past."
William Faulkner, *Requiem for a Nun*

The first step is to develop a sense of time, appropriate to the driving forces of automation and mobility. Usually, as human beings, our sense of time is restricted to quite short segments. If we are losing the moment, we take a deep breath to slow down. A reason for this shortness might be the relation of time to activities: something lasts "a cigarette" or "a cup of coffee"; the talk was boring, awful moments at the dentist—activities we can experience, repeat and remember. If you try to imagine

a 10-year period, most of us will fail. If you have a child, you will celebrate its 10th birthday, while struggling with the feeling that 10 years have flown by. Working in the car industry, a short timespan of a single breath—inhale and exhale—takes round about 7 years. 7 years is the average time to create and develop a new model, the next S Class for example. The whole lifecycle of a Mercedes-Benz car is calculated over 25 years. Aviation marches to an even slower beat: Boeing's emblematic 747, known to the public as "Jumbo Jet" or "Queen of the Skies", has been in operation in its basic form for more than 40 years. Her maiden flight was with long gone Pan Am! In 2013, we had our first Future Talk, a workshop on Engineer's Utopia with international media and several experts, in the 1960s' Pan Am Lounge in Berlin. Brands can be immortal, after all.

## Collective Desires in Time

The US Interstate Highway System was accomplished in a 35-year period, starting in 1956 with the Federal Aid Highway Act. The initial plan goes back to 1925. Robert Moses, the master builder of New York, was roughly four decades in charge to render NY into the model of a modern city, replicated worldwide[2]. Investment in infrastructure was orientated at the "Level of Service"; the more car traffic, the better.

The collective desire driving these massive developments was about speed and order, rational, technological, and efficient—in short: to be modern[3]. Henry Ford's factory, River Rouge, democratizing the automobile, was the icon of 20th century modernity. Le Corbusier ventured out to visit Detroit in 1935. His Ideal Cities were designed for fast automobiles[4].

Today, the collective desire for speed is long gone, there are no land speed records in the news, and the supersonic jets are moved into museum spaces. The built infrastructure however has not vanished like the desire; it is still there, most of the time overused and, in effect, a far cry from the speedy transportation once imagined. Most important: the infrastructure cannot be adapted to the growing demand anymore. There is simply not enough unused, free space. Additionally, it is not car traffic alone that must be accommodated: in ever growing urban areas, pedestrians, residents, cyclists, public transportation, and businesses, are demanding their own lanes, separate spaces or recreational areas. Streets are increasingly treated as the last remaining buffer in this heated competition.

Considering the growing density in all attractive places, it is obvious that sharing of public spaces[5] must be re-invented. As a practical prerequisite of the needed remodeling, in August 2014, "California Has Officially Ditched Car-Centric 'Level of Service'", as the LA Streets Blog reported[6].

Infrastructure and cities are neither scalable, nor can they easily be updated or replaced by a 'new version'. The resulting inertia stands in stark contrast to the fluidity of Internet-based applications[7]. Re-using, re-modeling and re-purposing seem to be the most promising way out.

## Cybernetics

> "One of the great future problems which we must face is that of the relation between man and the machine. Render unto man the things which are man's and unto the computer the things which are the computer's."
> *God and Golem, Inc.*, Norbert Wiener 1964, p. 71–73

The root concept for automation is Cybernetics, initiated by Norbert Wiener and broadly discussed in the Macy conferences, 1941 to 1960. Cybernetics as a driving force is far from dead, on the contrary, it has developed branches like the Internet, Machine Intelligence, Robotics, Smart City, IoT, the Sharing economy and on and on. Current AI concepts and automated cars have a 75-year history[8].

Cybernetics from the beginning had issues with the differentiation between life and technology. The "Negative Feedback Loop" was seen as a constituency of living beings and machinery alike, which leads straight to the concept of the replacement of humans with robots, or Ray Kurzweil-style intellectual pranks such as mind transfer and transhumanism. Transhumanism revives the soul-body metaphor where the mind is prisoner of the body, waiting for liberation. This concept is fed by cybernetic ideas about the path to the creation of artificial life, only hindered by insufficient computing power. Besides readily available proof of the inseparability of mind and body (try: fall in love and maintain a clear mind), neuroscience is about to prove a very tight connection between organic matter and mind[9].

In today's discussion about autonomous cars, the conceptual confusion on artificial life brings up misguided concerns about robots, as if they could decide at will on life and death.

## Sharing: The Collaborative Economy

At the crossing of technological and social innovation, a new driving force has established itself: The Collaborative Economy. In our case, it is not only the car or the empty seat inside the car to be shared, but also the public spaces once they are freed from monofunctional use. The conceptual idea, the "Shared Space", stems from the 1980s to 1990s, made popular by Hans Monderman, a radical Dutch traffic engineer. He proposed to translate the car-only street into a place where traffic, leisure and business coexist in harmony. In his time, he had as means only goodwill and architectural remodeling at hand. Technology-wise, there was nothing helpful in reach. In effect, the 1990s Shared Space concept failed as a mainstream movement.

Today, the Sharing, or Collaborative Economy is a working concept. With the help of technology, it is possible to activate commons (like GPS and the Internet) in combining underused resources (like apartments, couches or cars) with people, acting as consumers and entrepreneurs alike. Automated mobile devices are promising to enable people to share public spaces in an economically and flexible, creative way using scalable platform approaches.

## 2. Explore: Contribution of the Avant-Garde, Artist-Inventors and Activists

> "Art is always a search for understanding, and the different levels and frequencies of that search feel completely comfortable and natural to me."[10]
> *In search of perpetual fluidity,* Californian artist Doug Aitken, FT, June 27, 2015

Innovation today is heading in the collaborative direction. The rationale behind this movement lies in the interdependence of technological and cultural innovation, as in the potential of the always-growing diversity in the global, networked world. It can't be done by experts staying in their echo chamber of conventional wisdom; we need specialists with expertise and entrepreneurial spirit, cross-fertilized by broad and diverse participation. Diversity has to be invited on the basis of power parity and mutual respect. Therefore I like to get in contact not only with the scientific community, but also with creative people, artists, activist, and artist-inventors. In short: the "naturally curious" crowd. Take for example the "Megatrend Connectivity". The overwhelming majority of trend researchers will agree to "Connectivity" as a megatrend without thinking twice. A so-called "no brainer".

But then, look what artists are doing with the device that is most strongly identified with this trend, Apple's iPhone. The artist-inventor Dennis de Bel remodeled an iPhone as a device for a Smoke Message Service. What does that mean? The perfected connectivity of an iPhone was degraded to an ancient way of communicating with smoke signals! The Megatrend Connectivity was dissolved into smoke.

Dennis de Bel, *SMS–Smoke Message Service*

Mark Lascelles Thornton, a British artist, created a very large painting using Rotring pens, called *Happiness Machine*. His artwork showed a city: The financial world, expressed through their iconic status buildings, is sitting above a dungeon-like mall where people are busy buying stuff. Shockingly, in the middle of this mall is a fetus on display, lying inside a large booth. Helpless on one hand, on the other hand a symbol of life and change, a symbol of the future. I discussed this image with many executives, designers and engineers in the company. "Do we like this kind of 'Happiness'? Can happiness be produced with a machine approach?"

Not one agreed, but everybody was motivated to explore ways how Daimler as a company could contribute to a very different "Happiness Machine".

Mark Lascelles Thornton, *Happiness Machine*

In San Francisco 2015, I searched for parklets[11] and found Heidi Quante, a linguistic artist and activist[12]. We had an intense chat about the change in values regarding urban life. People were working on a different San Francisco, preferring rich street life over efficient traffic. Her topic then was to enable activism against climate change through a new language. Her "Bureau of Linguistic Reality" utilizes art and language for action.

Putting it together, it seems that artists and activists today are in motion, back from the immaterial digital, to the collaborative real world. The digital in itself is losing its "cool"[13]. The Internet of Things is more about the Things, than the Internet.

## 3. Make: Automation in the Shared Space of Tomorrow

> "Anyone who focuses solely on the technology has not yet grasped how autonomous driving will change our society".
> Dieter Zetsche, CES, 2015

In the face of ever denser living environments, it seems inevitable that the public space has to be shared for different use cases. Micro-Housing[14] only works if public spaces, now used exclusively for transportation, can transform into useable space for various activities. Willful action is the core of human creativity: Sharing concepts therefore should be as open and flexible as possible. Otherwise, a "Smart City" will emerge as a dystopian nightmare of pre-programmed choices. Automation has to fit in the fabric of human interaction, enhancing human autonomy, not otherwise around.

For our latest research car, the 2015 "F015 Luxury in Motion", we created an interactive environment where the automated car was enabled to communicate its intentions to the outside. The idea to use the technology of automated cars to create a diverse, safe and joyful city life was born in a creative workshop in Tokyo, 2011. Communicating with the citizens was a key feature in our concept that we named internally "Car Giving Back".

Car Giving Back Concept: automated cars serving as infrastructure, for business and fun

In 2014 we were able to test some of our concepts in a Future Talk about Robotic Interaction. We used gestures, postures, light and movement as media to interact from human to machine and vice versa. The Ars Electronica Futurelab created a drone set-up with their *Spaxels* to experiment and demonstrate the different interaction models.

We choose drones, because they have a strong enough appearance through noise and physicality to be compared with a car, but they are more flexible and easier to modify and steer. For novices, they can feel quite threatening. One experiment showed an exceptional mood change from experiencing the automated drones as a threat, towards feeling safe and having fun.

In the experiment, a drone was flying a safe course towards a calling person, briefly waiting in the air at face level, then proceeding to a parking zone a few meters beside. The drone was aware of the person and the whole environment through a sensor setting in the roof of the experimental arena. Awareness could be displayed by the drone, using light signals combined with a nodding movement, or it could fly without any added interaction. Results showed that the simple "Hello" blink and nodding was sufficient for the participating people to feel safe and in control. The experience of this communicative act made people feel safe enough to play with the drones using hand gestures.

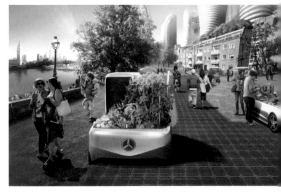
Automation scaled to self-moving booths for micro-farming and other entrepreneurial activities.

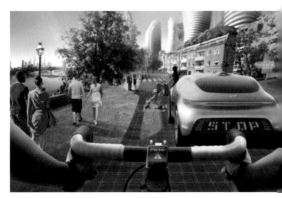
Car lights serve as dynamic traffic signals to enhance safety and comfort.

Spaxel drone is blinking and nodding "Hello" to Martina Mara from the Ars Electronica Futurelab.

For our Mercedes-Benz research car we applied and developed interaction concepts relying on light signals and physical devices. For example, through projecting a zebra crossing via laser light on the street surface, the car signals the pedestrian that he or she can safely cross the street.

Concepts of Sharing will need an interaction model between mobile robots and humans as foundation. Mobility can be seen as an interaction process, driven by continuous, non-verbal communication. As Paul Watzlawick's famous 1st axiom of communication says "One cannot not communicate–Every behavior is a form of communication". Human talents invested in this process are manifold, but social perceptiveness stands out. Traffic participants will

immediately recognize unfamiliar behavior and create meaning out of perception. Computers on the other side can't go beyond pre-programmed and stored interpretation of a situation[15]—meaning is beyond the robots' reach.

In experimental settings, humanoid robots were tested behaving very similar to human beings. In effect, almost perfectly imitating human behavior arouses unease and revulsion.[16] Autonomous cars are not humanoid, but since anthropomorphism is unavoidable when interpreting moving machinery (moving dots on a PC screen are sufficient[17]), we should take the emotional relation between human and mobile robot into account. An autonomous car, denying behavioral communication, will be interpreted anyway. The emotional and rational conclusion of the observer will decide over success or failure of the robotic design.

Our approach, partially shown in the F015 research car, is to bridge the separated realms of human talents from robotic functionality through media.

In the spirit of Norbert Wiener's dictum: *"Render unto man the things which are man's and unto the computer the things which are the computer's",* we think it is important to research what is not be automated.

1   When Béla Barényi developed the crumble zone for the Mercedes-Benz cars in the mid 1950s, major manufacturers avoided mentioning accidents, because they didn't want to scare customers away.

2   Today's new megacities in China are built after the image of NYC, enhanced with high-speed trains, as a city planner from Shanghai told us, and many business districts have been modeled on Manhattan.

3   "Modernity" as an undisputed goal got the first serious cracks through the publication of Rachel Carson's *Silent Spring* in 1962.

4   *http://mitpress.mit.edu/sites/default/files/titles/ content/9780262015363_sch_0001.pdf*

5   See Elinor Ostrom about the principles of sharing – Commons *https://en.wikipedia.org/wiki/Elinor_Ostrom*

6   *http://la.streetsblog.org/2014/08/07/california- has-officially-ditched-car-centric-level-of-service/*

7   The WWW shows a special inertia on its own: the sheer mass of content will make any radical innovation of HTML impossible. For example, in his book *Who owns the Future?,* Jaron Lanier suggests Ted Nelson's two-way linking, which would enable a different Internet economy. Obviously, to reprogram the WWW is absolutely impracticable.

8   cf. Norbert Wiener's cybernetic *Moth* from 1949, or Grey Walter's various cybernetic tortoises. *http://cyberneticzoo.com/cyberneticanimals/ 1949-wieners-moth-wiener-wiesner-singleton/*

9   Jennifer M. Groh (2014) provides readable insight in current brain research in her book *Making Space: How The Brain Knows Where Things Are.*

10  Aitken's Movie *Station to Station* hints at what will happen to car-traveling once the driver is relieved from observing traffic: "When the 'landscape is framed through a window... You will never get enough!" The car will become a reality-cinema for travelers. *https://vimeo.com/116913918*

11  *http://nacto.org/usdg/interim-design-strategies/ parklets/*

12  *http://invokingthepause.org/page75.html*

13  In 2015, we presented our research car, the F015 Luxury in Motion. My task was to give speeches about the "Shared Space of Tomorrow". I did—62 times in 10 days— and asked the visiting journalists at the end if the digital is losing its cool: 80 % agreed.

14  In 2012, then-mayor Michael Bloomberg temporarily relaxed the city's zoning rules to launch a competition, adAPT NYC, encouraging designs for one and two-person homes. The winner was *My Micro NY* by nArchitects, the city's first micro-flat complex currently being assembled at 335 East 27th Street. The building's 55 prefabricated, modular units range from 23–34 sq. meters, and feature kitchens, wheelchair-accessible bathrooms and small balconies. Despite hyperventilating media coverage—"Desperate New Yorkers to live in glorified shoeboxes" was one headline from the *New York Post*—there is already a waiting list.
    "How Americans think about resources must change, and housing is one aspect of that," Eric Bunge of nArchitects says. He believes that the gratuitous floor space of recent decades has been an aberration. Living within fewer square meters in dense, walkable centers is his vision of a more eco-conscious future. "It's not just a question of densifying cities but thinking about optimizing the way we live in them," he says. "Micro-units can be delightful to be in and to live in if well-designed."
    Financial Times, June 19, 2015
    *http://www.ft.com/intl/cms/s/0/ 355ff9aa-1052-11e5-ad5a-00144feabdc0.html*

15  There will be a steadily growing set of "interpreted situations", but machine learning differs fundamentally from human insight.

16  cf. The Uncanny Valley Hypothesis (see *https://en.wikipedia.org/wiki/Uncanny_valley*)

17  cf. Reeves, B. and Nass, C. (1996). *The Media Equation: How People Treat Computers, Television, and New Media like Real People and Places.* Cambridge: CUP.

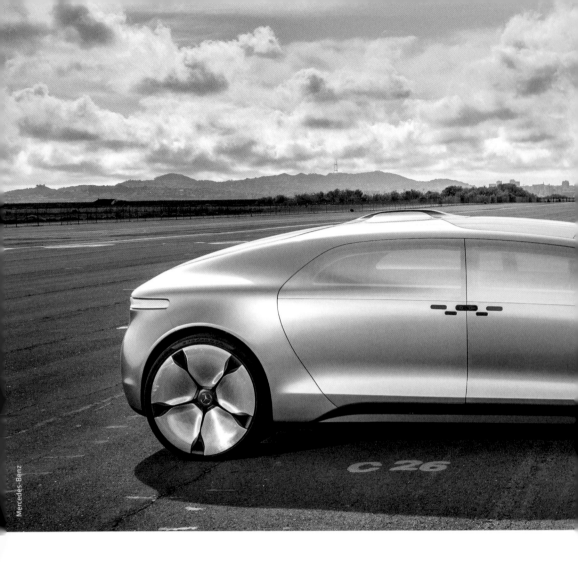

Martina Mara & Christopher Lindinger

# Talking to the RoboCar

New Research Approaches to the Interaction between
Human Beings and Mobility Machines in the City of the Future

At least a few of us still remember "Knight Rider," a TV series that was a big favorite of viewers in the mid '80s. Instead of riding an intrepid steed, Michael Knight, the title character played by David Hasselhoff, drove the ultimate futuristic car. K.I.T.T. was conceived as artificial intelligence on four wheels, as a self-driving buddy Michael Knight could summon via a wrist-worn device that resembled a Smart Watch to bail him out of a jam.

Now, 30 years later, the world's leading carmakers and automotive technology vendors have long since gotten to work on the nonfictional equivalent of the K.I.T.T. robot car. So when we talk today about the city of the future, then the self-driving automobile has to be one of the chief protagonists in our urban scenarios. Carmakers are currently predicting that fully autonomous vehicles will already be among our fellow motorists between 2025 and 2030. Accordingly,

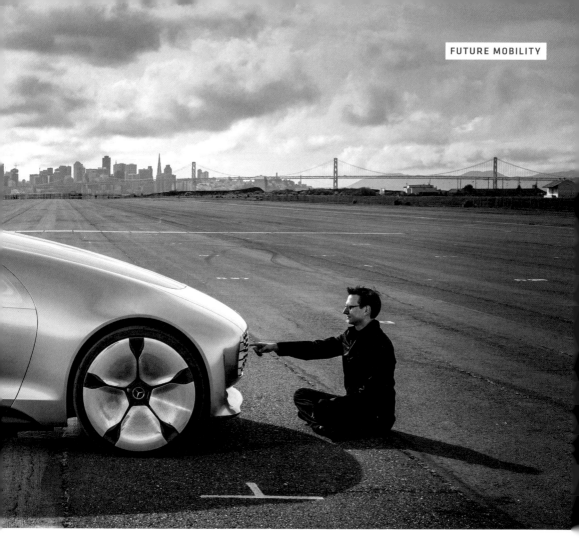

what's in store for us consumers is a completely new form of mobility: autos in which there's no longer a steering wheel because the computer knows its way around without having to ask for directions from a leather-padded user interface; cars that, due to their high level of system-immanent intelligence, should get much better mileage and hardly ever cause an accident; cars that can drop us off at the pedestrian mall and then proceed unaccompanied to a parking lot out on the edge of town; cars that comprehend that when a soccer ball rolls out into the street, an excited little kid just might be in hot pursuit, and that also pass this information along to the vehicles behind it. And keep in mind: an individual automobile will be only one of many nodes in the extensive communications network of robotic vehicles constantly sharing information with each other.

Now, this all sounds like technology from which humankind could certainly benefit. After all, one of the inherent advantages of this utopian concept of fully autonomous vehicles is to give us back a luxury good we seem to be deprived of these days: Time. How about just relaxing in the back seat, solving a Sudoku on your tablet, or teleconferencing on one of the interior displays while the robot-taxi drives you to your next appointment or on a chauffeur-driven holiday? Or maybe just reclining your seat and enjoying a little care-free shut-eye!

### K.I.T.T. happens—and raises new questions

In addition to enactment of a legal framework and implementation of suitable infrastructure, a factor that should by no means be underestimated is that these usage scenarios of completely autonomous

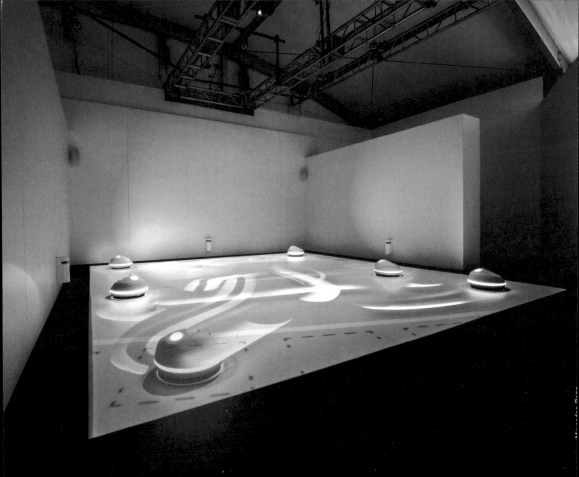

mobility also presuppose a high degree of trust on the part of users. Of decisive importance here is effective human-machine communication, which has to function error-free all the time. If human users and their wishes and needs, as well as any concerns they might have, are to occupy the focal point of these technological achievements, then, aside from addressing purely technical issues, we will have to deal with a lot of novel questions having to do with how we perceive mobility robots in urban public spaces, with the subjective experience of security and control on the part of human motorists, and with intuitive mutual understanding between a human being and a robotic car. What effect will a driverless taxi have on the urban social fabric when it's not just a one-of-a-kind phenomenon but part of a whole swarm of self-driving vehicles? How are pedestrians and cyclists going to handle sharing the streets with these smart contrivances? Do we want to issue commands to tomorrow's robot autos in a verbal language, through the use of gestures, via haptic interfaces or by some other means when, for

instance, we want it to go park itself? And for that matter, what sort of content do we even have to communicate to such a car, and, conversely, what do we want it to tell us and when do we want to hear it? Ultimately, this is a matter of developing a bilateral repertoire of signs, a human-auto parlance that's so intuitive, clear and unequivocal that any child can instantaneously ascertain whether an approaching vehicle is a manually-driven model or an autonomous one, and whether that child has been recognized as a human being and can safely cross the street.

### Transdisciplinary research on something that doesn't exist yet

These are the sorts of issues that are currently being confronted in the context of a transdisciplinary project at the Futurelab, Ars Electronica's in-house R&D facility, where a lively exchange of views with Mercedes-Benz has been going on since 2013. The aim of this collaboration is to make it possible to actually experience robotic mobility scenarios, as

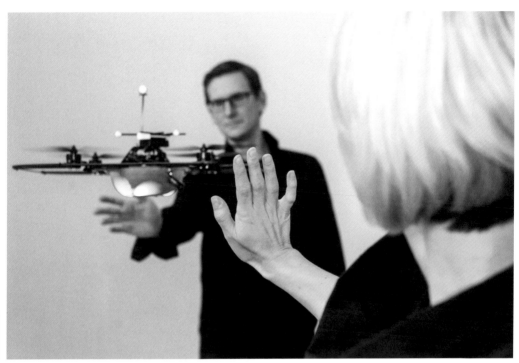

Mercedes-Benz

well as to develop concrete design & interaction approaches that can serve as the basis for actively configuring human-automobile communication in the future. The Ars Electronica Futurelab's research team is, as always, characterized by its transdisciplinary makeup and the capacity to combine artistic approaches with technological competence and expertise in the social sciences. On this project, it's working together with Mercedes-Benz's divisions that have been assigned the task of developing autonomous concept cars—among them, Future Studies, Advanced UX Design and Research Communication. Since there currently exists no real-world proving ground for interaction among human beings and robotic autos, it quickly became clear that the investigation of issues these various divisions are facing calls for new experimental approaches. After all, aside from occasional tête-à-têtes with vacuum cleaner & lawnmower robots, most people still have no experience with how it even feels to be surrounded by autonomous machines. Thus, one of the initial assignments in this collaborative research

effort with Mercedes-Benz was to enable a human motorist, cyclist or pedestrian to tangibly feel the shared space that, someday soon, will be populated by human beings and mobile robots. The point is to play out various interaction scenarios that could well be occurring in big-city traffic by 2030. As an initial approach to this assignment, the Ars Electronica Futurelab created two interactive test environments that can be made available to the general public at events.

### Settings in which to experience futuristic mobility

For the first Shared Space experiment conceived collaboratively with Mercedes-Benz, we deployed the Spaxels, a swarm of computer-controlled, LED-equipped quadcopters developed by the Ars Electronica Futurelab. Thanks to their ability to fly at up to 60 kilometers/hour at an altitude of about four feet—and thus shoulder-high to a test subject—they served as workable "avatars" of autonomous vehicles. In an 8x8-meter, camera- & sensor-studded

interaction space, the Spaxels depicted various traffic scenarios and communicated with the people in its immediate surroundings via light signals or predefined maneuvers. The human interactors, in turn, could "talk" to the quadcopters by means of a haptic interface called a "magic car key" or by physical gestures—for instance, summoning it with an upraised arm or directing it in a particular direction to a parking place by pointing a finger. Even though communication via gestures entails numerous challenges—of which cultural differences and interpretational problems in cases of a suboptimal camera angle are only two—very simple arm & finger motions such as a vertical, outstretched palm meaning "STOP!" have proved to be an intuitive, viable form of communication. In any case, it's absolutely essential that the mobile robots speak in unmistakable terms when they have something to say to us. Proactive communication by self-driving cars—early warnings of states, processes and upcoming maneuvers issued by the computer system—will constitute an essential precondition for pleasant human-machine coexistence. In an interactive scene designed to simulate a pedestrian crosswalk, visitors to the Spaxels test environment were called upon to cross a quadcopter's intended flight path, whereupon the simulated vehicle reacted in a timely manner by issuing an LED signal acknowledging the person's presence and announcing its intention to brake. A second test environment dubbed Shared Space Bots was set up with six specially developed terrestrial robots, each of which could be augmented by projections onto the ground. This made it possible, for example, to display the otherwise invisible sensor field and the route that the robot had just taken. Here, an upward-pointed LED eye and an LED wreath encircling the robot's outer shell enabled it to issue current status reports. The point of this installation was to let observers experience a metropolitan mobility zone in which human beings and autonomous vehicles interact considerately, as well as to explore concrete interaction concepts in quite a practical way. Based on current ideas for future urban settings, test participants could, for example, position four reflective demarcation objects to stake out a protected sector of the proving ground, which the robots automatically recognized as a Human Zone and then continued on a route that bypassed

the designated no-go area. This also served as a setting for the simulation of various crosswalk situations in which the approaching robots not only indicated whether and where they had detected a human pedestrian but also displayed their assessment and intention in the form of zebra stripes projected onto the street surface.

## Basic vocabulary for communiqués between human beings and mobile robots

The two interactive test environments set up jointly by the Ars Electronica Futurelab and Mercedes-Benz manifest an innovative approach to answering questions having to do with human-auto communication in the future. This effort has already yielded initial insights that are being applied in the interaction design of robotic cars such as the innovative Mercedes-Benz F 015. In comparison to virtual research & simulation environments, the robotic experience space the Futurelab has come up with is particularly distinguished by its high degree of hands-on quality, and by the kinetic energy and tangible physical impact of the robots deployed in it. Nevertheless, this represents only the initial stage of a necessarily long-term confrontation with the many issues that fully autonomous mobility raises for the configuration of future human habitats. Accordingly, the process of cooperation between the Ars Electronica Futurelab and Mercedes-Benz will continue beyond the 2015 Ars Electronica Festival. High priority on the to-do list prior to the introduction of completely autonomous vehicles is developing a standardized "basic vocabulary" which provides for bilateral human-car communication that functions quickly and securely. This isn't meant to pave the way for autonomous mobility machines to replace human beings, but rather to become user-friendly tools that deliver convenience in everyday life and on the job. We are jointly striving to make an important contribution to enabling high-tech mobility in the city of the future that puts the needs of city dwellers in the focal point of planning initiatives. And this is completely in accord with the interdisciplinary approach employed at Ars Electronica, which has always entailed considering emerging technological developments not as discrete phenomena but rather in conjunction with their artistic and social potentials and challenges.

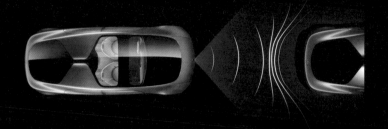

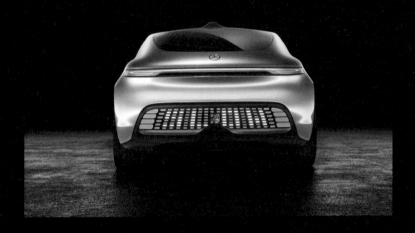

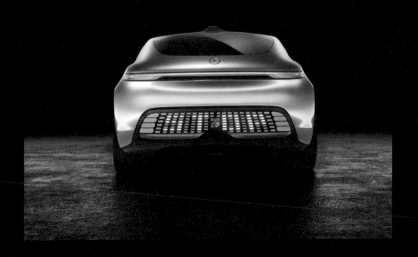

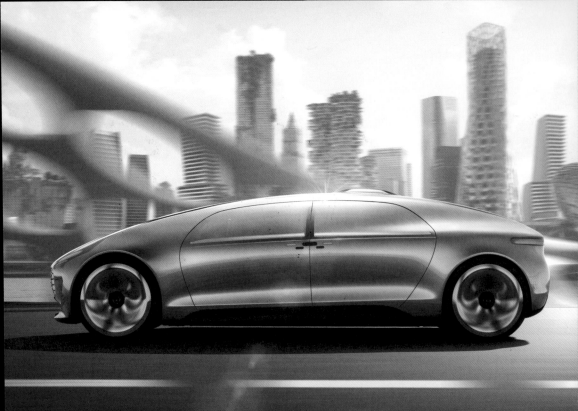

Jürgen Weissinger

# Time Travel into the Future

The Golden Gate Bridge, cable cars and Fisherman's Wharf—San Francisco's sights are world-famous. But an attraction of a very different sort was making headlines there this spring. "SF goes crazy snapping pictures of driverless future car spotted on city streets," reported CBS Online. And the German magazine *AutoBild* wrote: "When Mercedes' F 015 cruises the streets of San Francisco these days, traffic comes to a standstill while the memory cards of pedestrians' camera-equipped cell phones fill at high speed."

Among the little cable cars climbing halfway to the stars, the new star is an autonomous vehicle, the F 015 Luxury in Motion. Photo and video recordings made by Mercedes-Benz in the Northern California metropolis document a road trip into the future. Driving down Columbus Avenue or Market Street in the heart of downtown, this concept car gave a photo-realistic preview of what urban mobility just might look like in the year 2030.

Whereas, in the case of many autonomously-driving test vehicles, the automotive revolution is happening far from the inquisitive eyes of spectators—a driver takes his hands off the steering wheel of a conventional-looking car—the F 015's futuristic look makes it clear that this is the shape of things to come. "With its eye-catching exterior, the F 015 Luxury in Motion signals its pioneering character at first glance," emphasized Gorden Wagener, Vice President Design Daimler AG.

A visionary concept packed in a visionary design— the monocoque construction makes it look like a totally integrated unit. Even the proportions (length/width/height: 5,220/2,018/1,524 millimeters) are extraordinary: The F 015 is as long as a luxury sedan and as low-slung as a sports car. The low front end, streamlined roof, flat windshield and deep-set stern endow the prototype vehicle with a dynamic silhouette. "The F 015 Luxury in Motion's spatial configuration bespeaks an extremely pro-

gressive formal vocabulary. The total integration of the Space Flow silhouette is revolutionary. An emphatic line runs from the grill over the roof to the rear end, integrating the classic components of hood, interior and trunk into a single unit," is how head designer Wagener described the vehicle's contours. The body is visibly tapered, and large areas of the exterior shell are nothing less than taut. The F 015 dispenses with the classic B (center) pillar, and the two doors on each side open out in opposite directions at up to 90° to thus provide spacious, passenger-friendly entry and exit.

The extravagant exterior isn't stylish for its own sake, though; it's the expression of a radically new automotive architecture. Within the vehicle, autonomous motoring frees up plenty of space that can be utilized to excellent advantage. This manifests itself especially in the four-seater's interior, where a strict front & back row setup for driver and passengers is a thing of the past. Four swivel seats enable those on board to face one another just as they would in a lounge. A steering wheel is no longer the focal point of the interior furnishings; instead, it emerges from the dashboard when its services are needed. If manual mode is desired, the driver can swivel his seat forward to keep his eye on the road. Automobiles manufactured by Mercedes-Benz are

already much more than just means of transportation, and in the future they'll develop even more strongly in the direction of a mobile habitat. Since the autonomous vehicle relieves the driver of duty in situations in which motoring isn't much fun—heavy traffic, for instance—it imparts a real quality upgrade to time spent in the car. Passengers in self-driving vehicles can take advantage of the free time gained thereby in a variety of ways—relaxing, working, whatever.

An essential idea of this concept car is ongoing exchange of information among the vehicle, the passengers and the environment. Serving this purpose are six displays installed throughout the interior—harmoniously in the dashboard as well as on the rear & side walls. The interior thus becomes a digitized, active space in which passengers can use gestures or physically touch the high-definition displays to intuitively interact with the networked vehicle. Built-in sensors recognize passengers' hand motions. There are also conveniently located user interface surfaces that make appropriate options available in any particular situation.

But that's not all: the F 015 also features large-format communications displays on the front and rear of the exterior to exchange information with the outside world. For instance, this prototype vehicle

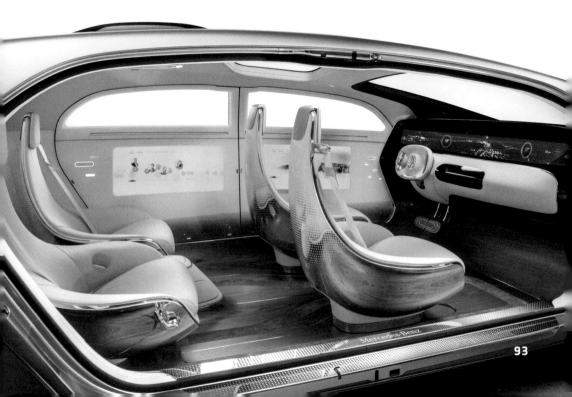

uses the color of these LED fields to signal which mode it's in: blue stands for autonomous, white means manual. When the F 015 detects a pedestrian at the curb, the LED grille displays a wavelength to confirm awareness of the pedestrian.

As a considerate motorist, the F 015 even gives pedestrians the right of way. For instance, if a pedestrian indicates that he/she would like to cross the street, the F 015 stops and checks in all directions to make sure it's possible without danger. If so, the car uses a high-precision laser system to project a virtual crosswalk (so-called zebra stripes) onto the street surface and also emits an audible message ("Please go ahead") to let the pedestrian know it's safe to cross.

The information that makes this possible is delivered by a 360° sensor configuration. "The stereo cameras, radar and other sensors don't miss much, and they never become inattentive or tired. Plus, the vehicle is online and thus constantly derives current information from the internet, including information about things occurring beyond the range of the vehicle's sensors. All of these data are combined, assessed and appropriately interpreted. We call this Intelligent Sensorfusion", explained Thomas Weber, member of the Board of Directors of Daimler AG, and the man responsible for company-wide R&D and Mercedes-Benz Cars development.

The drivetrain technology as well points the way towards the future. The F 015 Luxury in Motion was conceived in such a way that an electrical drive system using fuel cells can be integrated into it. This is based on the trailblazing F-CELL PLUG-IN HYBRID used in the F 125! concept car developed in 2011 and combines on-board electrical current production with an especially high-output, compact, high-voltage battery. For hydrogen storage, this concept calls for a high-pressure tank made of carbon-fiber-reinforced plastic (CFRP).

So the inventor of the automobile is now in the process of reinventing it. Just as the Benz Patent-Motorwagen replaced the classic carriage in 1886, the first self-driving cars are launching a radical upheaval of their own. "Whoever thinks strictly in terms of technology has yet to recognize how autonomous motoring will change our society," explained Dieter Zetsche, chairman of the board of Daimler AG and director of Mercedes-Benz Cars. Thomas Weber summed this up nicely: "Autonomous driving is one of the greatest innovations since the invention of the automobile."

Self-driving cars also open up completely new options for the configuration of urban infrastructure. For example, city planners could institute special security zones that are modeled on today's downtown environmental zones and are off-limits to vehicles other than self-driving cars. Streets could be made narrower and traffic signage reduced to thus free up valuable space in densely populated megacities. Relegating autonomous vehicles to parking lots on the outskirts of town is another way to regain coveted real estate. For the F 015, programmers developed a "Pick me up" app to instruct a self-driving car parked on the edge of town to turn up at a specific place and time.

Are these just fantasies of a distant future? Vehicles made by Mercedes-Benz are already capable of recognizing many dangerous situations in traffic and reacting to them in an appropriate way—such as by automatically braking. Many Mercedes-Benz models from C- to S-Class already drive semi-autonomously in traffic—for example, with the help of DISTRONIC PLUS with steering assistant and Stop&Go Pilot that can semi-autonomously inch forward in traffic jams. The Active Parking Assistant with PARKTRONIC provides for active steering and braking interventions that enable the automobile to park itself—including parallel parking and pulling into a diagonal space.

In August 2013, Mercedes-Benz impressively demonstrated that autonomous driving is already possible, even in complex big-city traffic and on the interstate. Before going into serial production, the Mercedes-Benz S 500 INTELLIGENT DRIVE went for a completely autonomous spin from Mannheim to Pforzheim, the same approximately 100-kilometer route on which, in 1888, Bertha Benz took the first long-distance trip in automotive history.

This pioneering drive in late summer two years ago likewise made headlines. In comparison to the F 015's recent appearance in San Francisco, only a few passers-by on the roadside whipped out their cell phone cameras to capture that historic event—after all, it was only an inconspicuous S-Class car that was successfully mastering complex situations such as traffic circles, bottlenecks with oncoming traffic in villages, and "whose right-of-way" situations.

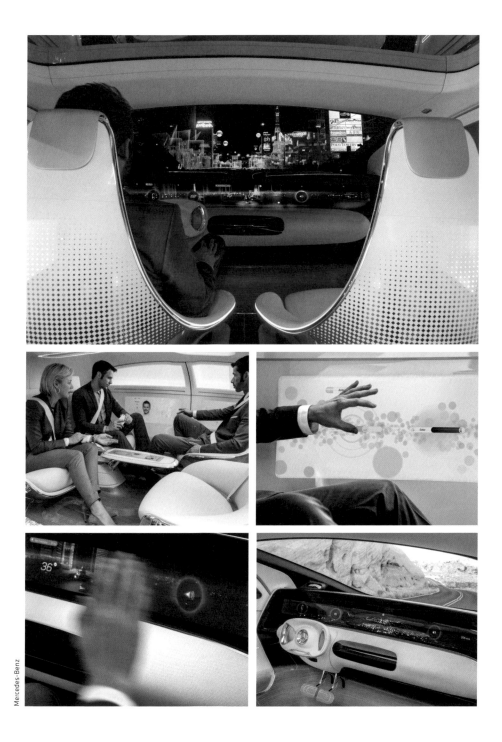

Mercedes-Benz

# Post City Kit
## Initiative by Future Catalysts Hakuhodo x Ars Electronica

The *Post City Kit* is a collection of ideas, strategies, tools and prototypes to enhance our cities. A kit, in general, means any collection of items or components needed for a specific purpose[1]. And so what does the kit for the cities of the future look like?
A city is a place of ongoing social experiment for survival, an organic and creative system formed in a specific time and place. Holistically, a city represents the culture, society, and politics of the age, and today's digital age has transformed the lifestyle, the ways of communication (e.g. the internet), and the opportunities for community participation of those living in cities. So what will the citizens of the future look like?
Researching the case projects of Ars Electronica creations and some winning artworks from Prix Ars Electronica, we could find hints for forming the *Post*

*City Kit*. For example, the fabrication of a *The New York Times Special Edition*[2] with news stories offers an inspirational vision of the future city. Or Ars Electronica's *Shadowgram*[3], an interactive installation that engages visitors in social brainstorming and produces a silhouette of the visitor, which is then printed out and added to the big picture, while the visitor writes personal ideas on current social issues in speech balloons next to their silhouette. The city of Linz has used this tool to encourage community participation in city planning processes. *Goteo*[4] is an open crowd-funding and crowd-sourcing platform and project that specializes in collective funding for society, culture, and education. Kibera, a vast slum in Nairobi, Kenya, was a blank spot on the map until young Kiberans created the public digital *Map Kibera*[5], which has revitalized the community, and

the open-source square *El Campo de Cebada*[6] in the center of Madrid was created on a fenced-off site as a result of community participation in city planning. In fact, cities are no longer designed top-down; new city landscapes are created through the inspired visions of participatory citizens who share their individual knowledge and skills to meet social challenges and co-create their city with industries, the government, and cultural organizations.

The *Post City Kit* Initiative aims to create a platform to meet, exchange and create visions together for the *Post City Kit*. People all over the world can compare their reasons for creating their *Post City Kits*, what they contain, and how they can be used in their own city, and it promotes the exchange of ideas for solving local issues and global common issues.   In addition, the platform functions as an experimental environment to practice and to deploy the *Post City Kits*. The name *Post City Kit* implies that this initiative will provide people with the "tools" to develop their creative ideas.

At Ars Electronica 2015, the *Post City Kit*—the second project by Future Catalysts Hakuhodo x Ars Electronica—prototypes the platform, focusing on four themes: Future Mobility, Future Work, Future Citizens, and Future Resilience, which feature in interactive exhibitions, discussions, workshops and performances.  Based on the prototype of the platform, we are planning to apply the platform concept to many other cities in the world. In the process of realizing this framework in different cities, the *Post City Kit* Initiative will become a creative driving force to mirror both site-specific issues and solutions for all cities.

*Future Catalysts* is a joint project between Ars Electronica and Hakuhodo. As *Future Catalysts*, our goal is to be the catalysts that create the future of Japanese industry, administration, and local communities. As a focal point for cutting-edge creativity relating to the future of society in art, technology and science, Ars Electronica has offered concrete ideas for the future derived from the intersection of various fields of creativity since 1979. Hakuhodo brings together industry and society by carefully studying *sei-katsu-sha*, its term for real people with real lives, the essence of the modern world.

We at *Future Catalysts* go beyond traditional frameworks in utilizing and synergizing our respective experiences, specializations, and creativity to identify creative questions for designing the future and producing new creative solutions for various issues facing society. The *Post City Kit* Initiative embodies the idea of the Future Catalysts for our cities.

Text: Hideaki Ogawa, Ars Electronica + Kazuhiko Washio, Hakuhodo

1  Kit—Wikipedia, the free encyclopedia. Retrieved from *https://en.wikipedia.org/wiki/Kit*
2  Ars Electronica (2009). *The New York Times Special Edition.* Prix Ars Electronica Award of Distinction 2009. Retrieved from *http://www.aec.at/humannature/cyberarts/the-new-york-times-special-edition*
3  Ars Electronica Futurelab (2013). *Shadowgram.* Retrieved from *http://www.aec.at/solutions/en/shadowgram/*
4  Platoniq (2012). *Goteo.* Prix Ars Electronica Award of Distinction 2014. Retrieved from *http://prix2014.aec.at/prixwinner/12349/*
5  Map Kibera Trust (2010). *Map Kibera.* Prix Ars Electronica Award of Distinction 2010. Retrieved from *http://archive.aec.at/prix/#18741*
6  El Campo de Cebada (2010). *El Campo de Cebada.* Prix Ars Electronica Golden Nica 2013. Retrieved from *http://archive.aec.at/prix/#48584*

Shunji Yamanaka, fuRo—Future Robotics Technology Center

# Halluc II$_X$

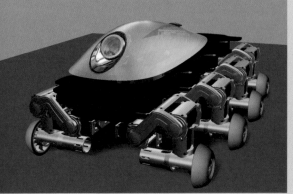
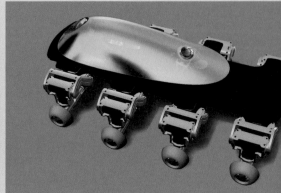

Like *Hallucigenia I, Halluc II* is a robot/vehicle that can cope with the natural and rough environment. It features a newly developed ultra-multi-motored system with 56 motors, which makes traveling on uneven surfaces possible and eliminates the need for paving. It has three different movement modes: vehicle, insect, and animal. The fusion of humanoid robot technologies and automobile technologies make the unprecedented mobility of Halluc II possible. Although Halluc II has been demonstrated at international venues such as DESIGN INDABA in South Africa, Ars Electronica in Austria and Miraikan in Japan, this is the world premiere of the newest creation of the Hallucigenia project, *Halluc II$_X$*.

Concept and Design: Shunji Yamanaka
System Design and Engineering: fuRo (Future Robotics Technology Center) at Chiba Institute of Technology

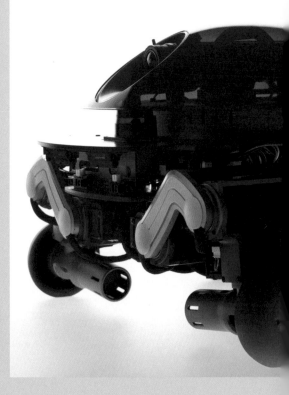

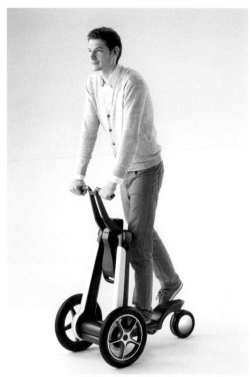

fuRo—Future Robotics Technology Center

# ILY-A

*ILY-A* is a three-wheel one-person compact electric mobility vehicle that transforms into four configurations to meet the needs of a wide variety of situations. The ultra compact body is about the size of a baby stroller and contains all-new robotics-based intelligent safety technologies. It recognizes all stationary and moving objects, e.g. a person or an obstacle suddenly coming into view, and automatically reduces speed and controls the brakes. It is a neo-futuristic vehicle that will serve as futuristic "legs" for people of all ages, from youths to active seniors, supporting their locomotion and activities in a wide range of scenes. With *ILY-A*, we propose a lifestyle with a greater range of activities and strive to establish this vehicle as a new standard tool for people's everyday life.

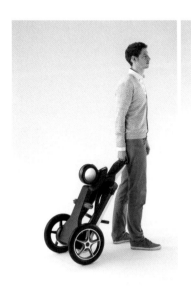

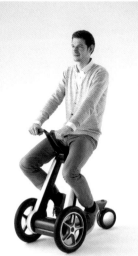

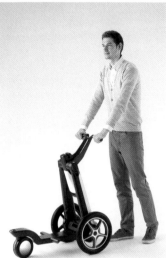

takram design engineering ,
fuRo—Future Robotics Technology Center

# ON THE FLY

*ON THE FLY* is an innovative infotainment system which integrates paper with digital media. As soon as you place a plain sheet of paper on the table, letters and moving images emerge, as if by magic.

Design and Development: Hisato Ogata (takram design engineering)
Collaboration: fuRo (Future Robotics Technology Center) at Chiba Institute of Technology and Shunji Yamanaka (L.E.D)
Sound design: Keiji Matsui

Otto Bock Healthcare

# Genium–Bionic Prosthetic System

© Ottobock

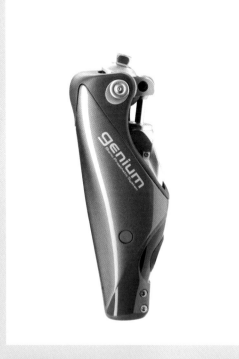

© Ottobock

The innovative Genium leg prosthesis system offers for the first time the opportunity to walk with a gait that is incredibly close to the natural physiological one. Innovative functions, such as optimized physiological gait (OPG), stairs and stance functions, give the user more freedom of movement and make it easier to handle daily activities.

Everything happens in real time—and certain situations are even anticipated. Thanks to the latest in microprocessor, sensor and control technology, using the *Genium* is straightforward, intuitive and incredibly flexible. This results in surprising movement possibilities for you: safely walking backwards, climbing stairs step-over-step, balanced standing even on inclines, and much more. Everyday mobility and quality of life have been entirely redefined.

© Ottobock

**101**

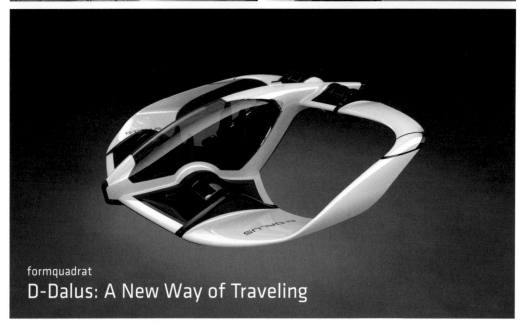

formquadrat
# D-Dalus: A New Way of Traveling

The *D-Dalus* is the "enfant terrible" of the aircraft industry with outstanding and surprising new flight features. The dream of flying has been around since time began—but the *D-Dalus* can do more than just fly ... It can also start and land vertically, float, and turn on its axis. When the engines are switched off for a fraction of a second, the *D-Dalus* can even suction itself onto the landing surface, thus enabling it to land on ships or other planes.

Thanks to the new four cyclogyro rotors, which are located in the wings and connected to each other, it can fly vertically—just like a helicopter—and has a significantly better forward flight performance, and is far quieter and more economical than a helicop-

ter. Stability and the aerodynamics are enhanced by these rotors, and the back wings are mounted much higher in order to ensure better airflow, thus creating a free entry and exit area. A further security plus is that the *D-Dalus* has no freestanding rotors like a helicopter. The unmanned *D-Dalus* drone has already seen a real "lift off", the manned version is a concept with 4 seats measuring approx. 8 x 8 meters at just over 2 meters high.

*http://www.iat21.at*
*http://www.formquadrat.com*

Inventor: Meinhard Schwaiger, IAT21 GmbH
Designer: Julian Pröll, formquadrat gmbh

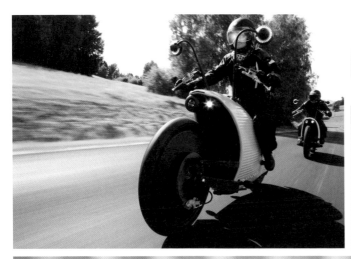

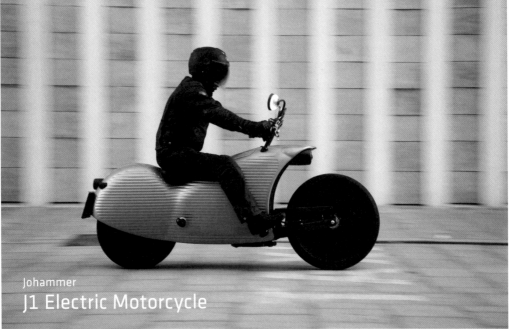

G. Zeidler

Johammer
# J1 Electric Motorcycle

The *J1 Electric Motorcycle* is a futuristic electric cruiser with innovative energy technology and first series motorcycle with a range of 200 km. A Johammer bike not only looks different, it really has been designed from scratch and offers unique EV mobility and technical features. The electric motor and controller are integrated into the rear wheel, so no maintenance is required. A very special advancement has been made in battery pack development and the extremely torsion-resistant aluminum main frame accommodates the shock absorbers and battery pack. The *J1 Electric Motorcycle* embodies perfect synergy in terms of weight, stability and function.

*http://www.johammer.com*

Peter Moosgaard
# Cargo Cult Segway

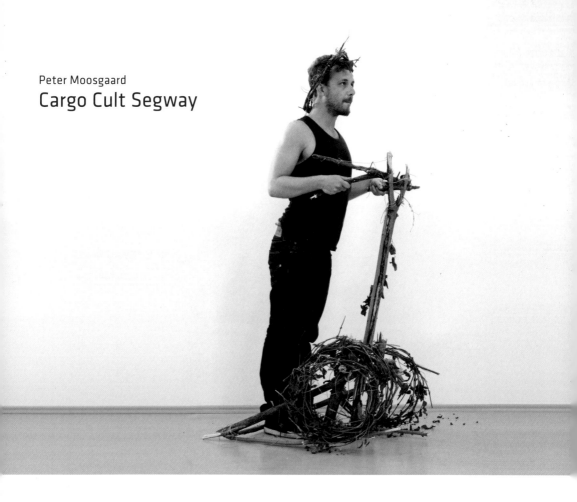

Indigenous tribes on the remote island of Tanna in the South Pacific nation of Vanuatu built giant airplanes from wood and carved headphones and radios from bamboo—and they await the arrival of a messianic serviceman called John Frum. The replicas of western technology are supposed to attract US airplanes carrying a cargo of material treasures and bringing happiness and prosperity to the island and its people. The villagers copy the devices and the routines of US soldiers, who descended on the islands with apparently endless supplies of material goods—which they did not have to work for—during WWII. These mockups may give rise to laughter, but did the soldiers truly understand their technology, their big global agenda?

The cargo shaman Chief Isaac once said: "You build your plane too and wait in faith. The waiting is the hardest part." According to some shamans in the past, the planes they awaited would also bring weapons to throw off colonialist oppressors. The cargo cults are strange mockups of imperialism, and at the same time the preservation of old traditions. But is the cult today for real or just an act for tourists and anthropologists? It does not matter; it is about The Tale of the Cargo, which rings true on so many levels. The cult of the cargo is almost exactly reflected in our world: We perform meaningless routines we call work, in the hope of future cargo. We possess the technology that can take us to the moon but we write LMAO. The western world itself is a giant cult concerned with replicating things that somehow worked—dressing in suits, using buzzwords …

In Peter Moosgaard's artistic practice the longing for god-given goodies on the horizon—the use of art & technologies we don´t understand—constitutes a parable of great desire.

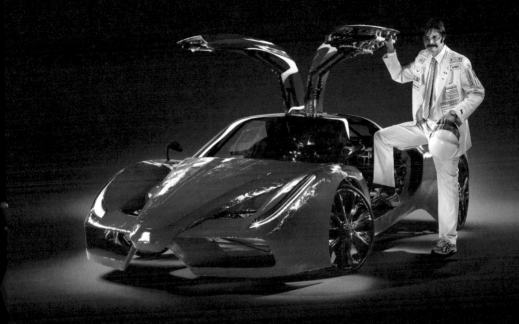

Hannes Langeder
# Fahrradi Farfalla FFX

Following the tremendous success of the predecessor object *Ferdinand GT3 RS*, the current model *Fahrradi Farfalla FFX* is an attempt to further develop the concept of the mimicry encasement based on muscle-driven drive technique (muscle car) in an evolutionary manner. Unlike *Ferdinand*, however, the *Fahrradi* is not a copy of an existing car model, but rather the anticipation of a future top model of an actually existing automobile brand. The external form of the vehicle is the result of Internet research into various real and fictive design ideas about how this vehicle could look, but also our own design ideas and, not least, a substantial portion of clairvoyance.

Another substantial difference to the predecessor model is a built-in butterfly mechanism. An angle gear attached to the rear axle moves the wing doors while driving, resulting in a wing beat similar to that of a butterfly (*Farfalla* in Italian). This ensures that it is possible to lift off slightly from the ground at all times (= anti-gravitation). An even better ventilation of the interior is a side effect. The next innovative step was the attempt to further constrain the already extreme slowness of the predecessor *Ferdinand* through an even greater transmission ratio. This makes the *Fahrradi* a serious rival for pedestrians in street traffic as well. By (Austrian) law, the *Fahrradi* can be driven at any time on public streets. Nighttime use is ensured by a modern lighting system based on approximately 200 ultra-bright LEDs. Along with the *Ferdinand GT3* and the *Veyron UC*, the *Fahrradi* is part of the racing sport team MT RACING, founded in 2011. MT–Mikadotrochus (Latin) or Millionaire's Snail avoids shallow waters. The habitat of this snail in the depths of the ocean is so difficult to access that it makes this individual an extraordinary delicacy.

*http://fahrradi.han-lan.com*

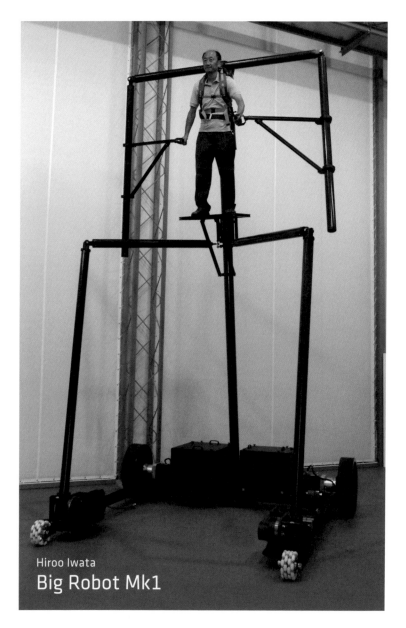

Hiroo Iwata
**Big Robot Mk1**

Large-scale humanoid robots, such as Gundam or Macros, are popular in Japanese animation and Manga. What if such robots appear in the real world? Those robots are used in battlefields in fictional stories. However, large-scale humanoid robots in the real world are highly vulnerable and so fragile that they cannot be used in battlefields. On the other hand, the existence of real large-scale robots may inspire courage in the audience. Thus, it has potential as an art form.

The *Big Robot Project* in the PhD program in Empowerment Informatics, University of Tsukuba, aims to develop the world's largest robot in which a pilot can ride and move. The *Big Robot Mk1* has two legs with wheels attached at the bottom, and the pilot is positioned 5m above the ground. The pilot controls the robot's movement forward by moving his or her own feet. The robot is programmed to follow the path of a 5m tall humanoid. Thus, the pilot feels as if he or she has the body of a 5m tall giant.

University of Art and Design Linz + Kuka
# Robots in Architecture

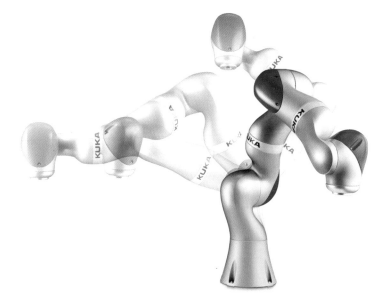

Kuka

Association for Robots in Architecture

The Association for Robots in Architecture was founded in 2010 by Sigrid Brell-Cockan and Johannes Braumann as a research consortium in applied creative robotics. In cooperation with the Institute of Industrial Design and Creative Robotics, University of Art and Design Linz, and German robot manufacturer Kuka, ideas and projects will be presented at this year's Festival, that demonstrate how robots can be put to good use in design and production processes by those working in the creative field. The exhibits will include numerous prototype applications, especially in the field of architecture.

A highlight of these presentations will be the introduction of the first sensitive lightweight robot iiwa which is suitable for industrial applications. iiwa (intelligent industrial work assistant) features flexible, sensitive mechanics and drive technology that will facilitate a new form of working partnership between humans and machines.

**107**

# eMotionSpheres
## Collision-free Motion of Autonomous Systems in a Space

With the *eMotionSpheres*, Festo shows how several flying objects can move in a coordinated manner and within a defined space. Whether individually or collectively—even in chaotic situations, there are no collisions as the spheres move out of each other's way. Each of the eight spheres is filled with helium and is driven by eight small propellers that are attached to their outer shell. The drives are adaptive and supply the same efficient thrust in a forward and reverse direction, which is a first when it comes to flying objects. Ten cameras installed in the space record the spheres via their active infrared markers and pass on the position data to a central master computer. The actions calculated from this process are sent back to the spheres, which then implement them locally. The intelligent networking system creates a guidance & monitoring system that could be used in the networked factory of the future.
*http://www.festo.com/cms/de_corp/13705.htm*

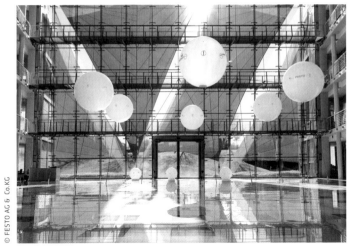

© FESTO AG & Co.KG

© FESTO AG & Co.KG

© FESTO AG & Co.KG

Rintaro Shimohama, Naoki Nishimura, Shinya Wakaoka
# Noramoji Project

The *Noramoji Project* is a Website and an Open-source project. The old fonts used on the signs of local stores may not be as sophisticated as a precisely designed commercial font, but these "stray letters" (Noramoji) still have their own unique charm. This project's starting point was the desire to rediscover and archive the charm of these signs, from their design to their antique-like craftsmanship and the aging of materials. The "stray letters" discovered through the project are analyzed and then converted into usable computer fonts. By then distributing the font data online, more people can learn about the fonts on the old signs. The profits generated by the sales are given back to the owners of the original signs, helping to support their maintenance for future generations, passing on the scenery of regional towns and cities, and creating what we might call a typographic folk art movement. During the Ars Electronica Festival, the *Noramoji Project* is linking Ars Electronica with Japanese Shops. T-shirts bearing designs based on shop signs will be displayed at Ars Electronica. Visitors will be able to take a T-shirt home in exchange for a donation to the shop concerned, thereby linking Ars Electronica visitors to the shops in faraway Japan. The *Noramoji Project* will establish a donation cycle.

Supported by Japan Media Arts Festival

IDPW
# Internet Yami-Ichi

*Internet Yami-Ichi* (Internet Black Market, Yami also implies "sick for" and "addicted to") is a flea market-style event to sell and buy internet stuff face-to-face. If virtual reality (the internet) represents the legal market for trading goods and services, then "reality" can be understood as the black market, although there's nothing illegal going on here. Target group and potential participants is anyone who has had meaningful experiences on-line which he or she would like to share off-line.

Accompanying the global spread of internet (and the mobile phone network) infrastructure and the communication possibilities it offers, various on-line communities and cultural forms are continuously developing. The emergence of social networks and the rapid sale of smart phones—on-line by default from mid 2000—have made our off-line lives increasingly dependent on our on-line lives.

Some people feel uncomfortable with this level of connectivity, and the extent to which society is dependent on this infrastructure necessitates the establishment of stricter internet rules compared to the relative freedom we enjoyed in early on-line culture. Maybe we are over-sharing on SNS. Maybe we don't want to format our social networks so that they are easier for corporations to mine. Maybe we want to watch videos or visit sites whose content doesn't strictly comply with the most stringent copyright policing, privacy and security standards for everyone. Maybe we don't want our every activity on-line to be observed. The internet we used to enjoy for the freedom it gave, is gradually metamorphosing into a very restrictive place.

The *Internet Yami-Ichi* exemplifies our inalienable right to turn off, log out, and meet up, in a new space for exchange. All the richness of the internet was put there by us. Everything that we enjoy(ed) on-line can be enjoyed off-line too. We want to communicate, exchange and enjoy our relationships according to individual "values," unmediated, face-to-face. This is the genesis of the *Internet Yami-Ichi*. Like the early internet, the *Yami-Ichi* atmosphere is rich with irony and humor. The best of what we share and exchange at the *Yami-Ichi* is witty, playful, provocative. Whether data, memory, internet-infused fashions, using a recipe found on the internet to cook, or selling and buying—these things are so easy to do on the internet but much more difficult in real life. What is actually on view, and participated in, are the attitudes and ideas of our evolving understanding about what post-internet values are exactly, in a creative and spontaneous and fun environment.

*Volksgarten*

Volksgarten—What gives somebody the right to persecute refugees a second time round?

The Trinity Session—Stephen Hobbs and Marcus Neustetter
# Renaming the City

When I first walked through the Volksgarten in Linz I did not hear any German being spoken. Yet the stories on the local news detailing the grim experiences of refugees and migrants living in Linz stood in stark contrast to the diversity I was experiencing in this public space. It reminded me of home—Johannesburg, South Africa—where overt xenophobia is felt in everyday mistreatment of foreigners that culminates in regular violent outbreaks. Sadly, our South African borders and behaviors have come to send a strong message of rejection, in a time of great need, to the people of the nations that so generously accepted and aided our exiled community. My experience in the Volksgarten highlighted connections between the South African apartheid experience which, much like the Austrian Nazi history, lingers on in subjective memories, through continued spatial injustice, and in pervasive othering. Indeed it is this that drives our artistic practice of socially engaged public art towards understanding whether there is a utopian inevitability of global integration. Is it that far fetched that the Champs-Élysées in Paris will one day host the cultural attractions of a francophone African city? Or that foreign culture and integration will need to go beyond the cliché

of the Chinese restaurant or Kebab store on the Hauptplatz? Can we imagine a future where a city's commitment to global growth and integration will be measured through the way in which they welcome the newcomer into their public spaces? It will start to define a city's wealth not for its infrastructure and its economic boom, but for its tolerance, engagement and cultural diversity. Dialogues held with immigrants in Linz produced both grueling tales of an arduous journey, as well as positive anecdotes of the support they have received. However, it is apparent that we still seem to be a long way from the welcome we would like to receive if the tables were turned.

Both Stephen and I are white born South Africans with European family roots. South Africa is home. Johannesburg is home. Yet, with the changing population in our city—from black South Africans that moved into the city at the end of Apartheid and the more recent influx of refugees and migrants from the continent—we are suddenly considered the tourists in certain spaces of our city. While we constantly question our presence and foreignness in a radically changing space, I did not expect to be reminded of the questions I ask myself on the streets of Johan-

Welcome home—Buses from abroad are welcomed.

Victor Neustetter

nesburg, while in Linz. My German speaking, male whiteness was just as alienating in the refugee and migrant circles in Linz—I was not painted with the brush of the tourist, but of the local, that might or might not be accepting of the foreigner.

Back home we look to the public spaces in which we operate and we try to make sense of how these spaces exemplify the layered history of our country, a sense of ownership, control and alienation. Our artistic interventions in public have helped make sense of these charged spaces. These interventions are both in the creation of permanent public artworks, as commissioning agents for the city, as well as temporary activations towards our own practice. Each project gives rise to new opportunities for engaging the new inhabitants of the city and getting to know our own neighbors.

Bordering on social practice and cultural activism these artistic interventions help illustrate a future reimagining of public space as a host for various cultural activities. Witnessing Johannesburg change as a city has provided much inspiration in exploring other options and tools for meaningful engagement and creating a sense of city ownership for its diverse public. On a national level, streets, parks, and public areas, are being renamed to celebrate local post-apartheid heroes and to attempt to create new identification with the very public spaces that were once only accessible to a few.

Victor Neustetter

Volksgarten

*Borderless*, live action, 2011. The stark juxtaposition of the wealthy Sandton Central and Alexandra Township is most demonstrative of the social, economic and racial inequalities in the city. By marching goats, an infinitely valuable commodity in the township, to the 5 Star Michelangelo Hotel in Sandton City, the performance provoked reflection on the origins of the xenophobia attacks of 2008.

Streets in Johannesburg are renamed.

Our project for POST CITY–Habitats for the 21st Century, responds to these very conflicts. It attempts to bring some of our processes for engagement and place making from home into a context that faces similar challenges. The primary intention of our project is to permanently rename the pedestrian roads in the Volksgarten. The new names will be based on incorporating names proposed by immigrants in Linz–a symbolic act that hopes to establish a social and political consciousness around ownership and inclusivity. This act is not only a conceptual link back to the transformations of public spaces where we come from, but an outcome driven process that

forces locals to engage and include those that are often marginalized. In developing the relationships with communities that have had to struggle with acceptance in Linz, leading up to the festival there will be attempts to connect through positive gestures. One of these gestures originated in the realization that many immigrants leave their homes in Linz during August to holiday in their previous homes. On their return, they will be met with personal gestures of welcoming by strangers–volunteer Linz inhabitants. "Welcome home" signs in languages appropriate to the arriving travelers will be held by local people offering a warm handshake or maybe even baked goods to a surprised neighbor who has never experienced welcoming in the city before.

For the festival, Linz will be mapped out in the large *Post City* venue. It is the artists' intention to "capture" a piece of public space and present it in this venue. The focus area of our renaming exercise, the Volksgarten public park, will feature in the space not only as a drawing on a map, but as a feature to be experienced. The mirroring of this "captured" space within the building, hopes to draw attention to the real park and its activities, as well as create opportunities to play with different parts of the park. Representing it so much larger and more real than the Hauptplatz in the map elevates its importance. In addition, it magnifies the people in it, as culturally diverse as they are, with their daily activities and exchanges. As part of the *Post City* Volksgarten experience, visitors will be able to contribute to the space by sharing their ideas for new names of the paths. This will become a collection point of public squares and street names emanating from various languages, cities and personal references and journeys.

These choreographed acts are a small attempt at re-imaging the future city, not in the sense of futuristic buildings and transport systems, but in simple gestures of naming ones everyday space, fostering a sense of belonging and ownership to that space, and forging neighborliness between global citizens.
Text: Marcus Neustetter

The Trinity Session–Stephen Hobbs and Marcus Neustetter (Johannesburg, South Africa)
With the contribution and collaboration of Jochen Zeirzer, PANGEA | Werkstatt der Kulturen der Welt, Integrationsbüro der Stadt Linz, and the broader network of the participating immigrant organisations and Linz community.

 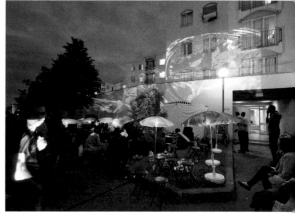

*Ataya–West African Tea Ceremony*, Johannesburg/Paris 2012–2013

The saying in Africa: If you are lost, sit down and make tea, serves as a starting point for Hobbs/ Neustetter's public tea ceremony actions with west African immigrants. Taking up to 2 hours to produce three stages of tea, the attendant conversation between friends and strangers often matures equally. For Hobbs/Neustetter, ataya serves as a form of "urban acupuncture"; raising questions in situ, about the potential for change. Since 2012 these interventions have happened in francophone immigrant neighborhoods from Hillbrow, Johannesburg to Saint-Ouen, Paris.

Ars Electronica Futurelab
# Focus

*Focus* is a smartphone app first developed by Ars Electronica Futurelab for Schlossmuseum Linz. This app enables visitors to take an active approach to the exhibits and zoom in or focus on what they like best. At the end of their exhibition tour, visitors are invited to upload their favorite motif to the *Focus* terminal and create a button badge they can take home. *Focus* thus represents a new approach to visitor engagement and perception of exhibition content. By creating a button visitors are actively involved with a theme and create something tangible they can take back home with them.

*Focus* is an ongoing cooperation between Ars Electronica and OÖ Landesmuseum.

University of Tsukuba + Ars Electronica Futurelab

# Post City Kits from the University of Tsukuba

In the Ars Electronica Futurelab Academy, experts from Ars Electronica's research laboratory mentor students who are working at the nexus of art, technology and society at eminent international partner universities, opening a field of creative exchange across cultures and disciplines. During the 2015 Futurelab Academy program with the Empowerment Informatics PhD program at Japan's University of Tsukuba—a leading research university with a visionary focus on human-centered cybernetics—two student teams have produced experimental projects that envision radically different interpretations of a "Post City Kit".

## IrukaTact
Aisen Caro Chacin, Takeshi Oozu

*IrukaTact* is a submersible haptic search glove inspired by dolphin (iruka) echolocation. It can locate sunken objects after a flood, translating ultrasonic range finding data into haptic feedback using a novel approach. Conceived as a kit for emergency situations, it is open source and can be constructed using readily available materials and digital fabrication processes.

## idMirror
Maša Jazbec, Floris Erich

*idMirror* is an artistic project that investigates how social networks and emerging mobile technologies have forever changed the perception of human identity. The piece uses tablet computers' inherent resemblance to mirrors to play with identity by turning the visitors' faces into objects of unexpected manipulation.

MIRAI Project Department TOYOTA MOTOR CORPORATION X Future Catalysts
(Hakuhodo x Ars Electronica)

# KURUMA-IKU Lab

KURUMA-IKU is a blend word that combines *Kuruma* (Car) with *Iku* (Nurture). The KURUMA-IKU lab is a research & development initiative that focuses on the relationships between people and cars and invites children and creators to join the investigation into sustainable roles for cars in our future society.

Cars are used to transport people from one place to another and driving is also an enjoyable experience for many people. But is this all a car has to offer? A car has "intuitionally judge-able materials" such as the shape, the color, the sounds, the motion, and also "the stories of makers". If we change the way of presenting cars and how they can be used, cars will become tools for nurturing inquiring minds and creativity. At KURUMAIKU-Lab we can use art to reveal the inherent and various merits of cars that have not yet been discovered. This program aims to nurture children's creativity and to build new relationships with citizens.

What role will the car play in society in the future Post City, and what will our lives be like? At the Ars Electronica Festival 2015, children who are going to play future roles will use KURUMA-IKU lab's workshop kits to learn about cars and to creatively reflect on future mobility and city. Currently, we collaborate with Future Catalysts (Hakuhodo x Ars Electronica) and our programs are beta versions.

## Kurumachi

*Kurumachi* is a workshop program to research and create new relationships between children and mobility. By personalizing a car model as oneself or a partner, this workshop stimulates the imagination and the individual, and allows participants to create the concept of their own original car. The *Kurumachi* workshop focuses on discussing both individual roles of self and forms of society through a combination of design process by digital media and hands-on experience constructing a paper craft.

## Steering-san

If you add a steering wheel to something, it will become a car. *Steering-san* is a workshop program to create story telling by using an everyday object around us that resembles a car. If everyday objects become able to move around freely like a car, what new benefits of mobility are created?

## Steering Jam

*Steering Jam* is a workshop program to design a personalized interactive steering wheel. The participant customizes both the appearance of the steering interface and the sound of mobility in running, turning and horning. Thus, it allows participants to design their own mobility experiences. Running with friends will lead to an unexpected jam session. This workshop discusses future mobility and the future city, through the creation of an original mobility interface.

# Quasar

*Quasar* is the first part in this new series of works by FIELD, and describes the spirit of pioneering as three human archetypes—each with their own means of perception, rationale and communication. We observe their acts of exploring and creating, their willpower, creative strength, and physical exhaustion. *Quasar* explores visions of a near future and what it will mean to be human. Comprised of wearable sculptures, interactive experiences and photo artworks, all elements of *Quasar* characterize the three archetypal explorers from different viewpoints. The *Quasar* series comprises of three sculptural helmets and interactive experiences, fifteen photographs and three VR screen captures. Each of the sculptural helmets houses a VR headset, which is connected to a PC.

Concept, Design + Direction: Marcus Wendt
Co-direction: Vera-Maria Glahn
Production: Maran Coates
Fabrication: Studio MakeCreate
Interaction Design: David Li, Tim Murray-Browne, Jonas Johansson
Sound + Music: Ben Lukas Boysen
Assistance: John Jones, Chris Corless, Matteo Zamagni
Models: Calvin How, Donja Rose, Emma Zang
Styling + Costume: Natalie Caroline Wilkins
Hair + Make-up: Elvis Schmoulianoff
Motion Direction: Marquez + Zangs

Katia Cánepa Vega
# Beauty Technology

New technologies often require the handling of complicated technical devices to control them. With *Beauty Technology* the Brazilian artist Katia Cánepa Vega plays with the possibility of using skin and other body parts as interfaces for controlling technology, and considers how to empower disabled people to enrich their lives by creating simple access to technology, mobility and smart homes by designing interfaces that are connected to the body without the aesthetics of cyborgs who are wired and tied up in cables and devices. The artist merges control engineering with the human desire to achieve beauty through enhancing their appearance—she combines wearable technologies with beauty products by integrating electronics into make-up, nail polish, and fake hair. By applying these, controlled movements of facial muscles or touching sensors in the hair with false fingernails can trigger appliances such as window shades or a smartphone. This demonstrates how the human body can act as an interface.

This project was awarded an Honorary Mention at this year's Prix Ars Electronica [the next idea] voestalpine art and technology grant, a program within the framework of the Ars Electronica Residency network.

Hannah Perner-Wilson, Andrew Quitmeyer
# A Wearable Studio Practice

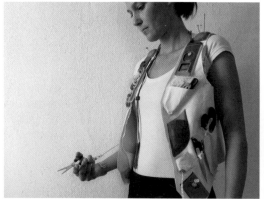

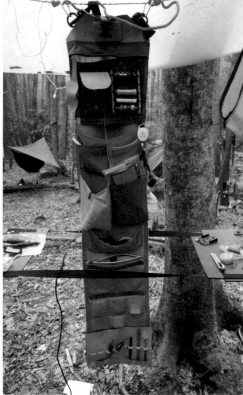

A *Wearable Studio Practice* packages a physical computing/new media studio into a series of portable items that can be worn or carried on the body. This mobile infrastructure provides the functionalities normally contained in static architecture of traditional labs, while allowing engineers and designers to become nomadic in their practice. At Ars Electronica the *Wearable Studio* is a reconceptualization of digital design work happening in spaces beyond the traditional idea of the city. We will inhabit the studio and flesh out more items to add to it. There are workshops for visitors at certain times in our studio in which they can make their own wearable, digital devices. The *Wearable Studio* collection consists of items that are primarily fabric, lightweight, and easy to carry/wear/transport on the body. When set up, the *Wearable Studio* provides a work environment (lighting, power...), work surfaces (soldering, building...), and organization structures as well as easy-access storage for materials, tools and parts.

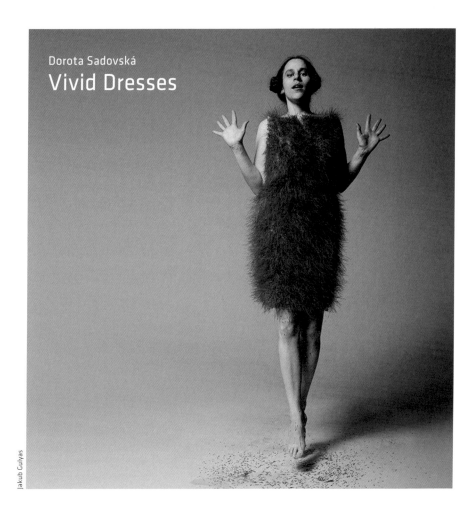

Jakub Gulyas

Dorota Sadovská
# Vivid Dresses

In *Vivid Dresses* Dorota Sadovská takes as her theme natural creative processes, the deformation of nature, and the self-inflicted distortion of human nature. The constantly growing sprouts stand for the spontaneous, fertile power of the earth. Clothing, on the other hand, represents the regulative element of modern civilization in which people need to cover up their bare skin and thus enwrap their own original naturalness. In photographic works and performances, the artist makes her own body a projection surface for a hybrid ambiguity of body and anti-body. Thus, the plant-clothing can be understood as an enveloping foreign body, or as a second skin, a botanical epidermis. In this sense, the tufts of grass on the surface of the dress might bring to mind hair that protects the body below it. The artist isn't just interested in the human body; she also enjoys experimentation that entails combining extremely diverse materials and media, and consciously overstepping their bounds.

Text: Lucia Miklošková, *SADO 3* art magazine 2015

Shiho Fukuhara, Georg Tremmel

# Biopresence

*Biopresence* is an art venture by Shiho Fukuhara and Georg Tremmel that focuses on exploring, participating in, and ultimately defining a top relevant 21st century issue—the impact of biotechnologies on society and the human perception of these coming changes.

*Biopresence* creates Human DNA Trees by transcoding the essence of a human being within the DNA of a tree in order to create "Living Memorials" or "Transgenic Tombstones", and is a collaboration with scientist and artist Joe Davis on his DNA Manifold algorithm, which allows for the transcoding and entwinement of human and tree DNAs. The Manifold method is based on the naturally occurring silent mutations of base triplets; this means it is possible to store information without affecting the genes of the resulting tree. *Biopresence* Human DNA Trees do not modify the genes of an organism, so they are not genetically modified organisms (GMOs). *Biopresence* presents current developments of its research and encourages the public to explore the proposed issues and to envision possible futures.

Katrina Spade
# Urban Death Project

The project's mission is to create a meaningful, equitable, and ecological urban alternative for the care and processing of the deceased.

The *Urban Death Project* is a compost-based renewal system. At the heart of the project is a three-story core, within which bodies and high-carbon materials are placed. Over the span of a few months, with the help of aerobic decomposition and microbial activity, the bodies decompose fully, leaving a rich compost. The *Urban Death Project* is not simply a system for turning our bodies into soil-building material. It is also a space for the contemplation of our place in the natural world, and a ritual to help us say good-bye to our loved ones by connecting us with the cycles of nature.

The *Urban Death Project* is a solution to the overcrowding of city cemeteries, a sustainable method of disposing of our dead, and a new ritual for laying our loved ones to rest.

Conventional burial is chosen by more than half of Americans today. The annual tally of buried materials in U.S. cemeteries is more than 30 million board-feet of hardwood and 90,000 tons of steel in coffins, 17,000 tons of steel and copper in vaults, 1.6 million tons of reinforced concrete in vaults, and more than 750,000 gallons of formaldehyde-laden embalming fluid. It is disrespectful both to the earth and to ourselves that we fill our dead bodies with toxic fluid before burying them in the ground.

Cremation is a less wasteful option, but it still emits 540 lbs of carbon dioxide per body into the atmosphere, contributing to climate change. The more options we have to safely and gently dispose of our dead, the better.

Text: Taken with permission from
*http://www.urbandeathproject.org/*

Búi Bjarmar Aðalsteinsson
# The FlyFactory

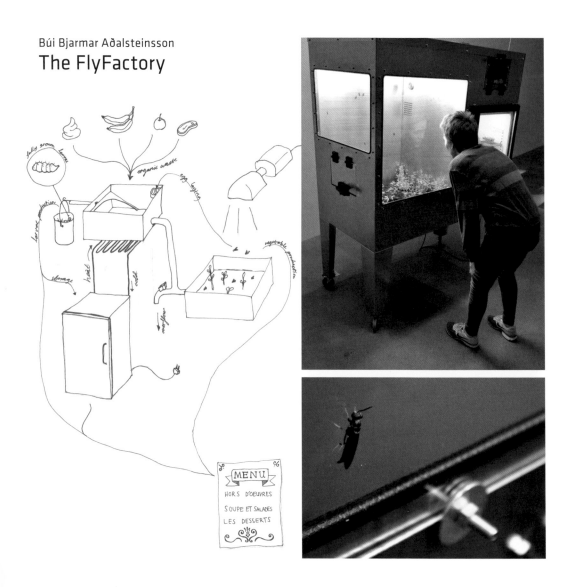

The *FlyFactory* is an ecological food production concept with Black Soldier Flies as the main component. The larvae become rich in fat and protein, which can then be harvested for human consumption. They also produce a clean and nutrient-rich soil, which is subsequently drained into compost canisters and then used for vegetable, fruit and spice production. Finally, heat generated by refrigerators that are used for larvae preparation and storage will be employed as a thermal source to maintain the humidity and temperature of the flies' environment. Larvae are similar to meat when it comes to protein, fat and nutrients. But larvae need 5 to 10 times less food to produce the same amount of growth. Larvae—and insects in general—are also very resourceful when it comes to feeding, as they are able to digest almost any biomass available in the natural environment. This makes insects a valuable resource in the search for ecofriendly methods of farming and the production of protein rich foods.

XXLab (Irene Agrivina Widyaningrum, Asa Rahmana, Ratna Djuwita,
Eka Jayani Ayuningtias, Atinna Rizqiana)

# SOYA C(O)U(L)TURE

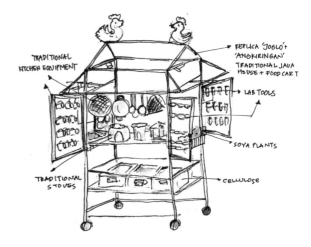

*SOYA C(O)U(L)TURE* can be found as a simple kitchen in the middle of the Post City's Fashion District: The Indonesian female art collective XXLab works on a program to create fashion while dealing with environmental problems. In countries and cities with high soya consumption the wastewater from tofu and tempeh production is problematic for the environment. XXLab develops simple, cheap, and eco-friendly processes to turn it into useable biomaterials—bio-fuel, fertilizers, and leather-like materials. A simple kitchen is used as a laboratory to transform the wastewater into these biomaterials, and as an atelier to design clothes, accessories, and shoes. But their knowledge has to be spread: in their workshops XXLab enables citizens to combine basic kitchen equipment with free technology and open source software in order to upcycle everyday wastewater.

The *SOYA C(O)U(L)TURE* project is the winner of this year's Prix Ars Electronica [the next idea] voestalpine art and technology grant 2015, a program within the framework of the Ars Electronica Residency Network.

127

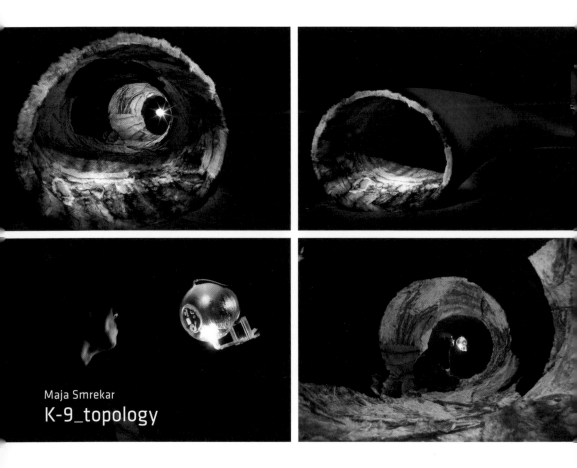

Maja Smrekar
# K-9_topology

The interaction of biology and culture is the central concept in the understanding of human evolution, geographical dispersion, diversity, and health. Within this frame, we are interested in metabolic pathway processes that trigger an emotional motif which enables two species—humans and dogs—to successfully coexist.

*K-9_topology* researches the co-evolution of genes, evolution psychology, behavioral ecology, and hence cultural evolution through the paradigm wolf-dog-human. The project focuses on evolution and domestication—patterns of human movement across the globe, rooted in data sets by analysis of ancient DNA and contemporary gene polymorphism research. This purely scientific data leads to a cross-disciplinary dialogue on the mutual domestication of animals and humans.

The installation is an immersed living environment, shaped like an archetypical horn and with wolf fur covering the inner walls. It is equipped with an interactive sensor installed respirator that allows visitors to experience the smell of the serotonin isolated from the platelets of the artist and her dog—the essence of their relationship.

Produced by: Kapelica Gallery, Ljubljana
Thanks to: Lord Byron (Scottish Border Collie)
Co-designing, planning: Andrej Strehovec
Planning, execution of lab infrastructure and protocols: Marko Žavbi, MA lab biomed
Molecular biology consultancy, execution: Alja Videtič Paska, Tilen Konte, Institute of Biochemistry, Faculty of Medicine, University of Ljubljana
Field research and consultancy: Miha Krofel, Department of Forestry, Biotechnical Faculty, University of Ljubljana
Installation execution: ScenArt
Glassblowing: LabTeh d.o.o.
Supported by the Ministry of Culture of the Republic of Slovenia and Municipality of Ljubljana, Department for Culture, Slovenia

Soichiro Mihara
# bell

The artwork *bell* (2013) is the second part of the ongoing *blank* project, started in 2011, which investigates the relationship between technology and society. When a microchip under a glass dome detects radiation that is imperceptible to humans, the sound of the wind chime within the dome can be heard. Long ago wind chimes placed on territory borders warned people of imminent danger and the as yet unseen evil that was about to befall them.

*bell* gives perceptible form to nature and science's imperceptible threats, sending out an audible warning about radioactive waste.
*http://mhrs.jp/project/blank/*

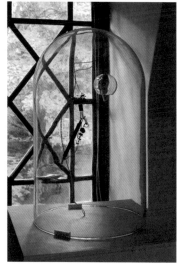

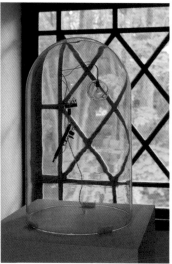

Keizo Kioku

Salvatore Iaconesi, Oriana Persico

# Ubiquitous Infoscapes
## The participatory performance of the city

The exponential rise in the quantity and quality of data and information that individuals generate every day is the single most important driver of the evolution of the Big Data concept. Each of our gestures, movements, relations, transactions, and expressions tends to become an occasion for the generation of digital data and information. This happens whether we realize it or not, consciously or unconsciously, in direct, indirect, transparent or completely opaque ways.

At the present time, most individuals generate data in ways they don't realize or even understand, due to the opacity of collection processes, algorithms, classifications, and parameters. They don't (can't) know how this information is used: inaccessible profiles are used to generate personalized interfaces, services, advertisements, and content. We are constantly becoming the unknowing subjects of social experiments, communication campaigns, national security scrutiny, dots in dashboards and information visualizations.

Individuals are, currently, the only ones who cannot fully benefit from Big Data to organize themselves, to create meaningful, shared initiatives, or to understand more about themselves and about the world around them.

On top of that, when data becomes so detailed that the sample can be as large as the actual population, and it is possible to use complex algorithms to process it, the perception of the possibility to use all of this data to eliminate all risks recurringly comes to mind, and thus its impacts in terms of the elimination of the possibility to comprehend and value what is different, unexpected, transgressive, adventurous, and possible.

This overall scenario may lead to a deterministic, data-biopolitical scenario, which is what we confront with our projects.

We aim at describing an ubiquitous infoscape, in which data becomes an accessible, usable part of the landscape, just as buildings, trees, and roads, and in which it is clear and transparent (although complex and fluid) what is public, private, and intimate. And in which people are able to express how they wish their data to be used and can actually use it to construct meaningful actions. We aim to create a participatory, inclusive performative space in which people, as individuals and as members of society, can express themselves and do things, defining new forms of public/private/intimate spaces that are agible, accessible, and usable.

ARTI–Agenzia Regionale per la Tecnologia e l'Innovazione della Regione Puglia (IT); Artsci Salon (Toronto, CA); ARTSHARE (PT); City of New Haven (USA); City of Rome (IT); Décalab (FR); EF - Eisenhower Fellowships (US); Fondazione Bruno Kessler (IT); Foundation for P2P Alternatives (NL); Internet Festival (IT); ISIA Design Florence (IT); Yale Center for Engineering Innovation and Design (USA); Yale Center for Emotional Intelligence (USA); Yale World Fellowship (USA); Yale Urban Design Workshop (USA); York University (Toronto, CA); LabGov–Laboratory for the Governance of the Commons (IT); Sapienza University of Rome (IT); King's College (London, UK); Maker Faire Rome (IT); Nexa Center for Internet & Society (IT); Rural Hub (IT); ODI - Open Data Institute (UK); SESC Vila Mariana (BR); Transmediale Festival (DE); Universidade Metodista (BR).

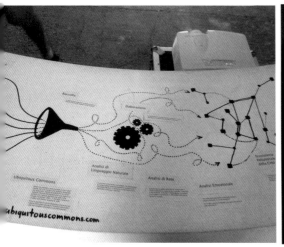

Ubiquitous Commons, 2015, Bari. Diagrams of Ubiquitous Commons integrated with Human Ecosystems.

Ubiquitous Commons, 2015, Brussels. Presenting Ubiquitous Commons at NetFutures 2015.

## Ubiquitous Commons

*Ubiquitous Commons* (UC) is an international research effort dedicated to the production of a legal and technological toolkit which enables individuals to express how they wish their data to be used, and to create shared, participatory processes in which data, information and knowledge can be generated and accessed within a high quality, trust-based relational environment.

UC takes the form of a protocol (both legal, technological and philosophical) that can be autonomously used by single individuals and that can also be integrated in services, devices and processes. UC operates according to the possibility to use emerging technologies (such as the BlockChain) to create peer-to-peer (P2P) networks in which a variety of types of identities can co-exist and express themselves. Individual, collective, anonymous, temporary and nomadic identities can manifest themselves on UC and use strong cryptographic mechanisms to ensure that their data, information and knowledge are used in specific, desired ways.

This possibility creates unexpected opportunities. Collective identities can be defined for neighborhoods, cities, and communities of practice. Anonymous identities can be created for activists, individuals and groups. Temporary identities can be created for events and initiatives. Nomadic identities can be created to generate value that can then be passed on, to share it with other individuals or entire communities.

First working implementations of UC have already been prepared for social networks and online services, and current efforts are directed to including it in network connected devices, Internet of Things, wearable technologies, biotech devices, and more.

Ubiquitous Information and Knowledge is about the data, information and knowledge produced by bodies, locations, movements, desires, expectations, and cultures that are created, reproduced and mediated ubiquitously, online/offline, through mobile applications, sensors, cameras, augmented reality, maps, Internet of Things, and more. Consciously and unconsciously. And about the ways in which this information and knowledge is used.

Ubiquitous Commons is the commons in the age of Ubiquitous Technologies. It constructs a novel identity model in which data forms a Common Resource Pool that is managed collectively through the presence of a High Quality Relational environment.

# Human Ecosystems

*Human Ecosystems* (HE) is a complex technological system for cities and a new space for artistic, cultural and creative performance, in which citizens and other types of urban dwellers are able to use the city's infoscape—its informational landscape. The project has already been instanced in various forms in urban settings such as Rome, Sao Paulo, New Haven, Montreal, Toronto, Berlin, Lecce, Bari, Florence, and Budapest.

HE massively captures data in real-time in the city and transforms it into a commons, available and accessible to anyone, and manageable collaboratively. Data is captured from major social networks (Facebook, Twitter, Instagram, Google+, Foursquare, Flickr) and other data sources (such as census, land registries, energy, mobile traffic, and the many types of Open Data source which can be present in the city), and processed in near-real time using a variety of techniques (georeferencing, natural language analysis, emotional analysis, network analysis, data integration and fusion techniques, and standard statistics techniques). The result of these processes is a real-time Open Data source which forms a commons and which is made available to the collectivity, to be preserved and managed collaboratively.

HE represents a new form of digital public space in the cities in which it is implemented. It facilitates better understanding of the flows of information, knowledge, communication, emotion and opinion that take place in the digital public space of the city, and allows this understanding to be used for multiple purposes—to "ask the city questions ", to create information visualizations and urban dashboards on multiple topics, to compare multiple cities, to create artworks and designs, to understand how different cultures express and relate in the city, to allow people to use the public Relational Ecosystem of the city to understand how to organize themselves in peer-to-peer models, to enable participatory decision making and policy shaping processes, and to create new services and processes.

A wide, inclusive education program is developed in the city as *HE* starts, teaching citizens, children, the elderly, artists, designers, researchers, public administrators, professionals, and others to understand how to use *HE* and the Relational Ecosystem of the city and how to engage citizens in the process. All of the technologies related to *HE* are released as Open Source, and are actively maintained by an international community of practitioners in technologies, arts, sciences, and humanities.

One Million Dreams, Maker Faire, Rome, 2014.
Dreams on social networks.

Stampede, Luohu, 2015. The city district of Luohu in China, during a stampede crisis.

Learning, 2013, Cava de' Tirreni. Students during a workshop, learning to use the Relational Ecosystem of the city

*The Real-time museum*, 2012, Rome. The desires for the transformation of the city, expressed on social networks

## The Real Time Museum of the City

*The Real Time Museum of the City* (RTMC) is the physical public space manifestation of the *Human Ecosystems* (HE) project. It is a physical museum (although many of its exhibits are accessible online) in which multiple exhibits allow you to experience the digital public space of the city. The exhibits range from the more useful to the most abstract ones; from actual service and research tools, to games and playful, critical or surreal investigations on the real-time expressions of the entire city. Visitors to the museum find themselves completely surrounded by the data, with which they can interact, using devices, gestures, keyboards, voice and other forms of interaction, and by collaborating with one another: people can explore the flows of data, information, knowledge, emotions, opinions, and languages as they are captured through HE, also being able to go back and forth through time (to see how different topics, emotions or geographies transformed in the city), or even to compare different cities in which *HE* is present.

Different experiences have different valences, from the more entertaining to the more critical ones. In one exhibit visitors, for example, are able to "find themselves", by providing their user name on major social networks, through a street address or some other type of identification. This kind of experience is exciting, useful and critical, at the same time. On the one hand, it allows museum visitors to explore the Relational Ecosystem of the city from their own point of view, analyzing connections, topics, relational distances, community belonging, and the form of their identity as it shows in the digital public space of the city. On the other hand, it may be an unsettling experience. Wondering "Why am I in the museum?" can be a thought-provoking issue, touching critical topics such as privacy, surveillance, rights, freedom of expression, cultural representation, power architectures, and more. All experiences are built in ways that allow for critical reflection but also for positive construction, enabling visitors to understand how to confront these important issues, along protective and constructive directions. The RTMC is also the place where the HE educational program takes place, providing people with engaging experiences in which they can learn how to use the city's digital public space completely immersed in the data, information and knowledge from their city.

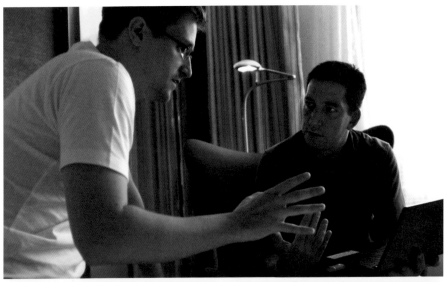

```
ES: Hey.
ES: Are you there?
LP: yes!
LP: Are you ok?
```

# CITIZENFOUR
A film directed by Laura Poitras

In January 2013, filmmaker Laura Poitras received encrypted e-mails from an unidentified sender who referred to himself as CITIZENFOUR and claimed to have proof of illegal covert programs of mass surveillance being conducted by the NSA and other American intelligence agencies. In June 2013, Laura Poitras and journalist Glenn Greenwald flew to Hong Kong to meet their mystery contact, who turned out to be Edward Snowden. *CITIZENFOUR* is a real-life thriller in which these dramatic events unfold by the minute right before our eyes, the breathtakingly exciting account of the courageous step taken by a young whistleblower—urgent, disturbing, politically explosive. Poitras had already been working on a film about surveillance for two years when, in January 2013, she was contacted by Snowden using the name CITIZENFOUR. He reached out to her because he knew she had long been a target of government surveillance, had been stopped at airports numer-ous times, and refused to be intimidated. When Snowden revealed he was a high-level analyst driven to expose the massive surveillance of Americans by the NSA, Poitras persuaded him to let her film. Laura Poitras is a documentary filmmaker, journalist and artist. Her work has been singled out for recognition with many important honors worldwide—among them, a Peabody Award as well as Oscar and Emmy nominations. Poitras' NSA reportage based on the documents made public by Edward Snowden garnered her the 2014 Pulitzer Prize for Public Service bestowed by the Guardian and the Washington Post.

Courtesy of Polyfilm
Directed, filmed, produced by LAURA POITRAS
Edited and produced by MATHILDE BONNEFOY
Produced by DIRK WILUTZKY
With: Edward Snowden, Glenn Greenwald, Ewen MacAskill, William Binney, Jacob Appelbaum, Jeremy Scahill et al.

# TPB AFK: The Pirate Bay Away From Keyboard

A film directed by Simon Klose

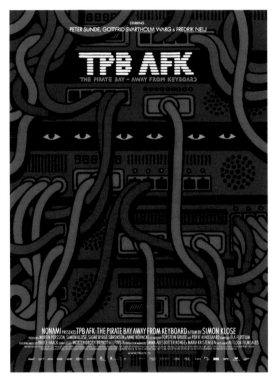

Founded in 2003 by "a couple of guys in a [internet] chatroom," P2P file-sharing website, the Pirate Bay was responsible for coordinating half of the world's bit-torrent traffic by 2009. With an estimated 22-25 million users downloading from the site at any one time, TPB is clearly a principal player. It's claimed that major motion picture studios suffered $6.1 billion losses at the hands of piracy in 2005. That's the kind of thing that puts a trio of Swedish tech-geeks firmly in the sights of Hollywood's big guns. Their ongoing trial is the focus of Simon Klose's documentary, *TPB AFK: The Pirate Bay Away from Keyboard*. Spanning a period of around 18 months, TPB AFK documents the continuing battle between the state prosecution in Sweden and the site's runners Gottfrid Svartholm, Fredrik Neij, and Peter Sunde. February 2009 saw the three partners embark on their crusade against the machinery of the movie industry and what they view as stagnant copyright law in the modern information age. The trials and tribulations of the following year and a half take their toll on all three young men in different ways.

Text, photos: *cine-vue.com; http://moviespix.com/ tpb-afk-the-pirate-bay-away-from-keyboard.html*

Directed by Simon Klose; Produced by Martin Persson
Screenplay by Simon Klose
With: Gottfrid Svartholm, Fredrik Neij, Peter Sunde

# Future Innovators Summit 2015

AEC, Florian Voggeneder

The Future Innovators Summit (FIS) is a creative system to develop ideas and prototypes for the future. The FIS has been developed by Future Catalysts Hakuhodo x Ars Electronica through the Incubation Training Workshop at the Ars Electronica Festival 2014.

Following its successful premiere at Ars Electronica 2014, in 2015, the Future Catalysts will realize a new project for the special theme of the festival. The participants of the FIS will develop a *Post City Kit*– ideas, strategies, tools and prototypes to improve our cities.

The challenging topics and questions for the *Post City Kit* are:

- How smart does a city have to be before we are afraid to live in it?
- "Publicy"... the transformation of private and public
- Smart democracy
- Strategies to elicit community involvement
- Informed trust–In a world of autonomous machines
- What types of resilience should we develop?

The process of the FIS is based on three steps: unlocking creative energy, facilitating creative process, and triggering creative questions. The Future Catalyst Program is a setting of collaborative deliberations and workshops in the inspiring ambience of the Ars Electronica Festival for art, technology and society. Seasoned experts and young entrepreneurs, activists, engineers, scientists and artists as well as designers will work in different groups.

Each group will create a new idea for the *Post City Kit*. The FIS program includes individual flash talks, intensive workshop sessions and meetings with mentors. At the end of the process, all groups will hold their final presentations in public.

For implementing the FIS, there are three important factors to consider. First of all, the FIS needs unique locations and artistic inspirational spaces. The special atmosphere of the disused postal service center venue takes the participants out of their comfort zone, at the same time stimulating and unlocking creative energy. Secondly, facilitators play an important role, as they guide the brainstorming process to the final outcome. Hakuhodo's professional facilitators will utilize their own methodologies to elicit creative questions by maximizing the participant's individual skills and expertise. Finally, mentors will advise the participants on how to implement the idea in society. Through this process, the participants will prototype their ideas and come up with creative solutions.

Since 2014, Future Catalysts Hakuhodo x Ars Electronica have utilized the FIS to develop innovation processes for society. The focus is not on finding solutions for specific problems but rather on coming up with visionary questions. The challenge of the FIS 2015 is to build a bridge between the processes of triggering creative questions and finding creative solutions in order to improve our cities.

Text: Katharina Bienert, Kyoko Someya, Hideaki Ogawa

AEC, Tom Mesic

Derrick de Kerckhove

# Connected Intelligence in the Post City
# The Internet as a Social Limbic System

My understanding of Post City is smart city with people inside. No need to remind anyone that "smart city" is a dominant buzzword today. As a metaphor, following upon others such as "Cloud Computing", "Internet of Things" and "Big Data", like yeast to bread, it has done wonders to raise new markets. Although the smartness is not quite there yet, it is bound to mature as cities eventually get equipped with a truly functional nervous system. The question is whether it will be central or distributed, autonomous or controlled, self-organizing or monitored and administered. As Steven Poole wrote in *The Guardian*: "The phrase itself has sparked a rhetorical battle between techno-utopianists and postmodern flâneurs: should the city be an optimized panopticon, or a melting pot of cultures and ideas?"[1]

*If Post-City can be defined as "Smart City with People", then indeed there is a great need for kits to better connect those people who have the city in mind.*

## Connected Intelligence

All electronic technologies from the telegraph to the Internet and social media derive their properties from weaving connecting routines to elicit selected modalities of relationships and knowledge. The present trends of information and cognition technologies have been based and guided on connecting people and things in specific configurations to improve awareness, intelligence and knowledge, as well as generating flows of emotion. This is the core meaning of connected intelligence: making the right connections—mental, social and/or technological. The potential of electronic technologies to foster intelligent connections has increased continually from the telegraph to "cloud computing", Twitter and the Internet of Things. It brings people and things together instead of separating them as print

literacy did. It allows for any number of individual entries in a fluid information space definable for individual as well as collective and connective needs. It can take many forms whether pooling individual resources in services such as Google, Wikipedia and social bookmarking or externalizing and objectifying imagination in fictional but live 3D shared environments such as Second Life. This environment of knowledge functions both as an extended memory and as a processing intelligence for each one of the users individually or in association with others. It is in constant evolution because intelligence, collective or connective, benefits enormously from the very minds and skills that have been changed and trained precisely by technologies arriving on the market. Data Analytics, for one, is already modifying the way we think about "intelligence". Big Data, for another, is bound to make asking the right question a top priority in business, government, education or research. For millennia, we have taught answers in schools. Won't it be time soon, to teach questions? Over the last three decades I have shared with Gary Schwartz[2] a fascination for connected intelligence and how to harness it for the benefit of my students. We invented together and separately several iterations of collaborative software. My last one is iWall, a hybrid between a portal and a PowerPoint presentation to facilitate collaboration in classes and other research situations. And now Gary has come up with ThinkWire *(www.thinkwire.com/Ars-Electronica)*, a superb concentration and simplification of many complicated ideas we shared long ago and, as well, a perfect example of how connected intelligence *can work* on line. ThinkWire is an application of Twitter, with the difference that it invites groups of people interested in studying or resolving or producing something of value to get together in virtual panels. A person who is willing to take charge of stoking the discussion moderates

each panel. The added value of ThinkWire is that the software upgrades Twitter to allow imputing 280 characters rather than the skimpy 140. That, as Gary explains, is a deliberate and rigorous cognitive strategy. It has the double merit of permitting more substantial arguments, but at the same time restricting the length of interventions to a manageable size. ThinkWire is a sort of cognitive discipline for groups. In reality, ThinkWire is a typical model for how to sculpt connectivity for the most pertinent effects in given cognitive enterprises and environments. It is the platform that Culture and Technology International (CTI)—our international team of experts—has used to explore some dimensions of Post City. Among the observations that emerge from the discussion is that, while Post City as a concept is its own space, it seems to contain and integrate the others.

### The Space of Post City

> As Pierre Lévy famously said, "Internet is not *in* space, it *is* space".

> Post City bridges the physical, social and mental spaces.

Concluding on preliminary observations in the introduction of a very influential book, *La production de l'espace*, Henri Lefebvre defines space as constituted by three distinct but interrelated environments: *"physical space:* nature, the Cosmos, *mental* space (including logical and formal abstractions), and finally *social* space"[3]. Inspired by Lefebvre, sociologist Anna Cicognani adds cyberspace as yet another distinct but complementary kind of space:

> "Online Virtual Communities (VCs), in particular, represent an increasing resource for people using the Internet as a tool for various purposes, among others, information exchange and storing, communication, socialisation. More and more frequently, these communities are populated by a variety of citizens who look for more interactive aspects of online tools. Apart from obtaining information, there is the possibility of interacting with other users and ultimately to "leave a trace" of themselves in the online community"[4].

In Post City, the four kinds of space cross over and are coordinated, the physical, the mental, the social and the virtual. People's individual roles, choices and moods in Post City are affected and modified by this bridging. As observed by Salvatore Iaconesi, another member of ThinkWire for Ars Electronica:

> "We find ourselves in a digital Third Space, more inclusive, in which information is not only attached to places, spaces, bodies and objects, but constantly recombines, remixes and re-contextualizes itself, creating constantly new geographies that are emotional, linguistic, semantic, relational. All of this is relative to the many patterns that non-human algorithms can glimpse emerging from data, information and knowledge, correlating different spaces, times and human networks."

The continuity of flows influences the perception and sense of the continuity of being. The sense of one's being unfolds in space as well as in time as networks create bonds across distances. Rosane Araujo, member of CTI, is one among a growing number of thinkers such as Michel Serres, who see themselves as nodes and interfaces in a single material, cognitive, sensitive and emotional environment. Her book, *The City is Me*, makes a good case for expanding one's identity and sensibility to the proportions of the city. This approach is germane to "Post-city thinking".

Understood and supported in positive terms, Post City could be a systemic response to disruptions of systemic proportions occurring in politics, society and the economy. Today cities and nations are facing huge challenges of connected intelligence. It is not an option anymore to go one's way without minding the effects. Another conclusion drawn from the ThinkWire panels, as seen through the three thematic challenges, community involvement, publicy, and smart democracy, is that Post City is really a Smart City that also takes account of people's emotions.

## COMMUNITY INVOLVEMENT: The Social Limbic System

In his seminal approach to intelligence, Daniel Goleman[5] has added a critical element, which is its emotional component. This element proves important for social activism more often than not motivated by indignation, anger, fear, or a feeling of social solidarity as in so many examples since the world movements of Indignados, Occupy Wall Street, Anonymous or the Arab Spring. The Internet has a very important emotional dimension. People increasingly feel the need to share more and more personal details about themselves, their thoughts, feelings and ideas with the wider world, as part of their online existence.

This is true not just for the "friends" on Facebook, or for couples using match-making sites, but also for the whole of our lives as lived on this medium. It is true for how we share our politics via Twitter or our viral videos on YouTube. Social media act as the agent for conveying and sharing emotions. The online world works as an integrative system of impulses, desires and frustrations, all of which is moving at the speed of light. The grassroots activist sites such as Ushahidi or Avaaz articulate collective emotions and foster connectivity amongst peoples across borders and cultures.

The immediacy of social media enables the individual to get involved on an emotional level with current social and political issues. The readiness to respond emotionally to external public events results from the perception on the part of social media users, that they are connected personally with others sharing their own political views, with whom they are willing to share information and news in real time.

Democracy is not only based on equal rights and proper representation of the individual by power and institutions, it also based on sharing a vast mental space, that is, the awareness—at different degrees of intensity—of belonging to a common situation bound neither by physical nor virtual space, but including the social in the mental space as a kind of background intuition. Cyberspace adds a global extension to all the other spaces to allow a "global social being" to emerge at the subconscious level of everybody.

The concept of the social being is not just a new metaphor. It was probably the main experience of being for members of early tribal cultures, but nowadays even in a modern city, where people are part of the connective social being, they are continually subjected to the emotional currents of the moment from the neighborhood to the globe. The great theorists of the crowd, Gustave Le Bon (The Crowd: A Study of the Popular Mind, 1895), Elias Canetti (Crowds and Power, 1960), and Jacques Ellul (Propaganda: The Formation of Men's Attitudes, 1973) have all made similar relevant observations about man's social being. Similarly, it is also understood that where people have physical and social needs in common, an emotional exchange also occurs as part of the interaction. The arrival of real-time media, radio, television and now the Internet, magnify this process and speed it up more than ever before. In summary, therefore, we can say that the Internet has mimicked the biological limbic system of the individual body to extend its influence to the social body.

## PUBLICY: The Digital Unconscious and the Ethics of Transparency

Publicy is a term invented by Mark Federman (member of CTI and moderator of the eponymous panel on ThinkWire) to signify the melding or hybrid-

ization of public and private in the Post City. The advent of the Net introduces a new dimension of collective and individual unconscious, the digital unconscious, that takes shape through the set of data and reports available online. Sharing everything with everyone as in Social Media represents one of the many effects of the connective properties of electricity. Transparency now looms as the unexpected effect of electricity's capacity to penetrate all substances, including the human body, and even the mind.

Cyberspace, physical space and social space are public spaces by definition, evidence and practice. The one we deem to be and remain private is our mental space. We feel and know that we are always in a position to withhold information and keep private what we decide is such. The idea or sense of the self that we all have at one degree or another seems to be non-negotiable. Whatever could possibly be known about you, there is only one you and that's it. However that very privacy and uniqueness are being threatened in all manners by digital data collection, digital analytics and cross-referencing. As we stand talking to each other face-to-face, on line, under our feet so to speak, flows of data about our most intimate recesses stream into databases from which they can eventually go public.

The problem is to live in a society that has two ways of thinking about reality and no one knows exactly how to integrate them: one is the private model and the other is the invaded or otherwise known as the "shared" one. The way of the private self generally believes that identity and the way one sees oneself is a private affair, a space reserved for our personal use, my mind occupied by myself alone and not penetrated or shared without permission.

The commercial and social pertinence of knowing everything about us—to say nothing about security issues—makes that trend irreversible. Our destiny as a society immersed into digital culture world-wide is to become transparent. This is the exact opposite of the effects of literacy that made people individually opaque by internalizing and silencing speech thus privatizing thinking. The ethics of opacity that guaranteed privacy were long in coming from the time of extortion and "question" during the Spanish Inquisition to the separation of Church and State and the rise of the private individual. This long-term trend is being reversed today. A new ethics based on transparency appears inevitable. It will probably give precedence to community over individuality.

Our quasi permanent concentration on some screen or other introduces a reversal in our mental orientation. The space of the network is essentially relational. Instead of being oriented towards the inner person, our focus is mainly on our communication ports and contacts, that is, to that which is external to our physical being. The identity formation in social and other media occurs outside the body. Our digital identities will forever come back to haunt us, gradually shaping our lives and our bodies in unsuspected ways.

The signs of this happening are everywhere, and Wikileaks, PRISM and Big Data are only some of the frontrunners of transparency, bulldozing privacy. Under the conditions of generalized surveillance due to applications of big data, because eventually anybody will have access to the profile of anyone else without permission or notification, the obligation of all will be to not have anything to hide. Not paying one's taxes will eventually incur social opprobrium. Reputation Capital signals the return of a shame culture.

## SMART DEMOCRACY: Democracy, Privacy, même combat?

Democracy, a concept invented in Ancient Greece, means "people power". It came along when people, learning to read, became individuals. One could presume that now that these individuals have become transparent, their vulnerability to total control makes democracy mere wishful thinking. But in reality, people never had as much power as now. In the republican past, people didn't have power aside from voting their representatives into the real power, a situation that more often than not invited abuse of power from institutions. Paradoxically, the people are actually more powerful now than ever

before thanks to social media. There they can and do express more than their vote, their opinion, good or bad, and they can put pressure on their governments to effect change.

What makes democracy smart? Primarily smart citizens, that is, people who actually take an active part in the affairs of the city. In most countries smart citizens arise more or less spontaneously, like artists or innovators, usually without organized support, except that of those who connect with them. There is no school to raise smart citizens. In fact what is missing in most schools of the world is a formal education to civic behavior and sensibility, two qualities that are needed more than ever. It is up to philanthropic societies to generate smartness in democracy.

In Milan, Fondazione Riccardo Catella has funded "Smart Community", a project to allow the 20,000 inhabitants of the Porta Nuova area to take part in discussions and decisions that concern the area. The project is especially relevant to a Post City kit in that it has equipped a center dedicated with tools for research and visualization to find out how people interact and feel about their day-to-day conditions of life, creating, with the use of *Moodmix.com*, a map to monitor people's sentiments (as expressed primarily but not exclusively via Twitter) about what is going on around and for them. In Naples, in the difficult zone of the Rione Sanità, where youth unemployment—and consequent unrest—is high, special projects to help them find the right training and subsequent job are launched and monitored according to how the youth and their parents and neighbors feel about their progress, thus allowing organizers to adjust strategies almost in real time. This is smart democracy in action. So is the case of the recent release of two Moroccan women who had been imprisoned for the last month because they were wearing dresses above the knee. No less than 500 Moroccan lawyers and a slew of other people put out a petition to liberate them and the society in general from the application of henceforth irrelevant laws[6]. Petitions function as spontaneous plebiscites and obtain satisfaction in a growing number of cases. Vincenzo Susca, moderator of the Smart Democracy panel on Thinkwire has another word for it:

"Every blogger network, electronic tribe, local community or flash mob generates a "communicracy". This is the form of puissance, and not power, that emerges today every time that a community vibrates unanimously, in communion around an act of communication. This configuration is valid and acts within an ongoing "situation", inside a precise experiential and/or imaginary origin. It is thus limited in time and space as well as suspended in its way of living. It is so intense as to impose upon the law of the State or the laws of economy the group's agreements, a pact of blood and also of images filled with high emotional density."

This way the subversion grown in the interstices of everyday life, in the shadow of politics or in the Undernet, takes nourishment from the symbolic and affective dimension. Because of this "trans-political" sensibility, the thick barrier of modernity crumbles. Seemingly banal and trifling phenomena like pokes, tagging, chat lines, role playing games, or new jokers' jests and pranks, release into the ether the ghosts which haunt the collective imagination and urge this at last to mold physical reality in its own image.

All this to say that democracy is still possible and that, as Churchill said, democracy is a terrible model but it is the best we have.

Connected Intelligence to defend the Civil Society: The history of the Internet has demonstrated at every turn that all attempts at controlling it have engendered swift countermeasures to protect neti-zens. In this regard connected intelligence on and off line will prove effective to defend civil society in the Post City. In activism it is important to know (or sufficiently know about) the other participants to trust them. That presents the obligation to connect in the right way. Many applications exist already to strengthen and sustain activism, but I have no doubt that customized and democratized Big Data mining applications will soon give even more powerful tools than anything invented so far. My general trust (and thrust) is that in the end the Internet and cyber-space will continue to self organize and eventually fashion all of society into a tolerable shape, and that the Civil Society extended and respected globally will prove to be the only tolerable shape humanity should strive for in the era of transparency.

1 http://www.theguardian.com/cities/2014/dec/17/truth-smart-city-destroy-democracy-urban-thinkers-buzzphrase
2 Canadian businessman, creator of ThinkWire, author of several bestsellers, including The Impulse Economy, international speaker and consultant.
3 "De quels champs s'agit-il? D'abord du physique, la nature, le Cosmos—ensuite du mental (y compris la logique et l'abstraction formelle)—enfin du social", Lefebvre Henri. La production de l'espace. In: L'homme et la société, N. 31-32, 1974. Sociologie de la connais-sance marxisme et anthropologie. 15-32. Full text: http://www.persee.fr/web/revues/home/prescript/article/homso_0018-4306_1974_num_31_1_1855
4 Cicognani, A. (2006). Defining a Design Language in a Text-based Virtual Community. Retrieved from http://www.encore-consortium.org/Barn/files/docs/cve98.html#Heading2
5 Goleman, Daniel (1995). Emotional Intelligence: Why It Can Matter More Than IQ. Bantam Books.
6 Le Monde.fr, (2015, July 13).

Maria Pia Rossignaud

# Multiplying Mind by Mind
## Connected Intelligence Atelier

During this year's Festival, Ars Electronica offers Future Catalysts the opportunity to take part in a Connected Intelligence Atelier, an innovative brainstorming method created by Derrick de Kerckhove. The objective is to provide a kit of tools, ideas and strategies in three of the six topic areas proposed in the call:

### Strategies to elicit Community Involvement

The primary target area for improvement is not merely technology or policy, but involving all the people in their own progress. Evolving from a top-down socio-political system to a bottom-up open one requires long-term adaptation—as evidenced by recent European history. What tools and strategies can help people start and support participation, in what social, cultural, educational or political contexts, at what level, with what responsibility...?

### "Publicy", the Hybridization of Public and Private

The Internet has picked up and immensely accelerated drive that began with the telegraph, that is, to foster transparency. Our society is now evolving from opacity to transparency. In Big Data lies the present and the future of our unconscious drives. As people become more and more transparent, what sorts of behaviors, what new ethics, can we expect or adopt when nothing that concerns you can remain permanently hidden? What new legal protection, what education is needed for one's digital persona? What social adjustment should we be ready for?

### Smart Democracy

Paradoxically democracy is both supported and challenged by social media and the digitization of human activities in general. There is an urgent need to give people a voice in all levels and sectors of society and fostering dialogue—especially for the purpose of planning and implementing opportunities for the future. What suggestions, or dedicated sites, or tools to assist benevolent, responsible and effective social activism should there be?

## METHOD
### Connected Intelligence Workshop

The method used to guide collaboration is called *Connected Intelligence Workshop* (CIW). CIWs are brainstorming sessions designed to channel the storm and put minds to work together—rather than against each other as in many forms of brainstorming. Participants distribute themselves in small, interconnected groups. Each group is entrusted with responding to a different but complementary aspect of the challenge, whether this be business, government or cultural enterprises, production, design, or strategy. The purpose of a CIW is not merely to solve a problem, or to invent the future, but principally to provide a way for people to design that future together, in whatever professional or social context, with the help of specific and highly trained local and international experts.

Each group (6 to 10 participants) addresses a sub-theme of the overall task at hand. To better collaborate and develop a specific responsibility, each group member must initially select one of six basic roles (some can be attributed to more than one person):

The COORDINATOR (animator) takes responsibility for the management of the overall process, keeps the deliberations on course, distributes specific tasks for the other roles and schedules the timing of CONNECTORS and PRODUCERS.

The RESEARCHER(s) posts useful elements of the research and fetches images, videos and texts to build content for the PRODUCER.

The CONNECTOR(s) makes lists of ideas and tips to bring to other groups, thus exchanging innovative suggestions, and returning with ideas from these other groups' discussions.

The IMPLEMENTOR (reality-checker) brings up objections, and makes alternate suggestions wherever reasonable, also in charge of the practical aspects of the project, providing introductions, addresses, email or telephone numbers of contacts that could contribute to actualize the process.

The PRODUCER requests, selects and assembles elements proposed from the other participants, to

arrive at a digital presentation (PowerPoint, blog, site, portal, video, etc.).

The PRESENTER contributes the rhetorical values in the production of the presentation as it is being developed, thus taking an active and critical part in the process, and eventually the person to do the final presentation.

All sub-themes are synthesized at the end of the process. What is expected from this CIW is a set of formal presentations on the topics proposed, in this case in the format of a kit, along with a preliminary outline of how to achieve the project.

The workshops are proposed in three basic stages:

- First meeting: presentation of the challenge and elaboration of projects in each group
- Second meeting: presentation of first drafts of projects to the assembled groups, testing their coherence and applicability and work on the finalization of the individual projects
- Final meeting: final presentation, request for approval of the project, and subsequent work on implementation or amendments and adjustments

During the interval between the meetings, the collaboration can be supported to continue sharing ideas and suggestions. This can be done in one of two ways: either by appointing a monitor (perhaps the coordinator) who is responsible for keeping close contact with the group until the next meeting, or by using collaborative software such as *ThinkWire.com* to share the elaboration and the progress of the project. *ThinkWire* is the brainchild of Gary Schwartz. It is an extension of Twitter to set up moderated panels and allows participants to use 280 characters instead of the usual 140. Ars Electronica invited the experts of Culture and Technology International (CTI) to contribute their thoughts via *ThinkWire.com/ArsElectronica* and share their visions about *Post City*.

CTI is an open international consortium of experts in different fields—cultural, academic, social and other—related to digital culture. Including sharing resources to improve research and applications, CTI's mandate is to help institutions, enterprises and persons to manage the transition to the digital condition. It operates by fostering face-to-face meetings among members twice a year and it also offers Connected Intelligence Workshops as a consulting service.

Here are some excerpts from statements and exchange of ideas by CTI members as they discussed the three issues over a few weeks in May and June of 2015:

## ON COMMUNITY INVOLVEMENT

Giorgos Cheliotis (US based consultant who did not participate in the panels but whose selection of five main features of community were proposed by Maria Pia Rossignaud @mediaduemila as a starting point):

- A community is based on shared interests and weak ties; less so on social characteristics or strong ties;
- It is ego-centric (mass individual): individuals create social networks based on their interests and motivations and are not tied to one community;
- But these are not either–or distinctions; communities come in many shapes and sizes;
- The traditional ideal of community is a "pastoral myth" (Wellman and Gulia, 2007);
- The real question to ask is how is this or that community seen by its members?

**Malu Fragoso** @malu_fragoso:
Comments on Cheliotis' definitions:
Shared interests are structural, but they may change. Are ties grounded by interests or affections? How do we see ourselves in the community? I believe we are now in a social system of individual actions. Collectivity rarely represents us.

**Derrick de Kerckhove** @ddek: Community involvement is "unrelated people sharing interest and participation in projects". The problem is to find the right kind of project. Many arise spontaneously as in a protest. What kind of social innovation could involve people communally?

**Agnès Yun** @agnesyun: As people are exposed to so many fragmented "communities", it is not easy to get them "involved". We can make people gradually involved using virtuous cycle mechanisms. One possible approach is to gamify community activities. At first, people participate to have fun, then become aware of their activities, and finally have increased responsibility by understanding the consequences (value) of their activities. E.g. if we are interested in making cities greener, bike riding can be gamified, show riders how much energy they have saved and

how they have reduced $CO_2$ as they ride, and finally help them see the consequences of their collective actions.

**Mark Federman** @MarkFederman: Here's a possible example that I co-organize/host: Sidewalk Salsa, a weekly, open air, free salsa party in downtown Toronto. A public parkette, music, and dancers every Thursday evening. It opens space for random participation, creates community, especially for newcomers to the city. Over the ten years that we've been doing it, people new to the city (esp. university students since it's near U of T) have connected to social groups, local neighbors have come out to enjoy an evening of music, passers-by have started to learn to dance. It's a weekly pop-up happening that enables live, in-person interactions. The concept has spawned other similar ventures in other parts of the city with other dance styles, ranging from organized, funded major events (one at Harbor front) to other guerrilla-type events. Key is fun, participation, openness.

**Agnès Yun:** I consider these phenomena as 'organic/continuous collaborations' in a connected world. I'd like to reformulate Derrick's Q as: how to augment the degree of awareness and responsibility (instead of involvement and belonging) in a connected world where everyone is a maker of value?

**Mark Federman:** We're also seeing social innovation via crowd-funding of social causes, especially those that are controversial. Have a look at this:

*http://www.theglobeandmail.com/news/world/crowdfunding-emerging-as-platform-for-political-speech/article24472107/*

> "Initially founded to finance small passion projects... people are opting to express politically charged opinions via digital donations."

**Gary Schwartz** @ImpulseEconomy

Crowd funding is powerful as we can finally reap digital community benefits such as driving gender equality for entrepreneurs. Over 40% of successful crowd funding campaigns are women-led (while only 8% of companies run by women receive traditional venture capital.)

**Derrick de Kerckhove:** I see crowd funding as the most innovative change in the economy since the invention of the banknote. Finally we can put our money where our heart is. But more to the point investment is participatory and generates feelings of belonging.

## ON PUBLICY

**Derrick de Kerckhove:** What I like about publicy is that the word itself somehow describes, by its very structure, the kind of serious intermingling of private and public not only in the networks, but through their effect on people too. We are becoming publicy people developing a new way of being.

**Mark Federman:** We used to control our own privacy, especially private thought. Publicy initially suggested curation of multiplicity of e-personae; now, with ubiquitous telemetry via digit-footprints & big-data collection, what we curate is only a partial story. Publicy speaks to the amalgam that is one's collaboratively constructed identity. This Pico Iyer TED talk is thought-provoking.

*http://www.npr.org/2013/10/11/229893758/what-do-you-call-home*

... "Where you come from is less important than where you're going. Identity is more rooted in the present than in the past." Whereas I believed the experiential effect of the online world was private, I no longer think so, especially among those born on this side of the Internet break boundary. Millennials experience their life in public; publicy is the sometimes intimate sharing of first-person living.

**Derrick de Kerckhove:** I am working on transparency in the era of Big Data. McLuhan claimed that electricity would wipe out privacy. In fact we are evolving rapidly from the era of opacity (literacy's silent and personalized control of language) to transparency. How does publicy replace privacy?

**Mark Federman:** We literally carry everything that is known about ourselves via mobile devices—phones, watches, later implants. Our psyches are open books to Google, Apple, Facebook via monitored, aggregated, analyzed behaviors; hence PUBLICY that we only indirectly curate.

Publicy suggests that our data trail can and is being used against our own interests via marketing manipulation of partisan interests. That so many people vote against their personal interest b/c of data-driven psychological manipulation is political effect of extreme publicy.

However, when everyone can see everything about our lived behaviors, no one will particularly watch anything about anyone. The issue is asymmetric surveillance: privacy is over for the masses, but

protected for the powerful, the corporations, and governments. And then there's Anonymous.

**Gary Schwartz:** Our communities expanded globally with print, then radio, film, and television. They now have collapsed again to the individual with cost-effective sensors and internet. Now we are all media and data broadcasters. The next challenge is to weave individual data back into a community narrative. This is the challenge of the IoT (Internet of Things) where we are all nodes and the community takes its instructions from the aggregated data. This is new community; it is also the new democracy. Maybe, as Pico says, we are all a "floating tribe" only connected to our present geography based on our digital actions and the impact those actions have on animate and inanimate things around us.

Derrick de Kerckhove: Rosane Araujo wrote a book that reflects Pico and the preceding exchange: *The City Is Me* where she claims that we carry everything we know about ourselves and about where we live and where we plan to go in the real-time of consciousness reconstructing decor according to both our needs and evidence.

**Maria Pia Rossignaud:** Zuckerberg: said it "privacy is over". The question then is how to behave under such henceforth, unavoidable circumstances? There is a need to discern the coming shape of people's attitudes, manners, protocols, social and personal behavior etc. A sociological rather than moralist intention.

Derrick de Kerckhove: If privacy is over, so is democracy. Both are inextricably tied by their origin in literacy and opacity. Both are already gone. We only pretend they still exist because our social order is still based on appearances.

## ON SMART DEMOCRACY

**Vincenzo Susca** @vincenzo_susca: Is postmodernity bringing us toward a post-democracy?

Derrick de Kerckhove: And what is the best of democracy? Individual freedom and an equilibrated participatory relationship between rulers and ruled. The ruler should be bound by responsibility. In the era of transparency, compensation is honor not power.

**Mark Federman:** I would suggest that we are far from having the "best of democracy" today—in any country. Oligarchy and plutocracy are better descriptors, especially when people are manipulated to vote against their own interest (e.g. the US Tea Party Republicans). Post-Occupy must get much smarter via technology.

Smart citizenship means well-informed, well-reasoned, and engaged. Partly enabled by social media as well as vested-interest cable news, these three prerequisites are systemically being eliminated by partisan and other (sometimes completely stupid) interests.

Because social media technologies amplify voices w/o discrimination or privilege, ultra-minority discourses are given equal weight to dominant knowledge. As anti-hegemonic practice this is good. As dissemination of populist BS, less so. Smart democracy must be able to distinguish.

**Rafael Mira** @rafaelmirapm:

Digital media bring many new opportunities. However, the key for the development of a true democracy is the ability for people to collaborate through spaces for deliberation. The digital world allows for the creation, expansion, and large participation on these spaces/platforms.

**Gary Schwartz:** Digital media is the new representative democracy. It has allowed democracy advocates to keep political memes alive and to make their issue go viral.

**Leticia Soberon** @LSobern: For me the clue to democracy is deliberation, not only opinion. And deliberate supposes information + reflection + dialogue. Are we ready to deliberate on line? The binary "like" or "don't like" is not enough! We need to invent new platforms for dialogue. An essential part of the "smartness" of a group is 1: good and pertinent shared information. 2: the goals they try to achieve. And 3: the process of dialogue between them.

**Mark Federman:** (It's) hard to say what legal & political criteria will create neo-democracy as fair, socially-acceptable, & based on well-informed participation as opposed to "truthy" populism. Democracy has always been based on the supporting institutions; merely voting creates sham governance.

When we figure out intersection of local rights & participatory obligations among multiple social subnets, new/smart democracy creates rules for active participation, policy creation, etc.

The conversation will have continued well beyond the time of printing and, inspired by the projects retained from the proposals of the *Future Catalysts,* will have fed more content and focused suggestions to support the *Connected Intelligence Workshop* CIW.

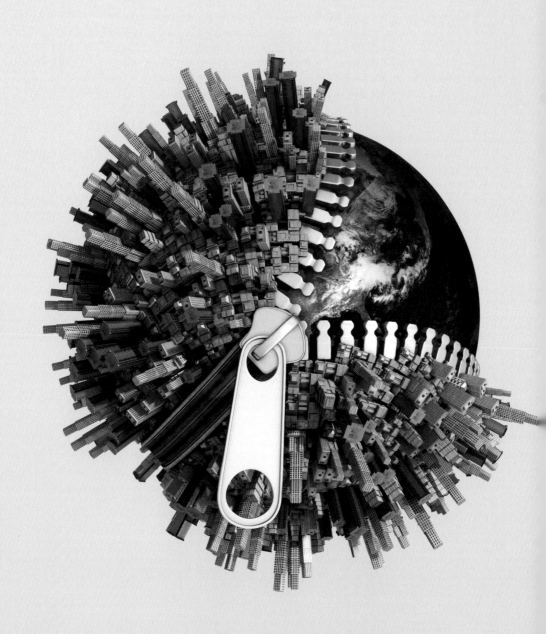

# CONNECTING CITIES

Dietmar Offenhuber

# Civic Technologies: Tools or Therapy?

The "Smart City" is dead. This sentence is not a provocation or the beginning of a manifesto, but merely a plain observation, since even its evangelists have given up on the idea. The Smart City is a comprehensive concept in which all urban systems talk to each other, governed by a control system that, invisible to the public, keeps everything in an optimal equilibrium. Meanwhile, even the companies that originally promoted the concept have come to realize that cash-strapped municipalities are unlikely customers for such comprehensive solutions. The messiness of urban infrastructure with its historical legacies, institutional idiosyncrasies, the brittleness of sensor networks in the harsh outdoor environment, or the contractual constraints of public employees: all these complications can make the Smart City a losing proposition. Instead, IT companies increasingly focus on what they can do best and what is more profitable: offering analytic services for the huge amounts of data that cities already have, instead of directly dealing with the complexities of the cities' physical hardware and organizational structures.

There is no shortage of criticisms of the Smart City.[1] These criticisms can be summarized in two points. The first criticism is the observation that the Smart City concept is unduly reductive and apolitical. In its techno-centric approach, the Smart City resembles the 1960s model of the cybernetic city, which failed to account for the complexities of the actual society. An often-cited example in this context is the failure of New York's fire response system

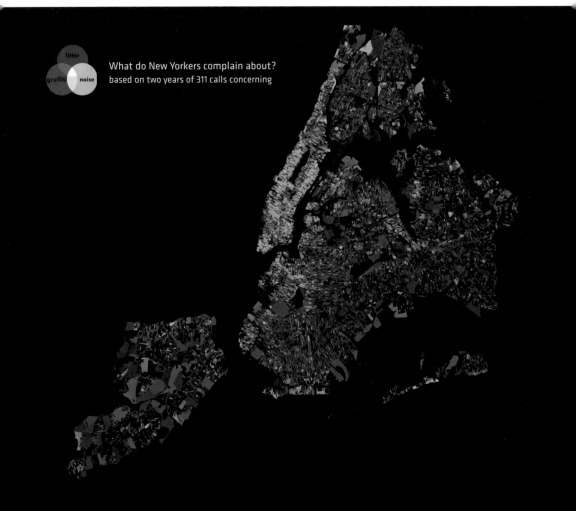

litter
graffiti   noise

What do New Yorkers complain about?
based on two years of 311 calls concerning

reorganization in the 1970s, based on a simulation model by the Rand Corporation. The project ended with an unprecedented series of fires in the poorer neighborhoods of the city, because the model did not consider the political power structures that ultimately determined the distribution of fire stations.[2] The cybernetic legacy of the Smart City is often illustrated with the aesthetics of "total control" signaled by the IBM Intelligent Operations Center in Rio de Janeiro, bringing live data streams from citywide systems into a single control room equipped with large wall displays. However, such criticisms can also be reductive. The main advantage of the Operations Center is not a capacity for total surveillance, but the simple fact that it brings city employees from different departments together in the same room, as an IBM engineer from Rio de Janeiro noted. Even the Rand Fire Project for New York was path-breaking—despite its initial failure—and influential for contemporary emergency response systems.[3]

The second criticism is not about shortcomings of the Smart City, but about lost opportunities. The argument goes like this: why should we attach sensors to every light pole, when each citizen already owns an array of intricate sensors? I am not referring to sensors in smartphones and gadgets, but to the eyes, ears, and the local knowledge of each individual, for which the smartphone is just a conduit. This argument has gained traction during recent years. Initiatives such as *Code for America* and its various global spin-offs[4] connect young coders with city departments where they collaborate on the nuts-and-bolts of participatory governance. The notion of *government as a platform*[5] recasts urban governance as an informal and problem-focused collaboration between the city and citizens. The supporters of *Civic Technologies* emphasize the advantages of this arrangement for both constituents and institutions. For the city, citizens make the city legible by contributing data about the urban environment, create new services that make use of these public data, and directly participate in solving problems. The constituents, on the other hand, gain direct influence in governance decisions and benefit from a more responsive city. In summary, civic technologies are hoped to introduce a new appreciation for the public good.

## The politics of popup anything

What will the aspirations of civic tech mean for the future of the city, its physical appearance, and its governance? It could mean that cities gain more freedom to experiment. Since all their interactions with citizens become open data, the public will judge the decisions of officials based on their outcomes, not by whether they strictly followed administrative guidelines.[6] In everyday urban environments, this freedom would mean less standardization, more informality, improvisation, and creative hacking—a motley utopia of "popup anything"—hackspaces, fablabs, knitbombed potholes.

But it should also be mentioned that the shift from process-oriented to outcome-oriented accountability is rooted in the 1980s doctrine of New Public Management (NPM) and Margaret Thatcher's ideas for reforming government. NPM introduced business management practices into public administration, modeling the relationship between citizen and city as the relationship between customer and company. The ambition of civic technologies to involve private citizens in solving urban problems and enlist them as stewards of their own neighborhood can also entail a push towards individualization of responsibility and the privatization of public services. Prime Minister David Cameron's policy initiative of the "Big Society," publicly showcased during the 2012 London Olympics, embraced local activism, volunteerism, and private initiatives, while at the same time cutting back funds for public services.

Civic hackers and neoliberal reformers make strange bedfellows. This can be illustrated by emerging concepts of decentralized algorithmic governance using *Bitcoin* technology, which is in a sense also a civic, commons-oriented technology. In 2013, developer Mike Hearn presented his vision for the future of infrastructure, governed by a hypothetical, blockchain operated and distributed entity he called TradeNet:

> "In this future scenario, the roads on which Jen is driving will have also become autonomous actors, doing trades with the car on TradeNet. They can submit bids to the car about how much they are going to charge to use them. If she is in a hurry, Jen can choose a road that is a bit more expensive but which will allow her to get into the city faster. Awesome, right?"[7]

While civic technologies emphasize ideas of the public good and infrastructure as a commons, TradeNet completely abandons the idea of public infrastructure. In a scenario where even miniscule consumptions of infrastructure services can be measured and billed, infrastructure becomes an entirely private good. In the face of these seeming contradictions, one has to ask: what is the politics of civic technologies, are they neo-liberal or neo-weberian, service-oriented or activist? I argue that the answer to this question depends on what is entailed by the elusive term "participation."

What do we mean when we talk about participation? Participation is almost universally accepted as a positive value, so much that Sherry Arnstein commented somewhat sarcastically in 1969, "the idea of citizen participation is a little like eating spinach: no one is against it in principle because it is good for you."[8] But only, as she argues, until participation is understood as a re-distribution of power and control, in which case enthusiasm quickly wanes. To disambiguate the different meanings of the term, Arnstein introduced her famous "ladder of citizen participation" as a conceptual continuum of different levels of control bestowed upon the participants—from pseudo-participation as an empty ritual on the one end, to complete citizen-control on the other. We can apply a similar lens—a ladder of participation in civic technologies—to differentiate the modes of participation of the "smart citizen."

Often, participation is not much more than compliance. This is the case for contemporary forms of behavior engineering under the terms "gamification" or "nudging": using game mechanics to motivate and reward people for behaviors that are, like eating spinach, considered good for us: taking the bike instead of a car, recycling, and generally being a nice citizen. Here, participation is about succeeding at the rules, not questioning the rules. What does it mean if an Aluminium company releases an app for encouraging people to recycle beverage cans by rewarding them with points for recycling? It is a way of saying that it is the individual consumer who is responsible for a healthy environment, and not the beverage companies, who have designed their supply chains around disposable packaging made from problematic materials. In this sense, "saving the world one step at a time" is a great way of staying in place—maintaining the status quo.[9]

A second step is participation as feedback. Citizen issue trackers, the classic civic technology app, are a good example of this category: smartphone apps that allow citizens to report problems in the environment, from potholes to graffiti, from litter to streetlight outages. Pioneered by systems for non-emergency community requests, many large cities around the world have implemented citizen-reporting apps. The value of the information collected through this means is huge, giving the city access to accurate data from street level. Noting that the majority of reports are submitted by a small number of individuals, cities encourage individuals to become stewards of their own street.

But citizens are not just passive sources of information for the city, which might or might not use this information. The next step is therefore participation as monitoring. Through data collection, citizens can also create pressure on the city and to some extent challenge its authority and expertise. They become what Kuznetsov and Paulos call the "expert amateur."[10] In the Japanese *Safecast* project, a collective of activists built and deployed mobile radiation monitoring units after all Geiger counters in the country were sold out following the nuclear disaster at Fukushima Daiichi. The volunteers not only documented radioactive pollution but also uncovered flaws in the official radiation measurement methodology.[11]

A further step is participation as co-production: involving citizens in planning, implementing, and managing public services. The theorist of governance of commons, Eleanor Ostrom, observed that if people are involved in planning and implementing infrastructure or housing projects, they are more satisfied with service provision and have more sense of ownership.[12] The city benefits from the local knowledge of participants and can better react to their needs, the individual gains by having more influence in the design of services which they will eventually be the primary beneficiaries.

On the other end of the spectrum is participation as self-organization: systems that are entirely created and managed by their users, or "Inverse Infrastructures."[13] Truly self-organized, or even crowdsourced infrastructures that are sustained over a long period are rare, with Wikipedia being the obvious and overused example. The inverse infrastructures of the open source and citizen science communities show

us the potential, but also the limitations of sustained participation. Some inspirational examples exist. Founded by the media artist Usman Haque, Pachube was a community platform for sharing live data feeds from sensors deployed by a community of citizen scientists and enthusiasts. In many ways, Pachube delivered what the Smart City concept promised to do, surpassing most official sensor networks in scope and completeness. Ed Borden from Pachube posted in June 2011:

> "BigGov has become irrelevant in the public sector, eclipsed by someone with a supercomputer in their pocket, open source hardware and software at their fingertips, and a global community of like-minded geniuses at their beck and call: YOU. YOU are the Smart City."

The urbanist Adam Greenfield gently objected:

> "There are some things that can only be accomplished at scale—I think, particularly, of the kind of heavy infrastructural investments that underwrite robust, equal, society-wide access to connectivity. And for better or worse, governments are among the few actors capable of operating at the necessary scale to accomplish things like that; they're certainly the only ones that are, even in principle, fully democratically accountable."[14]

He was proved right—just a few weeks after this exchange, Pachube was sold, renamed, and turned into a closed service. Its groundbreaking idea, the enthusiasm of its community, and its short life as a community project illustrate a central dilemma of infrastructure and participation: the dilemma between the creative energy of participatory projects and the expectation of longevity, reliability, and accountability. Any concept of a future city will have to come to grips with these two opposing forces. This is not necessarily a limitation or a problem, just an indication that cities are too complex to be "fixed" by a single group, whether they are Silicon Valley entrepreneurs, Smart City engineers, civic hackers, or governmental institutions. The tradeoffs of participatory governance can be generative and open up a rich space of experimentation between technology and policy, once we understand that no simple solutions exist, and that none of the involved actors can claim a neutral, objective position. The involved protocols and algorithms should not be seen merely as the technical substrate on which democratic discourse unfolds, but as an object of this discourse. Collectively defining protocols and standards is a democratic concern in the 21st century city. In this respect, the designers and coders of civic technologies find themselves in an unfamiliar role: not only as mediators of experience, but also as policy makers, who design the technical frameworks that not only facilitate, but also shape urban governance.

1  Greenfield, A., & Kim, N. (2013). *Against the Smart City (The City Is Here for You to Use)*. New York, NY: Do projects; Townsend, A.M. (2013). *Smart Cities: Big Data, Civic Hackers, and the Quest for a New Utopia*. New York, NY: W.W. Norton & Company; Kitchin, R. (April 1, 2014). Big Data, New Epistemologies and Paradigm Shifts. *Big Data & Society 1, no. 1:* 2053951714528481, doi:10.1177/2053951714528481.

2  Flood, J. (2010). *The Fires: How a Computer Formula, Big Ideas, and the Best of Intentions Burned Down New York City—and Determined the Future of Cities*. New York: Penguin.

3  Gianino, C.E. (1988). The Rand Fire Project Revisited, *Fire Technology 24, no. 1*, 65–67.

4  https://www.codeforamerica.org; http://codeforall.org

5  Lathrop, D., & Ruma, L. (2010). *Open Government*. Boston: O'Reilly Media, Inc.

6  Goldsmith, S., & Crawford, S. (2014). *The Responsive City: Engaging Communities Through Data-Smart Governance*. San Francisco: Jossey-Bass.

7  Hearn, M. (2013). Future of Money. Retrieved from http://www.slideshare.net/mikehearn/future-of-money-26663148

8  Arnstein, S.R. (1969). A Ladder of Citizen Participation. *Journal of the American Institute of Planners 35, no. 4*, 216–24.

9  MacBride, S. (2012). *Recycling Reconsidered the Present Failure and Future Promise of Environmental Action in the United States*. Cambridge, Mass.: MIT Press.

10  Kuznetsov, S. & Paulos, E. (2010). Rise of the Expert Amateur: DIY Projects, Communities, and Cultures. *Proceedings of the 6th Nordic Conference on Human-Computer Interaction: Extending Boundaries*, 295–304. http://dl.acm.org/citation.cfm?id=1868950

11  Offenhuber, D. & Schechtner, K. (Eds.). (2012). *Inscribing a Square: Urban Data as Public Space*. Vienna, New York: Springer.

12  Ostrom, E. (June 1996). Crossing the Great Divide: Coproduction, Synergy, and Development. *World Development 24, no. 6*, 1073–87. doi:10.1016/0305-750X(96)00023-X.

13  Egyedi, T.M. & Mehos, D.C. (2012). *Inverse Infrastructures: Disrupting Networks from Below*. Cheltenham, UK: Edward Elgar Publishing.

14  Borden, E. & Greenfield, A. (2011, June 30). YOU Are the "Smart City." [Web log message]. Retrieved from http://blog.pachube.com/2011/06/you-are-smart-city.html

Veronika Pauser, Claudia Schnugg, Susa Popp

# Connecting Cities
## Artists and Researchers Empowering Citizens since 2012

The *Connecting Cities Network* (CCN) is a worldwide initiative of cities and institutions in the field of media art and new media. Within the framework of a 4-year artistic research program, the CCN partners link their research and diverse artistic activities to investigate the creative potential of urban screens and media façades. The main goal is to reflect on the increasing presence of large-format digital media façades in public space and to examine their unique communicative function within local culture and international communities. In practice, the projects aim to establish urban media façades as open platforms for citizens to engage in participatory city-making processes, to exchange data and experiences, and to create cultural hubs that reach out to others beyond the border of a single city.

When the EU-funded project *Connecting Cities* was launched in 2012, the partners could build on fertile ground laid out in previous efforts by the contributing partners. In particular, in 2008 Public Art Lab Berlin initiated the Media Façades Festival to reflect on the increasing presence of massive infrastructures with digital visual elements in public spaces. In 2010 Ars Electronica collaborated with the Media Façades Festival Europe to present a fascinating array of art projects on the LED façade of the Ars Electronica Center and on the tobacco factory grounds during the Ars Electronica Festival 2010. Media façades were transformed into local stages and thus opened a global window for cultural and societal processes to create a dialogue and connect the local public virtually with other places throughout Europe.

Besides this communicative aspect, media façades represent an interesting medium from a media artistic and an architectural perspective. Thus, this is a highly interesting topic for researchers from different disciplines as they provide a range of possibilities for artistic experimentation as well as social and cultural exchange. Based on the increasing presence of these massive infrastructures with digital visual elements in public spaces, researchers and cultural activists aim to investigate the utiliza-

tion of new communication strategies and initiate intercultural dialogue. In this field, CCN supports the idea of the public space as a space for creativity, visibility and exchange of culture through redefining urban media façades as platforms for co-creation of cities through bottom-up strategies. Moreover, such urban media environments and media façades demand new forms of curating and artistic productions.

To approach these topics, a broad range of artistic and research activities has been undertaken by all of the partners: production and adaptation of artworks for their own city, common workshops and conferences, test screenings, urban media labs and other specific research activities. All these actions are characterized by an interdisciplinary collaborative approach in defining research questions, developing research design and producing artistic projects.

In the course of the *Connecting Cities* artistic research program the CCN partners explore these research questions from different perspectives:

· The main topic *Networked City* in 2013 led to a focus on interlinking the urban media infrastructures by opening them as real-time windows between the cities and connecting local neighborhoods beyond national borders.

· The main topic *Participatory City* in 2014 aimed at the investigation of community building through participatory involvement by engaging the citizens in the collaborative creation of their urban environment and encouraging them to use urban media for communication, public debate and investigation.

· The main topic *In/Visible City* in 2015 led to exploring the visualization of invisible data streams and open data generated through sensor and data networks on urban media environments. As a result, invisibly generated data becomes visible through artistic scenarios and creates an awareness of the digitalization of our society.

Research questions that have been investigated from these perspectives range from very practical issues to more theoretical and socio-cultural developments. The partners and artistic researchers

explored, for example, site-specific problems like the challenge of how to create access for human interaction and trigger new forms of participation, engagement and bottom-to-top activism. Which interfaces and devices can enable a direct exchange between local scenes and trans-local communities? How to develop socially relevant scenarios in a playful and at the same time critical way? Moreover, they worked on questions like: What are the communicative and socio-cultural potentials of these often only commercially used urban media infrastructures? How to provoke social and political action through artistic intervention using urban screens and media façades? What does it mean to give the public space back to citizens and enable interaction, communication, critical reflection of information, and set actions?

In 2015 within the framework of the *In/Visible City* topic three partner institutions, Ars Electronica Center in Linz, FACT in Liverpool and PAL in Berlin, could host research residencies. In the course of these residencies Ars Electronica Futurelab worked with the residents on generating artistic perspectives on hidden information and interaction and thus making the invisible visible, at the Public Art Lab residencies focused on potentials of connecting the fields of science, media art and light technologies to develop new contexts and services, and at FACT the residencies explored the political and social impacts of connecting people beyond western culture narratives.

Over the entire term of the CCN research program, researchers and artists developed a new understanding of cities and citizenship, moving away from a pure technological understanding of the smart city towards the city as platform for social and cultural interaction by reconfiguring layers of digital and physical space. The rhetoric of flow and dematerialization associated with the Internet in the Nineties is now being turned into a call for hybrid place-making and meaningful re-appropriation of the public sphere. This leads to a rediscovery of the condition of citizenship in the face of a shrunken globe: a planet that we can grasp simultaneously in an ever-changing configuration of networked tangible and intangible spots.

Besides research and artistic production the CCN also aims for exchange and circulation of artistic and socially relevant contents. This mainly happens in form of the Connecting Cities Events where a broad public audience can interact with the commissioned artworks and can experience the artistic research results. Often designed as city-to-city interventions, these events connect the CCN infrastructure of media façades, urban screens and projections in real-time. All these events are adjusted to the local situation and interest of the participating CCN partners: some develop artistic content for permanent large media architectures like the Ars Electronica Center in Linz, Medialab-Prado in Madrid, the Digital Gallery at the SESI Building in Sao Paolo; others work temporarily with existing infrastructures that are otherwise mainly commercially used screens or projection walls like m-cult in Helsinki, FACT Liverpool and Public Art Lab in Berlin; others work with exhibitions and permanent showcases of how to utilize urban media environments for participatory city-making like Quartier de Spectacle in Montreal and the Federation Square in Melbourne.
*http://www.connectingcities.net*

The *Connecting Cities Network* is supported by the European Union Culture Programme 2007–13.
It was initiated by Public Art Lab Berlin in cooperation with Ars Electronica Futurelab Linz, Medialab-Prado Madrid, FACT Liverpool, Videospread Marseille, iMAL Brussels, Riga 2014, BIS (Body Process Arts Association) Istanbul, m-cult Helsinki, Media Architecture Institute Vienna, Museum of Contemporary Art Zagreb, University of Aarhus, MUTEK & Quartier des Spectacles Montreal

Currently the following cities are part of the constantly growing network: Aarhus, Berlin, Bogotá, Brussels, Dessau, Dortmund, Frankfurt, Guangzhou, Helsinki, Hong Kong, Istanbul, Jena, Linz, Liverpool, London, Madrid, Marseille, Melbourne, Montreal, Moscow, New York, Pula, Riga, Ruhr, Saarbrucken, Sao Paulo, Sapporo, Sydney, Utrecht, Vienna, Wuhan, York, Zagreb, Zaragoza

nita.

# blindage.

A Connecting Cities Research Residency 2015 Project

*blindage* **is the french word for a wall, a shield or an envelope, which protects what's inside.**

inbetween disclosure and disguise. how can you hide your face without losing it—how can you divulge it without getting transparent. *blindage.* is the poetic trial of freedom in a world of monitoring and data superabundance. the project focuses on the use of digital masks by contemporary human beings. *blindage.* is divided into three chapters—fleurêve. synanthrope. and abîme. each one translates metaphors into visual art by using dance, taxidermy and handmade organic masks. archetypical as well as surrealistic imagery accompanied by different ways of projection. *blindage.* coquettes with the distinction between high res and low res. a mélange of analogue and digital techniques—overhead projection, microscoped organic footage, and digital

intervention focusing on ways to camouflage reality. façades are also masks. the project invites the audience to peek beyond the Ars Electronica Center façade.

*http://blindage.at/*
*http://www.studionita.at/*

This project was realized within the framework of the Ars Electronica Residency Network.

idea/masks/visuals: anita brunnauer (nita.)
camera/edit: benjamin skalet (simp)
audio: simp & STSK
technical support: leonard prokropek
postproduction/motion graphics: ludwig tomaschko, benjamin skalet, anita brunnauer

vocals & protagonist chapter n°1 fleurêve:
sophia hagen (soia)
dancer chapter n°2 synanthrope: paz katrina jimenez (cat)
faces chapter n°3 abîme: dusty crates, improper walls, sen7even, shakiba ravazadeh, soulcat e-phife

Anita Brunnauer

Ursula Feuersinger

# Deep City

A Connecting Cities Research Residency 2015 Project

*Deep City* is a data visualization experiment investigating the collective information that defines a city's present and future. Findings from Linz, Vienna, Berlin, and New York are represented as visualized data layers and displayed on the four sides of the Ars Electronica Center building. By comparing the data sets, assumptions about individual behaviors and social customs can be explored and challenged. What information characterizes a city and reflects its future? How effectively does data represent the complexity of cities, and how do inhabitants interact with and make sense of these representations? Social, political, and personal properties of urban spaces were considered in the context of sustainability and quality of life. Ultimately, 8 data sets that explore the tension between individuals, spaces, and resources were chosen and grouped into pairs: Growth / Diversity, Green Spaces / Bike Paths, Water Usage / Waste, and Density / Noise Exposure. An interactive terminal was designed and constructed to return the data to its source, the urban population, for reconsideration and evaluation. Observers of the project become participants,

extracting hidden artifacts from the deep and bringing them to the surface. A crank allows participants to browse through color-coded topologic layers. When users pause on a given color, animated content is revealed, both on the Ars Electronica Center façade and on the terminal's screen.

The second interaction element is a 3D printed cube, a hand-sized, miniature model of the AEC building. By rotating the cube on the interface terminal, users can switch from one city to another and view the respective city's content. Participants are encouraged to explore the particularities of their own urban spaces, and to compare them to others. Deep City invites residents to critically engage with their surroundings, but also to enjoy browsing through colorful, animated public data on a large media display.

This project was realized within the framework of the Ars Electronica Residency Network.

Design & Animation: Ursula Feuersinger
Sound: Richard Eigner & Roman Gerold (Ritornell)
Technical Support: Leonard Pokropek

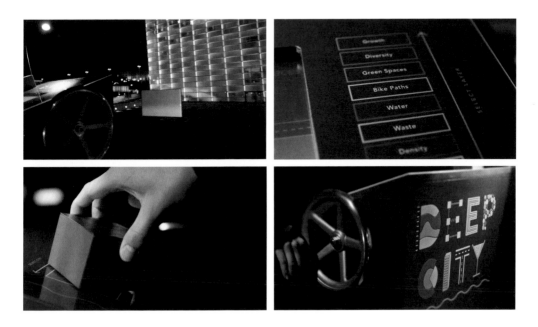

Dietmar Offenhuber

# Urban Entropy
A Connecting Cities Research Residency 2015 Project

*"Maintenance is a drag; it takes all the fucking time".*
Manifesto for Maintenance Art, Mierle Laderman Ukeles, 1969

Is complaining an act of civic participation? *Urban entropy* is a public display of complaining and repair, a drama of maintenance and things that do not work. The façade of the Ars Electronica Center visualizes the work queue of the city of Linz public works department and reads the litany of citizen complaints to pedestrians passing by the building, which is conveniently located across the street from City Hall.

The proliferation of citizen issue trackers, feedback and grievance systems are part of an emerging paradigm of participatory infrastructure governance. The evangelists of this paradigm emphasize issues of transparency, accountability, and nuts-and-bolts collaborative problem solving between the city and its residents. The local version of an issue tracker, the *"Schau auf Linz"* service, displays its submissions publicly on the website of the city. Data repositories such as the archives of the service are considered part of the digital equivalent of public space. By bringing complaints from the city's website into the physical space of the city, *Urban entropy* makes a point about an important difference between these two spaces. While civic participation increasingly takes place online, we stay inside a filter bubble and only find what we are looking for. IRL ("In Real Life"), the public space of the city, we cannot foresee or choose whom we might run into, for better or worse, just like the involuntary listeners to the chorus of *Urban Entropy's* complaints.

Urban writers such as Jane Jacobs and Richard Sennett have defined public space as the sometimes unpredictable exposure to diversity, unlike the controlled environment of segregated suburban neighborhoods, which share many similarities with online public space. When citizen reporters know that their submissions are not just compartmentalized on the city's website, but broadcasted into public space, would they write their complaints differently? *Urban Entropy* moves the process of maintenance into the foreground, shows that infrastructure (to paraphrase Susan Leigh Star) is not a thing, but a relationship: between physical structures and organized human practices.

This project was realized within the framework of the Ars Electronica Residency Network.

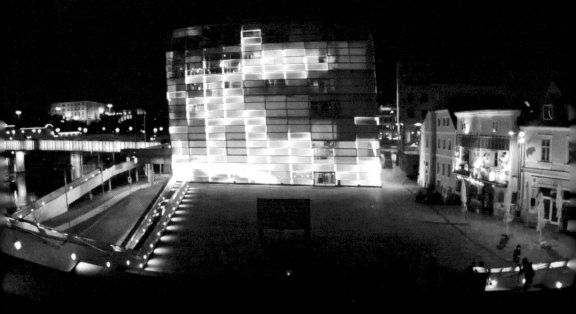

Florian Born, Christoph Fraundorfer

# ESEL-Complain
A Connecting Cities Research Residency 2015 Project

Urban space can be divided into many different types of spaces: living space, space to relax, space for interaction, or space for unexpected things to happen. Moreover, it is also a space of noise or lost places. There is a close connection between urban mobility and the quality of public spaces in cities. *ESEL-Complain* shows opportunities and the potential provided by the use of bicycles in public spaces. It connects two projects that try to make riding your bike in a city as pleasant as possible.

*Auto-Complain* detects potholes by mounting your smartphone on the handlebar of your bike. These potholes are entered into an online database and marked with a spray can. *myESEL* develops bikes that can be adjusted to meet individual needs in the manufacturing process. This flexibility is the perfect opportunity to integrate the auto-complain system into a bike.

This project was realized within the framework of the Ars Electronica Residency Network.

Florian Voggeneder

Tamer Aslan, Onur Sönmez

# Flame

A Connecting Cities Visible City 2015 Project

Fire has been strongly associated with human society since early civilization. For the first hunters and gatherers, and even more for settled societies, fire defined the central gathering point and meeting place. Food was prepared over its heat, and wounds were cleaned with its ash. Good times were celebrated, and bad times lamented by the fire.

As civilizations became more complex and villages evolved more and more into cities, fire started to become the power that forged the tools and weapons of this complexity, and hence initiated the progress of technology. Its symbolic representation rose to its highest form with the industrial revolution, where steam engines converted this power directly into usable energy, which eventually became the main driving force of the cities.

At the same time, however, this power was taken from the hands of the public and placed under the control of a few. When fire and its accompanying customs and traditions started to disappear from the cities, the people lost their say in the rules that governed them and their cities. Both fire and the mechanisms of the city became invisible, disappearing from sight and becoming incomprehensible to its citizens. *Flame,* wants to give the fire back to the people, to help them forge the tools of the new century, and to burn to the ground the institutions that restrain them, if necessary. *Flame* wants to remind them once more of the forgotten fact that their own breath constitutes the very basis of this fire.

Special thanks to Bernhard Ranner for the metal work and fire sculpture. Fire hardware provided by TBFpyrotec.

Mark Shepard, Julian Oliver, Moritz Stefaner

# False Positive

A Connecting Cities Visible City 2015 Project

Welcome to candygram, where you are more than just a number.
Tired of being treated like yet another anonymous subscriber?
At candygram, we get to know our customers personally, and we know you better than you think.
Candygram—let's get personal®

It is not just the trust we place in network infrastructure but also our willingness to trade bits of personal data for access to online services that render us vulnerable. Caught between ruse and exploit, we find ourselves subject to ever more sophisticated forms of profiling, both online and off. Yet if algorithmically generated data bodies are our future, they are also prone to error. *False Positive* deploys text messaging, stealth infrastructure, street intervention, and data visualization to enact a surveillance conspiracy engaging the public in an intimate, techno-political conversation with the mobile technologies on which they depend.

# Smart Creativity, Smart Democracy

Council of Europe

The impact of digitization on culture has been recognized by the Council of Europe as entailing momentous societal transformation. Digitization has provided an unprecedented means for people to access, express, generate, assemble and disseminate culture in a variety of different ways. It has further led to a more collaborative culture and seen the genesis of innovative schemes such as crowd-funding, crowd-sourcing and collective creation. This has meant political implications for the Council of Europe's mandate of upholding human rights, democracy and the rule of law, such as by providing a means for governments to enhance citizen access and participation in digital culture, but also by showing up threats such as the breach of citizen privacy and the propagation of hate speech, all of which call for due action.

In this context, the 2013 Council of Europe Conference of Ministers of Culture requested the setting-up of a multi-stakeholder platform of exchange for policy makers and cultural and media practitioners to discuss these issues. A first platform meeting was held from 4 to 5 July 2014 in Baku, Azerbaijan. It collected the different views of various actors and explored the egalitarian promise of digital culture that had already dissolved countless boundaries and removed many hierarchies in culture creation and dissemination. This first meeting subsequently provided insights for a Council of Europe Recommendation to European Governments on the "Internet of Citizens," meant to complement the now well-known concept of the "Internet of Things." Promoting a people-centered approach to the Internet, it will be adopted later in 2015 by the organization's political stakeholders.

In summer 2015, the Council of Europe, through its Steering Committee on Culture, Heritage and Landscape, and in cooperation with Ars Electronica, will organise the second of such platforms. Entitled *Smart Creativity, Smart Democracy* it will be held in Linz at the Ars Electronica Festival. In this way, it hopes to take advantage of the latest trends and information on the digitisation of culture, so as to keep the organization's cultural policy-making informed, involved and up-to-date. The Platform's theme aims to reveal further evidence of the mutually reinforcing relations between citizens' digital creativity, media competence, access to and participation in culture, civic engagement, public outreach and democracy.

While the platform exchange will be open-ended and its outcomes determined by the contributions of the participants, answers to the following questions will be sought: How can digitization be best used for facilitating access to and participation in culture and creativity with a view to strengthening democratic participation and thus contribute through "Smart Creativity" to "Smart Democracy?" What are the examples of the most recent innovative cultural practices and digital applications in Europe, what are their specifics? How were they set up, run and financed? Do they actually boost audience engagement and attract a larger audience? Do they boost creativity and participation? What are the lessons learnt, what are the good practices observed, and can these be translated into inspirations and principles for innovative cultural policy-making, to be recommended by the Council of Europe to its member states?

The conference will once more be practice-oriented and bring together senior policymakers with artists and cultural producers, practitioners from cultural institutions and professional associations as well as researchers, civil society actors and representatives from international bodies active in this field. This multiple stakeholder approach is aimed at including the widest number of players and perspectives in the field and reflects their shared responsibility for shaping the present and the future.

The work on Digitization and Culture will continue after the platform meeting and be reflected in the forthcoming Council of Europe "Internet Governance Strategy 2016–2020." Synergies are welcome with relevant initiatives from other organizations.

# KNOWLEDGE CAPITAL
## The Emergence of Osaka in Action

Knowledge Capital is a center for the creation of new intellectual values through interaction and collaboration, and a core facility at Grand Front Osaka, the multi-purpose complex of commercial facilities, offices, hotel and service apartments. It is located in the center of Osaka, and everyday 2.5 million people pass through this largest station in western Japan. Businesspeople, researchers, creators, ordinary citizens, and a wide variety of other people come together there to pool their knowledge and create something new and valuable. We believe that collaborative activity creates an innovative culture, ideas, goods, and services.

Osaka has flourished as a river city since ancient times, and it was the people, rather than the authorities, who built bridges to ensure better service. Knowledge Capital has inherited this spirit of the people and seeks to innovate business and lifestyle. This spirit has traveled 9,000 km from Osaka to Linz along the Danube. We hope you feel the heartbeat of what is happening over here, and participate in the activities of Knowledge Capital.

Takuya Nomura, General Producer

# What is Knowledge Capital?

### River Capital

The city of Osaka, established in the 7th century, surrounded by a major river and waterway, is known as the city of merchants. The river, like the Danube, has always been an inspiration for innovation among the people, in terms of transport and as a place for entertainment. They might mean a leisure area.

### People's Capital

Osaka was built by the people. The schools along the riverside provided a diverse and talented work force. To meet demand and improve business, merchants and locals built more than 200 bridges in the Edo period (1603–1868), whereas the government only built 12. Public works continued to be built by the people. In the 20th century, entrepreneurs, not the government, built several academic facilities along the riverside–including public libraries and the Osaka City Central Public Hall.

### Knowledge Capital

Even today, innovation in Osaka continues to be led by the business sector and individuals. Knowledge Capital is a core facility of the complex established by private companies and works as an intellectual creation hub to realise interactive and collaborative environment at the heart of Osaka. Just as rain forms a stream that becomes a river and the river flows into ocean, we at Knowledge Capital have offered places and opportunities for unique and creative individuals to bring forth new ideas that will spread to the rest of the world.

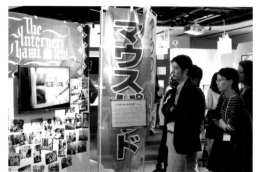

KNOWLEDGE CAPITAL Osaka, the „Knowledge Salon" and „The Lab"

The exhibits are by enterprises, universities and entrepreneurs from the Knowledge Capital facilities The Lab., the Knowledge Salon, and the Knowledge Office.

### Colloidal Media Compositions / Anti-gravity sound scape
Digital Nature Group, University of Tsukuba

How can our imagination be physicalized? We present two art works utilizing acoustic field technologies: colloidal compositions in which programmable soap bubbles represent the ambiguity of our mind and memory. The other is an anti-gravity soundscape–media composition that expresses the malleability of the physical world. Small particles in the air are manipulated, burst and stabilized.

### A tree tweets. A tree reacts.
ISI-Dentsu, Ltd. Open Innovation Lab., MIT Media Lab., OUJ, Obayashi Co., and Aoyama Gakuin Univ.

What if we could add humanity to trees, and robotinity to humans? What will the mutually beneficial futuristic relationship of trees and human beings be like? We explored ways of sound communication by monitoring sap flow and pulse. Here come tree tweets.

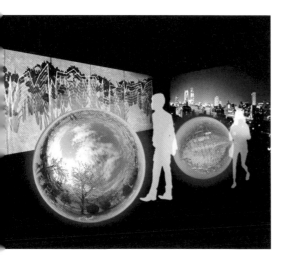

**Folklore Sphere**
Kansai University

*Folklore Sphere* is an attempt to rediscover regional values in both the city and nature, which have been evolving organically in a timeless way, and to present the values as multiple works of digital media for the civic pride of the future generation.
In cooperation with Daiko Advertising Inc.

**Bunraku Robot**
Muscle Corporation

*Bunraku Robot* fuses state-of-the-art robotics technology and the traditional Japanese puppet theater artform. The human puppetmaster can teach the robot original lithe movements, and the robot can re-play the motion as many times as needed.

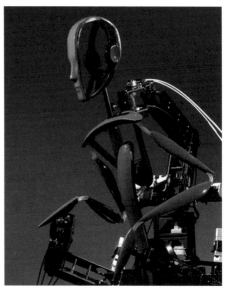

**What Color is your City?**
Osaka Institute of Technology

1. Progress report about the Japanese National Project on innovative Robot Service.
2. Pilot experiment of social art for graphical interpretation of latent urban structures and attractions through digitally visualizing casual behavior of visitors and habitants in cities, using the Japanese-friendly tool "Uchiwa."

## Incendiary reflection
Shigeo Yoshida, Takuji Narumi, Tomohiro Tanikawa, Michitaka Hirose, The University of Tokyo

Do all of your emotions really come from inside? *Incendiary reflection* influences your emotional experiences by slightly modifying the reflection of your facial expression. Although you do not change your facial expression, the face in the mirror is either a happy or a sad face.

## GOKAN Response Activating Space
Takenaka Corporation

We offer the architecture that affects human senses in response to the human's movement by images, sounds, perfumes and air-flows and will activate human's body and mind. You will experience the response of architecture that makes humans smile, communicate with people and dance. This is the prototype of space designed for the super-aged society that Japan will face in the approaching future.

## Lost Physical Existence
VisLab Osaka: Osaka Univ., Kwansei Gakuin Univ., Osaka Electro-Communication Univ.

The barcodes are attached to humans and mismatch personal information. Barcode readers are also used as a visual display. A 3D Fog Display could be screening senseable city. An umbrella-like device called FUNBRELLA entertains people with weather data and an umbrella is the user interface. These objects are paradoxical in the face of digitization.

## Twee-Shirt
### XOOMS × U-SOFTFACTORY

*Twee-shirt* is a tool to facilitate the communication between strangers. A person wearing the *Twee-shirt*, on which a specific AR-marker is printed, registers their Twitter-ID and other personal records on the server in advance. Any person who wants to speak to them is able to get the information through a mobile application before starting a conversation.

## Being There Without Being There
### iPresence LLC

We are planning to connect multiple locations using remote presence technologies. We will be connecting between the Knowledge Capital in Japan and Ars Electronica in Austria, and even some other Ars Electronica locations, and visitors from both sides will experience the other side without being there.

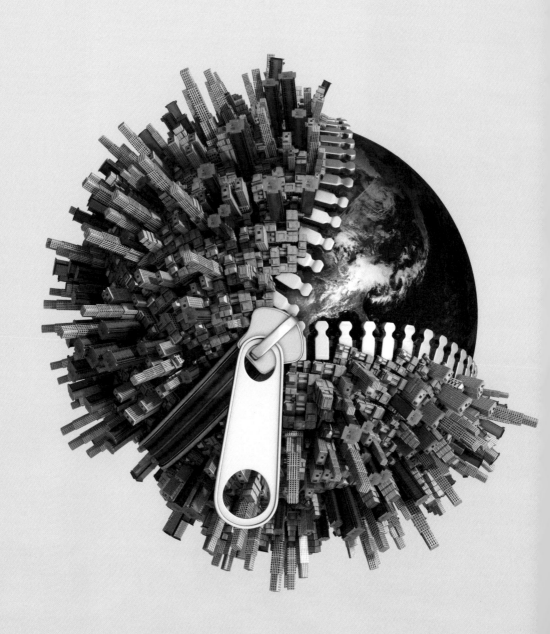

# ART &
# SCIENCE

Gerfried Stocker

# The Challenge of Art and Science

Since its very beginning Ars Electronica has always focused strongly on the many interrelations between Art and Science. From the Sky Art Conference in 1980 or the 1992 festival dealing with Nanotechnology to the Hybrid Art category of Prix Ars Electronica that was started in 2007, Ars Electronica has made major contributions to the development of this field and introduced challenging scientific topics into the discourse and practice of media art. For a long time, artists seemed to have a greater interest in this field, but in recent years the interest in exchange and collaboration has increasingly come from scientists and researchers, which is largely due to the popular idea that many of the challenges of our present time can only be solved with creative new approaches and even more extensive collaboration.

The challenges we face in these many transformations that are now taking place are bigger than the capabilities of each individual group of experts, and so collaboration which is going beyond just the mere joining of forces but has the potential to lead to transformation and innovation is the mantra of our time. No doubt the large attention that art and science collaborations are getting right now is driven by very profane expectations that a new wave of creative innovations could boost the weak economies and become the much needed competitive edge for the next decade.

If one really wants to meet these expectations, an altered understanding of the role of the artist and even more of the role of the institutions of art and culture is also needed.

But how can it be changed without compromising the autonomy and integrity of the artistic process because after all this is the one thing that makes it so promising and valuable?

What kind of practices can be established to successfully tap into this special energy? How can it be translated and conveyed beyond the art? How can the art itself benefit from this and gain momentum of innovation for itself? What experiences and findings can be drawn from the prototypic encounters and collaborations of the many artists in residence programs that are currently aiming to bring artists and scientists together?

These are the questions that are presently being discussed in many programs and places, and that is why Ars Electronica teamed up together with seven experienced European art institutions and two of the most exciting research facilities that we can find today: CERN with its Large Hadron Collider, looking into the smallest possible structures of our matter and ESO's high end observatories in Chile looking into the furthest distances of the universe.

Besides these unique artist in residence opportunities, Ars Electronica is also devoting a big part of the festival to the field of art and science collaboration.

# European Digital Art and Science Network

art & science
european
digital art
and science
network

The main idea of the network is to draw a bow between micro- and macro-cosmos of science and digital arts.

In cooperation with seven artistic & cultural institutions as well as CERN and ESO (European Southern Observatory), Ars Electronica launched the European Digital Art and Science Network, an international initiative offering artists the chance to spend several weeks at CERN, ESO, and the Ars Electronica Futurelab. The network aims to link up scientific aspects and ideas with approaches used in digital art. Fostering interdisciplinary work and intercultural exchange as well as gaining access to new target audiences are among its declared goals. There is also strong emphasis on art's role as a catalyst in processes of social renewal. By creating images and narratives dealing with the potential risks and rewards inherent in technological and scientific development, artists exert an important influence on how our society comes to terms with these innovations.

Co-funded by the
Creative Europe Programme
of the European Union

Half the financing of the European Digital Art and Science Network is being provided by the European Union programme Creative Europe, the other 50% is contributed on an equal basis by the participating institutions. Creative Europe is the European Commission's framework programme for the cultural and creative sectors.

In cooperation with the seven European partner organizations, Ars Electronica issued two worldwide calls for submissions. The first call (fall 2014) was for a residency at the European Southern Observatory (ESO) in Chile, the second call (spring 2015) for a residency at CERN in Geneva, Switzerland.

From among the entries, the juries of top-name experts selected two artists (artistgroups) to take part in the residencies. The artists will spend a few weeks at the scientific institutions (ESO and CERN) and derive inspiration from their mentors and their scientific work. Subsequently, they'll spend an additional residency at the Ars Electronica Futurelab, where mentors will assist the artists in the creation and development of new works that were inspired by their previous residency at ESO or CERN.

The results of the respective residencies will be presented at the Ars Electronica Festival 2015 for the ESO residency, and in 2016 for the CERN residency. The results will also be presented in modular traveling exhibitions that will be running at the seven partner institutions. In addition to the exhibitions, the network will also stage workshops and discursive projects such as conferences and symposia having to do with the artistic themes of the respective works.

# Scientific Partner Institutions

The basis of the *European Digital Art and Science Network* is a big manifold network consisting of two scientific mentoring institutions, CERN and ESO—representing Europe's finest in scientific research, the Ars Electronica Futurelab—providing state-of-the-art technical production possibilities in a transdisciplinary discourse, and seven European cultural partners who represent strong and diverse European cultural and artistic positions.

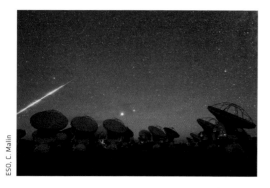

ESO, C. Malin

**ESO (CL):** The European Southern Observatory (ESO) is an intergovernmental organization that has its headquarters in Munich and its observing facilities in Chile. Founded in 1962, today ESO consists of many different observation facilities which helped to make a lot of important discoveries in astronomy. ESO has built and operated some of the largest and most technologically-advanced telescopes in the world. *http://www.eso.org/public/*

## Arts@CERN
Great Arts for Great Science

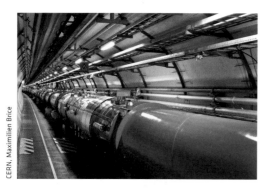

CERN, Maximilien Brice

**CERN (CH):** As the cradle of the World Wide Web and home of the Large Hadron Collider which investigates the mysteries of our universe, the European Organization for Nuclear Research—CERN is an eminent center of digital culture as well as science and technology. As an international center of excellence in these fields it is an inspirational place for artists and designers to explore and extend their research in order to find new artistic approaches. *http://www.cern.ch*

**Arts@CERN** is CERN's arts programme, designed to make creative connections between the worlds of science, the arts, and technology. It is part of CERN's Cultural Policy, agreed in August 2010, which led to the creation of its flagship arts programme "Collide@CERN Artists Residencies—Creative Collisions between the Arts and Science"—in 2011. The "Collide@CERN" residency programme is already well established and highly regarded, having run successfully for 4 years, with a proven track record in transdisciplinary artistic excellence and exchange between artists and scientists. *http://arts.web.cern.ch*

# European Cultural Partners

 **GV Art** (UK): GV Art is the UK's leading contemporary art gallery which aims to explore and acknowledge the interrelationship between art and science, and how the areas cross over and inform one another. The gallery curates exhibitions and events that stimulate a dialogue focused on how modern society interprets and understands the advances in both areas, and how an overlap in the technological and the creative, the medical, and the historical fields are paving the way for new aesthetic sensibilities to develop. *http://www.gvart.co.uk*

**DIG gallery** (SK): DIG gallery is the alternative platform for presentation of the contemporary forms of digital and media arts. Activities of DIG gallery are focused on mapping and popularization of this area, developing local and international connectivity, and support- ing artistic practice and creativity in general. DIG gallery collaborates with several institutions and independent initiatives within the interdisciplinary research, alternative education, and partnership networks. DIG gallery was founded by DIG nonprofit organization in 2012 as a model of the open-source gallery based in Kosice. *diggallery.sk*

 **Science Gallery** (IE): Science Gallery is an organization dedicated to igniting creativity and discovery where science and art collide. Science Gallery, since opening in February 2008, has welcomed over a million visitors with over 24 exhibitions ranging from *EDIBLE*, which examined the future of food, to *BIO-RHYTHM*, which got to grips with music and the body, to *INFECTIOUS*, an exhibition which show- cased the first ever live simulation of a pandemic using RFID technology. Science Gallery is ranked amongst the top ten free cultural attractions in Ireland and is all about opening science up to passionate debate. It is uniquely located in Ireland's leading research university, Trinity College Dublin, with a recognized expertise in astrophysics and astronomy as well as a focus on public engagement with creative science, art and design. *http://dublin.sciencegallery.com*

 **LABoral** (ES): LABoral is a multidisciplinary institution which produces, disseminates and fosters access to new forms of culture rooted in the creative use of information and communication technologies (ICT). LABoral has been working in crossovers between arts, science, and technology since its creation in 2007. The hybrid nature of the institution is seen through its focus on produc- tion, a practice that involves an intense knowledge exchange amongst professionals from different disciplines with a common objective. In this context, the collaboration with all these professionals has always been a new challenge, due to the differences and similarities between practices. Thus, this experience is to be shared, agreed, and formalized with similar hybrid institutions through the production of various research projects and related activities. *http://www.laboralcentrodearte.org*

**Zaragoza City of Knowledge Foundation** (ES): Zaragoza City of Knowledge Foundation is an independent public-private organization that is in charge of the program for the Etopia Center for Art & Technology. According to this mission they developed some interesting projects with international scope, providing valuable experience for the Foundation. The most relevant are: *Paseo Project* (in collaboration with Ars Electronica), to promote technology-based creativity in the public space, *Innovate! Europe* (a European event on startup culture), and *Das Detroit Projekt* (coordinated by Schauspielhaus Bochum). Zaragoza City of Knowledge Foundation has also been quite active in participating in events and projects of the European Union, especially in the field of smart city initiatives, urban innovation, and Future Internet PPP. *www.fundacionzcc.org*

**Kapelica Gallery / Kersnikova** (SI): Kapelica Gallery was established in 1995 as an art space with focus on Contemporary Investigative Arts and a production platform for research, investigation, and experimenting with the limits of artistic discourses and art poetics. Kapelica art program is constituted by exhibitions, performances, and artistic research. The gallery presents works of artists that dare to go beyond safe and pleasant themes and challenge visitors to contemplate and wonder with them. Together with BioTehna Wetlab, Kapelica is an active production platform which encourages, facilitates, and showcases investigative artistic production, creates public debate, and stimulates a critical understanding of the times we live in. *http://www.kapelica.org*

**Centre for the promotion of science** (RS): Promotion of science is one of the major tasks for every European country. In this field, the Centre for the Promotion of Science (RS) is already actively engaged in bringing the science community closer to a larger public, with the ambition to become the top institution that binds together, provides help, and supports all science popularization organizations and initiatives throughout Serbia. Special attention is given to the cooperation with scientific institutions—the Serbian Academy of Sciences and Arts in the first place, but also with leading scientific institutes and all universities in the country. *www.cpn.rs*

# Residencies

**art & science**
residency
european
digital art
and science
network

## Residency at the European Southern Observatory (ESO) in Chile

In early 2015, more than 140 artists from 40 countries submitted ideas and concepts to the Open Call issued by the European Digital Arts & Science Network. They were vying to take advantage of an extraordinary opportunity: a residency for artists at the European Southern Observatory (ESO) in Chile and a residency at the Ars Electronica Futurelab in Austria. Representatives of the member institutions of the Art & Science Network awarded this residency to María Ignacia Edwards.The decision was reached by a 10-member jury made up of representatives of Ars Electronica, the European Southern Observatory (Fernando Comerón), and the seven cultural partner institutions.

"The artist works with space, endeavouring to maintain the balance, suspension, lightness and weightlessness of objects, which are sustained by their own weight and counterweight. The constructions are the result of exquisite prior calculations, mechanisms, solutions and interventions. María Ignacia Edwards calls these pieces *self-sustainable* because they require no more than their own weight to exist, and the objects tend to rotate constantly around their own axis. The artist invites beholders to observe each object as if they were stars in the firmament. While, at first sight, her approach might seem purely plastic, it transcends science and particularly physics and mathematics, and in the jury's view, it is especially attractive for the potential it offers for the residency. The artist makes a great effort to connect both the inspiration and the outcome of the work to characteristic features of astronomy: isolated objects in weightlessness. The work is thus intended to evoke astronomy-inspired awe. The presentation is very well elaborated and clearly transmits the idea of the project, though it also promises great potential for development in both residency venues."

(Statement of the Jury)

**Fernando Comerón**
Head of the ESO Representation in Chile

ESO, the European Southern Observatory, is the main organization in the world for ground-based astronomy. Its facilities in Chile include the Very Large Telescope (VLT) array of four telescopes each with a 8.2 m diameter mirror at Paranal Observatory, and the Atacama Large Millimeter and Sub-millimeter Array (ALMA) at Llano de Chajnantor of 66 antennas sensitive to radiation in the microwave regime. ESO also operates the La Silla Observatory, where two telescopes with 3.5m diameter mirrors and other smaller ones are also carrying out forefront scientific research.

While most scientists would tend to see those facilities only as big tools for astrophysical research, ESO's sites in Chile become many additional things when seen from the perspective of visitors from other backgrounds: they are also showcases of advanced technologies, examples of the complicated logistics required for operating in remote places, flagships of international cooperation for peaceful purposes, or places of inspiration, as felt by artists who have had the chance to be there. It is indeed enriching to see the observatories through their eyes. In chosing the location for her residency, María Ignacia Edwards—as first selected artist within the European Digital Art and Science Network—has felt especially attracted by the blend of history, landscape, and peace found at La Silla observatory, and by the remoteness and other-worldly appearance of ALMA, themes to be combined with the persistence of reduction to the simplest forms, spatial arrangements, and motions in her work so far.

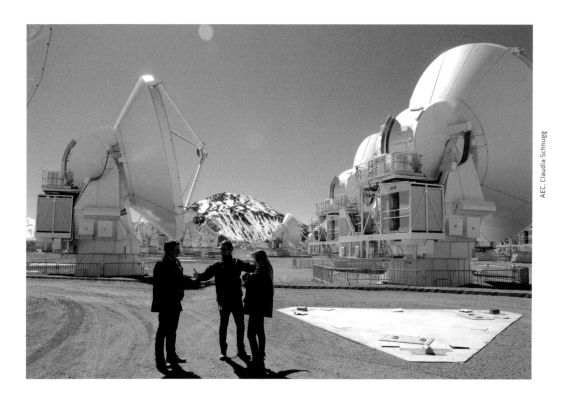

AEC, Claudia Schnugg

María Ignacia Edwards at ALMA, the Atacama Large Millimeter/submillimeter Array. At 5,000 meters above sea level, the world's largest radio telescope has 66 antennas spread out across this arid expanse to scan the sky in all directions. "ALMA inspires me: There is the power of the desert, the sun and the illusion of understanding and witnessing the mechanism in action with all those antennas moving at once...The harmony in the accuracy of the movement, which is one of the essential elements that inspire my work."

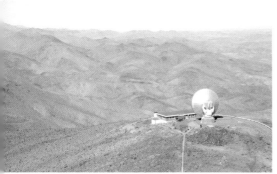

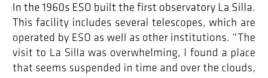

In the 1960s ESO built the first observatory La Silla. This facility includes several telescopes, which are operated by ESO as well as other institutions. "The visit to La Silla was overwhelming, I found a place that seems suspended in time and over the clouds, with the beauty and the weight of past time on things, it touched me deeply. I could feel a nostalgia and melancholy for what it used to be and that somehow still is, moving at its own time and rhythm. A place apparently full of stories."

The artist spent a few weeks at the scientific institution and derived inspiration from her mentors and their scientific work. Subsequently, she spent an additional residency at the Ars Electronica Futurelab, where mentors assisted the artist in the creation and development of new works that were inspired by her previous residency at ESO.

María Ignacia Edwards, born in 1982, is an artist from Santiago, Chile. After receiving her BA from the Finis Terrae University in Santiago and her Diploma in Cinema, Art Direction and Photography from the University of Chile, she lived and worked in New York City from 2009 to 2012. During this time she also did an artistic residency at the School of Visual Arts and in the Lower East Side Printshop. In 2012, she received an invitation from the Arts Cultural Center in Mexico, Reinosa/Tamaulipas, to stage an individual exhibition, *In Between* at the Tamaulipas International Arts Festival. The artworks of María Edwards were also exhibited in Chile, Spain, USA, Argentina, Peru, and Mexico. She has also taken part in international fairs: Pinta Art Fair in New York; ArteBA in Buenos Aires; Art Lima in Peru; and ChaCo in Chile. Recently she has been awarded the honor prize "Art for Science", granted by the National Commission for Scientific and Technological Research (CONICYT) in Santiago, Chile.

# Residency at CERN, Geneva, Switzerland

After selecting Maria Ignacia Edwards for a first residency at the ESO in Chile, followed by a residency at the Ars Electronica Futurelab, the Collide@CERN Ars Electronica Award open call was the second opportunity to realize a new scientific inspired project in a fully funded residency for up to 2 months at CERN, followed by a residency at the Ars Electronica Futurelab. After three successful years within the Prix Ars Electronica Collide@CERN Award, CERN and Ars Electronica decided to continue their fruitful cooperation.

The Collide@CERN Ars Electronica jury, formed by Mónica Bello, Michael Doser (both CERN), Horst Hörtner, Gerfried Stocker (both Ars Electronica), and Mike Stubbs (Fact), met in early July in Linz. The jury selected the British artist duo Semiconductor (Ruth Jarman and Joe Gerhardt) as the winners of the international competition, granting them a fully funded two-month residency at CERN in Geneva and one month at Ars Electronica Futurelab in Linz. A good range of 161 projects from 53 countries was reviewed by the jury leading to a great debate, discussing what was of value and who would gain most from the opportunity offered by the Collide@CERN Ars Electronica award. The winning artists demon-

strated in previous projects a broad sense of speculation, complexity and wonder, using strategies of analysis and translation of the phenomena into tangible and often beautiful forms.

Semiconductor (UK) has a long track record of scientific research and previous collaboration with research institutes, e.g. NASA Space Sciences Laboratory in California, and the Smithsonian Museum of Natural History. Semiconductor embraces processes that remind us of how our experience of science is framed by tools and artifacts. Their work brings together a deep understanding of materiality, data, and models of natural environments and phenomena. We believe that they will be greatly inspired by their time at CERN and the fundamental physics research being carried out there, and that similarly they will have an impact on the researchers working in the laboratory. In their project proposal *A particular kind of conversation* they express a specific interest in exploring quantum phenomena and the subjects of theoretical and experimental practice as carried out at CERN. We foresee multiple outcomes in a variety of media, which we hope will greatly impact the practice and the legacy of science-inspired art.

Statement of the Jury

Rolf-Dieter Heuer
Director-General of CERN

## Great art for great science

When we launched the Arts@CERN programme some six years ago, little did I know that it would enjoy the great success that it has. In large part, that is due to the partnership we have enjoyed with Ars Electronica, and the quality of the artists who have held the Prix Ars Electronica Collide@CERN.

CERN's decision to engage with the arts comes down to a deep-seated conviction that art and science form two aspects of a single culture. The level of heated debate about the so-called Two Cultures is a constant source of bafflement to me. Of course arts and science are linked. Both are about creativity. Both require technical mastery. And both are about exploring the limits of human potential. That's why the motto of the Arts@CERN programme is "Great art for great science".

Through the three years of the Prix Ars Electronica Collide@CERN, we have certainly experienced great art. From the remarkable Julius von Bismarck's award winning collaboration with Gilles Jobin, to Bill Fontana's soundscapes and Ryoji Ikeda's *Supersymmetry* installation, all three laureates have not only contributed fully to the cultural life of CERN, but they have all produced fantastic works of art, bringing the complementary realms of arts and science closer together. Through the remarkable relationships that have been forged during each artist's residency at CERN, the laureates of the Prix Ars Electronica Collide@CERN have each shown just how closely intertwined arts and science are. Over the years, the programme has brought this important message to thousands around the world, amply fulfilling one of the key goals we set ourselves when we launched the programme.

But all good things come to an end, and as we enter this fourth year of collaboration with Ars Electronica, we are evolving the partnership. This year, the collaboration becomes part of the European Network of Art and Science and is renamed the Collide@CERN Ars Electronica award. As in previous years, the winning artist will spend two months at CERN and one at Futurelab. The artists duo Semiconductor who steps up to receive the award at this year's Ars Electronica Festival has not just one, but three hard acts to follow. I am very much looking forward to seeing the result.

Mónica Bello
Head of Arts@CERN

## In search of the fundamental

For centuries science and art cast together the contour lines of our reality. The way we comprehend our environment, the interactions with other beings, or the understanding of the complex laws of nature, constitute the common drives of art and science through human history. At the current moment, there is a major interest in exploring these hybrid cultures where these two domains of knowledge collide. Today it is possible to imagine a place where artists and scientists can meet and influence each other by using formal strategies and universal imperatives. Far from commenting on scientific facts, illustrating science or communicating advanced technologies, art provides a framework for discussing the complexities that underlie our contemporary scientific culture.

CERN is an exceptional laboratory dedicated to the most recent discoveries about the universe, a place where thousands of scientists, engineers, and scholars have met since 1954 in a continuous exchange and with a common goal. It is also the birthplace of great discoveries and technical advances such as the Large Hadron Collider, the most powerful man-made machine that has ever existed, or the World Wide Web, a true milestone in recent history whose invention in 1990 transformed our society as a whole. These efforts would not have been achieved without tremendous international collaborations and without the understanding of an openness, demonstrating the relevance of exploration of the unknown to society.

The pursuit of fundamental research is an essential factor for human survival. Not only because it helps us to improve our understanding of the universe, but also—and primarily—because it enables us to work together towards positive cultural and social changes. When the CERN Cultural Policy was launched under the name "Great Arts for Great Science" in August 2011, CERN's engagement with the arts was placed on a similar level as the excellence of its science. At the time it became relevant to form collaborations with international partners that were following the same objectives: to activate the most innovative way of understanding art and creation through fundamental research. As part of this global ecosystem, Ars Electronica immediately

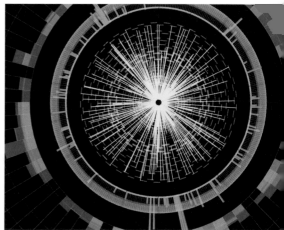

became a natural match for CERN because of the common interest of encouraging synergies between disciplines and an understanding of the benefits of this to society.

Establishing the Collide@CERN Ars Electronica Award partnership has provided unique and exciting opportunities to share our combined expertise in cutting edge arts, science, and technology over these four years. Since then CERN has partnered several leading international organizations, such as the Onassis Culture Centre in Athens, the Ministry of Culture of Taiwan, the Federal Chancellery of Austria, or the Swiss Arts Council Pro Helvetia. Other organizations are joining this unique network dedicated to the artistic exploration of scientific ideas in the multidimensional domain of particle physics. The arts program at CERN provides an opportunity for creators to develop their practice in an incomparable location during a 3-month residency. During this time the artist is invited to become part of the community of researchers at CERN. His/her perception will be challenged by the idiosyncrasy of the place, where conversations are formed by numerous terms that are far from everyday speech, to slowly become mimetic by the routines of the lab. Meeting physicists and engineers, visiting experiments, reflection, researching, arguing, exploring, question-ing, these and other actions are part of the daily routine and the residence experience. What constitutes CERN, the different labs and the scientists and engineers that work as part of a huge tireless hive, constitutes the fascinating environment in which the artist becomes immersed.

At CERN the goal is to investigate the fundamental structure of our universe. In order to do this, some of the most powerful and largest machines have been designed and crafted to allow the modeling of the primordial stage of the cosmos. Fundamental particles are collided at the speed of light allowing physicists to discover their properties and the laws of matter, as well as the forces involved in the process. Art and science, as essential forces, help us to discover the substantial human condition, that is, the drive of curiosity, play and discovery. Science opens up new routes to explain nature, while art offers us original paths to interpret new realities. Both domains provoke ways to experience knowledge by detecting unique and unexpected connections in the natural system. Technology provides the potential for modeling conditions that were previously only imagined. And this is how, by creating experiences, by inciting interaction and stirring forces, common threads of inquiry are found between the hybrid practices of art and science.

# Art and Science Program at Ars Electronica 2015
## Exhibitions, Symposia and Workshops to chart the Territory

Besides these unique artist-in-residence opportunities, art and science collaboration is highlighted at the Ars Electronica Festival 2015.

Two big symposia and several workshops are also dedicated to Art and Science.

1. The symposium "Future Mobility—a Challenge for Art and Science" looks at the potential of artistic input into shaping one of the most popular future topics, expanding it way beyond the mere discussion about electric and autonomous cars. The research collaboration between the AE Futurelab and Daimler to develop new strategies for the communication of two-man and autonomous machines serves as a best practice model for this discussion.
2. The "Prix Forum—Art and Science" is completely dedicated to the artists, their expectations, and their experiences in the collaboration with scientists and science institutions. The prize winners of the Hybrid Art Category of Prix Ars Electronica, as well as curators of outstanding international art and science activities, will present their programs and discuss their experiences.
3. The Future Innovators Summit brings artists, scientists, social activists, and young entrepreneurs together for a three-day workshop program on "informed trust" and "shared spaces."
4. The roundtable and workshop on STARTS brings together policy makers and practitioners from the creative sector to discuss the new program of the EC for the support of Art, Science and Technology collaboration.

A large exhibition program spans three different locations:

1. The Ars Electronica Center with two exhibitions—a joint development with ESA from the science side and another that includes artistic projects funded by the European Network of Digital Art and Science,
2. the OK Center for Contemporary Art which presents Hybrid Art Prix Ars Electronica projects, and
3. the Post City Kit exhibition in the former logistics center of the Austrian postal service.

The aim of the first series of programs that we are producing with the support of the EU is first of all to chart the territory.

Obviously we are starting with some cutting edge art projects which artists have recently developed in close relationship with scientists, resulting from deep engagement with and understanding of the scientific matter they are dealing with—including the outcomes of the artists in residence projects at CERN and ESO.

But it seems necessary also to widen the scope and include works and projects that are exploring the wider surroundings as well as some rare niches: Projects that are dealing with questions of perception and interpretation or projects dealing with the possible impact and implication of new scientific developments on culture and society. Projects that critically question the assumptions, promises and possible consequences that may accompany the introduction and application of new sciences and technologies.

We think that we also have to deal with a very common topic in the art science discourse, the question how far the artistic work can help to better explain and understand the world of science.

And last but not least, all this cannot be separated from the tradition and history of art and technology—an area Ars Electronica is home to since the very first festival in 1979.

Victoria Vesna
# Art&Science
# Relationships and Emergence

Throughout human experience, art and science have influenced, inspired, and informed each other in many ways. Nevertheless, we are still grappling with an artificial division that is a legacy of the industrial age. But, as we collectively began sharing and utilizing the common computer / communication tools—like the Berlin wall—the barrier is starting to give way and has become progressively more open. In parallel, the established reductionist methodologies of sciences are showing signs of limitations and becoming too constricting, especially for those that have emerged with the advent of new technologies—bio, nano, neuro, to name a few.

In search of new methodologies, scientists are increasingly turning to artists and opening up to an equal voice for listening and engaging in transformative type of collaboration. In my own experience, I have witnessed a growing shift in the perception of art and science work, and see it encouraged and sponsored actively by various communities. With cautious optimism, I would like to offer two fundamentally important aspects of engaging in such ventures—relationships and emergence. It takes time to move through the brain patterning of scientific or artistic training and work—the methodologies employed are very different.

Meeting in between and building a relationship requires mutual respect, dedication and hard work—the motivator being excitement of the shared idea—driving the attraction of two or more people to create something new. This has the potential of emergence that is related to self-organized criticality (SOC) that eludes scientists and artists alike as it is unpredictable and resides somewhere in the collective unconscious. In my mind's eye, ideas are an intelligence that emerge as a result of a network of consciousness and need a particular set of qualities and circumstance slowly driven in order to manifest as an avalanche of creativity. If the artist / scientist group is unable to overcome the limitations of social and educational programming, then the great idea "fails" to manifest and moves on to another potential group. How do I prove this speculation you may ask? That is exactly what cannot be done in the existing paradigm, as it is more an experiential satori. Work done with calculation and too much planning may succeed in a limited manner, but it will most likely miss the magic that is the essence of art and science for which we have to develop a new vocabulary.

Victoria Vesna is a speaker at the *Prix Forum—Art and Science* and a member of the Prix Ars Electronica 2015 Hybrid Art Jury.

Jurij Krpan

# Art&Science
# The relationship that is not existing but yet it's functioning

The subtitle is taken from the notorious J. Lacan seminar: *Encore*, 1972–1973, where he introduced the non-biological, denaturalized sexual difference between a woman and a man and formalized it in the scandalous one-liner: "There is no sexual relationship". Being inspired with theoretizations of the relationship between two genders, where theoretical psychoanalysis created the gap between the sexes to be able to depict the inherent out-of-sync between something that is apparent to everyone as being contingent. With this inspirational quote in mind, I want to emphasize that the Art&Science which is taken for granted and objectifies anything in arts that is related to media, electronics, and other contemporary technology, is not a solid praxis where art and science merge, but rather a dichotomy where one struggles with the other. Conceptual difference between science as *production of knowledge* and art as *production of meaning,* plus structural discrepancy between linear thinking in science and non-linear (synchronous) comprehension, are leading us to a number of possible approaches and intersections between the two which may be tried out one by one or all together at the same time.

Being attracted by the ultimate questions–who we are, where we come from, and where are we going as humankind, artists and scientists are sharing the same field of metaphysical interest, but the way they approach these ulitmative questions are intrinsically different. If we are looking for a symmetrical relationship between artists and scientists, we should look for a relationship where the work of both are mutually inspirational. There are some mundane examples where scientists can be inspired by artworks and artists can be inspired by the scientific findings (sometimes still just concepts), but such inspirational premises are never really smooth and uni-directional. There might be a case of negative inspiration as well and also just an unscrupulous transposition of a scientific experiment into a gallery or another art context.

The relationships between Art&Science might be asymmetrical and abusive where artists are merely using knowledge, expertise, and tools that scientists can provide them with for an art project, while scientists, on the other side, can instrumentalize artists to draw and design visualizations of their findings to communicate their complex scientific results better.

In the art projects where artists are problematizing and criticizing the effects of scientific findings and technological applications on society, the science figures only as relational field. Artists are using materials, tools, and protocols that are typical for the phenomena caused by scientific agents, in order to be more precise in their thematizations. If I put it simply, artists can't use the oil on canvas technique when arguing about the effect that biotechnologies are having on the consumeristic ideology that proposes to design life as a product.

I might go on forever with descriptions of possible types of relationships between artists and scientists, but the format of this short text enables me to extend the whole discourse just inside this one-page essay. However, I believe, it is enough to underline the impossibility of the Art&Science term, since there is nothing that you can "point your finger at" and determine what Art&Science precisely is. If I wrap up, there is no such thing as Art&Science, but yet it is clear, that that dichotomy is producing extremely fruitful tensions. Exactly like theoretical psychoanalysis enables us to understand the functioning of non-existing relationships between the sexes, we should understand the dynamic intersections between arts and science and shouldn't be frustrated because we see how "out-of-sync" the two practices are. The whole axiomatic statement "There is no sexual relationship" has its rhetorical follow-up: "But yet it's functioning".

Jurij Krpan is a speaker at the *Prix Forum–Art and Science* and a member of the Prix Ars Electronica 2015 Hybrid Art Jury.

Art and Science Exhibition Part I

# HYBRID ART

As part of the annual CyberArts exhibition, showing the prize-winning works of the Prix Ars Electronica, a selection of outstanding art and science projects is being shown.

After the festival, these projects will move into the Ars Electronica Center as part of the *Elements of Art and Science* exhibtion or to exhibitions of the other network partners.

Detailed descriptions of these projects can be found in the CyberArts 2015, International Compendium–Prix Ars Electronica 2015

*Omote / Real-Time Face Tracking & Projection Mapping,* by Nobumichi Asai, Hiroto Kuwahara, Paul Lacroix

*Augmented Hand Series* by Golan Levin, Kyle McDonald, and Chris Sugrue

*PSX Consultancy* by Pei-Ying Lin, Špela Petrič, Dimitrios Stamatis and Jasmina Weiss

*Plantas Autofotosintéticas* by Gilberto Esparza

Drosophila *titanus* by Andy Gracie

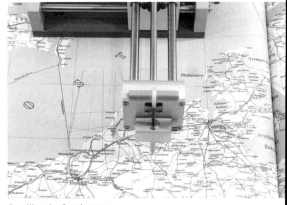

*Satelliten* by Quadrature

*Chijikinkutsu by Nelo Akamatsu*

*Mirage by Ralf Baecker*

*Teacup Tools by Agnes Meyer-Brandis*

*ReBioGeneSys–Origins of Life by Adam W. Brown,*
*Robert Root-Bernstein*

# Elements of Art and Science

Ars Electronica Futurelab, Claudia Schnugg

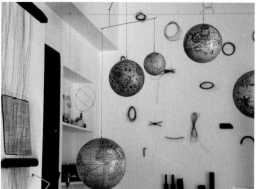
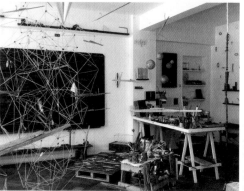

María Ignacia Edwards

## María Ignacia Edwards
# Mobile Instrument

María Ignacia Edwards works with equilibrium, lightness, and weightlessness of objects that she brings into balance by deploying their own weight or counterweights. Though, at first glance, her works are perceived as purely aesthetic, artistic objects, it soon dawns on those who behold them that these constructions are the result of elaborate mathematical and physical calculations. On one hand, the artist is inspired by astronomy; on the other hand, she aims to create works that get others interested in astronomy.

Based on her experience at the ESO observatories La Silla and ALMA, María created a "Mobile Instrument," as the artist calls it, which is able to capture the movement of pieces located at distant places by a musical mechanism as a reference to time and the motion of the universe.

This project has been realized within the European Digital Art and Science Network in collaboration with ESO and the Ars Electronica Residency Network.

*Catching the Light* is a moving image installation which explores how science and technology frame our experiences of the natural world.

Semiconductor (Ruth Jarman and Joe Gerhardt)
# A particular kind of conversation

In their art works the artist duo Semiconductor explores the fundamental material nature of our world and how we experience it through the lens of science and technology, investigating how devices mediate our experiences of nature and position man as an observer of the physical world. They combine methods of filming, animation, sound and dialogue; re-working and combining actual elements of the scientific language of particle physics (verbal, visual, aural, technological...) into new forms. This includes using actual particle physics data to generate cutting edge animations and working in such a way that the sound is born from the process of the particles being studied. Semiconductor make distinctive and innovative works which push the boundaries of moving image as a visual language. Always looking to extend man's experience of the natural physical world, their works delve into unseen worlds and create visual interpretations of these through self-developed technical processes and unique aesthetics. Their works transcend the tools that have been used to make them, instead creating new forms of expression that defy genre and provide new experiences for audiences.

Ann-Katrin Krenz, Michael Burk

# Kepler's Dream

*Kepler's Dream* is an aesthetical investigation, exploring obsolete projection technologies in combination with computationally created content that is given a physical shape through 3D printing. Mixing digital aesthetics—parametric and generative shapes—with the qualities of analog projection creates an otherworldly look. Interacting with the installation provokes a deeply immersive effect, as the instant reaction of the projection and the "infinite frame rate" let this fantastical world come to life. The installation lets the user explore an abstract, non-linear story, inspired by the *Mysterium Cosmographicum* of Johannes Kepler, who thought the geometrical basis of the universe could be explained in terms of the Platonic solids. Each of the elements (fire, water, earth, air) is represented by a body that transforms into parametric shapes and landscapes. Following the path of these structures back to the initial Platonic solids, one can find the conclusion in the all-connecting dodecahedron.

http://www.frau-krenz.de
http://www.michael-burk.de

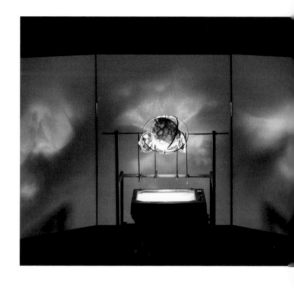

formquadrat

# D-Dalus: A New Way of Traveling

*D-Dalus* can do more than just fly, it can also start and land vertically, float, and turn on its axes.

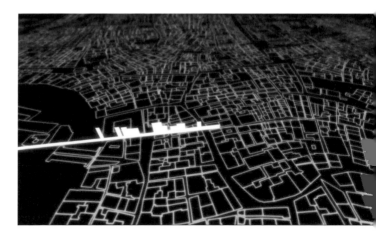

Cédric Brandilly
# Architectural SonarWorks

The aim of this project is to create a musical / audio language based upon cartographic statements and architectural characteristics which belong to a definite space. It also consists in imagining architecture as a partition. Each architectural element, each building has characteristics that can be turned into sounds. The determination of a musical language from a linear—from point A to point B—is made possible. For this project the artist does not capture urban sounds to broadcast them at a later date, but instead writes real musical scores using map data. At Ars Electronica *Architectural SonarWorks* will also be presented as a live performance by the artist.
*http://cedricbrandilly.com/*

IAAC—Institute for Advanced Architecture of Catalonia
# Minibuilders

The construction industry is wasteful and inefficient, slow to adopt technologies that are already well established in other fields, such as robotics. Robotics and additive manufacturing offer great potential for innovation within the construction industry. However, in their current form, these systems all share a specific limitation. The objects they produce are linked to and constrained proportionally to the size of the machine. This methodology for production and construction is not scalable. *Minibuilders* is scalable, it supplants one large robot for a number of smaller agile robots, that work together effectively towards a single outcome.
*http://robots.iaac.net/*

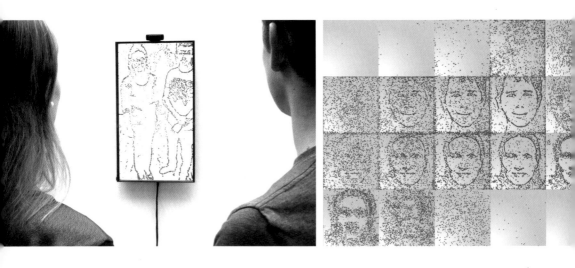

## Laurent Mignonneau and Christa Sommerer
# Portrait on the Fly

*Portrait on the Fly* consists of a series of interactive portraits and plotter drawings. The work was inspired by Guiseppe Arcimboldo's fantastic composite heads from the mid 15th century. Roland Barthes maintained that the artist was doing something akin to scientific research when he painted those portraits, as they were composed of many details taken from zoological and botanical specimens. He also believed that the artist thereby experienced a kind of artistic freedom and took pleasure in the depiction of lurid and monstrous elements.[1]
For the series *Portrait on the Fly* Sommerer and Mignonneau modeled virtual insects that can align themselves so as to compose human portraits in real time. The interactive version consists of a monitor that shows a swarm of a few thousand houseflies. When a person positions him/herself in front of it, the insects try to detect his/her facial features and then begin to arrange themselves so as to reproduce them, thereby creating a recognizable likeness of the individual. Within seconds the insects invade the face, but even the slightest movement of the head or of parts of the face or body drives them off. The portraits are thus in constant flux; they construct and deconstruct, they are living systems[2] and depend on interactions with the subjects.[3]
*Portrait on the Fly* also exists in the form of a series

of plotter drawings and as short video sequences. Snapshots of the digital fly portraits are printed out in the style of 1960s plotter drawings. Ephemeral moments of interaction are thereby secured as original illustrations. The first of these artworks is an autoportrait of Sommerer & Mignonneau. The growing series includes portraits of important media art experts, theorists and artists, such as Frieder Nake, Mark Wilson, Hans Dehlinger, Edmond Couchot, Marie-Hélène Tramus, Hannes Leopoldseder, Christine Schöpf, Peter Weibel, among many others. The aim of this installation is to conserve images as well as video sequences of the historic figures who are involved in media art–an ephemeral field that is characterized by novelty and change.

Laurent Mignonneau and Christa Sommerer are represented by DAM Galerie Berlin, Galerie Charlot Paris and Galerie Peithner-Lichtenfels GPLcontemporary Vienna.

1 Ferino-Padgen, S. (2007). Giuseppe Arcimboldo: Court Artists, Philosopher, "rhétoriqueur", Magician or an Entertainer? . In S. Ferino-Padgen (ed.), *Arcimboldo 1526–1593*. Milan: Skira Editore and Vienna: Kunsthistorsches Museum.
2 Sommerer, C. and Mignonneau, L. (2015). Art as a Living System (Excerpts), In E. A. Shanken (ed.), *Systems– Documents of Contemporary Art Series* (p. 172–175). Massachusetts: MIT Press,
3 Rancière, J. (2009). *The Emancipated Spectator.* London: Verso.

Yasuaki Kakehi

# Transmart miniascape

*Transmart miniascape* is an art installation for displaying volumetric images that blends in with ambient surroundings. This piece consists of 8 transparent sheets of glass arranged in layers at regular intervals. The work is installed in a well-lighted area, especially in the sun. Technically, this system is a non-luminescent volumetric display that etches the shapes of volumetric images in 8x8x8 pixels on the sets of glass. In this work, varieties of sceneries appear like a miniature garden. To be more exact, a volumetric animation expressing a cycle of the seasons is repeated. Owing to the high transparency of the glass, audiences can also see the actual scale of natural sceneries through the miniature garden. Furthermore, this work changes its appearances according to ambient light conditions even if we play the same animation. For example, the pixel contrast changes according to climate conditions. If it is dusk, the pixels develop orange contrasts to the sunset. Through the pixels, we can observe and be

aware of slight differences in the ambient environment and beauties included in them. Moreover, the display switches images interactively by responding to the positions and movements of audiences' hands held in front of it. They can control images and sounds, actively like playing a theremin.

Jonathan Keep

# Seed Bed
3D printed ceramics

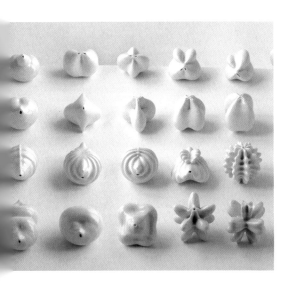

Nature—not objective nature out there but subjective, universal nature within us all, artist and viewer, is what my work is about. The *Seed Bed* relates to the fundamental concept of evolutionary morphologies but also creative growth. Generated in computer code my working method lends itself to altering the code to make related and evolving shapes. Being able to 3D print these unique and individual forms directly from the computer in clay represents the strength of this technology and fulfills my desire to explore the possibilities of ceramic form. My interest is in how at a basic evolutionary level we respond to natural forms. We have an inbuilt propensity towards natural forms and patterns, such as curvature, repetition, and symmetry because we are part of that same natural world. For me art and science are inexplicitly linked.

*http://www.keep-art.co.uk/*

Nick Ervinck
# VIUNAP

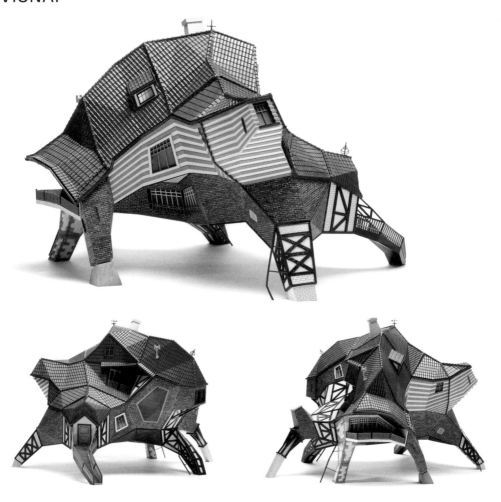

The *EGATONK* project was developed for the exhibition *Horizon 8300* in Knokke, promoting new architecture for this Belgian seaside town. Zaha Hadid presented a complete new vision for the train station that was in high contrast with the usual white cottage "obligations" in this town.

Nick Ervinck was invited to contribute an artwork to the exhibition. As a starting point Nick Ervinck uses traditional cottages, which he turns into absurd buildings. The cottages become figures with connotations to crabs and other sea animals that walk along the beach, resembling the impossible structures in the engravings of the mathematician Escher (1898-1972). Their double identity, both building and animal, also relates to the well-known duck-rabbit image puzzle that challenges our way of seeing and interpreting. *VIUNAP* is a 3D print of one absurd building initially presented as 2D wall print.

Photo: Peter Verplancke

# Nick Ervinck
# Selected Works

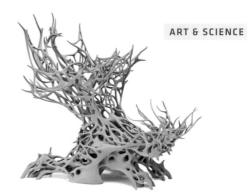

## ELBEETAD

As *ELBEETAD* is a 3D print inspired by the voluptuousness of the so-called "Rubens woman," it brings into question the "skin" of the sculpture.

Photo: Peter Verplancke

## AYAMONSK

*AYAMONSK* is derived from vegetable structures and coated with a glossy varnish which in turn refers to the virtual genesis of this form. This sculpture seems rooted in the ground, and therefore focuses attention on what is invisible, but lurks beneath the surface.

Photo: Luc Dewaele

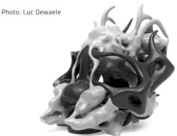

## NIKEYSWODA AND GARFINOSWODA

*NIKEYSWODA* and *GARFINOSWODA* (2011–2012) seem made out of two components but are printed as one entity. The blue smooth form almost embraces the yellow explosive structure. This combination evokes a dynamic, yet tense liaison, a symbiotic wrestle fought to control the physical space.

Photo: Peter Verplancke

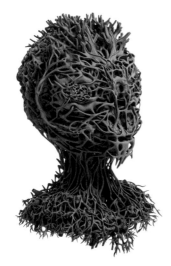

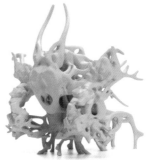

## AGRIEBORZ

For *AGRIEBORZ*, Nick Ervinck used imagery of human organs that he found in medical manuals as construction materials to create an organic form, a larynx (or voice box) "gone wild." Though imaginary, *AGRIEBORZ* seems to retain some familiarity due to its visual connection to human organs, muscles, nerves, etc.

Photo: Luc Dewaele

## BORTOBY

*BORTOBY* is clearly animal-like, but is impossible to define well. One can see a lion-like body, crab-like legs and devils, but also a transformer robot or a monstrous creature.

Photo: Luc Dewaele

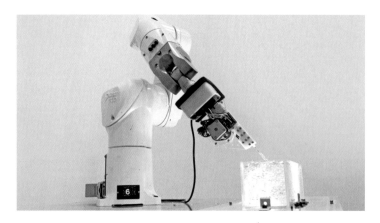

Brian Harms
# Suspended Depositions

*Suspended Depositions* is a novel rapid prototyping approach that aims to blur the line between processes of design and fabrication. The ubiquitous FDM (Fused Deposition Modeling) printing methods we are now so familiar with heavily rely on the presence of support material. Constructed layer-by-layer, typically in the same material as the printed object, this support material is tediously broken off bit by bit and thrown away as waste material. *Suspended Depositions* takes a very different approach, by injecting a continuous stream of UV-curable liquid resin into a viscous gel. With this method, the support material is always present and never wasted. A "print" does not need to be formed layer-by-layer, and can instead be "drawn" in 3D within the gel. In addition, any injected resin remains suspended in the gel in liquid form until it is cured with UV light. Because of this, the creation of objects can be "un-done" by extracting resin before the curing process.
*http://nstrmnt.com/*

Dana Zelig
# Traces

The project explores the concept of programming everyday materials, a form of "physical programming", where objects are "made to act" on some form following specific instructions. To explore this idea, Dana developed 12 processed-folding objects, using custom built software in processing and various physical techniques—printing, twisting, laser-cutting, knotting, and framing. Both the digital tools and the physical techniques were used systematically in order to explore spatial, structural & geometrical conditions, leading to the emergence of prototypes.

Julian Melchiorri
# Silk Leaf

In a period where global carbon emission and urbanization are growing exponentially, the need for creating sustainable solutions for the indoor and outdoor urban environment arise. Melchiorri's interest in natural phenomena and the recent scientific discoveries in biology and materials science enables him to explore the potential for creating photosynthetic materials aiming to bring the efficiency of nature into the man-made environment. Inspired by natural mechanisms and physical phenomena, Julian Melchiorri conducted laboratory experiments in order to explore the potential for making materials that photosynthesize, and their possible applications. *Silk Leaf* is the first result of this research. It is a modular device that photosynthesizes, made of a biological material mostly composed of silk protein and chloroplasts. It absorbs carbon dioxide, major reason of global warming, and produce oxygen only using water and light. Julian Melchiorri develops socially and environmentally sustainable biological and reactive materials that improve and stimulate our lives, our indoor, and our outdoor urban environment.

*http://www.julianmelchiorri.com/, http://www.arboreia.io*

FIELD
# Quasar

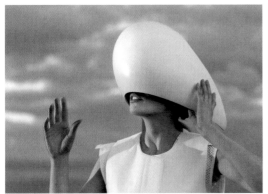 

*Quasar* explores visions of a near future and what it will mean to be human.

exonemo
# Body Paint
Mixed media (Acrylic paint on LCD display, video imagery)

To us smartphone-addicted contemporaries, to connect to the Internet at all times and in all places is to become a complete person. This work uses body painting to examine our physical definitions, our physicality, in a world of networked information devices.

Each work in this portrait series features a person, nude, shaved, and painted entirely in a single shade of color, displayed on an LCD that has been entirely painted in the same color except for the human subject on the screen. The boundaries between background and foreground are erased—a human body and an electronic display body are both covered in the same color paint—and the works evoke the themes of ambiguity and confusion, and whether the individual depicted is a human being or a picture of a human being. Apart from these formalistic aspects, this work also deals with issues of "existence" within media. The human body has a fairly well understood longevity horizon, but the longevity horizon for data, for paint, and for art remains open to debate. The multiple time scales of body art, figurative painting, and media art engage with one another as the work seeks common ground for the present, and for existence itself.

Supported by Japan Foundation

ZEISS

# ZEISS VR ONE

The ZEISS VR ONE is an innovative device that allows us to take our novel steps in the world of virtual reality. Its lightweight design, high quality optics, and 100% portability make it the perfect companion for videos, games, and augmented reality.

VR ONE is the first and only VR headset that is made with a leading-edge optical design and ZEISS precision optics. When you put on a set of VR goggles you get the premium experience you expect.

With the VR ONE, the smartphone you carry in your pocket can take you to worlds of virtual and augmented reality. Compatible with many smartphones and hundreds of apps made for mobile VR devices, you can simply download and launch the app, lock your smartphone in the VR ONE precision tray, and slide it in the VR ONE. Experience VR games, videos, and amazing experiences that were never before possible.

Text and photos: *zeissvrone.tumblr.com, vrone.us*

# VIENNA 3000
## Can you see the Superfuture?

*Vienna 3000* was a 3rd year architectural design studio run by Hannes Mayer and Daniela Herold at the Institute of Art and Architecture, Academy of Fine Arts Vienna. Dissatisfied with the reality of architecture as well as urban planning, the studio was driven by the ambition to explore the radical uncertainty of the far future. Students were invited to develop individual trajectories into the unknown and encouraged to develop design projects that embody the potential to question our beliefs and standards of today. Funded entirely by the City of Vienna, the studio placed great emphasis on planning scenarios for the Austrian capital.

For the 20th Century the year 2000 was synonymous with future, motivating daring thought. Yet little time passed and the new millennium showed serious signs of teething troubles. 9/11 exposed the vulnerability of the superpower of the 20th century, marking an end to experimentation and irony, heralding an age of renewed puritanism. The financial crisis put further pressure on many Western countries. More recently, promising signs of a turn towards more liberal societies in the Arab world were replaced by civil wars and political oppression. Even the gold rush in China and the Emirates has lost its strong appeal, Russia has tumbled into isolation. In Europe, German Sparsamkeit and English austerity have set the tone while the southern countries are still on the brink of bankruptcy.

While architecture is highly dependent on money, conceptualizing both architecture and the city within an academic realm should allow for freedom and optimism as an alternative to the outer gloom. However, obsessed with the idea of turning our thoughts into buildings quickly, the reality of restrictive budgets permeates the criteria for design reviews. Thus, a condition no one welcomes starts to define the future. "Adequate" and "appropriate" become words of appraisal without clarifying their reference. We should ask: If we judge our thoughts by the condition of today, are they adequate for the condition of tomorrow?

The City of Vienna defines its future of the built environment on two levels: Its urban master plan called *Step 2025* and its overarching strategy *Smart City Vienna* with its target year 2050. Development and change are frequently defined by targets and percentages. Therefore, is 2050, being only 35 years ahead of us, too close to break from the thinking in increments? Whether 3% or 15% of all cars are electric and therefore emit neither noise nor pollutants makes a difference to the environment but little difference to the built environment. But should all cars suddenly fall silent, the city will change.

While we can debate whether this will happen by 2050 we can be certain that the world will be a different one in the year 3000. Vienna of the far future will always remain hidden to us. Yet, if we start to speculate, no one will prove us wrong for the next 984 years. Enough freedom to go and make the most out of our creative energy.

Text: Hannes Mayer

Anna Krumpholz
**A Land of Honey**

The citizens of Vienna—naked and without possessions—live in honey shelters. The whole city fabric consists of a semi-organic thread structure that produces and evaporates honey plasma. The plasma exists in gaseous and gel form and accumulates softly on the body, responding to individual sleeping patterns. Thus, Vienna is a city of constantly changing shape, always growing and shrinking.

Cenk Güzelis
**Queer City**

What if our body would not have to limit itself to a specific time and space? Liberating the body: dissolving boundaries and limits, departure from horizontal linearity. What are the consequences for the urban fabric? What does the condition of "in space" mean?

A vertical movement is introduced to the idea of space and city, placing emphasis on the space in-between, the space where people meet and interact. Dynamics of a future urban reality between order and disorder. Frozen for display.

Clemens Aniser & Wolfgang Novotny
**Urban Stimulus**

*Urban Stimulus* is the description of an artificial paradise driven by the stimulation of senses and sensations, envisioning an urban future based on perception.

*Urban Stimulus* is recording and storing sensorial data, distributing information like radiant visuals and vibrating sounds; vaporing essences of aromatic memories via haze and mist; achieving tactile diversity through its ever changing surface and skin, shifting from oily to rough, hairy to hard, constantly blurring the borders between object and subject until they merge and create a complex unity.

Helvijs Savickis
**Time Capsule—a nuclear waste information center**

In the year 3000 the safe storage of nuclear waste will remain a challenge even if the use of nuclear energy has stopped. To highlight the danger of buried nuclear waste around the world a nuclear waste information center is built in Vienna—seat of the IAEA, International Atomic Energy Agency. An impressive underground space functions as a time capsule whilst also open to the public—safeguarding the continuity of knowledge about a major threat to humanity.

Matea Ban
**Welfare State 3000**

*Welfare State 3000* displays a social housing unit for hybrids between animals and humans. It is built at a time when men and animals are all the same and DNA engineering has sufficient power to modify the human genome. People acquire major animal attributes like flying or a much-prolonged life span and require appropriate accommodation. Five cross species live in a hybrid habitat, the so-called "unity of architecture and landscape". Hybrids between ladybirds, elephants, anacondas, crocodiles, seagulls and humans reside in this housing estate.

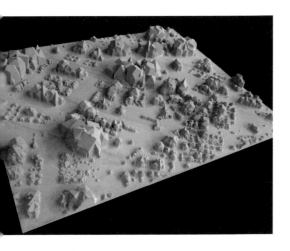

Michael Glechner
**Enlightened Being**
**Vienna as an energetic dynamic reality**

Due to evolution human beings have developed abilities to handle energy more directly. They can survive on absorbing energy that light and atmospheric vibrations emit. The properties of the city have changed accordingly. Light has become the major driver of a constantly changing urban planning process. Consequently, architecture is adaptive too. Matter and energy cannot be seen as separate anymore. Like nature, architecture depends on light conditions. Where there is light, there is life and the potential for urban development.

Sasha Konovalov
**Memento**

The *Memento* project is dedicated to help find digital versions of reality that existed at some time in the past. These prior versions are called Mementos, and can be found in spatial archives or in systems that support versioning. *Memento* is a digital archaeology project that reconstructs virtual artifacts from the present time—in this case glitches from google earth—mistakenly understood as the past reality by the future inhabitants of our planet.

Marlene Lübke-Ahrens
**Movements**

In the far future any need for action has disappeared. Movement is pure leisure. Without the need for transportation infrastructure, the planning of the city is driven by notions of pleasure and experience. The bicycle has a renaissance as the ideal object for a pleasure ride and to retain the wellbeing of an otherwise passive society.

Art and Science Exhibition Part III

# Spaceship Earth

This exhibition consists of a scientific educational part showing some of the most beautiful satellite images of the Earth, curated by ESA, along with some interactive terminals providing the scientific background information. Several examples of artistic works with satellite imaging and historical references to the field comprise the second part of this exhibition.

**The artworks presented are among others:**
*G-Player*, Jens Brand
*Watching the Watchers*, James Bridle
*ARTSAT1:Invader*, ARTSAT: Art and Satellite Project

*Spaceship Earth* is a co-production by ESA and Ars Electronica Center.
Additional content provided by: Catalysts, EOCD
Co-curators: Robert Meisner, ESA; Kristina Maurer, Ars Electronica
Production managers: Kristina Maurer, Pascal Maresch, Stefan Rozporka
Educational program and text editing: Nicole Grüneis, Maria Pfeifer
Exhibition design: Gerald Priewasser
Implementation and production: Ars Electronica Solutions
Special thanks to Christian Federspiel from Catalysts.

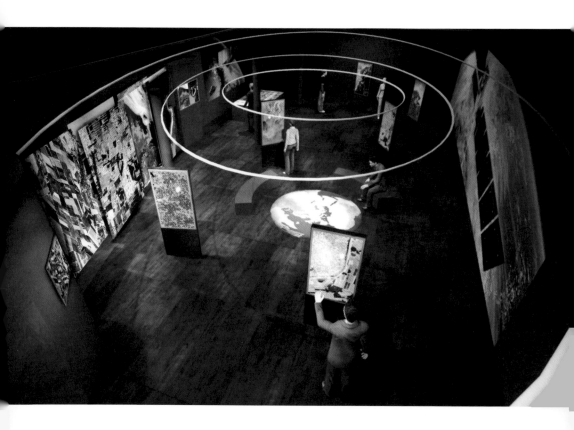

Eyjafjallajoekull Ash Plume, Iceland, Envisat (MERIS), ESA

# ESA–European Space Agency

Ever since the first satellites were developed in the late 1950s, their watchful eyes have been providing us with information about the state of our planet. How fast are glaciers melting? When is the best time for a farmer to plant and harvest his crops? What can be done to improve civil security after a disaster like Fukushima or the recent earthquake in Nepal? Modern Earth observation technology is even advanced enough to provide an extensive view of what's going on beneath Earth's surface, allowing us to make predictions about geographical, geological and atmospheric developments. This information can be used to steer us in the right direction when making decisions that affect the state of our natural habitat. The European Space Agency has made the monitoring of our planet one of its top priorities through the Agency's Earth Observation Programme. The Sentinel satellite missions aim to provide comprehensive, long-term insights into all aspects of our environment, while the Earth Explorers are smaller missions dedicated to specific research projects as well as tracking areas where certain environmental issues are of immediate concern. Meanwhile, the Meteosat weather satellites are dedicated to gathering continuous meteorological data of Europe, Africa and parts of the Atlantic and Indian Oceans.

Términos Lagoon, Yucatán Peninsula, Mexico
Landsat-8, USGS/ESA

Mississippi River Delta, USA
Landsat-8, USGS/ESA

ESA's satellites help us in our everyday lives—whether it be predicting the weather, the continuous surveying of expanding urban areas, ocean surface monitoring or the detection of wildfires. By observing Earth from space, ESA aims for a better understanding of our environment in the long run, as well as provides guidelines for implementing positive changes to the way we treat this planet we call home.

The fine line between the marvel of seeing our world from above by way of a satellite images and the often devastating implications of these same stunning pictures—regarding issues such as deforestation, spreading desertification, water and air pollution, radiation levels or melting glaciers—have been the starting point of ESA's prior exhibition projects surrounding the topic of Earth observation. For Ars Electronica, which since its birth in 1979 has been concerned with the influence and impact of cutting-edge technologies on society and our everyday lives, cooperating with ESA on *Spaceship Earth* opens up a discussion around the theme of satellite observation. The festival audience, as well as visitors to the Ars Electronica Center year round, gain an insight into the benefits and research findings of Earth observation which go beyond the widespread conversation involving satellites, often centred on military surveillance, espionage or telecommunications. Examining the satellite as an evolution of earlier techniques of mapping and cartography, *Spaceship Earth* strives to underline the depth and wealth of information about soil moisture, crop yields, land cover, the ocean surface and coastal areas, water quality, air quality, ozone and solar radiation, climate change and vegetation monitoring, which can be gathered by making use of the satellites' unique viewpoint and their ability to delve under Earth's surface with a multitude of high-tech instruments. *Spaceship Earth* positions the satellite image at the core of its attention, focusing primarily on the knowledge gained from interpreting these pictures without disregarding the highly advanced machinery used to procure them. The exhibit unfolds in a spatial concept meant to evoke satellite orbits,

with installations arranged on a system of ellipses spread throughout the exhibition space. Large-scale, movable prints of satellite images serve as the introduction to the exhibit, confronting the visitor with beautiful, compelling, yet at the same time abstract and elusive pictures which evade immediate interpretation and whose subjects at first sight don't seem to correspond to any existent place on this planet. Interaction with a monitor in the vicinity provides detailed information about the print and offers examples of similar areas on Earth. Without disregarding the aesthetic qualities of the satellite images, the exhibit forces the viewer to look beyond this surface layer, showing how different aspects of our environment such as agriculture, forests, deserts, water bodies or urban areas are represented by satellites.

An elevation model of Linz and Upper Austria, spreading all the way to the Alps and the Großglockner area is also featured. A table of small 3D-printed objects is connected to the model, the objects triggering projections on landmarks of the area, traffic, air quality and land cover. Rather than being centred on the aesthetic experience, the elevation model focuses on the workings of the satellite in a much more concrete way, showcasing the functionality of sensors such as infrared or radar, introducing the multispectral instrument and its varieties of optical data, and showing how satellite data are used to develop elevation models.

A global perspective on the theme of Earth observation then dominates the centrepiece of the exhibition. Surrounding a representation of the main subject of the entire exhibit—a model of Earth in the form of a large projection—monolithic revolving steles representing the continents place the satellite images on the map and provide more background information with thought-provoking questions and associating them to the story behind each picture. What leads us to continuously develop these highly advanced satellites and turn our attention firmly inwards, towards our own habitat, rather than outwards toward the great unknown? *Spaceship Earth* aims to provide answers to this very question.

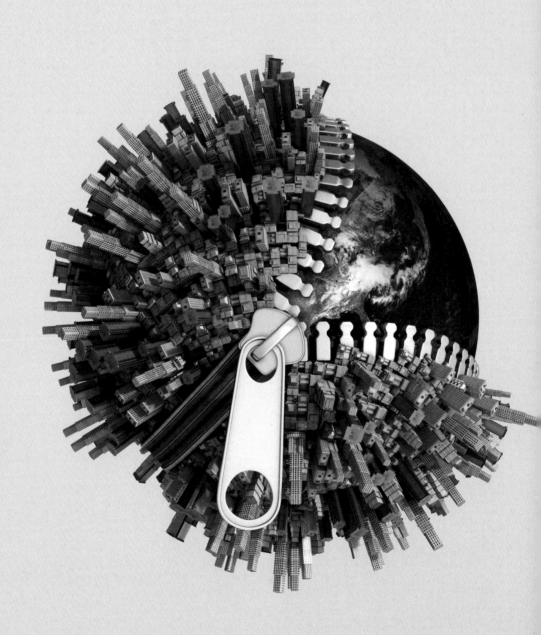

# EXHIBITIONS & PROJECTS

Néstor Lizalde, Félix Luque & Íñigo Bilbao, Pablo Valbuena

# The NAKED VERITI Project

The *NAKED VERITI* project, realized by the Spanish artists Néstor Lizalde, Félix Luque & Íñigo Bilbao, and Pablo Valbuena, uses memory, interaction and light, and composite and manufactured parts to express feelings and thoughts about technological art at the Ars Electronica Festival 2015. The "naked truth" from the silent, painstaking and methodical work of representatives of the new creative and artistic wave from Spain, who build a reality for a specified time frame and strive for permanence in the collective and critical memory. Not restricted by

a specific topic, each of them is absolutely free to create their own individual work that expresses their own artistic language and materials.

Project Manager, Producer: Javier Galán
Technical Chief: Gustavo Valera
Exhibition Design: Anna Biedermann
Supported by: Spanish Ministry of Culture, Education and Sport, AC/E Acción Cultural Española, Ars Electronica
Co-Producers: ETOPIA Center of Art and Technology, Spain; Secteur Arts Numériques, Fédération Wallonie-Bruxelles, Belgium; Arcadi Île-de-France, France

Félix Luque & Íñigo Bilbao

# Memory Lane

*Memory Lane* is a series of sculptures and audiovisual works that depict the artists' important childhood places. Uptake by 3D scanners and data processing generate a fusion between real environments and their virtual replicas, where some elements appear clearly defined, while others are blurred and merge; light behaves atypically, solid becomes incorporeal and the laws of physics are disrupted. Places are not merely represented—for memories can be distorted— and a surreal atmosphere exists. When reproducing the sets of children's games of the authors, the work seeks to recover the joy and excitement of those

moments, which, by having a visionary and dreamy nature, awakened their interest in artistic creativity.
*http://www.felixluque.com/*
*http://ibl3d.com/*

Design: Damien Gernay
Arduino programming: Vincent Evrard
Mechanical design: Julien Maire
A coproduction of the Spanish Ministry of Culture, Education and Sport; Secteur Arts Numériques, Fédération Wallonie-Bruxelles, Belgium, and and Arcadi Île-de-France, France. With the support of iMAL (FabLAB)

Néstor Lizalde
# Pii

*Pii* relies on the development of an interactive sculpture by using sets of mirrors, matrices of light and different types of sensors that analyze the environment to computationally generate a light response, thereby creating a variable work that interacts with the audience and its environment. The work explores the aesthetic possibilities arising from the meeting between technological elements with analog visual effects achieved by controlled reflections with calibrated mirrors, enabling the luminous body to expand simulating an infinite spatial depth. The combination of these analog and digital systems creates a variable and reactive sculpture.
*http://www.nestorlizalde.com/*

Builder and Developer: Guillermo Malón
Audio Samplers Composer: Kim Fasticks
A production of the Spanish Ministry of Culture, Education and Sport. With the support of ETOPIA Center of Art & Technology, Zaragoza, Spain

Pablo Valbuena
# Time Tiling
Site-specific intervention, video-projection on architecture

"Architecture is not a synchronic phenomenon but a successive one, made up of pictures adding themselves one to the other, following each other in time and space, like music."

<div align="right">Le Corbusier. Modulor I.</div>

Architecture is a prolific field for patterns in a diverse range of scales: street pavements, tiles, modulated facades, standardized measures or city grids are good examples of a certain sense of order. Order is also present in time-based structures like language,

film or music. The rules organizing both levels of order are equivalent, revealing links between still structures and the ones in motion. This site-specific project brings to light a tiled room exploring the intersection of architectural systems and time-based structures.

*http://www.pablovalbuena.com/selectedwork/time-tiling-stuk/*
*http://www.pablovalbuena.com/*

A production of the Spanish Ministry of Culture, Education and Sport.

Summer Sessions Network / V2_Institute for the Unstable Media

# Summer Sessions

Pop-up Exhibition and Event feat. Johannes Langkamp,
Roel Roscam Abbing, Mate Pacsika, Carina Hesper

*Summer Sessions* are short-term residencies for young and emerging artists, organized by an international network of cultural organizations. Each summer, the partners that participate in this network for talent development collaborate to offer professional production support and expert feedback to artists in the realization of a new artwork or design. Local talents from each partner's geographic region are scouted and selected for a residency abroad, where they are offered highly productive atmospheres and specific kinds of expertise at one of the international partners in the international network. This collaboration does not only result in the development of a large number of new projects in a relatively short period, but also provides the participating emerging artists with an international experience that helps them jumpstart their art and design practice.

The *Summer Sessions* pop-up exhibition at the Ars Electronica Festival 2015 shows a selection of outcomes realized through this international exchange of emerging talents. While the pop-up exhibition illustrates the kind of results that this pressure cooker residency format results in, the live event at the Ars Electronica Festival highlights the experiences that participants had abroad, and the effects these experiences have had on their early careers.

By doing so, V2_Institute for the Unstable Media, the initiating partner of the *Summer Sessions* network, wants to inform ambitious early-career artists about the opportunities that the international network for talent development offers, and reaches out to other cultural organizations with an invitation to join the network. Furthermore, the pop-up exhibition introduces the Ars Electronica Festival audience to a selection of promising emerging artists who have participated in the network. The event will close with an informal drink to continue conversations about the opportunities for young artists and cultural organizations within the Summer Sessions network for talent development.

This event will also form a meeting point to discuss how to strategically further develop these international opportunities for emerging and young professionals amongst past and present partners of the network, which include Chronus Art Center (China), the National University of Tres de Febrero (Argentina), the National Taiwan Museum of Fine Arts (Taiwan), PNEK (Norway), BALTAN Laboratories (the Netherlands), Revolver Galeria (Peru), LABoral (Spain), the Canadian Film Center (Canada), iMAL (Belgium), TASML (China), SAT (Canada), and Harvard Medical School (USA).

This program is made possible with the generous support of the Creative Industries Fund NL.

Johannes Langkamp
## Analog Sun Tracking

Johannes Langkamp developed *Analog Sun Tracking* in 2013, during a Summer Sessions residency at Chronus Art Center in Shanghai. The device he developed during his residency allows a camera to mechanically track the path of the sun. The resulting video displays a 24 hours time-lapse of the optical movement of the sun. The video thereby reverses our point of view in relation to the sun: From our normal point of view, the star at the center of our solar system moves continuously, which is why we say it "rises" or "sets", even though we understand that it is actually the earth that is moving around the sun. *Analog Sun Tracking* corrects this visual illusion we tend to accept on a daily basis.
*http://joway.eu*

Roel Roscam Abbing
## Border Check

As one surfs the Internet, data packets are sent from the user's computer to a target server, hopping from server to server until they reach the desired website. In each of the countries that the packets pass through, different laws and practices may apply to the data transferred, which influences whether or not authorities can inspect, store, or modify the data. *Border Check* is a browser extension that maps how your data moves across the Internet's infrastructure while you surf the web. It shows through which countries and networks a user 'surfs' when browsing the Internet, thereby emphasizing the physical character of the Internet and the political realities that come with it.
*http://www.bordercheck.org*
*http://joway.eu*

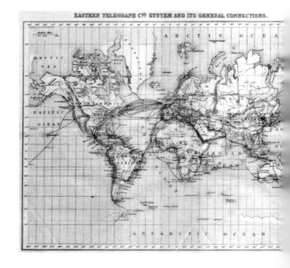

Carina Hesper
## Portrait Series

*Portrait Series* is a series of interactive portraits developed by Carina Hesper during the Summer Sessions of 2012. The interactive portraits play with the gaze of viewers when looking at an androgynous model portrayed in a style reminiscent of portraiture in classic oil painting. Many of these paintings give the viewer the impression that the character portrayed is always looking at you; in *Portrait Series* they actually do.
*http://www.carinahesper.nl*

Máté Pacsika
## Vertigo System

*Vertigo System* is the 2014 Summer Sessions residency project developed by Máté Pacsika at Chronus Art Center, Shanghai. The project attempts to automate the cinematographic technique known as the *Vertigo Effect*, named after Hitchcock's famous 1958 movie. The installation *Vertigo Effect* is a relatively simple in-camera effect with a strong emotional impact, which is why it is widely used in film to emphasize the drama of events in a storyline. Automating this event translates this effect into a real-time process, which suddenly transfers one to a frightfully different reality that results in an elementary feeling of subconscious distress.
*http://www.kupiczacola.com*

NOPER + SAINT MACHINE

# Feed Me

*Feed Me* is an interactive multimedia project created in 2014 by Romanian artists NOPER (Radu Pop) and SAINT MACHINE (Marilena Oprescu Singer). With a self-ironical approach, the project is calling the subjects of the monstrous and perpetually insatiable Tra to her feeding ritual. The entire exhibition takes place in the *Womb of Tra*, a giant cocoon-shaped sensorial capsule created by SAINT MACHINE, that can pulse, change color and give you sound feedback as you approach and enter it. Inside the womb everything moves and reacts to motion on a common rhythm. Feeding Tra is very much like making a ritual journey; she swallows her visitors through the input opening and vomits them, transformed, through the output orifice. The exhibition space is structured in narrowing concentric circles, creating worlds that include each other and cocoon around a magical protection space, thus the public is activated on several levels. Once you immerse into the womb, *The Secret Memories of Noper*, seven 2.5D animation movies called *The Fool*, *The Magician*, *The Empress*, *The Emperor*, *The Hanged Man*, *Death*, and *The Star*, break the organic substance of the cocoon and urge you to pass through into an eerie world of repetitive sequences beyond time and space. However, the interaction with them is deceptive; while they feed on your attention, they only feed you back with hallow symbols. Around the seven portals of Noper, *Womb of Tra* formed some scar tissue, called *Innerform*, through which you can communicate—a network of tubes that demand that you feed it with your whispers and amplifies them. In the middle of this organic world, lies the *Sacred Egg*, an interactive egg-shaped installation by SAINT MACHINE that invites you to offer your head, swallows it, and feeds on your energy to return to life. After connecting your head to its orifice, you are able to determine the actions of the artwork and become part of it. Insatiable Tra sucks your attention through your head and only breathes as long as you stay connected, leaving you voided of individual will and responding only to her needs, your body hanging beheaded from the giant egg.

*http://www.feedmeritual.ro*

Concept and illustrations: NOPER (Radu Pop) & SAINT MACHINE (Marilena Oprescu Singer)
Music: Mitos Micleusanu
3D modeling and animation: Reniform (Sergiu Negulici)
Animation: Tudor Calnegru
Software engineer: Marius Farcas

Project created by Artmix Cultural Association with the support of: ARCUB – Bucharest Municipality Cultural Centre; Romanian Cultural Centre; RKI WIEN – Romanian Cultural Institute Vienna; AFCN – Administration of the National Cultural Fund

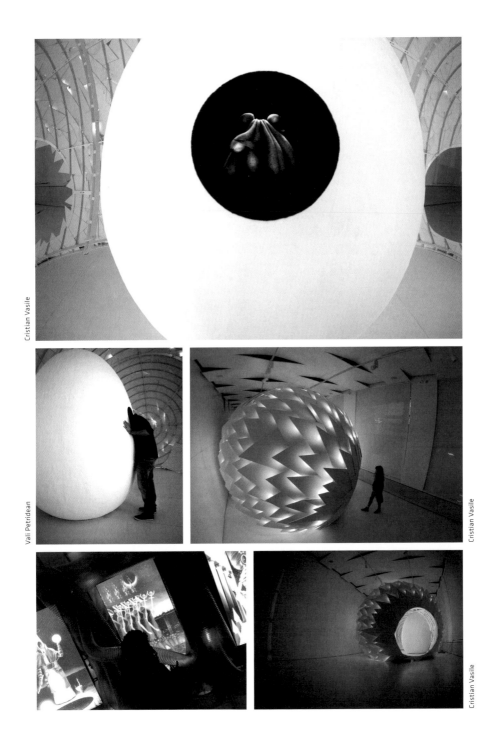

Cristian Vasile

Vali Petridean

Cristian Vasile

Cristian Vasile

**European Commission**

# So similar

## so different

# so European

Did you know that as a result of successive enlargements the **EU is the largest economy in the world**, with more than 500 million citizens?

The **EU's enlargement policy** aims at preparing for membership those European countries that aspire to join the EU. Albania, Bosnia and Herzegovina, the former Yugoslav Republic of Macedonia, Kosovo*, Montenegro, Serbia and Turkey are **candidates or potential candidates**.

* This designation is without prejudice to positions on status, and is in line with UNSCR 1244/1999 and the ICJ Opinion on the Kosovo Declaration of Independence.

**GROWING TOGETHER**

Enlargement Negotiations

Want to know more?
**ec.europa.eu/enlargement**

# So similar, so different, so European

Under the title *So similar, so different, so European* the European Commission's Directorate-General for Neighbourhood and Enlargement Negotiations initiated a campaign in order to foster intercultural exchange and raise awareness in the field of enlargement policies. The projects welcome you on a journey through the Western Balkans and Turkey.

Robert Pravda
## Monoid a.k.a. My New Speaker
**kinetic speaker installation**

*Monoid* is a kinetic speaker installation based on the construction principle of a gyroscope, with 360° freedom of rotation on three axes as a sound object and a static microphone as the "ear" of the space. The relationship between the sound source—in this case the moving speaker as the sound object—and the space is explored in a form of a dialog. Noise bursts, rising and falling pitched sound, and text fragments taken from a poem by Brion Gysin are projected in all possible directions in the space. The microphone listens to the reflections of the sound and feeds back information to the speaker, influencing it and adjusting its behavior. This enhances/alters the visitors' spatial and sonic experience. The

properties of space and the kinetic properties of the installation are the basic ingredients of the composition for this spatial-auditory experience. The sonic experience of the space is characterized by the interference patterns of the projected sound waves, and the timbre (color) of the sound is determined by the room itself and the speed of the sound source movement. This sound installation is a part of an ongoing research project on sounding space and spacing sound.

Concept, composition, and design: Robert Pravda
Construction: Quirijn Smits, Niels Steigenga, and Robert Pravda

**219**

Kokrra.tv
# Momentum
**Motion Graphics and Photography**

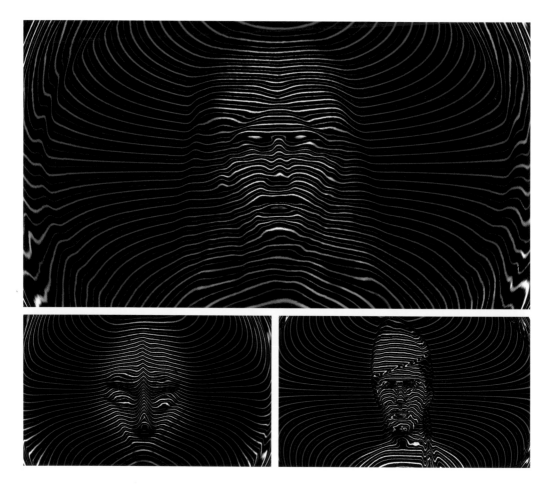

The video portrays the journey of Albanian women in society, or rather, in the heart of the "organism" of our people. From matriarchy 6,000 years ago to the idealization of women in Neolithic symbols and Queen Teuta, the role of women in society diminished—almost sinking into oblivion. However, the Albanian National Renaissance, Dora d'Istria, and Shote Galica have done much to restore the importance of women in our collective social lives. This video highlights the crucial work of five women who play a key role in building a vital history for this organism we call the people. More than 40 people at TEDx Prishtina Women—an event that celebrated innovative women, great thinkers, taboo breakers, and inspirational ideas—pledged to join the efforts to further social development.

Company: Kokrra.tv
Artist, Photographer: Leart Zogjani
Video made for: TEDx Prishtina Women

Şirin Bahar Demirel
# Living with Leviathan
2013 / Turkey / 11 min

"Because when ordinary people who share funny cat videos on the social media start to spread information about what to do in case of being taken into custody, it's called state terrorism." This is a personal story about a nationwide uprising, the Occupy Gezi movement in Turkey, in the summer of 2013. More of an open letter than a documentary, this movie tries to show how Turkish youth say "No!" to the despotic regime and police brutality.

# Campus Exhibition
# Paris 8 University

The Campus Exhibition event organised by Paris 8 University presents thirty years of digital research and creative work from pioneering artists and researchers in the early years as well as from young contemporary artists today. It is divided into five categories: film screenings in 3D CGI; interactive art installations and experimental videogames; digital literature, such as hypertext novels and generative poetry; virtual reality systems and augmented interactive books; and behavioural objects and sensorial prototypes. The exhibition perfectly coincides with the determination of Paris 8 to showcase its dynamism in the digital field by naming 2015 the year of "Université 8.0: Le pari numérique!" (University 8.0: the digital challenge!)

Since it was founded forty-five years ago, Paris 8 University in Vincennes has asserted its central presence in artistic disciplines. A strong dynamic of interdisciplinary research has fostered a significant body of artistic work and led to the emergence of research groups and teams particularly active in the digital field. The Arts et Technologies de l'Image (ATI) department grew up around pioneers of computer art in France—a somewhat "off-beat" development for the young university. As well as artistic and scientific experiments, the Image Numérique et Réalité Virtuelle (INREV) team carries out research that opens up perspectives created by the emergence of interactive virtual stages. The Esthétique des Nouveaux Médias (EdNM) team worked on interactivity in art; now called Théorie Expérimentation Arts Médias et Design (TEAMeD), it has extended the scope of its research to include new relational modalities via the use, development, appropriation and invention of mainly electronic and digital technology. The founders of the Paragraphe team have taken part in the development of the concepts of hypertext and hypermedia both in France and abroad. The Pratiques Textuelles Numériques (PTN) and Création et Edition Numériques (CEN) master's programs have now opened up their field of inquiry to include all information technologies, from mobile devices to augmented reality, digital ergonomics, and human development.

For the last five years, Paris 8 has offered a unique framework and a privileged environment for research initiatives: the "Laboratoire d'Excellence: Arts et Médiations Humaines (Labex Arts H2H)" and the "Initiative d'Excellence en Formations Innovantes: Création et Technologies de l'Information et de la Communication (Idefi CréaTIC)" are funded by French government investment programs and are original transdisciplinary research and training initiatives rooted firmly in the 21st century and focusing on digital art as it relates to the human and social sciences. This rich panorama illustrates the expertise and thinking of Paris 8 University in the field of Digital Art and New Media.

*http://www.univ-paris8.fr*
*http://linz2015.univ-paris8.fr*

Translation: Martyn Back

Project manager, Campus Exhibition: Chu-Yin Chen
Curator, Campus Exhibition: Jean-Luc Soret

Team coordinators: Marie-Hélène Tramus, Isabelle Moindrot, Alexandra Saemmer, Pauline Cellard, Ghislaine Azemard, Laure Leroy, Anne-Fleur Guillemin, Jean-Marie Dallet, Philippe Bootz, Filipe Pais, Jean-François Jégo, Adèle Sicre.

Campus Exhibition 2015 – Paris 8 University has received support from: Ars Electronica, Kunst Universität Linz, French Embassy in Vienna, YIliSU, Université Paris 8: l'Année du Numérique, Service de la coopération et des relations internationales, Labex Arts-H2H, Idefi CréaTIC, the INRéV, TEAMeD and EansadLab teams, and the ATI, CEN, and PTN master's programs.

Bérénice Antoine, Clément Ducarteron, Gaël Labousse
## Le Désert de Sonora
3D CGI animated film (2015)

Mescaline is a hallucinogenic substance produced by different cactus species, including the peyote cactus. Incilius Alvarius is a toad that secretes powerful toxins. These plant, animal- and mineral-based psychotropic drugs all occur in the same location in the Sonoran Desert, near the Mexico–United States border. This video is an introspective journey into a microscopic universe. Three aesthetic visions of different psychotropic drugs are brought face to face in a digital triptych. Shapes, movements, structures, materials and sounds bear witness to a recursive metaphysical journey.

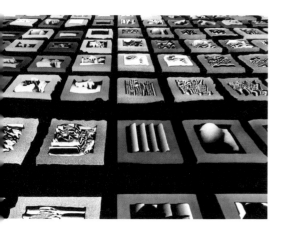

Woody Vasulka & SLIDERS_lab (F. Curien, J-M. Dallet)
## Digital Vocabulary
Experimental digital video Installation (2014)

The images illustrating the *Digital Vocabulary*, video art pioneer Woody Vasulka's attempt to create a grammar of digital technology in the 1970s, are here revisited by SLIDERS_lab. Now placed in a virtual space, the sixteen illustrations are arranged side by side. A camera moves above them, getting closer and moving further away, transforming what we see into a data landscape. This is all the more striking because at certain moments a phenomenon of extrusion produces an impression of depth, with black areas in the background and white areas in the foreground.
Project supported by Labex Arts-H2H

Caroline Bernard, Damien Guichard
## Journey: Fossils
3D prints (2010)

In *Journey: Fossils*, the image is no longer two-dimensional; it becomes an object that can be grasped. The objects printed in 3D relate to a sedimentation between living things and architecture, time and space, camera motion and moving through the environment. They reflect the space-time continuum as it was at the time the images were recorded, showing the desire to make reality and its recording into a single object undergoing transformation.

Jean-Louis Boissier
## Pékin pour mémoire
**Interactive installation with videodisc (1985–1986)**

In September 1985, a twelve-hour walk connected the temples of Peking, located at the four cardinal points: Earth, Sun, Sky, and Moon. One photo was taken per minute—the cameras printed the time on the picture—to record the itinerary, and a second camera recorded picturesque details. The videodisc was the precursor of programmed management for sets of images. The performance produces a logical diagram for this. It relies on minimalist interactivity: at the four corners of a square Chinese table, four buttons for the departure points and, at the center, a button for taking a photo.

Sophie Daste, Karleen Groupierre, Adrien Mazaud
## Miroir
**Interactive augmented reality installation (2013)**

*Miroir* is an augmented reality installation that refers to the world of fairground sideshows. It combines tricks of light with new technologies: imagine a mirror, in a mysterious Victorian setting, able to transform you into a reflection. You can now interact with your anthropomorphic double. By entering the strange world of *Miroir,* you have merged with the supernatural, and you are now part of its bestiary.

Michel Bret, Edmond Couchot
## Pissenlit
**Interactive installation (1988)**

At the bottom of the screen connected to the computer lies a dandelion clock. When you blow on the image, thanks to a sensor fixed onto a transparent plate, countless seeds are released and drift away in the wind. Another version shows a little feather. When you blow, the feather rises at different speeds and in different ways depending on how hard and how long you blow. When you stop, the feather floats back down, following a different complex trajectory every time.

Michel Bret
## Dynasenza
**Interactive installation (2015)**

*Dynasenza* is an interactive installation pro-grammed by the artist, featuring small autono-mous virtual-reality dancers controlled by neural networks, interpreting sounds emitted by a thumb piano (sanza) played by the viewer.

## Vivarium for Solar Insects
**Interactive sound installation (2015)**

Visitors are invited to use a flashlight to interact with "solar insects" housed in a vivarium. When they light up their little solar cell wings, these "e-insects" emit a glow and sing to the light in impro-vised polyphony!
Made by first year Masters students in Arts et Tech-nologies de l'Image (ATI) Paris 8 University in the framework of the international Labex Arts-H2H initiative. Directed by Laurent Mignonneau, Christa Sommerer, Chu-Yin CHEN, and Jean-François Jégo.

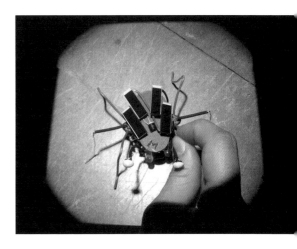

Chu-Yin CHEN
## Vitamorph II
**Interactive installation (2012)**

Seeding virtual microfauna within marine flora... When the visitor touches or strokes a double-sided touch screen, proteiform artificial life forms are born and move. We can grasp these virtual creatures with our fingers and push them around to provoke encounters and reproduction... By pointing directly at them, we make them stop moving; they emit frightened cries and try to escape... This installation is comprised of two back-to-back screens, and the virtual creatures appear on them and migrate from one to the other. Visitors pursue them by moving around the screens, in a game of hide-and-seek...

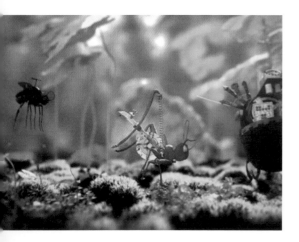

# Best animated image technology films
### 3D CGI Animated films (1985–2015)

For almost thirty years, the Arts et Technologies de l'Image (ATI) department at Paris 8 University has been giving broad-based training in computer graphics, providing openings in several creative fields: animated films and special effects, videogames, virtual and augmented reality, and digital and interactive performance. Be they experimental projects made over several months or intensive projects completed in just three weeks, the films in this selection illustrate a teaching philosophy based on the acquisition of both artistic and technical skills.

Hervé Huitric, Monique Nahas, Michel Saintourens, Marie-Hélène Tramus
## Pygmalion
**Facial animation (1988)**
Music: Patrick Boujet

Hervé Huitric and Monique Nahas
## Masques & Bergamasques
**Facial animation; 16mm color film (1990)**
Music: Gilbert Louet

Since the 1980s Hervé Huitric and Monique Nahas have worked on facial animation using laser digitalization of artificial, then real faces. Their works entitled *Pygmalion* (1988) and *Masques & Bergamasques* (1990), produced via programming using the RODIN software they developed, demonstrate the complexity of the task for computers at that time, and highlight the contribution of laser scanning with millimetric resolution, using Cartesian coordinates to represent a face in 3D with a degree of realism that was impossible back then.

## Philippe Bootz (1982 – 2015)
# 5 generations of digital literature

A panorama of digital literature produced at Paris 8 covering the period 1982–2015 and showing the work of 5 generations of researchers and students.
This retrospective has three main angles:
- chronology, in other words the continuity of creative work and the investigation of digital literature at Paris 8 since the early 1980s.
- literary approaches, in other words text generation and animation, which are embodied here in generated and/or animated poetry and generative and/or interactive fiction.
- the question of the medium, showing a wide range of digital works: closed works on computers, works published on line, applications for digital tablets, e-books for e-readers, cross-media works using digital technology and printed books, spatial installations.

Philippe Bootz, Nicolas Bauffe – MIM Production
# Joue de la musique pour mon poème (poème percutant)

A poem that is "uncomfortable to read", exploring the question of Man being controlled by machines.

Alexandra Saemmer
# Böhmische Dörfer
**Digital Literature Performance**

*Böhmische Dörfer* by Alexandra Saemmer is a digital literature performance. At the end of World War II, Sudeten Germans were expelled from territories in Czechoslovakia where they had lived for several generations. This marked the beginning of the deadly Long March, in which the author's mother, then a child, took part. The performance invites the viewer to circulate, in a necessarily fragmented way, within this painful memory.

Lucile Haute, Alexandra Saemmer
# Conduit d'Aération
**Hypertext novel for tablets and e-readers (2015)**

*Conduit d'Aération* is a choral novel for tablets and e-readers, freely inspired by a news item and narrated by four of its protagonists. Their fragmented accounts can be read independently to follow a single point of view of the mystery, or the reader can jump from one to the other to compare the different accounts. The story has several threads and interpretations. The "today" of the introduction is the vanishing point towards which the different storylines converge. Everything begins at the end: "A body is discovered".
Project supported by Labex Arts-H2H

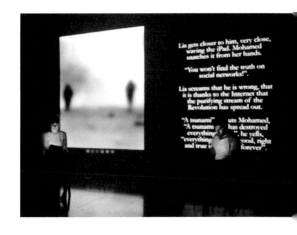

Dominique Cunin, Mayumi Okura
## Book Tales
**Interactive book for iPad (2011-2012)**

*Book Tales* is a series of interactive artistic apps for iPad that challenges the omnipresence of the physical book, a set of bound pages that is consulted by leafing through it, as a model for the design of interfaces for e-book reading software. Why such an analogy with the book on mobile devices, whose potential for interactive presentation remains largely unexplored? The answer is, *Book Tales* is based on a simple design principle: photographs of physical books provide a pretext for interactive reading situations on mobile screens.

Corentin Bertho, Christine Lumineau, Parnian Haghbin, Ana Cristina Villegas
## Pan!
**Augmented book (2014)**

*Pan!* Is the result of an exploration of the relationship between paper and digital media in the context of art. The challenge was to create a graphic artwork that explores the limitations of the digital format and the new possibilities it can offer in terms of narration, the reading process, and interaction with the reader. *Pan!* offers an interactive experience where the smartphone guides the reader as he or she discovers an illustrated riddle. The two objects thus become complementary.

Project supported by Idefi CréaTIC

Clémence Bugnicourt, Ulric Leprovost, Thomas Revidon, Laure Le Sidaner, Swann Martinez
## Immersio
**Interactive book (2015)**

This project involves a concept for an interactive book following the principle of the pop-up book. The viewer is invited to handle the book and discover the world of a fairy tale on a screen, thanks to a camera. He or she can move freely in the world of the tale. This is thus a fun interactive book that involves the participation of the reader.

Cédric Ciebien

## Dumping in the imagination
**Augmented reality system (2015)**

Welcome to the world of *Dumping in the imagination*, a project consisting of a book that features several images whose purpose is to allow you to discover a 3D world. This world is viewed on a mobile device built into Google Cardboard glasses to provide you with a total immersive experience. You can then wander around these magical worlds while listening to music. The connection between books and 3D images will no longer be a mystery to you.

Salma Chaabane, Ghaya Khemiri

## Chath'a: La danse de Carthage
**Augmented reality installation (2014)**

The project entitled *Chat'ha: La danse de Carthage* is an interactive Tunisian dance show viewed in augmented reality on a tablet. The user interacts with virtual marionettes, acting as puppet master by moving his or her hand; these movements are detected using a Leap Motion system. Each movement executed by the dancer is controlled naturally and intuitively by hand movements.

Sophie Daste, Eric Nao Nguy

## Parallèles – Moi, EZIO
**Interactive digital installation (2014)**

The *Parallèles* project consists of interactive video screens. The parallel is created by the interaction of the viewer on the touch screen. The viewer plays with the video to discover the zones of another video, combining the two viewings in a single image. Through an identical film frame, the videos show the assassin from the video game *Assassin's Creed* in an imagined past shown in parallel with a view of the same places filmed in modern cities, while the body of the viewer replaces the avatar.

Kevin Bernard, Julien Capone, Charles Grillet-Courbières, Nicolas Gommez, Léo Menant

## Grizz
**Touch-sensitive pedestrian navigation jacket (2015)**

Currently, pedestrian navigation relies only on visual signals (via smartphone), or sound signals (instructions transmitted via earphones). The *Grizz* project is mainly designed for sight-impaired or blind people, but it could be extended for general use. *Grizz* has three innovative features: it uses only touch for pedestrian navigation, it doesn't involve hearing, and it minimises the attention paid to the phone as you walk around.

Project supported by Idefi CréaTIC

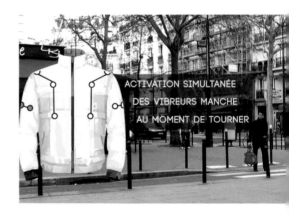

Samuel Bianchini, Didier Bouchon

## Hors Cadre
**Wall Installation (2014-2015)**

A frame is hung on the wall. It is empty and plain: white, no content, no background, no moulding or decoration. But intermittently, it subtly moves, twisting on itself. From time to time, its movements become more pronounced, even violent, as if it were twitching involuntarily like someone having a fit of hysterics.

*Hors Cadre* was developed in the framework of *The Behavior of Things* project. Supported by Labex Arts-H2H.

Reflective Interaction team

## The MisB Kit
**Demonstration of a basic robotic toolkit (2013)**

The *MisB KIT* was developed by the Reflective Interaction team (Diip / EnsadLab) headed by Samuel Bianchini, Didier Bouchon, Cécile Bucher, Martin Gautron, Benoît Verjat, and Alexandre Saunier, in the framework of *The Behavior of Things* project, coordinated by Emanuele Quinz for Labex Arts-H2H. The research area *Behaviors* focuses on objects that display behavior, and investigates how we can create animate objects with simple abstract or everyday forms (a table, an ashtray, a utensil, a dustbin, etc.), whose movements give them a particular behavior. How can we give the impression that such objects have a personality that allows them to initiate actions and decide to do things themselves? We have created a toolkit (hardware and software) that makes it possible to quickly prototype and experiment with such objects.

Benoît Verjat
## Métre Métrologue
Installation (2013)

A large carpenter's rule moves along, folding and unfolding like an animal lost in the space where it has been released, looking for what it must measure. Its motorized articulations are also sensors sensitive to the resistance of the contours of the space. When this resistance is too strong, the movement stops and gives way to another type of articulation. The object's behavior is the result of a combination of its morphology and the sensitivity of its articulations.

*Métre Métrologue* was developed in the framework of *The Behavior of Things* project. Supported by Labex Arts-H2H.

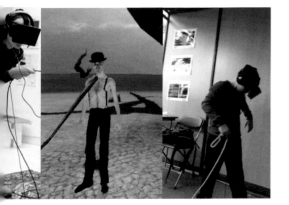

Cédric Plessiet, Salma Chaabane, Ghaya Khemiri
## Lucky 2.0
Virtual reality installation (2014)

This project immerses the viewer in a virtual world directly inspired by Beckett's play *Waiting For Godot.* Using a Kinect and a virtual reality helmet, anyone can put themselves in the virtual body of one of the characters: Pozzo. Opposite him is Lucky, the other character, a kind of virtual slave tied to a rope. Thanks to a haptic system and a voice recognition device, the interactor can give orders to Lucky and feel him pulling at the rope. The strange bond between the viewer and the virtual actor Lucky prompts us to take a new look at this play from the great tradition of the Theatre of the Absurd.

Judith Guez, Guillaume Bertinet, Kevin Wagrez
## Lab'surd
Virtual Reality installation (2014)

"Sit in front of the table, put on the headset, take the glass in front of you and let yourself be taken into a waking dream". *Lab'surd* is an individual experience that uses the Oculus Rift DK2 virtual reality headset: an immersive and interactive installation that invites the viewer to gradually enter a world of magic and supervirtuality, challenging our habitual perceptions through illusions halfway between the real and the virtual.

Christina Chrysanthopoulou
## Cauchemar, le jeu
**Virtual Reality installation (2014)**

*Cauchemar, le jeu* (Nightmare, the game) is a project created by Christina Chrysanthopoulou, for the Greek-French master's degree "Art, Virtual Reality and Multi-User systems of Artistic Expression". The goal of the project is to immerse the player/user in a virtual environment where the presence of the Shadow (the Jungian archetype: the darker side of the unconscious) is dominant. The experience begins with the player wearing the Oculus Rift, standing in darkness. The Shadow approaches and touches the player on the shoulder (a physical gesture in the real world). By turning around though, in the virtual world, a mirror reflects a vague and shady representation of the player. The mirror then starts asking the player questions. Depending on the answers, the player has different nightmares.

Rémy Sohier, and Collectif Alinéaire
## Super!
**Art video game (2014)**

*Super!* is a videogame installation with a small screen and an oversized joystick. The installation is deliberately odd to create a sense of self-mockery and acceptance of failure. The game consists of finding one's way out of games that reflect the major categories of video games (beat them all, race, puzzle, rpg, platform, etc.).

Piers Bishop
## Super Giant Robots
**Art video game (2015)**

*Super Giant Robots* is a videogame project in the form of an interactive installation. The work is designed to look as if it was designed and made by a child. It allows the user to build and then control a giant robot using a control panel made of cardboard, sticky tape, and tinfoil.

Alain Lioret
## Painting Beings
Installation (2005)

The *Painting Beings* project focuses on art created by new techniques using several methods of implementation that combine the rules of construction of cellular machines and L-Systems with genetics, neural networks, couplings, and translation of codes. These methods result in the morphogenesis of bodies, as well as their structure (shape) and their functional aspect (neural networks with sensory neurons, balance, etc.). It is part of what we can call "a new kind of art", and we can see here how *Painting Beings* emerge.

Judith Guez, Jean-François Jégo, Dimitrios Batras, Marie-Hélène Tramus
## InterACTE
Interactive installation (2015)

The interactive installation entitled InterACTE makes it possible to improvise with a virtual character whose gestures are generated by a genetic algorithm based on expressive and linguistic gestures captured on real actors (a mime, a poet, a linguist, and a choir leader). The installation presents a variety of avatars and virtual worlds.

*InterACTE* was developed in the framework of CIGALE project supported by Labex Arts-H2H

Chu-Yin Chen, Jean-François Jégo, Dimitrios Batras
## Deaf Poetry: saying everything without speaking
Interactive installation (2015)

Here, hands don't beat the drum. Instead the drum speaks with its hands, projected onto its skin. They interact and create poems in sign language, specially for the deaf and the hearing impaired, because the drum has acquired the expressive and prosodic gestures of deaf poets.

Deaf Poetry was developed in the framework of CIGALE project supported by Labex Arts-H2H.

# Post-Post

University of Art and Design Linz, Interface Cultures
Faculty: Christa Sommerer, Laurent Mignonneau, Martin Kaltenbrunner,
Michaela Ortner, Reinhard Gupfinger, Marlene Brandstätter

Post-media, post-web and post-digital are the new buzzwords of our times. Media are now available anytime and anyplace; in fact, it is becoming difficult to switch them off and remain "off-grid." Smart devices, geo media and surveillance systems are spinning a dense panoptic web all around us[1]. The physical world is becoming increasingly infiltrated by digital technologies, while social networks have turned us into "smart mobs" whose behavior can be foreseen and pre-calculated. It has become the norm to have almost all facets of our lives augmented by media. "Post-media" merely means that media are now an integral part of our technological lifestyle. Herlander Elias states that in this post-media world nothing is ever finished and "update is the default setting[2]." According to him, our screen civilization is so accustomed to interaction and connectivity that interfaces have become invisible; we do not even notice them. But there is a downside to all of these increased interactions and connections: we need to constantly pull, save, collect, publish, edit and connect, but we are also beginning to realize that all of this is not really necessary. A kind of protest movement is emerging in this "post-Google" and "post-Snowden" world, where the old is the new new and being passive and critical is the new trend. So how about being post-post, instead of being post-media? Being beyond something else is a sign of progress, but what about being beyond being beyond? Are we really there yet? This year's Interface Cultures student project exhibition constitutes a provocative answer to the new post-media trends. The projects presented are futuristic, retro, post-, pre-, post-post or just art. While we of course need to be aware of new technological and societal trends and to reflect on them, we do not need to feel obliged to follow all of them. Being post-post is our artistic answer.

## Interface Cultures – Campus Exhibition

The location of this year's student exhibition in Interface Cultures is interesting: Whereas the Ars Electronica Festival is taking place at the former Austrian Post logistics center close to the train sta-tion, the Interface Cultures student exhibition is located at the former headquarters of the Austrian postal service close to Linz Main Square. Last year Austrian Post moved out and this year the Interface Cultures students have moved in. Here, 23 international students are exhibiting art works that they realized during the past year of studies. Inspired by the Games Workshop, Nathan Guo developed his project Wanderlust, which utilizes the digital dartboard system as an agent of a Google map navigator. Patricia Margarit Castelló produced a collective videogame called Eisenbahnbrücke's nightmare (The Nightmare of the Railroad Bridge), that has to do with urban development and shows us how historical buildings are currently being treated. The lecture in media archeology probably influenced the installation OHP III, which was created by Davide Bevilacqua and Clemens Bauder. They use overhead projectors with additional film rolls in a manner that turns them into alternative cinematic devices. By hacking objects Yen Tzu Chang develops her series of works called Transplanting. She originally comes from Taiwan and has noticed a difference between how frequently many everyday objects are used in Austria and in her home country. This observation inspired her to develop electronic products and combine them with parts of the human body. In Jure Fingust's project Take your time, a common traffic light is used in a totally different context to the usual one. Daniel Samperio and Gisela Nunes are two exchange students from the University of Minho in Guimarães, Portugal. They made use of their residency at Interface Cultures to develop their current projects. Gisela Nunes' installation Break the Ice invites the visitors to participate. It asks them to step on a sheet of ice and see what happens! Daniel Samperio developed the artwork Medium Standard together with Mario Costa. In the collaborative space it defines, three tangible objects—coins, dry leaves and a Newton's cradle—control the multi-media environment in real-time. The critical use of technological developments is the basis of LARD by Oliver Lehner. He employs long range acoustic devices (LARDs), which are normally used by the

*TimeBasedGhosts*, Ivan Petkov

OPH_III, Davide Bevilacqua, Clemens Bauder

*The gesture of drawing light with a body movement,*
Isidora Ficovic

OPH_III, Davide Bevilacqua, Clemens Bauder

*The gesture of drawing light with a body movement,*
Isidora Ficovic

military and the police to control agitated crowds, as an organ of speech for the voices of protest from all over the world. Nina Mengin's critical statement on the usage of social platforms is called *#innerstagram*. She questions the widespread belief that every single moment of our life is worthy of being captured with a mobile phone. Pictures of a different kind represent the point of departure for Isidora Ficovic´s exhibit, which is called *The Gesture*

*of Drawing Light with a Body Movement, Form 24.* There, a digital camera becomes the object, which displays abstract graphics that are digitally produced in the course of an interactive performance. Movement or not? That is the question posed by three art projects that are presented in the exhibition. Martin Nadal's *Death of Things (DoT)* is a series of moving figures representing public personas. What they do depends on whether the people

**235**

*LARD*, Oliver Lehner

*Death of Things (DoT)*, Martín Nadal

*Pop the movie*, Carina Lindmeier, Federico Tasso

*Break the ice*, Gisela Nunes

*Wanderl_st*, Nathan Guo

*Take your Time*, Jure Fingust

*Eisenbahnbrücke's nightmare*, Patricia Margarit Castello

*Interfight*, César Escudero Andaluz

*Netz*, Jens Vetter

*vermine*, Viktor Delev, Didi Bruckmayr

*Bull shut app*, Marta Perez Campos, Tassilo Posegga

*#innerstagram*, Nina Mengin

*Medium Standard*, Daniel Guerra Samperio, Mario Costa

they represent are still alive. While the pictures in Ivan Petkov´s installation *Time Based Ghosts* are switched off, you won't see any content. Shapes seem to emerge from irregularly blinking points until the video is stopped. The installation *Pop the Movies* by Carina Lindmeier and Federico Tasso is based on a popcorn machine which activates the movies. Every time a piece of popcorn pops, the movie moves forward by one frame.

What if, in real life, we were able to make a connection with a conversational topic instead of a person? *BullShut App* is a mobile phone application which attempts to make it possible to avoid awkward moments at all kinds of social events. The goal of the project which Marta P. Campos and Tassilo Posegga present is to create a conversational space that connects two individuals for a brief period of time. An interaction of a total different kind is the basis of *Interfight* by César Escudero Andaluz. He uses an Android app, which he developed by duplicating the Android GUI. In it, desktop icons are made to behave like animals and react aggressively to the physical interface. Another project of a more applied nature was developed by a group of Industrial Design and Interface Cultures students. In it, they elaborate future scenarios for car breakdowns in 2050. In their collaboration with the Austrian ÖAMTC, they discuss service issues such as "What will mobility be like in 2050"? Jens Vetter developed the *Netz*, a net of flexible rubber tubes which is suspended in a room. In the middle of it, there is a speaker. Touching or stretching the net generates a sound that it will play back. As we see, this year's student projects really do move freely between the different media: digital, analog retro, new and old. They are composed of media, post-media and post-post media.

### Interface Cultures – Seminar

Besides featuring the student projects, we also hold a small international seminar. There, scholars and artists such as Herlander Elias from the University of Beira Interior in Portugal, Machiko Kusahara from Waseda University in Tokyo, Erkki Huhtamo from UCLA in the USA, Ryszard W. Kluszczyński from the University of Lodz in Poland, and Stahl Stenslie from Aalborg University in Denmark discuss the latest trends in media art with Christa Sommerer and Laurent Mignonneau. They also reflect on the topic of post media and interface criticism from an artistic point of view. Herlander Elias, for example, talks about technological changes that impact contemporary society and have resulted in the formation of a "post-computer" and "post-Internet" person. He explains the characteristics of this new type of person, whom he calls "Homo Cypiens"–a combination of both "Intelligence" (Sapiens) and the "cyberspatial" or "digital" (Cyber)–while Stahl Stenslie reflects on "Prêt-à-Post: Joy, Fear and Ecstasy." He argues that dead technologies, dead communities, dead life or any other post-condition are a new form of Prêt-à-Porter, custom fit to your custom written game-of-life. Ryszard W. Kluszczyński talks about relations between new media art and the art@science phenomenon. In his paper *Towards the Third Culture* he writes that the @ symbol linking both sides highlights that in the newest practices which combine art and science the digital and media technologies play a very important role[3]. Using as examples works by artists such as Ken Feingold or Guy Ben-Ary, he discusses the thesis that art@ science is a post-media chapter in the history of new media art. Christa Sommerer and Laurent Mignonneau from the University of Art and Design Linz talk about their latest project *Portrait on the Fly* where interactive portraits of media experts and scholars are converted into plotter drawings. The aim of this post-media strategy is to conserve images of historic figures involved in media art–an ephemeral field that is obsessed with novelty and change. Machiko Kusahara talks about post-media tendencies in Japanese Device Art, e.g. the Post-Pet projects by Kazuhiko Hachiya, where artists consciously commercialize their artistic products. Erkki Huhtamo reflects on "Post-O–Media Archaeologies of Imitation and Innovation" and the significance of the post label in media culture through the concept Post-O which he recently launched.

1  Elias, Herlander (2012). *Post Web-The Continuous Geography of Digital Media* (p.20). Lisbon: Formalpress.
2  i.d., (p.31).
3  Kluszczyński, Ryszard W. (2011). art@science. About Relations between Art and Science. In R.W. Kluszczyński (ed.), *Towards the Third Culture. The Co-Existence of Art, Science and Technology* (p.33). Gdansk: CCA.

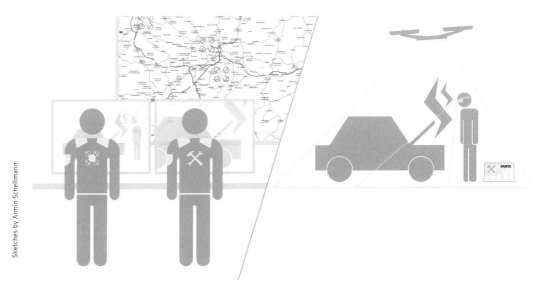

Sketches by Armin Schellmann

# 100 Percent Mobility

In 2015 the Austrian Motorist and Touring Club ÖAMTC approached the University of Art and Design Linz, asking students and teaching staff members to reflect on how mobility will change in the future. In a joint project students from the scionic® Department of Industrial Design and Interface Cultures envisioned future scenarios for car breakdown services in 2050. These were presented within the context of visions which the students elaborated for future smart cities and networked rural areas, including novel types of infrastructures, distributed networks and services, self-driving vehicles, renewable energy sources, new forms of vehicle ownership as well as personalized and customizable support solutions.

It was thereby taken for granted that the balance between work and life would assume greater importance and that mobility would have even greater relevance than it currently does. The Motorist and Touring Club ÖAMTC would therefore have to be able to support its members by managing complex mobility situations with the help of simple and efficient procedures for guaranteeing mobility. The students, for example, envisioned flying drones that would send spare parts to the site of the car breakdown, as well as new types of smart interfaces that would enhance communication with the central control unit at the ÖAMTC headquarters. They also agreed that there should be a large palette of available mobility options for ÖAMTC members, who would be able to select which type of vehicle they wanted to use at any specific time and in any situation. Within the framework of discussion topics on vehicle ownership and responsibility, self-driving capabilities and new and adapted means of transportation, students and faculty members elaborated various future scenarios for the Motorist and Touring Club ÖAMTC, which would guarantee 100 percent mobility to its members 35 years from today.

Partners: Austrian Motorist and Touring Club ÖAMTC, University of Art and Design Linz, Department of Industrial Design scionic® (Elke Bachlmair, Florian Nimmervoll), and Interface Cultures (Christa Sommerer, Michaela Ortner)

Sketch by Christopher Hable

# STWST48
## Crashing the information in 48 hours

Convert yourself into E-waste, ferment yourself, chase honeybees for weather report, launch fungi into outer space, send your mobile on a slow boat to China, set your electric sheep free range, grow your android plants, tune in to ghostradio, stream in the orchestra, piss off to compute, eat your data raw, read your pulse loud, make your own bed, make love to your tattoo, hand over your hangover, take a dip in the Danube, check into the underwater eel hotel, admit yourself to a world without compromise, a world whose dreams greet reality, and technology is treated with great caution.

In 2015, Stadtwerkstatt, the nerve central of Linz' free/open culture takes up "the nature of information" as matters of inquiry and launches information LAB to house its many ongoing information research projects. For Stadtwerkstatt, which always presents a reference to the established system, an information laboratory is a challenge of the presence. While the world of natural sciences updates and releases information through logical conclusions, information LAB retrieves seemingly meaningless information data without seeking conclusive arguments. It is about the interplay between reality and information, about the observation of observation, taking in contingency randomness in the process of encoding unique information, looking deeper into concepts of decision-making and conclusion. From STWST cultural space to Am Winterhafen where Messschiff Eleonore is anchored, along the Danube, across the continents, *STWST48–crashing the information in 48 hours* brings together events/non-events, information/non-information, hack/fab labs, reality/dreams, unfiltered/raw/random/mined/cooked/processed infodata. The 48-hour programs are organized under the four headlines:

- infoLAB,
- infoDETOX,
- infoCRACH, and
- Nightline's CRASH THE FUTURE.

**infoLAB features three projects:**

*The Eel Hotel* by Donautik. An underwater research buoy with webcam streams for homebound eels.
*myco-logick* by taro. Fungal spores bound for stratosphere travel in weather balloons.
*Ghostradio* by Markus Decker, Pamela Neuwirth and Franz Xaver. A second order cybernetic mechanism generating random numbers by chance.

*myco-logick* by taro

*The Eel Hotel* by Donautik

*Ghostradio* by Markus Decker, Pamela Neuwirth, and Franz Xaver

<<<file found>>> by aTxE & La Pelos

Ferment Lab by Agnieszka Pokrywka

**infoDETOX features three Eleonore summer 2015 residency projects:**

Bee Frequency Farming by Bioni Samp. Sounding loud protest with bee frequency log hive electronic apiary.

**infoCRASH features nine projects.**

Piss(on)Logic by Martin Howse and Jonathan Kemp. Pissoir flow as operating system for a citywide leaky computational architecture.

⊚ NSA -(critical) Networked Streaming Action by APO33. Cut-ups of web radio in flux, doomed crash of information overload.

GIASO (Great International Audio Streaming Orchestra) by APO33. A distributed orchestra mixing multiple audio-streams through a spatial diffusion.

Makery. Around the world of labs in 48 hours by makery.info. An information marathon on labs heralding the worldwide maker movement.

River Studies by Michael Aschauer. Durational video loops featuring rivers as carrier of cultural landscapes and identities.

Pulse project by Michelle Lewis–King. Listen to the interior space of the body through pulse reading and notation.

Mirror Party Sisters' Play by sister0 with sisters'. Who will execute relayed codes, free from the lion's share of toxins?

Plantoid by Primavera de Filippi, David Bovill, Vincent Roudaut, and Sara Renaud. A blockchain-based autopoietic plantoid, self owned and financed, reproduces itself.

Electromagnetic Dimension by Erin Sexton. Performing a series of spatiotemporal experiments with radio, objects, and an antenna.

<<<file found>>> by aTxE & La Pelos. Bio-toxic performance with tattoo machines scratching in anger. Ferment Lab by Agnieszka Pokrywka. Feast on fermented food with tales of bacteria's micro life.

⊚ NSA -(critical) Networked Streaming Actionn by APO33.

**CRASH THE FUTURE–Nightline programs**

Among others, KIKERIKI, COMMAND YOUR SOUL, OWL RAVE, MS. MUTT, ELEKTRO GUZZI take over the deep nights and crash the future, unabashedly loud and danceable.
http://stwst.at

STWST48 is a Stadtwerkstatt project.
Curation: Shu Lea Cheang, Franz Xaver
Nightline programming: Richie Herbst
Production: Andreas Heissl, Felix Vierlinger, Jörg Parnreiter
Art & Web design: Veronika Seyr
Sound engineer: Christian Viteka
Catering: Cafe Strom

# Art Curating in the Digital Age

For the first time Ars Electronica will offer a program especially for curators during this year's Festival. A lineup of workshops, talks and lectures over the course of three days will provide diverse settings to discuss issues and challenges curators are facing today. Staging this conclave in conjunction with the Festival is also designed to enable professionals in this field to engage in meet & greet with their colleagues. The Festival as a hub for exchange among people and projects thus has the potential to become an effective springboard for curators aiming to expand their networks. Also high on our agenda is facilitating up-close-and-personal encounters with artists so that curators can gain insights into the substantive questions and production & implementation challenges that artists are facing today and the positive contributions curators can make. Furthermore, we understand curatorial work as an investigative process; accordingly, we look forward to getting acquainted with emerging talents on the verge of their breakthrough as well as to Q&A with seasoned veterans and, in the process, reconsidering our own curatorial activities.

This year, the Korea Arts Management Service is sending five up-and-coming young Korean curators to Linz. They'll be working together with Ars Electronica staffers and selected Festival participants to work on eight themes within three days.

- Ars Electronica–Curating digital art: challenges and possibilities
- New audiences–Curators as translators mediating between artists, their works and the public
- Ars Electronica Festival – Demands in curating a festival and exhibitions
- Ars Electronica Futurelab–Curating processes: Curation at the intersection of art and science
- What kind of curators does an institution like the Ars Electronica Center need?
- Curating in Asia and Europe–A comparative case study
- Curating art in the Digital Age
- Curatorial metamorphism–From concept to media to digital art: A historical approach

Text: Manuela Naveau

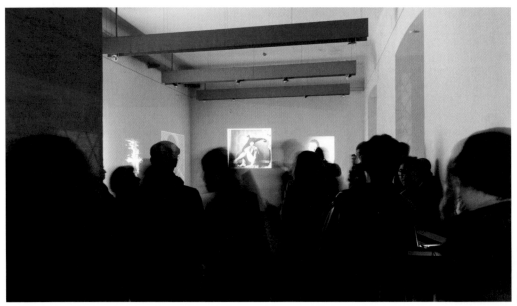

Florian Voggeneder

*exhy–a curation service*, Rosi Grillmair

Rosi Grillmair
# exhy
## a curation service

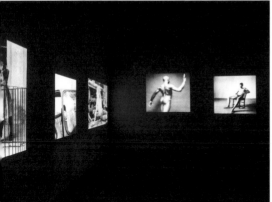
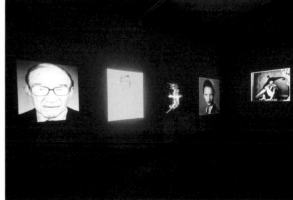

*exhy* curates exhibitions—automatically. The curation service offers to organize art events from finding a topic and a title to putting together a group show and arranging the works of art in the gallery space. The selection of art works is of course not a random assembly. Each show is a unique experience involving the visitor in relationships, juxtapositions or contrasts that are being reflected by works and themes of art history and contemporary developments—like any well curated group show, but it comes without the heavy workload for the curators. You may entrust *exhy* with your project not only because it knows over 15,000 artists—more than a human mind could ever comprehend, but because it also draws lines between artists who are active in very specific fields—an arts researcher may not have come across the connection in years.

*exhy* is based on the huge database of *artsy.net*, an online art gallery. It comprises thousands of artist profiles that are linked by the logic of the *Art Genome Project*.

From a user's perspective, the service works quickly and efficiently—in a similar way to finding goods on Amazon and ebay.

"If you like that artwork, you might also like this one"—the *artsy.net* art classification and recommendation system.

The *artsy.net* art recommendation system tries to define the users' taste in art and suggests works they might like. Each work of art is defined by specific characteristics. *exhy* filters similar works on the basis of these characteristics and generates a list of artworks. By following the *artsy.net* path, it will find the next most similar work. The list of featured artists, the specific title, and the exhibition text are generated by using the information collected during this process. At Ars Electronica the visitor can be part of art events curated by this algorithm. Every other hour there will be an exhibition opening and the room will be filled with new art.

Development: Manuel Berger, David Brüll, Florian Jennett, Sebastian Oschatz, David Theil, Gregor Woschitz.
Supported by: Art University Linz, Artsy.net, Meso Digital Interiors, Kepler Salon Linz

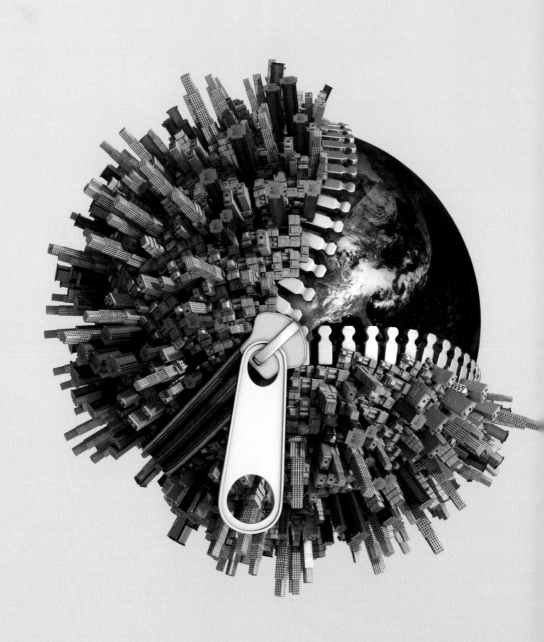

# EVENTS
# & CONCERTS

Anatol Bogendorfer, Peter Androsch (Hörstadt)

# Diaspora Machine

"No matter how he pouts his lips, we push him away with our elbow, but however much we push him away, back he comes."

<div align="right">Franz Kafka</div>

It could be a sound wave that Kafka's talking about. A sound wave propagating in a space in which it encounters resistance in the form of a hard surface. We perceive the delayed reflection as an echo.

What the author is actually alluding to in the last sentence of his short story "Fellowship" is the way a community deals with strangers. "We don't know him and don't want him to join us. (...) He doesn't do us any harm but he annoys us, and that is harm enough." The five persons in Kafka's "Fellowship" aren't even sure if they actually know one another, but they're positive that they don't want to get acquainted with the sixth one, the stranger. The image that Kafka draws of an unsettled majority society is easy to recognize in the discussion that's been going on for years about the integration of foreigners. Now, we're gradually beginning to comprehend what disastrous consequences this form of rejection of "the other" can have for a city—and for the global community, for that matter—as cities worldwide become battlefields in asymmetrical wars. The rejection of outsiders means nothing other than the very same rejection being reflexively cast back upon us. The resulting feedback effect in the form of violence and terror is a destructive force. The description of future cities will continue to be an account of immigrants and the process of dealing with them. Human migration is enlarging cities, not only their spatial dimensions but also their importance for the transnational global community. More than ever, the city is becoming a reflexive place of political, economic and social developments.

The post-democratic sphere has developed—that is, gotten bigger—even more rapidly in reality than those who foresaw its emergence had feared. According to Slavoj Žižek, "contemporary capitalism delimits democracy." Peoples and democracies who are forbidden to decide on matters of their most fundamental interests give eloquent testimony to how they've been made deaf and dumb in neo-feudal Europe. Parliaments are morphing from deliberative assemblies to places for tacit complicity. Here we stand, stunned, aghast, beholding the abject failure of politicians who permit thousands of refugees to drown at sea, condemn huge segments of the European populace to unemployment and poverty, permit the unbridled speculation of financiers, and labor assiduously on deregulation and the dismantling of social solidarity.

And this is the destination into which masses of refugees from Syria, Iraq, and North Africa are crowding. Fleeing poverty, they're spreading out an (inter) urban diasporic network, interweaving and interlayering it into a different Europe. New cities are the result. Amongst African or Armenian diasporas (Ancient Greek: διασπορά, dispersion), new strata—Syrian, Iraqi, Kosovar networks—are accreting.

The *Diaspora Machine* is dedicated to the phenomenon of scattering, diffusing, disseminating (διασπείρειν diaspeírein, strewing about). The gigantic spiral packet chutes in the former Postal Service logistics center on the grounds of Linz's main train station stand like a pre-modern mechanical signal warning of these diasporas. As a huge *organon*, it distributes voices, sounds, light and objects that are smuggled in through channels with plenty of twists and turns, and arrive and dock at various places where they announce their presence. Singers, trumpeters, choruses, musicians, loudspeakers, and light, physically occupy the chutes. They seep through the machine, are dispersed and spat out. They make the machine quake, resound, and groan.

Text: Anatol Bogendorfer

*Diaspora Machine* is realized with the collaboration of the Landestheater Linz's Children and Youth Choir and Anton Bruckner Privatuniversität in cooperation with Landesmusikschulwerk OÖ. With the participation of Hard-Chor Linz.

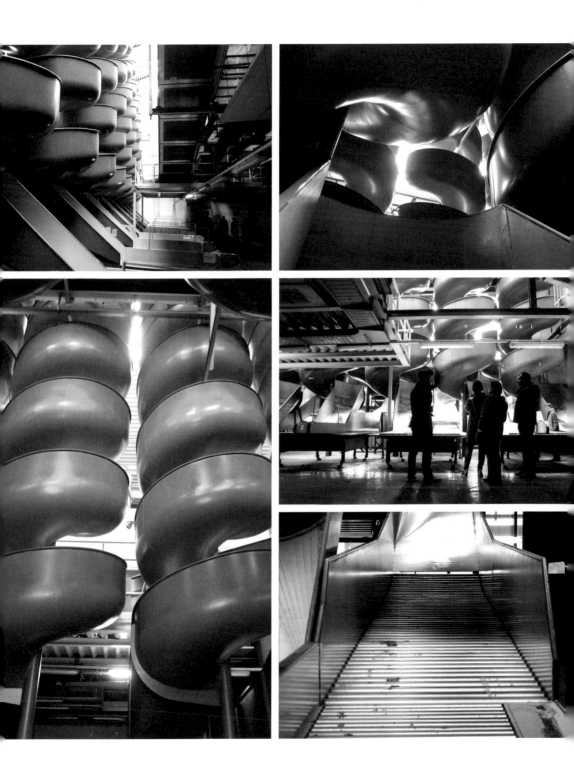

Anarchy Dance Theatre X Ultra Combos
# Second Body

Ro-hsuan Chen

Ching-Ju Cheng

The concept of *Second Body* comes from the experience of driving cars. If I want to steer the wheel, to brake, to step on the gas, I don't need to consciously think, yet the car can still go ahead, turn, and park at the correct spot according to my will. Moreover, when I am driving, I know how big my car is when I weave through narrow alleys, and I know where the four wheels are as the car proceeds in its tracks. Maneuvering a car is an experience done almost entirely out of reflex, without the need for the brain to actively think. This reminds me of the way we move our hands and feet, which move naturally without the need for us to think. When we are infants, we learn how to use our own bodies: we learn to stand on our feet, move, and run, and gradually learn to exercise our bodies as we want. We even learn how to use our bodies to the max in certain sports and exercises. In sum, the accumulation of knowledge, concepts and training allows us to use our bodies without conscious thought, making the use of our bodies an extension of the natural, physical body itself. The same happens when learning to drive, so that driving becomes a process achieved without thinking, with the car becoming an extension of the body.

The present work starts from establishing the presence of the body, while learning the structure of the natural body through setting up knowledge of the body itself. In addition, the knowledge of the structure of exercise is used to represent what we know of our own first bodies in the moment. Afterwards, a fully functional body starts to build up, then change the environment for itself. Gradually, the environment starts to change the body as well. The following section is a 360° full body-length projection that enters the picture to create a non-natural second body, which creates an experience of movement distinct from the movements of the first body. We are re-learning this new body. Adaptation? Conflict? Do we, during the conversion between these two, produce new knowledge to define our bodies with the change in our viewing perspective? Furthermore, how does the second body replace the definition and existence of the first body in the process?

Concept/Choreography: Chieh-hua HSIEH
Software Architecture/Video Design/Music Design: Ultra Combos
Music Design: Yannick Dauby
Lighting Design: We Do Group
Custom Design: Yu-teh Yang
Visual Operator: Hsiang-ting Teng
Dancer: Shao-chin Hung
Project Support: QA Ring
Project Mentor: Justine Beaujouan
Project Consultant: Kevin Cunningham
Commissioned by the Ministry of Culture, Taiwan and Quanta Arts Foundation
Sponsored by Quanta Computer Inc.

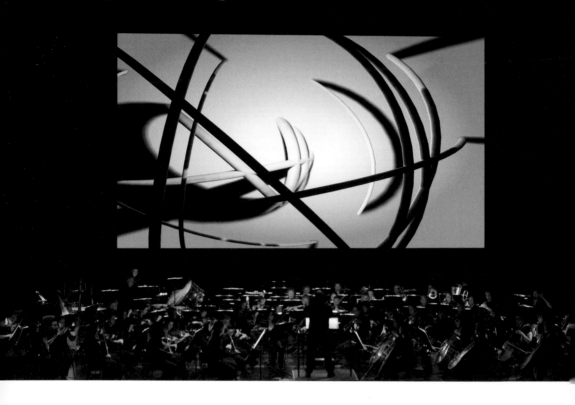

## Program

For many years now *The Big Concert Night* is one of the very popular and unique elements of the festival program. Thanks to the wonderful collaboration with Dennis Russell Davies and the Bruckner Orchester, these special concert settings are offering unique journeys between quite different musical styles and even more different types of performing the music—from the big orchestra instrumentation to the digital sound processing of slick laptops. In addition visual artists are invited every year to interpret the music with real-time computer-generated graphics.

This year it won't be just a journey through musical styles, but a physical one as well, since the various performances are spread throughout the vast area of the Post City.

The program starts with a musical intervention at the famous "ABC Buffet" in front of the big bus terminal next to the Post City. This used to be a pub in the typical 1950s style, which was still running in its original interior design until it was demolished about a year ago.

ABC Buffett, Linz

From there we walk through the kind of ravine formed between the Post City building and the nearby parking garage, which—for this evening—is not home to cars but to multichannel sound equipment that will create some fine sound environment which guides people towards the backyard of the Post City. There, surrounded by rails and trains, a small stage is setup for the third act of this evening. Next step is the big stage inside the rail hall of the big Post City building where the Bruckner Orchestra will perform three pieces.

With the next piece composed and performed by Wolfgang "Fadi" Dorninger, the long stretch of the rail hall is converted into a spatial sound experience. Maki Namekawa will perform some of the piano etudes from Philip Glass on a freight train wagon converted into a stage.

And the spectacular three stories high spiral mail chutes will be the stage for the concert performance project *Diaspora Machine* by Bogendorfer and Androsch and for the final piece of the concert night, the massive *Soundfalls* performance by Karl Ritter, Wolfgang C. Kuthan, and Herwig Bachmann.
*Music on the Move,* l ight design: Rainer Jessl

## The orchestra pieces

### Music for a Great City
Aaron Copland
**Performed by Bruckner Orchester Linz /**
**Dennis Russell Davies**

*Music for a Great City* was commissioned by the London Symphony Orchestra in celebration of its sixtieth anniversary season and was first performed in 1964. Aaron Copland composed the score based on the music he wrote in 1961 for the movie *Something Wild* and said about it: "The nature of the music in the film seemed to me to justify extended concert treatment. No attempt was made to follow the cinematic action. The four movements of the work alternate between evocations of big city life with its external stimuli, and the more personal reactions of any sensitive nature to the varied experiences associated with urban living. *Music for a Great City* reflects both these aspects of the contemporary scene."

**Aaron Copland** (1900- 1990) was an American composer, composition teacher, writer, and later in his career a conductor of his own and other American music. Instrumental in forging a distinctly American style of composition, in his later years he was often referred to as "the Dean of American Composers."

### Ge Xu—Antiphony
Chen Yi
**Performed by Bruckner Orchester Linz /**
**Dennis Russell Davies**

*Ge Xu—Antiphony* was commissioned in 1993 by the Women's Philharmonic, San Francisco, and premiered in January 1995. In the early 1980s, Chen, then a student at the China Central Conservatory of Music, visited Southwest China's ethnic regions to collect folk music. She found that to celebrate the Chinese Lunar New Year and the Mid-Autumn Festival, Zhuang ethnic people often gathered in fields and sang songs in solo, choir or antiphonal forms. In the antiphonal singing, distinct groups or individuals make up the texts in the style of antithetical couplets, simulating a competition between the two. The vivid scenes inspired her to write music for keeping people in high spirits. The pitch and rhythms in the piece are taken from folk songs and dance music of Zhuang, Miao, Yi and Bouyei ethnic groups.

**Chen Yi**, born 1953, in Guangzhou, China, is an American composer of mostly orchestral, chamber, choral, and piano works that have been performed throughout the world.

## Symphony in G# Minor
Elliot Goldenthal

**Performed by Bruckner Orchester Linz / Dennis Russell Davies**

The *Symphony in G# Minor* was written for the Pacific Symphony and its Music Director Carl St. Clair as part of the orchestra's 2014 American Composers Festival. The piece consists of two movements: Moderato con Moto and Rondo Agitato. The first movement encompasses a four-note motive spoken from the bassoon and a five-note phrase in the oboe section. These motives happen against a "rocking gentle percolation" on the harp and violas, and the four-note motive is stated boldly at the end of the first movement before being repeated in diminution form in the second movement. In the program notes of the premiere, Goldenthal explains that using the unusual key of G-sharp minor was personal and intentional. He had always felt a connection to the timbre in the note G-sharp, as well as an attraction to the key of A-flat. It is a unique choice, as there are few other pieces in history to be written in this key.

**Elliot Goldenthal**, born 1954, is an American composer of contemporary classical music. He was a student of Aaron Copland and John Corigliano, and is best known for his distinctive style and ability to blend various musical styles and techniques in original and inventive ways. He is also a composer of film music, and won the Academy Award for Best Original Score in 2002 for his score to the motion picture *Frida*.

*Music on the Move* is the latest step in the successful collaboration of Bruckner Orchester Linz under Dennis Russell Davies and Ars Electronica. Their aim is to test innovative ways of combining music and new visual forms of expression. The possibility of taking the initial experiment (2003) to a profound level was fostered by the constellation of Ars Electronica, the Bruckner Orchester and its conductor, Dennis Russell Davies, and their shared interest in unconventional transdisciplinary performance practices.

**Dennis Russell Davies'** activities as opera and concert conductor, pianist and chamber musician are characterized by an extensive repertoire ranging from Baroque to contemporary modern works, by fascinating and brilliantly conceived programs. Since 2002, Dennis Russell Davies has been chief conductor of the Bruckner Orchester Linz and opera director at Landestheater Linz.

The history of the **Bruckner Orchester Linz** spans 200 years of tradition and excellence. In the last three decades, it has won an international reputation as one of the leading orchestras of Central Europe. Consisting of 130 musicians, the orchestra is not only the concert orchestra for the state of Upper Austria but also the opera orchestra at the Landestheater Linz, and participates in the Bruckner Festival, the Ars Electronica Festival and the Linzer Klangwolke. The Bruckner Orchester Linz has performed extensively in the United States (2005, 2009), Germany, Spain, and Italy under Chief Conductor Dennis Russell Davies and had appearances in Japan and France.

Curators *Music on the Move*: Dennis Russell Davies, Heribert Schröder, Gerfried Stocker

events and ear-piercing sounds can also temporarily take place. This new, urban attitude towards life gives the people and communities the possibility to develop a sound culture, aural cultures of remembrance and acoustic landmarks. *Post City—An Aural Fiction* consists of four movements: Before—Now—A soundwalk—Time stands still. The piece is made up of field recordings, sound design, and composed elements. It is conceptualized for subwoofer, loudspeaker, horns, and hypersonic speaker, as a concertante sound installation. In Post City it is not simply a question of less or being against something, but being for something radically new.

## Post City—An Aural Fiction
Wolfgang Dorninger

There is no more noise in the Post City. It is so quiet that the inhabitants have to add sounds. This happens through the settlement of animals, wind-operated sound sculptures, the creation of watercourses and cascades, but also through designed soundscapes and zones in which noise, very loud

Music and Sound Design: Wolfgang Dorninger

Sound stands at the center of Wolfgang Dorninger's artistic work, as the operator of the experimental music label *base,* performer, composer of theater and film music, sound designer, sound artist or lecturer at the University of Art and Design Linz. Two diametrically opposed sound worlds dominate the work, which is located between digital sound generation and concrete ambient noises. The arrays range from concertante space-sound-installations, multimedia performances, and acoustic presentations to theater music and techno.

## Selbsttonfilm
**Example of "Un chien andalou" [An Andalusian Dog] by Luis Buñuel and Salvador Dalí (1929)**
Peter Karrer

The sound doesn't make the music; the film does! *Selbsttonfilm* analyzes existing video material according to a prescribed set of rules and generates

a soundtrack on that basis. The film sets itself to music, so to speak, and the synchronized playback of the appropriately matched up images and sounds provides a fascinating audiovisual experience.

This work is a composition of excerpts from "Un chien andalou." From these film clips, *Selbsttonfilm* generated tones and assigned them to 12 orchestral instruments. Excerpts from this material were then arranged in such a way that the generated sound coalesced into a musical work. The film clips are screened together with their respective sound phrases and arrayed in 12 fields corresponding to their respective instruments. This musical interpretation of the on-screen action isn't a live orchestra's artistry; it's the output of software reacting to the visual content.

University of Art and Design, Linz, Time-based and Interactive Media program

**253**

## *Pianographique*—a performance of selected piano etudes from Philip Glass
performed by Maki Namekawa, real-time visualization by Cori O'lan

The 20 piano etudes were begun in the mid 90s and new music was added to this collection until 2013. Philip Glass writes about them: "Their purpose was two-fold. First, to provide new music for my solo piano concerts. And second, for me to expand mv piano technique with music that would enhance and challenge my playing. Hence, the name Etudes, or "studies." The result is a body of work that has a broad range of dynamic and tempo. The second set of 10 Etudes (now referred to as Book 2) has turned out quite differently. Just as Etudes 1-10 (Book 1) took up the technical matters of piano playing, Book 2 is an extension of a musical journey undertaken in the last 10 years. The subsequent Etudes have been about the language of music itself—developing new strategies regarding rhythmic and harmonic movement. The last Etude (No. 20) was composed just after Godfrey Reggio's latest film, *Visitors*, and follows closely its music."

**Maki Namekawa's** recent engagements include the Royal Concertgebouw Orkest Amsterdam, Munich Philharmonic, Munich Chamber Orchestra with the Ligeti Piano Concerto, Dresden Philharmonie, the Stuttgart Chamber Orchestra, and Bruckner Orchester Linz. Namekawa performed Hovhaness's *Lousadzak* with Seattle Symphony Orchestra conducted by Dennis Russell Davies. In 2013 Namekawa performed the world premiere of the *Complete Etudes for Piano* by Philip Glass at the Perth International Arts Festival with Philip Glass. Together with Dennis Russell Davies, she has been collaborating with the Ars Electronica Festival for many years to realize a series of live performances for piano with real-time computer-generated visuals.

254

## Diaspora Machine
### Anatol Bogendorfer, Peter Androsch (Hörstadt)

The *Diaspora Machine* is dedicated to the phenomenon of scattering, diffusing, disseminating (διασπείρειν diaspeírein, strewing about). The gigantic spiral packet chutes in the former Postal Service logistics center on the grounds of Linz's main train station stand like a pre-modern mechanical signal warning of the diasporas. As a huge *organon*, it distributes voices, sounds, light and objects that are smuggled in through channels with plenty of twists and turns, and arrive and dock at various places where they announce their presence. Singers, trumpeters, choruses, musicians, loudspeakers, and light, physically occupy the chutes. They seep through the machine, are dispersed and spat out. They make the machine quake, resound and groan.

*Diaspora Machine* is realized with the collaboration of the Landestheater Linz's Children and Youth Choir and Anton Bruckner Privatuniversität in cooperation with Landesmusikschulwerk OÖ. With the participation of Hard-Chor Linz.

## Soundfalls
### Karl Ritter, Wolfgang C. Kuthan, Herwig Bachmann

*Soundfalls* features the three protagonists of the *SoundRitual* project performing in the imposing heart of the Post City venue, where they'll display their tonal artistry on the spiral packet chutes in this former Postal Service logistics center. As in previous SoundRitual performances—from Vienna's St. Stephen's Cathedral to Grundlsee, a pristine Alpine lake—the essence of the matter is energetic tone painting with fascinating drone compositions consisting of stratified guitar feedbacks. "Musical pieces that draw the listener inside, that, throughout their entire duration, are based on the same bass drone tone and nevertheless reveal a multilayered microcosm deep within." *(Der Standard)* The complex oscillations of the basic keys also correspond to the spectrum of primary colors. The reduced LED visualization evokes barcodes and thereby alludes to the postcode system via the parcel distribution infrastructure that's now so conspicuously obsolete. *http://www.soundritual.com*

The exceptional guitarist Karl Ritter has long ranked as one of Austria's most innovative, experimental musicians and his constant search for new musical challenges led him to reduce the sound spectrum to a subtly formed monotone. Since 2011 he has been collaborating on the development of the artistic project *SoundRitual* with Wolfgang C. Kuthan, originally from Austria, who is a French multi-talent—director, author and photographer—who worked as an art director in the Paris fashion scene for twenty years. The two artists teamed up with visual communication expert Herwig Bachmann on this project.

**255**

# Russian Sound Art Showcase
Curated by Sergey Kasich

### Atonal Architectonics: Postroenie

Russian Sound Art Showcase is a standardized environment for presenting multichannel sound works by the residents of the recently emerged Russian sound art community centered around SoundArtist.ru (aka SA)) ). The concept of the Russian Sound Art Showcase is derived from the SA))_Q-O sound art framework, developed by SA))_residents in 2014 with the support of ANO ZA ART foundation and the Russian Ministry of Culture.

*Atonal Architectonics* (AA) is a series of artworks, based on communication between sound and architecture. The artworks are provided by SA))_residents and their colleagues and friends. The *Atonal Architectonics* started in 2014 with an interactive performance, sonificating architecture of the NCCA building (Moscow) at the Podgotovlenniye Sredy festival. *Postroenie* is Russian for "building" as well as "parade / turn / order" as well as "composition / construction". It has the same roots as the word *"nastroyenie"* (Engl.: "mood") and could be read as a play on words–*"post-nastroyenie"* (like post-mood). *Atonal Architectonics: postroenie* is a collective exhibition of multichannel sound works in a standardized environment. The exhibition shows recent pieces by several sound artists from the post-Soviet region. All the pieces are somehow or other related to architecture or urban mood of post-Soviet cities. Some of the works are specially produced for the showcase at Ars Electronica 2015 Post City. The works use different techniques: some of them are recorded audio, some are generative software adapted to the system. Custom algorithm is used to show the works one after another, producing this way a kind of "parade / order" and at the same time sound "construction / composition". The exhibition is fully automated.

*http://www.SoundArtist.ru*

## Participants

**Oleg Makarov** is a composer, sound artist, media artist, hardware/software interactive systems and instrument maker. He composes various kinds of music—chamber, instrumental, vocal, and electroacoustic, and has been composing music for radio plays for Radio Russia and Radio Culture since 2006. Since 2004 he has participated in international festivals and exhibitions of modern art as a composer, author of multimedia interactive installations and performances, multi-channel algorithmic audio installations. He regularly performs his electroacoustic pieces, both composed and improvised, in various art centers, and makes experiments in cross-media fields of arts, electronics, programming etc. He researches algorithms of sound, movement and video interactions using interactive graphical programming environments. *http://olegmakarov.ru/*

**Patrick K.-H.** is a sound / video artist, working with live and written acousmatic sound installations, graphical collage and animation. He has been a resident of the Theremin Center, Moscow since 1999 and Diapason gallery for sound art (NYC, 2008). Art director of Media Studio in Alexandrinsky Theater, co-founder of Floating Sound Gallery for spatial sound (currently St. Petersburg). *http://drawnsound.org http://soundartgallery.ru/*

**::vtol:: aka Dmitry Morozov** is a Moscow based media artist, musician and engineer of strange-sounding mechanisms. In the mid 00s Dmitry started actively using his DIY and circuit-bent instruments for his own music projects, as well as making instruments for other musicians and media artists. He is the first batch producer of music and video synthesizers in the post-Soviet area. Besides making music and instruments, Dmitry creates audiovisual art installations and promotes circuit bending and DIY electronics in Russia through lectures and workshops. *http://vtol.cc/*

**Sergey Kasich** is an experimental musician, multimedia artist, composer and interdisciplinary researcher. Since 2008 he has been creating interactive and generative sound and multimedia art installations and pieces alone and in various collaborations, providing interaction design, sound and visual design, creative coding, development, engineering and consulting. He also works as a composer and a sound producer for theaters, performances and in other spheres, including pop-music projects. Sergey is the founder and curator of Moscow Sound Art Gallery SA))_gallery and Moscow Sound Art Studio SA))_studio. Born in Sevastopol (Crimea), he is currently based in Moscow. *http://www.soundartist.ru/kasich/*

**Viktor Chernenko (aka Acousmatist)** is a composer and programmer. Styles: experimental electronic, contemporary composition for symphonic and chamber orchestra. He graduated from the Theremin Center at the Moscow State Conservatory. He is assistant professor in the Moscow Studio for Experimental Sound and Multimedia Technologies and a member of the Laptop Orchestra "CybOrk". *http://www.soundartist.ru/projects/acousmatist/*

**Alex Pleninger** is composer, electronic musician, and synth developer. He started work in the 80s as a computer composer and developer of sound patches for commercial synthesizers and now focuses on Buchla 200e and custom developments for musical and visual performances. He is one of the main figures in the new Russian synth-making movement, being a co-author behind sputnik-modular, traffkin & associates and other developers for modular systems. In 2015 he co-curated the СИНТЕЗ (Engl.: SYNTHESIS) exhibition in Moscow's GROUND gallery together with Andrei Smirnov. Alex is currently based in Moscow.

**Sergey Filatov** is artist, musician, composer, sound artist, video artist, author and developer of electro-acoustic musical instruments. He is a member of the Union of Artists of Russia and the International Association of Fine Arts UNESCO. He studied Fine Art and Graphic Design at Kuban State University and has been actively exhibiting his works as well as organizing a number of creative projects, personal and collaborative, including festivals of experimental music since 2000. He is the author and creator of *Neti Neti* sound theatre. The artist's works can be found in private and corporate collections in Russia, India, Canada, Switzerland, and the USA. He lives and works in St. Petersburg.
*http://sergeyfilatov.com/*

**Polina Dronyaeva and Alexander Senko** were both born in Moscow, and live between Moscow and Barcelona. They have been exhibiting together since 2008 with various soundscapes and interactive projects. Their main research interest is the interplay of inner and outer worlds of human beings.
*www.acousticimages.net*

**Vlad Dobrovolski** was born in Russia in 1974 and is a sound artist. He has released music and impromptu recordings under the Fitz Ellarald moniker for the Tokyo-based experimental music label Amorfon. In 2003 he started to perform improvised music as a part of the Las Kalugas quartet. For getting basic drone sound supporting improvisation, he often used vintage Russian analog systems. The improvisation style has been influenced from traditional Okinawa island music. Dobrovolski is also a band member of kurvenschreiber, a tape duo S A D participant and Cyland Audio Archive curator.
*http://dobrovolski.net/*

**Boris Shershenkov** is an engineer and sound artist from St. Petersburg, and curator of Spatial ElectroAcoustics Laboratory SEAL (former LEMESG) at the St. Petersburg Sound Museum. His sphere of interests includes applied media archaeology, musique concrète, electro-acoustic improvisation, spatial sound installation, musical instrument making and modification. *https://vimeo.com/shebos*

**Eugene Cherny & Gleb Rogozinsky** are young experimental musicians and sound and media artists from St. Petersburg, and professional programmers who work with self-developed computer algorithms. Their activity includes working on web-based projects, as well as recent multi-media theatrical productions for Alexandrinsky Theater.
*http://oscii.ru/*

Chris Bruckmayr & Dobrivoje Milijanovic aka raum.null

# The Sixth Wave of Mass Extinction

Future visions of the Post City are often dark scenarios of polluted regions, full of people, vehicles, robots, and darkened architecture—contaminated through pollution, shadowed through dirty clouds. Thus, artists, scientists, and researchers from all fields work hard to design the best possible future for Post Cities, perfectly smart environments, flooded with light on the perfectly designed green areas and with beautifully constructed technology that facilitates all aspects of life. In this plan of a Post City, nature as wilderness is preserved on the outskirts in small protected areas—and at the same time we are losing species every day through the scientifically proven accelerated modern human-induced sixth wave of mass extinction (see Ceballos et al., 2015). So will the Post City be a smooth and perfectly smart environment where the influence of wilderness and its soundscape are a concept of a lost past? As a sequel to last year's *Quadrature* that announced something dark coming, this year we reflect upon how the seemingly unnoticed mass extinction affects city dwellers. How does the loss of species affect city inhabitants? Does the change from an environment influenced by the wilderness to a designed world affect our (collective) psyche? Does it sadden us or have humans, in the meantime, evolved beyond the deeply ingrained life in the wilderness? What remains of the human animal we all stem from? The performance aims at the amygdala of our post-modern societies by revealing a view to the core of our collective fears. Sonically and visually it will unearth the hidden unease that we all might harbor, faced by the sixth wave of mass extinction. We pretend to feel safe, believing that society's amygdala is protected by smart technologies and 21st century policing systems. But the silent ghosts of all extinct species are still with us, and who is next?

Sound: Chris Bruckmayr & Dobrivoje Milijanovic aka raum.null *http://raumnull.tumblr.com/*
Voice: Didi Bruckmayr aka Fuckhead
*http://www.fuckhead.at/*
Visuals: Veronika Pauser aka VeroVisual
*http://www.verovisual.com*, Peter Holzkorn aka voidsignal
*http://voidsignal.com*, and Florian Berger aka Flockaroo
Producer: Claudia Schnugg

Ceballos et al. (2015). *http://advances.sciencemag.org/content/1/5/e1400253.full*

Robert Lippok and Wolfgang Fuchs

# Listening Post

Ars Electronica and LENTOS Kunstmuseum Linz have been jointly showcasing contemporary media art for years now. The 2015 Festival's program features a project curated by Markus Hofmüller: *Listening Post* by artists Robert Lippok and Wolfgang Fuchs. *Listening Post* deals with auditory perception. Its experiential horizon extends from the cityscape into the museum. The works by Robert Lippok (in the LENTOS Reading Room) and Wolfgang Fuchs (Main Staircase) are situated at the nexus of interior and exterior, and thus furnish perception concentrated on the auditory level. *Listening Post*, *Expedition Sonar*, and the works in their *Sound*

*Passagen* series constitute the basis for further intensive encounters with soundart at the LENTOS Art Museum Linz.

The point of departure of Robert Lippok's composition was *The River Flows and All Is Well* by his band To Rococo Rot. Pina Bausch used this piece for her production *Vollmond*. Inspired by this work, Lippok conceived 10 sound miniatures for the LENTOS.

Wolfgang Fuchs engenders a novel sonospheric experience. Methods used to listen to music in isolation or in private—wearing headphones, for instance—are thwarted by turning the volume way up.

*Listening Post* is a cooperation between Ars Electronica and LENTOS Kunstmuseum Linz

RAUM LENTOS / Listening Post—View of the installation

LENTOS Art Museum Linz / Reinhard Haider

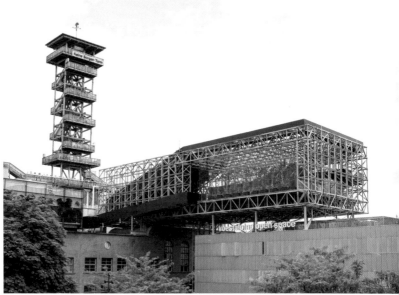

Otto Saxinger

Höhenrausch 2015
# metamusic
alien productions

In an expansive aviary especially constructed for Höhenrausch 2015 *The Secrets of Birds* in the voestalpine open space, a group of nineteen grey parrots and two Amazon parrots have taken up residence for the entire duration of the exhibition. Together with the artists and caretakers they playfully explore mechanical and electronic instruments and sound devices. These have been especially designed for them and are continually modified and further developed. In addition, the artists perform with their feathered partners—partly together with guests—in a special concert series. Like the entire *metamusic* project, alien productions regard this installation and the concerts as a long-term artistic research project with and for a group of grey parrots. The artists have been working with the birds since 2012, strictly observing animal protection regulations and in close collaboration with zoologists and biologists from the parrot protection organization ARGE Papageienschutz. They observe how the birds react to acoustic stimulation and accordingly develop instruments with which the animals themselves can actively produce sounds. In the course of this, the parrots are neither trained nor conditioned, but instead cooperate voluntarily. Whether the parrots actually become "musically" active of their own volition and what this "animal music" might sound like, are topics that are investigated in the project.

Translation: Aileen Derieg

Höhenrausch 2015 *The Secrets of Birds* is a production by OK Center for Contemporary Art, Linz.
*metamusic:* idea, artistic direction, and instruments: alien productions (Breindl, Math, Sodomka) Commissioned by OK Offenes Kulturhaus. With the kind support of voestalpine AG in Linz.

*metamusic* was the winning project of the ECAS Artist in Residence 2012 in conjunction with the project *Networking Tomorrow's Art for an Unknown Future,* Working Phase 2, on the theme Networks of Advanced Sound and Related Arts—Bridging cultural sectors and different media, and enabling citizen innovation, and was awarded the CYNETART ARTE Creative Commission 2015.

voestalpine Klangwolke 2015

# HOCHWALD
## Dance of the Trees in Donaupark
by Lawine Torrèn

**Adalbert Stifter's tale *Der Hochwald* as Alfresco Urban Theatrical Take on Paradise and Its Loss**

HOCHWALD [High Forest] is a love story set during the Thirty Years' War. In the Bohemian Forest, a father fears for the safety of his two daughters, so he brings them to a secluded cabin in the woods. Despite its secluded, pristine location, their hiding place is discovered by a young man, who falls in love with one of the girls.

Before the background of a story about the forest, innocence and longing for security, this production deals with the future of nature. In the words of director Hubert Lepka: "We're busy giving thought to the development of cities in the 21$^{st}$ century, but we've failed to establish an agenda for the future of those natural landscapes that have long since ceased to be independent of human beings. All the forests in Europe are man-made. So then, how do we plan to go about fabricating nature so that it's worth living in?"

In other words: the Bohemian Forest today is the site of commercial forestry. Huge old trees and cultivated nature, on the other hand, are to be found only in city parks and English gardens.

The show's libretto translates Stifter's romantic 1842 tale into the urban landscape & cityscape of the City of Linz in 2015. Since neither the Danube nor the downtown buildings can come to the forest, the forest has to come to Linz. In this colossal choreography, backhoes, forklifts, trucks, and ships get several dozen trees dancing—a veritable evergreen forest tripping the light fantastic around a cabin in the woods. The soundtrack updates marching music and the elaborate polyphony of the Late Renaissance into the context of contemporary electronic music and musical drama in the style of a moving narrative film score.

The banks of the Danube and the entire visible cityscape will be perceived as a moving natural landscape in which a winged creature tenderly hovers above a piece of demolition equipment.

*http://www.torren.at*

This is the third time that Lawine Torrèn is producing the Linzer Klangwolke. The previous productions were *Teilung am Fluss* (2005) and *Baby Jet* (2010).
The 2015 voestalpine Klangwolke is presented by LINZ AG
Design: Lawine Torrèn
Concept and director: Hubert Lepka
Libretto and adaption: Joey Wimplinger
Music: Peter Valentin
Lighting: Frank Lischka
Architecture: Wolfgang Czihak
Video: Stefan Aglassinger
Photography: Magdalena Lepka
Graphic design: Eric Pratter
Head of production: Klaudia Gründl de Keijzer
Pyrotechnics: Christian Czech
Artistic director LIVA: Hans-Joachim Frey
Business manager LIVA: Wolfgang Lehner
Project director LIVA: Wolfgang Scheibner

HOCHWALD Daniela Faria © Bernhard Müller

# Living as holistic organic interaction
The Mobile Ö1 Atelier

Staging the Mobile Ö1 Atelier in the heart of the city has become something of a tradition for the Ars Electronica Festival and cooperation partner Ö1, Austria's cultural radio station. 2015 the Ö1 Mobile Atelier is designed by Pneumocell, Vienna-based architect Thomas Herzig. Facing the bright, semi-transparent Pavillion, constructed out of inflatable building elements, it reminds one of biological cell structures. It's both an information point and a project exhibition venue throughout the festival, and is linked to the decentral, but pulsing, "Post City". There's the interactive, organic media installation *A tree tweets. A tree reacts* by Japanese ISI-Dentsu, Ltd. Open Innovation Lab, which connects visitors to the Mobile Ö1 Atelier at Linz Main Square with the Post City *Knowledge Capital.* Anyone standing under the tree in this installation may be surprised by the tree's perceptive reaction to their mood.

An acoustic installation can be experienced in Post City's glass-fronted hall that offers a stunning view of the Alps that backdrop the wide railway track system. Microphones in these urban traffic structures capture sounds that are relayed to Post City. Media artist Peter Karrer offers a unique live sonic experience with an acousmatic interpretation of the visual reality that will be transmitted from Post City to the Mobile Ö1 Atelier.

Another project in the Mobile Ö1 Atelier is Aquaponic-Austria's aquaponic system—a circulatory system in which vegetables and fish prosper naturally.

Another acoustic project investigates the question: How does Austria sound? While the "Digital Leben" (digital life) series was on summer break, a joint venture by Ö1 (production) and Hörstadt (concept, recordings, scripts) limned Austria's acoustic landscape and then broadcast 36 selected audible tidbits picked up somewhere in this tonally exceptional land. Over the course of a 3,500-kilometer aural reconnaissance tour, Hörstadt Linz staffers Anatol Bogendorfer (sound, photos) and Florian Sedmak

(texts) sought, found and documented things worth hearing: the foreign-sounding German spoken by the Yenish people; a Carinthian junkyard; blasting at the Erzberg open-pit iron mine; a walk-through concrete egg in Bregenzerwald; an Art Nouveau rest room in the heart of old Vienna; and the last indigo dyer in Burgenland. These are distinctive, typical and every-day emitters of auditory phenomena, scene makers, sound sources. The result was a series entitled *Land und Laute. Hörenswürdigkeiten aus Österreich*—a joint production by the ORF—Austrian Broadcasting Company's radio station Ö1 and Hörstadt, broadcast in July and August 2015, Monday through Thursday, 4:55 to 5 PM on Ö1. Now, festivalgoers can enjoy it in the Mobile Ö1 Atelier.

One special event will take place on Friday evening. Mons 2015, one of this year's European Capitals of Culture, has "Austrian Week" in its program. Austrian artists present their work at "Café Europa" in the Belgian city of Mons. As Ars Electronica's con-tribution Horst Hörtner, director of Ars Electronica Futurelab will present selected projects from Futurelab. His presentation will be broadcast live to Café Europa. (See p. 362)

Another program special on its way to becoming a tradition will take place on Saturday night: After the Klangwolke show in Donaupark on the banks of the Danube, *Electronic Theater* will start at Main Square—a screening of the top ten Computer Anima-tion winners at Prix Ars Electronica 2015. (See p. 286)

*http://oe1.ORF.at/mobilesatelier*
*http://www.pneumocell.com*
*http://www.aquaponic-austria.at*
*http://oe1.orf.at/landundlaute*
*http://www.hoerstadt.at*

The Mobile Ö1 Atelier is produced jointly by Radio Österreich 1 and the Ars Electronica Festival.

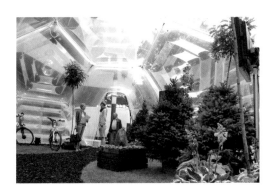
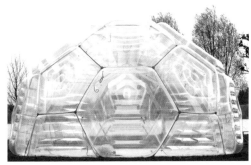

Werner Jauk

# Post-city-sounds.
## The sounds of diversity post plurality

It will be soundscapes that allow the connection of these three terms to be associated; acoustic covers, sound spheres as the products of sound waves through movement in an environment and their amplifying or weakening physical characteristics. Although originating from architecture, the approachable composition of this term has drawn upon the environment sound, the "field recording" in the city and the country, but also under water (Winderen, 2011), and has found a theoretical reinforcement of its doing therein: to store concrete sounds and to forge these in a compositional process directly on the sound (but oriented to the paradigm of composition, of the collocation, of codes for sounds) into a distinct dynamic form. Musique concrète as a composition with environment sounds is ultimately committed to the idea of the work to design an abstract composition in which the index-ical reference of sounds to their physical source is removed; the technoid music of the 1990s will first "use" the sound in the setting of hedonic lifestyles as a stimulation of physical arousal and thus break away from the understanding reception. What the theory of musique concrète formulated, its practice saw freer; sounds of landscapes are mixed and remixed not as citation-like usage, but as a contextualizing game; in the end, the perception of medial soundscapes creates "reality" that arises through the technical transmission (Fontana, 1987), resp., storage without appropriate physical existence.

Adopted by Murray Schafer in 1977 and established as a field between art and science, soundscapes are investigated with the means of "art-based research" (as McNiff, 2008, would have considered this), with qualitative methods of the clustering of perceptions. The perception of perception connects both the art and the science. The perception of soundscapes is carried out, so to speak, on three spatial and hence perceptual levels: the not always consciously heard *keynote sounds* in the (back)ground, the *signals* and the *soundmarks*, figures in the conscious foreground.

In soundscape ecology, however, a descriptive approach without (ideological) requirements is seldom found. Labeled as ecology, the conduct of nature is indebted to the interaction of the human

being with nature, without having to indicate a different theoretic reference as that of the phylogenetic development of hearing. The writings about soundscapes, like the soundscape compositions, worship a natural relation and lament the nature-supplanting cultural relation between body and environment. Although generally an urban culture that transfers the rural into the city, that lives the urban forms of life precisely in hip-hop and techno, some music coming from the pop avant-gardes and the ambient music anchored in techno is marked with the character of urban flight.

This understanding is basally shaped by a nature-bound and, in derivation of the observance of our nature through our bodies (Levy, 2000), by a mechanistic world picture. It will be the sciences of human communication and their extensions into the media arts that transfer this world picture into a communication-theoretical one; first committed to the attempt of the cybernetic description / explanation of the information transmission in information theory and increasingly to the hedonistic determination of "getting together," which sees its "reasoning" in a biologically-based life form.

After the heyday of the rational observance of perception in cognition, it will be the anthropological notions of perception that essentially bring in the "emotional" aspects in perception as an interaction process of the body with the environment. In artistic research it is the communication arts that explore the extension of interaction first in the form of mechanical information transmission as telematics, which increasingly see the narrowness of this understanding and see the frequently non-symbolically determined interaction as communication. Here the theory construction in the communication arts clearly makes reference to experimental studies and theories of social psychology, of dynamic group behavior, which leads to collective design and designing collectivization through interaction. Unreflective of their existence and their origin, these terms and mechanisms will be demanded as defining processes of net art: the collective and collectivizing interaction (D. de Kerckhove, 1995)—behavior that leads from interaction to a "communis."

The non-symbolic as non-emblematic interaction through language will first be expanded slowly through the communicative bodily expression—first as an instrumental gesture, then gradually as an emotional expression. In both cases music, as a collective shaping and as a formalization of the emotional, the physical as well as the correlating tonal expression, will be a paradigm of this development in the media arts.

What began with telematic concerts as a city-connecting switching of public communication media is possible everyday via touchable and handle-able mobile devices for "every body" without giving rise to the awareness of a global city—it is lived. What is everyday reality with face-time, the solely technically possible acoustic overlaying of soundscapes from distant places, was avant-garde exploration and enlightening realization in the 1980s—sound bridges between geographically remote, culturally "near" port cities (Fontana, 1987).

The derivation of ecological soundscape research from the human perception of physical sounds of the environment—based on the psychological knowledge of interaction in communicative processes of the 1950s and in the knowledge of perception as an intentional body-environment interaction and the function of sound thereby—can today be observed "extendedly" in connection with the mediatization of perception and hence the mediatization of the environment as an adaptive process, too.

Derived from survival acts, the anthropological view allows additional adaptations to be carried out through extended perception, through the technical mediatization of perception.

What is this anthropological approach based on? Sound is the artifact of a movement and is propagated through the compression and expansion of the surrounding air as a spherical wave to our ears. Sound thus informs us about its cause, a movement. This perception of the sound is one that is all around us. Physical differences in both ears convey to us the direction of the moved sound source; through the damping and reflection of the partial tones of a sound spectrum we learn to experience the distance and the characteristics of the surrounding space as implicit (Polyani,1958, 1966) body knowledge (Jauk, 2015a). Moreover, sound particularly informs us about the meaning of the movement for the body; it creates arousal in the body, which leads to an appro-

priate, adaptive survival behavior. Sound is thus information about a moved condition in a space and its arousal value. Sound gestures are communicative ways of behavior, the consolidation of this perception as a tracing of its movement imagination and the "reaction" of the body to it (Jauk, 2014); concrete sounds are communicated in the form of a "mimicking" (Godøy, 2006), the iconic reproduction of the indexical quality.

Sound is a medium of information about movement in the environment and arouses / activates a behavior, which in turn communicates other bodies as a sound movement of the perceiving body—to raise the survival value of the perception. In that respect, sound is socially interactive and communicative.

Social interaction is, according to this, an adaptive behavior—the city, the formalization of the communization in different stadia of cultural development. Sound of the city is not only the sound of moved nature, but of communicative behavior, of the sound gestures and their mediatization, of the mobility of the perceivers.

As a social system, the city is connected with power relationships, as an expression of *gouvernementalité* (Foucault, 2004). In sovereignty systems, the city adoringly forms itself around the devotion-provoking seat of power as a high sanctum, in sanction systems around the fortification of the seat of power demanding absolute subjection. Trade instead of self-subsistence produces an "information"-exchanging interconnectedness that uses the geographical "ways," rivers and natural roads. The insurmountable closes itself off to this communication and creates cultural islands like those still expressing themselves today in the Swiss valleys as language and life culture. Industrialization makes the seat of the city dependent on resources, the city forms itself around the production facilities, the power relationships are becoming increasingly liberal, the internalization of the promise of happiness through the medium of "possession," as an incentive for the acceptance of neoliberal power relationships.

The centers of such cities are different place structures. Houses of the sovereign, the churches, are surrounded by an open environment commanding distance and respect, their inner spaces are an enshrouding sound-location of the gathering and melding of individuals with the authority, where

sound builds itself up as hypnotic uniformity; the reverberant situation is musically utilized, for instance, in polyphony by melding decussating melody progressions into an internally moved, stationary sound texture which benefits the emotional reception structure. Houses of those who impose sanctions have bounded places in front of them that resoundingly amplify the imperious word of the "Führer" spoken from above and, like in stadia, lead to a physiological regeneration in immersive perceptual situations. Places in liberal trading cities are often "open" places of (product / information) exchange; they are permeable places that are marked by entrances and exits, they sound wide and fluid–against Schafer's fear of the loss of width sensitivity in hearing because of the city.

All these cities sound different–soundscapes first tend to the natural aspects, the physical movements mostly coming from nature, their modification through the city as a body, as a resonating space of the housing boxes and / or the spatia, the spaces between them, which function as reverberating devices (Jauk, 2008). The events clearly set themselves apart from each other; they are classifiable as light movements; their localization is easily decodable; the arousal value refers to the movement itself; adaptive behavior adequately reacts to this. It will be mobile devices that, in "parcouring" through the city, transform the sounds of the mechanical movement of objects into a sensual form in the *Mogees* project (Zamborlin, 2015). It will also be mobile devices which interlink the sounds of the current surroundings (also provided with geographic localization data) and create a global city-sound-ambient without having intended this–lived by a digital native generation which simply adopts this as technologically existent. A new amateurism in music and arts arises thereby (Jauk, 2009/Prior, 2010); a turn from the high, distinguishing culture to "people's" culture for everybody.

It is machines that overlay the impulsive single "figure" sounds; machines which, due to constant energy input, lead to movements with flat sound waves, to constant sounds of different frequency, or to rhythmized sounds as an artifact of rhythmized part production practices, strung together to ostinato sounds in loops. Their variety can no longer be heard as a figure; they coalesce into a stream of sound of higher consistent intensity–orientation through signal and orientation sounds is lost, the activation of those perceiving is high, their manner of reaction is permanently aroused–but no longer executable. As a consequence of the machinization of industrialization, this situation would lead to lo-fi soundscapes (Schafer, 1977).

Global cities as post-cities are other centers, centers of the administration of globally distributed labor and of finances–the communication via the Net makes this possible as a global life form, irrespective of space and time–global cities are more shaped by this function than by the adaptation to the immediate surroundings. Work happens in (mostly reverently high) "boxes" of steel and glass or via mobile devices in public space–global cities sound like multiple identity–rushing in diversity, but not intensively. The ostinato-like internal sound movement of the mechanical industrial city is overcome, just like the global village–for its part the conquest of the Gutenberg galaxy–thought of in the Sixties as collective identity with a "tribal" base (McLuhan, 1995) leading to a grass roots democracy; in contrast, the global city as the avant-garde of the post-city appears as a plural identity. What appears in the social form of hi-fi soundscapes as audible figure-ground structuring, but possibly also as autocratic orientation, is, in the plurality of the interconnected individual, the noise of the lo-fi soundscape, possibly the emancipation of democratic *égalité*; the "decline of figure and rise of the ground" (Tagg, 1994) of technoid, urban and interconnected music culture is, in that respect, the social soundscape of the Net-city-life.

If places of the mobile age were permanent communication nodes, the WWW is a interconnected system of place where information available everywhere and at any time, not a space in which communication takes place, but rather a sample space which dynamically and variably arises through communication. The Net is the space of the "all-at-onceness" (McLuhan, 1995) and an auditory space in which dynamic events move like sounds around the listener, whose selection happens through the mechanically passive, but hedonically active body: events moving around the body such as sounds will be adopted on account of their arousal quality–although there is little sound in it, it is thereby paradigmatically a sonic space, a soundscape of hedonically analyzable events.

Now this mediatized landscape shows itself as a communication form that is, apart from the sound, apart from the oral sound, increasingly based on the written word, the iconic illustration / depiction. The spoken word as an interaction between acting persons is reduced to the introduction; the initiation of the communication—other spoken words are uttered by artificial voices and do not intonate the gestures of the emotional expressivity (Wallbott, 1998)—is reduced to information transfer; there is no "fundamental tone" of such soundscapes that could mean the context of the information; lamentations about the atrophy of paralinguistic communication forms are becoming loud.

Mobile devices make global cities as nodes of the communication and administration culture superfluous and transfer into the post-city—the city becomes a virtual event space.

In the process, the protective cover of the body, the cultural space of the clothing, personal enclosure, will be taken back as the beginning of the belligerent distinction (McLuhan, 1995), the body is directly, expressively brought to sound with "wearables"— soundspheres of intimacy become public, the *iHome* (Jauk, 2015b) is in the all-at-onceness; conversely, public soundscapes are private ones. Designed according to an arousal-based sequence of grains in the form of cue lists as music-making activity (Nakamura, 2012), intimacy sounds are imposed upon the public space, but also shared with this. With the increasing availability of technologies, this mix of personal and public spaces lives apart from any exhibitionism, on the one hand, apart from annoying badgering, on the other hand.

The notions of "own" and "foreign" (Waldenfels, 1997) possibly disappear in such cities; a sensitization for the problem of marginalization possibly occurs as a result, probably with effects in both directions (Gill, 2008).

This description of various types of soundscapes as references of sound and city is first archiving and exploratory in a longitudinal section—always with the pointing finger on the transgression of nature because of cultural developments: the industrialization, the mobility and, more recently in their inversions, the "manufacturing" of virtuality and the omnipresent availability in the virtual landscape. This mechanical culture image makes way with increasing non-material mobility for a com-

munication-theoretical, hedonistically determined world picture—the selection from the arousal-based analysis of the existent makes way for an auditory behavior. Previously described behaviors of the soundscape of the Net, as an auditory space, follow this hedonic "use" of what is available.

Without the ideological gesture of Barry Truax, soundscapes are feasible and not implicit or explicitly constructed results of urban spaces. City-soundscapes are made, not as an artifact of structural physics, but as spaces of occurrences by the open staging of the interrelation of the non-verbal as sound-gestural interactions in social space, as "social sound design" (Jauk, 2014)—not as a concrete guideline, but as potentiality. In this way, soundscapes are variable and adapt themselves to human interactions and not the other way around. The set of regulations of such adaptive soundscapes that ultimately lead to spatial imaginations lie in mood management (Hargreaves, 1999), an empirically-supported theory of media behavior based on anthropologically psychological mechanisms that take on the striving of a homeostatically balanced arousal level and the avoidance of extreme arousals—both lead to corresponding stimulus selection behavior in interactions with the environment; both ultimately construct personal, emotional *iHomes* (Jauk 2015b) and, in their interaction, environments as social design—adaptive (social) life, optimizing hedonically motivated lust or also purposefully functional as a guide system (Jauk, 2014). While architecture, committed to the stone building, tends to the erection of soundscapes as corporeally viable landscapes, derived from physical constructions and their sounding details, alternative approaches penetrate from the sound studies into the design of medial landscapes, into virtual landscaping, which no longer distinguishes between city and country, between I and we, into the design of post-cities.

Beside and in all these thoughts on soundscapes is the analysis or synthesis of communication as the creative power of spaces of occurrences, of soundscapes, that which constitutes the post-city as an unlocated space. The mechanical transport world of trade and its city networking precedes the interaction medium of the digital world and leads into the global cities; the exchange of letters precedes the verbally placeless communication—the post as a distribution medium of cool "things" and hot "loves"

will be reflected in the first communication arts; it is a meta-form of spaces / of occurrences following the being "post" of the global city.

Post-cities follow the paradigm of communication—emotional communication as music does formalize sound as a stimulus of interaction of the body with physical and social environments—but, freeing the body from any independence of these environments, creates its own living space, its *iHome* (Jauk 2015b). Music is the paradigm of this kind of "diverse" emotional communication. Music is nothing but creating cultural spaces, common living spaces just by creating its soundscape. Because being controlled by the basic human body-regulation-system, "diversity" goes along with being "communis" for every body in this process of "getting together." Interacting with sound indicating occurrences around every body just to gain the optimal arousal, the best mood, structures sound to common music and, at the same time, occurrences to common living spaces. Immateriality of the digital code allows this to be done by will, despite being done just by nature. While in the material world the body adapts to the environment in virtual post-cities, the environment adapts to the bodies. Creating *iHomes* this way, post-cities are cities not only of (postmodern) plural communities, but of social "places" of human diversity—post-cities sound individually and collectively for every body.

Translation: Brian Dorsey

References

Foucault, M. (2004). *Geschichte der Gouvernementalität (I, II)*. Frankfurt am Main: Suhrkamp.
Gibson, J. J. (1982). *Wahrnehmung und Umwelt*. Munich: Urban & Schwarzenberg.
Gill, R. (2008). Empowerment/sexism: Figuring female sexual agency in contemporary advertising. *Feminism & Psychology 18(1)*, 35-60.
Gill, R., Scharff, C. (2011). *New femininities: Postfeminism, neoliberalism and subjectivity*. New York: Palgrave Macmillan.
Godøy, R. I. et al. (2006). Exploring music-related gestures by sound-tracking: A preliminary study. *Proceedings of the COST287-ConGAS 2nd International Symposium on Gesture Interfaces for Multimedia Systems (GIMS2006)*, 27-32. Available from www.iscrim.org.uk/gims.
Hargreaves, D. J. and North, A.C. (1999). The Functions of Music in Everyday Life: Redefining the Social in Music Psychology. *Psychology of Music 27(1)*, 71-83.
Jauk, W. (2009). *pop/music+medien/kunst. Der musikalisierte Alltag der digital culture*. Osnabrücker Beiträge zur Systematischen Musikwissenschaft 13. Ed. Bernd Enders. Osnabruck: Universität Osnabrück.

Jauk, W. (2014). Intuitive gestural interfaces/adaptive environments and mobile devices/apps. Playing music and the musical work as a role model for personalized gestural interaction in social environments. *ICMWT International Conference on Mobile& Wireless Technology Congress Book*, Beijing, 280-284.
Jauk, W. (2015a). Basic instincts … Kultivierung / # Kulturen des auditiven Körperwissens. Auditives Wissen – implizites Körperwissen aus der Erfahrung des körperlichen Hörens bewegter Natur zur Orientierung in physikalischen und virtuellen dynamischen Umwelten. *Auditive Wissenskulturen*. Eds. B. Brabec de Mori, M. Winter. Springer-Verlag (in print).
Jauk, W. (2015b). Personal Home / iHome. Kulturelle Überschreitungen durch Unterschreitung der Wahrnehmung. *Überschreitungen II. Projektentwürfe und performative Beiträge*, 110-123. Ed. Heimo Ranzenbacher. Wien/Judenburg: Liquid Music.
Kerckhove, D. de (1995). Kunst im World Wide Web. *Prix Ars Electronica 95*, 37-49. Eds. H. Leopoldseder, C. Schöpf. Vienna: Österreichischer Rundfunk.
Lévy, P. (2000). Die Metapher des Hypertextes [1990]. *Kursbuch Medienkultur. Die maßgeblichen Theorien von Brecht bis Baudrillard*, 525-528. Eds. C. Pias et al. Stuttgart: DVA.
McLuhan, M. (1995). *The global village: der Weg der Mediengesellschaft ins 21. Jahrhundert* (Translation: C. P. Leonhardt, Introduction: D. Baake). Paderborn: Junfermann.
McNiff, S. (2008). *Art-Based Research*. London: Jessica Kingsley Publishers.
Nakajima, S. (2012). Prosumption in Art. *American Behavioral Scientist 56*, 550-569.
Polanyi, M.(1958). *Personal Knowledge*. Chicago: The University of Chicago Press.
Polanyi, M.(1966). *The Tacit Dimension*. Chicago: The University of Chicago Press.
Prior, N. (2010). The rise of the new amateurs: Popular music, digital technology and the fate of cultural production. *Handbook of Cultural Sociology*, 398-407. Eds. John R. Hall, Linda Grindstaff, Ming-cheng Lo. London: Routledge.
Schafer, Murray. (1977). *The Tuning of the World*. New York: Knopf.
Tagg, P. (1994). The Decline of Figure and the Rise of Ground. *Popular Music 13/2*, 209-222.
Waldenfels, Bernhard (1997). *Topographie des Fremden. Studien zur Phänomenologie des Fremden*, Bd. 1, Frankfurt/M.: Suhrkamp.
Wallbott, H. G. (1998). Bodily expression of emotion. *European Journal of Social Psychology 28*, 879-896.

Sound Works

Fontana, B. (1987). *Soundbridge - Köln / San Francisco*.
Jauk, W., Wicher, M.(2008). *sampling the spaces, Rethinking the "infinite potentialities"*. In Homage to Luigi Nono, 11. Mostra Internazionale d'Architettura. La Biennale di Venezia.
Schaeffer, P. (1948). *Étude aux chemins de fer*.
Winderen, Jana (2011). *Energy Field*.
Zamborlin, B. (2015). *Mogees Project*.

Werner Jauk

# iHome
## personal home & "diverse" cities

In reference to what the term "personal" denotes in the age of command language as an interaction medium of wo-men-machine, as an echo of what the "i" in the age of intuitive interfaces connotes, *iHome / personal home* wants to be the continuation in the gesture-interaction of human beings with spaces, to a life with partner-like living spaces. Being based on the body-self-regulation-system by arousal, on the social domain, creating these iHomes does not collectivize the "I" but individualize the "we"–"diverse" social "places" are coming up.

It is not about the automated mechanical control of spatial conditions that are regarded as variable in spatial design architecture, the light and its mood or the multi-media entertainment program consisting of word, sound, image ... it is about the emotional, whole body interaction with a multi-sensory environment, about mood management, it is about an adaption of the environment to the hedonic needs

Julian Jauk

The mechanical human being is the measure of all things–the hedonic human being is the measure of all dynamic virtualities.

of the body following the paradigm of music to formalize the hedonic interaction of the body with an environment–finally creating a virtual environment, the "Werk," by the relations of tension-relaxation. Transferred from film and especially music reception, mood management means the regulation of the body's state of arousal in different moods towards an optimally pleasant sense of well-being. In the process, good moods are generally affirmed by good feelings, bad feelings are compensated by good feelings, but sad moods in particular are also "lived out" through the reception of sadness-inducing media in the form of the meta-emotion. People generally prefer the boosting or compensating type of mood regulation.

Like the choice of partners happens according to the similarity or supplementation to one's own personality, that is, according to the strengthening or compensation of one's own personality, this selection is also necessary for the mood management of the iHome. This then adjusts itself to the needs of the human being–on the musical paradigm it regulates the sound of the space and para-sonically the light, the smell, the tactually felt air movement in the space ... The iHome recognizes the mood of the person by his/her gestural, whole-body expression, which primarily communicates arousal, and adaptively learns to homeostatically optimize the state of arousal according to the respective behavioral change–iHome is thereby an extension of the hedonic body and leads this way to the social domain: it creates common places for every body, it structures "diverse" post-cities.

Translation: Brian Dorsey

iHome is based on the University of Graz's sound-gesture research experiments and art-based research in the field of sound-gesture interaction in the social realm of "social sound design."

u19 CREATE YOUR WORLD

# u19 – CREATE YOUR WORLD
## Future Festival of the Next Generation 2015

The festival within a festival is celebrating its fifth anniversary! This is a conclave for kids and young people as well as for grown-ups to convene and give some thought to the world of tomorrow. This year's playground encompassing open labs, events and exhibits is a jumbo-format biosphere, a living room for the future. Once again, an open space invites lateral thinkers and actionist tinkerers, those thirsty for knowledge and hungry for experience, to take the plunge into an invigorating environment full of alternative models for modern real life.

This anniversary edition is also kicking off a newly developed format. Selected festival projects will now be touring Austria, which means that what began in 2011 as a spinoff of the Prix Ars Electronica's u19 category is now a year-round initiative staging workshops designed to propagate new technologies, media and socially relevant projects in their latest stage of development, and to support schools in rapidly integrating them into classroom instruction.

### POST CITY

u19 – CREATE YOUR WORLD is a showcase of projects having to do with sustainability, developing a sense of responsibility for the world of tomorrow, and lots of novel, creative ideas about how to configure the development of our future (digital) habitats. How will human beings coexist in 20 years?

AEC, Florian Voggeneder

What are the long-term consequences of mass exodus from rural areas to cities?

Kids and young people are invited to contribute ideas and models dealing with this development. This year's featured theme, Music and Sound, focuses on how noise affects human coexistence. What will the sounds of the future be like? How much noise can we actually withstand? Plus, the staff of a project entitled *UnterDemBeton (under concrete)* will be looking into what life will soon be like in our cities and on our streets. What will be the upshots of covering our planet with concrete?

### HEAR WHERE?

Sound has a particular advantage that's also a disadvantage: We can't turn off our sense of hearing. Ever! Nonetheless, our surroundings are getting louder and louder, and the need for silence and tranquility in everyday life is becoming increasingly prevalent. Excessive noise causes stress and sickness. How can we combat incessant noise pollution? What sounds are conducive to wellness, and which make people feel uneasy? *sound:city:lab*, a youth exchange event, will scrutinize many different festival projects in terms of their tonal qualities and report their results in a post:city documentation, a sound performance in which youngsters will present what they consider to be novel, possible acoustic realms.

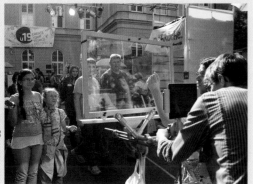

AEC, Florian Voggeneder

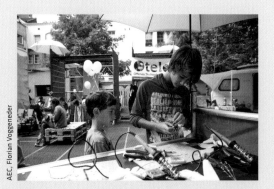

AEC, Florian Voggeneder

Otelo OPEN CITY LAB

## Industrie zum Anfassen
### BRP Powertrain Apprentice Workshop

BRP-Rotax apprentices simulate working in an industrial environment and demonstrate an innovative model of future production. In Industry 4.0, apprentices let visitors experience the possibilities of how production could function in the future. Plus, visitors can try out a 3D printer to see how it works. Get a fascinating, close-up look at how things will be produced someday soon.

## Open City Lab
### Otelo Network Linz and Vorchdorf

As a means of fostering playful experimentation, Otelo is erecting the construction site of the future. There's a place for everyone on this job and lots of room for design creativity. Also going up is a working & living lab as a prototype of futuristic habitats. Otelos are settings for open encounters that open people's minds. They're places for interrelationships to emerge. How could a whole city become a place like this someday? The watchwords: Hands-on experience, collaborative experimentation, and enthusiastic celebration!

Loopex

## Analog Network
### Ars Electronica

A huge network of tin-can telephones spreads across the festival village like a supersized spider web. Who's talking; who's listening?

## Plastics for Life
### Apprentice Training Center of the Greiner Group, Alexander Brenner, Nicolas Groß, Matthias Thym

Real art(ificial) material is created here! This open lab turns all sorts of plastic products into a filament that can be fed directly into one or more 3D printers. The 3D Printing Lab is conducted by apprentices of the Greiner Group, which plans to emphasize this technology in future apprentice training programs.

## Kids' Research Laboratory
Ars Electronica

In order to effectively prepare young people for the realities of life in these times and the near future, it's essential to begin exposing kids to technology, science and art at an early age. At this year's Ars Electronica Festival, we want to inquire into how best to configure very elementary encounters in these areas. In this spirit, this year's u19 – CREATE YOUR WORLD Festival provides the Kids' Research Laboratory with a spacious setting in which kids can be exposed to materials designed to stimulate their sensory perception and thereby encourage them to undertake independent investigations. Running one's fingers across sand, feeling the friction of the rough grains on one's skin, strewing a handful of sand into a container full of water and observing the resulting changes—all of these are unmediated experiences that convey to children a fundamental comprehension of volume, density, cause and effect. In such processes, children demonstrate intuitive scientific understanding. They count, measure and categorize forms and patterns. They willingly exert themselves, and can focus more intensively on what they're doing at the moment. They're far removed from what was and what will be. They're simply in a state of flow, in a zone in which everything is possible. The Kids' Research Laboratory takes advantage of this fruitful state and enables kids to take a playful approach to developing an individual area in which they're interested. The kids show us what their generation is into. They ask their own questions, not ours. Kids are permitted to present their own agenda of issues, and then, in cooperation with grown-ups, select methods, tools and sources appropriate to deal with them.

Through the application of the laws of physics in a lab situation, youngsters experience themselves as effective individuals within a gigantic organism of elements, and can position themselves in this complex matrix. This engenders self-confidence and thus furnishes the basis for innovative, achievement-oriented men and women equipped with the tools it takes to shape the future.

Could it be that our children will show us their way into the future?!

## TableTalks – Kids' Symposium
Ars Electronica

TableTalks is the name of this year's conversation & symposium format bringing together kids, young people, Prix prizewinners, festivalgoers, artists, visionaries of all ages and people with a lust for life in the future. We'll also furnish various tables, each one with a different theme, people and ideas. And, of course, all sorts of tasty food will be served. In short: the perfect setting for participants and festivalgoers to discuss their various experiences, projects and visions. The guest list including a colorful lineup of experts, and the assorted menu served up by Snack:Lab will make these TableTalks a real feast for the mind as well as the palate!

### Stadt(t)räume [Urban DreamSpaces]
actinGreen

Don't we all want to feel well in the city in which we live? The cityscape is configurable—every corner, every square can be reconceived, and the resulting concept can become a reality! actinGreen takes a proactive approach to conceptualization. We utilize the methods of the theater to creatively explore and portray our wishes, to discover what an ingenious city of the future could offer us. What's your urban "dreamspace" like?

Actin Green

### PELARS "learning + making"
The PELARS Project

PELARS "learning + making" is an experimental learning environment that aims to support teachers and learners understand what's going on when they do hands-on technology, science and math in the classroom. PELARS "learning + making" opens up new ways of learning with Arduino components for learners of all ages—without the need to solder and program. u19 – CREATE YOUR WORLD will present for the first time a novel Arduino kit that allows participants to explore concepts of physical computing in a playful way. By plugging together simple modules, you can build simple games and immediately play them.

The innovative learning space, especially designed for learning activities, consists of an interactive workstation and a novel physical computing kit and development environment. This space is linked to a learning analytics system that can track how and what learners are doing, and presents feedback about ongoing learning activities to both the learners and teachers in real time—e.g. helping you program and build, or recommending applicable games.

The PELARS Project is a European research project funded through the FP7 framework.

### perpetuum choir
Jerobeam Fenderson, Ars Electronica

social composing
This participative sound installation offers visitors the opportunity to influence a 8-voice loop and be part of a five-day festival symphony. Acoustic helmets distributed throughout the Festival Village let participants add their voices to the "organizational model." How will each individual contribution fit in? Special loop algorithms repeatedly redefine this *social composing* project.

## Science Shows
### Kids' College Upper Austria

Kids are proud, and love to talk about learning something new or making a discovery. A Science Show provides a stage for this enthusiasm. In these brief performances, youngsters age 7-14 offer insights into their approaches to research and elaborate on their findings in graphic detail.

This is a project of Kids' College Upper Austria, where young people can encounter material from various scientific disciplines, do experiments in workshops with experts, and acquire new knowledge.

Andrea Jindra

## holis market

When "tomatoes have seen more of the world than you have" and, oddly, fresh, organic fruits and vegetables come packed in plastic, then smoke starts to be emitted by the brains of people who advocate using resources sustainably. Shopping at *holis market* isn't only to check off your grocery list; it's also a great way to provide for your wellbeing, enrich your life, and deal considerately with resources and the environment.

## Sound:city:lab – virtual visuals
### Network of European Multimedia Competitions for Young People: u19 – CREATE YOUR WORLD, German Multimedia Prize MB21, C3<19, bugnplay

Tonal experiments, new recording techniques and a sound collage composed of 2015 Ars Electronica Festival projects blend into an extraordinary sound performance. These comprehensive explorations will be staged under the aegis of *sound:city:lab,* this year's international youth exchange event. Acoustic researchers will jointly engender visual imagery and recollections that sounds evoke in our minds, and investigate how noise, sounds and music can positively or negatively influence our life.

A Youth Exchange event subsidized by Erasmus+

## Sehnomaten
### Doris Scharfetter-Vogelsberger

Wherever innovation and change are summoned forth is where *Sehnomaten* (Yearn-o-mats) are called for. These devices are the results of imaginative paper-folding; multilayered and intertwined, they're conceived as tables. They underscore the complexity of visions and evoke associations. But they're not just showpieces; they're also showplaces of communication. Just like a table is furniture for people to gather around, *Sehnomaten* offer a setting in which to engage in exchange, negotiation, laughing, celebration and mourning. They impart impetus to the process of give-and-take.

The tables are set spinning and flooded with projections. Similar to Tibetan prayer wheels, concepts are first put into concrete terms on objects; then they're folded together, and the rotating movement enables the ideas to unfold.

## Snack:Lab
### Alfred Pointner, Gelbes Krokodil

Ever since "Morning Meal" at the 2013 Festival, we're aware of the benefits of a warm, healthy breakfast: We're in a better mood and lots of stuff comes a lot easier. In short, we feel better. And that has a big impact on how things go at school—urban, rural, suburban, whatever. *Snack:Lab* represents post:city's take on how a healthy school snack can already begin at home ... self-warming lunchboxes, exotic dishes as well as old favorites. This is a proving ground for lunch ideas for the school year and everyday life!

## Young Animations

The Ars Electronica Animation Festival's *Young Animations* lineup features outstanding animated films produced by young people. They're screened in the Moviemento art house cinema. The program was curated by Sirikit Amann.

## u19 Exhibition

CREATE YOUR WORLD showcases the prizewinning projects in the Prix Ars Electronica's u19 category as well as a selection of other especially impressive, exciting, creative or technically sophisticated works. This expanded u19 Exhibition is thus an overview of the fascinating diversity of this year's u19 entries.

## GrünStadtBeton

Simon Lukas Haunschmid, Adam Herz-Breitfuß, Isabella Panhofer, Linda Sommer, Sarah Weile

Greening bare walls with moss and other suitable plants is the aim of this *GrünStadtBeton* (Green-CityConcrete) project based in Vienna, Innsbruck, and Linz. The moss is applied to a wall with the help of stencils in the desired form. Within a few weeks, it starts to grow. The moss is autarkic—it extracts everything it needs to survive directly from the air. Plus, there are positive side-effects: the tiny leaves remove large quantities of harmful particulate matter from the air, and moss, like every plant, converts carbon dioxide into oxygen. The project's mission is to improve urban air quality and beautify the cityscape simply by making it greener.

## Forschungsstation Wal

Kerstin Nowotny, Debora Däubl

Over the course of the festival, this *Whale Research Station* project will produce an object that resembles a whale and evokes many other associations and inspirations. Design of the interior space and its interesting array of imaginative seating fixtures will proceed simultaneously to work on the exterior shell. This construction work is meant to stimulate exchange among the practitioners of artistry and handicrafts.

The whale symbolizes the social and creative space that forms during the five-day festival. The participants' many individual ideas that influence the whale's emergence as well as the plankton that nourish it manifest themselves in the form it takes.

## Barrier-free Play

Gerhard Nussbaum, Information Technology Competence Network to Foster Integration of People with Handicaps (KI-I)

Barrier-free gaming in the real world? Playing with toys without using your hands? Overcoming limits and discovering new horizons? The KI-Information Technology Competence Network and its partners use prototypes to demonstrate all that's possible in gaming nowadays to facilitate the integration of people with disabilities. All you need is just a bit of imagination, creativity, technology and knowhow. Immerse yourself into a differently-abled world and try it out yourself!

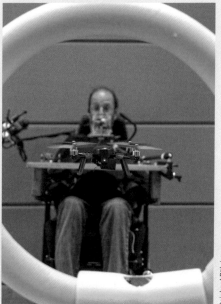

Reinhard Pühringer

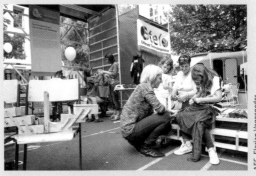

AEC, Florian Voggeneder

## City movements
### Verein FAB

Urban development offers a wealth of opportunities for inclusion and participation. With their diverse competences, people with disabilities can partake of city life in a variety of ways. Virtual Office participants invite festivalgoers to navigate a wheelchair obstacle course and to take a guided tour of the neighborhood around the train station to experience how important barrier-free design is to quality of life *(www.vo-fab.at)*. Everyone can participate in the audio editing of *Sound der Stadt*, which impressively demonstrates how music and sound relativize physical and social differences. The *City Sound* will be produced on site in cooperation with the musician PANAH.
*https://www.facebook.com/officialpanah*

## Street Tailor Shop
### Trotec

This year's post city *street tailor shop* features jumbo-format laser cutters that produce stencils to adorn all sorts of backgrounds and habitats. Use DIY techniques to create simple patterns and conveniently cut out models.

## Kinderstadt
### u19 CREATE YOUR WORLD

Kids' City focuses on the development of an alternative system and takes a playful, tongue-in-cheek approach to assessing currently prevailing institutions. For example, in a futuristic unemployment office, jobseekers can design their own position, and in tomorrow's post office, you can send mail to your former self.

## Laser Harp
### Leo Betinelli

The harp intones when installation visitors pierce a two-dimensional latticework of 16 laser beams. Invisibly produced sounds become audible. Whoever does a little dance with the bundled rays of light can even play a melody via body language!

AEC, Florian Voggeneder

AEC, Florian Voggeneder

## Wir drehen!

Students at Verein der Kreuzschwestern and HLW für Kommunikations- und Mediendesign, Fabrice Jucquois, Clemens Huber

"Wir drehen!" speaks with the voice of digital natives whose daily lives are saturated with reality, both the real and the virtual ones. They speak of friendships, gaming, and commercial & open networks that embody new relationships. They openly question which is more real, their virtual lives or their daily lives. Students from the elementary school at Verein der Kreuzschwestern, aged 6 to 10 years, are the active actors and creators in their own narratives, performed with choreography and media. Their mentors guide the student's creativity and imagination through dance, performance, and everyday media production methods that interconnect and spin narratives as a series of collaborative projects. *Wir drehen!* is a multiform project that contains the voice of an emerging generation. Listen as they spin their stories!

## Velo USB Charger

Effi Tanner, Marc Widmer, Dymaxion & SGMK– Swiss Society of Mechatronic Art

Charge your cell phone with power you generate yourself and do something for your fitness in the process! In the Velo USB Charger Workshop, CREATE YOUR WORLD festivalgoers can make a gadget to do so. A few components and a dynamo is all the Swiss Society for Mechatronic Art needs to build a personal, bike-powered mini-generator. A little tinkering is all it takes to charge your smartphone while pedaling!

EffiTanner

# Reality Levels—VIRTUREAL

The *under [my] control* research project was launched by an Expert Group in 2013; now, it's being reprised in conjunction with a project named *Reality Levels*. This is a matter of pop-ups that appear during computer games and challenge the player to complete a task in the real world. Once you accomplish the task, you obtain a code or a tracking that enables you to (more easily) continue the virtual game or gain access to secret levels or certain gimmicks. Associations, institutions and individuals can offer Reality Levels, and gamers can decide which ones they want to include in their computer game. By supporting this project, Ars Electronica aims to establish a link between gaming und social institutions, public places and private individuals, whereby the continuation of the game in the real world puts the accent on social contacts by gamers. The project's long-term goal is a social media app conducive to the formation of a community consisting of gamers and non-gamers alike, and thus the establishment of an important level of communication in the usage and social development of digital media.

### Form of Therapy

Aside from the fun factor for gamers, the project could potentially provide a therapy option or a form of aid for those at risk of gaming addiction and members of their family. There's a growing number of people having an increasingly difficult time dealing with the "always on" problem, and Reality Levels are meant to offer them an alternative to so-called withdrawal camps.

### The Minecraft AEC Pilot

A Reality Level for the game Minecraft has been offered since April 2015 in conjunction with the Highlights Tour of the Ars Electronica Center every Thursday at 6:30 PM.
Tour group members gain knowledge of a secret location where they can obtain access codes for the Ars Electronica Center's Minecraft level. This virtual AEC will be featured at this year's Festival.

### Further Development and Research

A Vienna-based youth culture research institution will ascertain the extent to which youngsters take advantage of this new offer. This qualitative research will commence in September 2015 in conjunction with the u19 – CREATE YOUR WORLD Festival. Evaluation and publication are set for September 2016.

# The CREATE YOUR WORLD Tour

More and more young people are making the u19 – CREATE YOUR WORLD Festival and the Ars Electronica Center the focal points of their ongoing efforts to develop their ideas and hone their skills in dealing with leading-edge technologies and media. But lots of kids have a hard time getting to the Festival and the Museum of the Future, which is why we've launched a new educational project.

At selected schools and institutions, we're offering a program of workshops to integrate content and ideas from u19 – CREATE YOUR WORLD into everyday classroom instruction. The tour is meant to offer pupils and faculty members means to access alternative learning & teaching methods and to playfully lay the foundation for new ideas and projects in schools. An assortment of workshops is designed to get a broad spectrum of pupils acquainted with educational alternatives and thus pave the way to integrating them into the curriculum. Plus, the tour features regional artists adept at passing along their creative ideas directly to students and teachers.

## Mobile education

The selection of projects is highly diverse. Thanks to Ars Electronica's extensive experience implementing a wide array of projects, each tour stop can be custom-tailored to the specific needs of each school. A visit by the CREATE YOUR WORLD TOUR sustainably enhances pupils' academic performance. On one hand, this transparent form of knowledge transfer is highly motivational; on the other hand, having fun and hands-on learning top the agenda here, which creates the necessary distance to conventional classroom instruction and thereby heightens youngsters' capacity to absorb and retain the material they're exposed to.

In cooperation with Mons 2015 European Capital of Culture, the CREATE YOUR WORLD TOUR constitutes a Europe-wide best-practice example for direct, uncomplicated supplementary educational offerings designed to foster integration of new technologies.

## Invented, discovered, used ... but not learned

New technologies proliferate so rapidly in our society these days that it's no longer even possible to implement them promptly throughout an educational system. Furthermore, the technologies and media that teachers learn over the course of their pedagogical training probably aren't even current anymore when the time comes to utilize them in a classroom situation.

This is where the CREATE YOUR WORLD TOUR comes in. Artists—whose job isn't primarily to come up with a didactic concept for a particular project—moderate a workshop attended by pupils and teacher at which the artist presents the latest applications and the professional use of the particular new technology, and focuses on conveying this information substantively. Pupils thus get new input they can work further with on an everyday basis in school, and teachers can create an adapted didactic concept that increasingly brings the latest technologies into practical use in classroom instruction. This can result in the development of a module that yields a win-win-win situation—pupils learn to deal more effectively with new technologies; teachers are presented with a continuing professional education opportunity right in their workplace; and artists benefit from a new occupational model.

Text: Hans Christian Merten

Jürgen Hagler

# Expanded Animation
## Deviations and Anomalies at the Intersection of Art and Technology

The *Expanded Animation* symposium that's been held annually since 2013 is a setting for an exchange of ideas among an international community of students, teachers, artists and theorists. It's all about the dissolution of boundaries, fringe areas, current trends, and future prospects in the field of computer animation. Highlights include screenings and discussions of experimental and hybrid forms in the broad interdisciplinary field at the nexus of art, industry, research, and science.

A fundamental theme in media art is the interaction of art and technology. A selection of relevant recent works that were singled out for recognition by the Prix Ars Electronica are now on display in *Technē–The Interplay of Art and Technology*[1], an exhibition at the Ars Electronica Center. One of the core issues it treats: How can, on one hand, technology and/or science influence artistic processes, and, on the other hand, how can artistic research and experimentation advance technological and scientific development?

Recent examples of these reciprocities are provided by the two works honored with Awards of Distinction in the Computer Animation / Film / VFX category in 2014. *Box* (2013)[2] by Bot & Dolly is a demonstration film for an innovative animation technology and shows a combination of 3-D animation, robotics and projection mapping. 3-D animation software makes it possible to control industrial robots that move jumbo-format screens onto which, in turn, animated images are projected. This type of animation brings forth unprecedented worlds of imagery such as those that astounded audiences in Alfonso Cuarón's prizewinning 2013 film *Gravity*.

*Shadowland* (2013)[3] by Kazuhiro Goshima is a textbook example of artistic experimentation with technology. Goshima works in a totally new way with a technology invented in the early 19th century: stereoscopy. Using a conventional video camera, he captures moving shadows and transfers them into a three-dimensional stereoscopic world of imagery. Here, stereoscopy assumes a different function, in that Goshima takes moving, two-dimensional shadow pictures and creates spatial constructions out of them. Instead of replaying the images with a spatial impression of depth of field as is typical of stereoscopy, the results are new spatial images that didn't exist in the real world in this form.

## What's the connection among art, technology and animation?

Two fundamental forms of interplay can be identified in animation: on one hand, technology is custom-developed for special applications and utilized accordingly; on the other hand, technological innovations of all sorts provide the impetus for new experimental approaches, are modified and used in new ways, or even destroyed, so to speak, or misused. The boundaries between these two strategies are fluid, just like the lines of demarcation separating art, research and science. The artist is a researcher and vice versa, and both use and develop technologies.

Animation—and especially computer animation—is closely linked to technology. The first work of computer animation was the result of a research project, the purpose of which was to simulate a satellite orbiting a planet.[4] Many milestones followed in the ongoing effort to further develop computer animation. The first artistic work of computer animation launched what has since become a sort of proud tradition: the re-use of a previously existing technology, in this case a piece of military equipment. John Whitney Sr. and his brother James modified jet fighters' steering mechanisms and combined them with cameras to thereby produce abstract computer animation sequences. Thus, a technology developed for the military was readapted to serve as the first artistic animation equipment.[5]

The alternative—or subversive, as it were—use of technology has been omnipresent ever since in computer animation. Two of this approach's defining characteristics are the violation of norms and imperfection. Playing and experimenting with animation and technology is diverse. Animation can be reflexive and take as its subject its own materiality and substance. Animation software and equipment can be modified and used in ways other than those intended by the manufacturer. Flaws and artifacts of established techniques aren't concealed, they're showcased! And motion-capture data aren't applied to characters, as is commonly practiced, but rather to abstract forms.

The 3rd *Expanded Animation* symposium is set for September 4-5. The theme: Deviations and Anomalies at the Intersection of Art and Technology. Once again, the focus will be on tracking developments on the fringe of computer animation, with special emphasis on the reciprocal effects of animation and technology.

Speakers: Alex Verhaest (Golden Nica, Prix Ars Electronica 2015), Pascal Floerks (Award of Distinction, Prix Ars Electronica 2015), Sebastian Buerkner, Mark Chavez, Ina Conradi, Devine Lu Linvega, Erick Oh, Anezka Sebek, Romain Tardy

*Expanded Animation* is a collaboration between the Hagenberg Campus of the University of Applied Sciences Upper Austria, the Ars Electronica Festival and Central Linz, organized by: Jeremiah Diephuis, Jürgen Hagler, Michael Lankes, Patrick Proier, Christoph Schaufler, Alexander Wilhelm / University of Applied Sciences Upper Austria, Hagenberg Campus | Department Digital Media

*http://www.fh-ooe.at*
*http://www.expandedanimation.com*

1 Technē—The Interplay of Art and Technology
   *http://www.aec.at/center/en/ausstellungen/techne/*
2 *https://vimeo.com/botndolly*
3 *http://www.goshiman.com*
4 Franke, Herbert W. (1971). *Computergraphik Computerkunst*. Munich: Bruckmann
5 *https://design.osu.edu/carlson/history/lesson2.html*

# Ars Electronica
# Animation Festival 2015

The Ars Electronica Animation Festival is a compilation of the best of 722 works from 58 countries submitted for prize consideration to the 2015 Prix Ars Electronica. It offers a fascinating overview of what's happening right now in the world of digital moving images and the variety of cultural positions emerging in this genre. A total of 13 programs invite festivalgoers to behold, scrutinize and come to terms with new visual creations from across the expressive spectrum. The screened works are the output of artists' studios, scientific labs, commercial institutions and university departments.

Before the Prix jury's actual deliberations took place over three days at the Ars Electronica Center in Linz, the five jurors—Sabine Hirtes, Gaëlle Denis, Joe Gerhard, Erick Oh and Rob O'Neill—got together with Jürgen Hagler and Christine Schöpf, the curators of the Animation Festival, to make pre-selections and thereby reduce the number of candidates to 126. This pre-selection process provided the pool of works for the Ars Electronica Animation Festival. The selections were made on the basis of the following factors: aesthetics, originality, innovation, concept, the quality of the storytelling, as well as innovative design & technical aspects. The individual programs were compiled according to substantive

and formal criteria. Thus, the Ars Electronica Animation Festival isn't just a showcase of excellence; it also spotlights current trends in the production of digital films.

A growing trend towards the expansion of animation has been evident in recent years. Works are no longer strictly screen-based; many are shown in "open-air" settings, and there are more and more museum-based forms of presentation that open up and expand the restricted realm of the movie screen. Mapping, jumbo-scale projections, landscapes that are extensions of buildings—these visual formats have now established a solid place for themselves in event culture.

Another development manifested by the submissions to the 2015 Prix Ars Electronica is interactivity. Computer animation is no longer conceived strictly as a linear representation; it's also "playable" via platforms that can be navigated online.

The eight individual programs that make up this year's Ars Electronica Animation Festival were composed from among the above-mentioned 126 films. We're also screening a *Young Animation* lineup consisting of films submitted to the Prix Ars Electronica's u19 – CREATE YOUR WORLD category for young people in Austria under age 19. *Young Animation* showcases some of the best of the growing number of films submitted for prize consideration in this category.

Plus, we'll be featuring a selection of prizewinning films from last year's Japan Media Arts Festival, Campus Genius Award, The International Students Creative Award (ISCA) and a special entitled *IN PERSONA: Erick Oh.*

Curation and Text: Christine Schöpf, Jürgen Hagler

## Experimental

A phone call brings to life a family portrait painted in the style of the Late Middle Ages; an installation programmed by Golan Levin manipulates hands in real time; animation at the nexus of the Web (David OReilly) and gaming—this program brings out innovative routes computer animation filmmakers have been taking lately.

*frequencies (light quanta)*, Nicolas Bernier

*Ghosts World*, Jérôme Boulbès

*This may not be a movie*, Kazuhiro Goshima

## Abstraction

In this lineup, animation takes leave of the screen. It's played out in public spaces, façades and landscapes, reconfiguring them in the process. It's also projected onto human bodies to thereby open up undreamt-of new perspectives. Impressive spatial experiences and bizarre illuminated landscapes emerge before our eyes.

*Inside Me (Nils Frahm—Me Rework)*, Dmitry Zakharov

*Time Of Flight*, Michael Pelletier

*[BRDG020] Lilium*, Yu Miyashita, Kenichi Yoneda, BRDG

*Bär*, Pascal Floerks

## Narration

Not only representing reality but also giving accounts of "other stories" whose boundaries exist only in their narrators' imagination as well as in the act of storytelling itself have been characteristic of artists' approaches to computer animation. This program contains personal matters, amusing plots and a healthy portion of satire.

*Rabbit and Deer (Nyuszi és Őz)*, Péter Vácz (MOME)

*Tulkou*, Sami Guellai, Mohamed Falilou Fadera

## Comedy

A beastly-bizarre discourse on the food chain in a highly cultivated TV studio discussion setting; the most adventuresome, totally awry, topsy-turvy Christmas you can imagine; advertising that celebrates its origins—this is a lineup full of fun, satire and irony.

*Border*, plan78 animation studio

*Missing one player*, Lei Lei

*Who will pay the bill?*, Daniel Nocke (Studio Film Bilder)

*Chase Me*, Gilles-Alexandre Deschaud

## Music Video

Videos are a mainstay of the music industry. A wide array of styles and techniques are used in current productions: 3-D and 2-D animation, stop motion, hand-drawn & generative animation as well as mixed media.

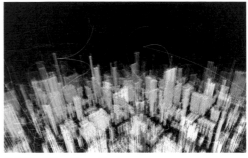

*Islands of Glass*, Polynoid

*Build the Cities*, Raven Kwok

## Position & Messages

The formulation of political statements has a long tradition in computer animation. Some filmmakers elaborate on current political issues; others go into the mental and intellectual wounds inflicted and dredged up by real events.

*Le labyrinthe*, Mathieu Labaye (Camera-etc)

*La fenêtre*, La fenêtre (ESMA)

*Black tape*, Michelle and Uri Kranot

*Remember*, Shunsaku Hayashi

## Mental States

The films in this lineup describe situations at the edge of psychosis—personal perceptions, couples' conflicts, therapeutic processes, breakups that make it seem like the whole world is breaking down. First and foremost, these are matters of individual perception.

*Meanwhile*, Stephen McNally

*PiPo,* Eliott Deshusses (Filmakademie Baden-Württemberg)

*Le Gouffre*, Carl Beauchemin

## Dark Stories

An action-packed program full of suspense, stories about friendship, challenge, threat and sacrifice, struggles for survival with and against nature—energies expressed in images of impressive visual power.

*Isolated*, Tomas Vergara (Peak Pictures)

*Mycelium*, Mycelium (ESMA)

## IN PERSONA: Erick Oh

Erick Oh is one of today's most interesting animators and filmmakers. The native of Korea studied art in Seoul (BFA) and at UCLA (MFA). His films have been screened at the world's most important animation film festivals and honored with numerous awards. He's been an animator at Pixar since 2010.

*The Dam Keeper*, Robert Kondo, Daisuke 'Dice' Tsutsumi

*Heart*, Erick Oh

*Günther*, Erick Oh

## Young Animations

Witty, off-beat, subtle, tragic and serious animated work produced by young filmmakers will be screened during the Festival Ars Electronica. Every year, gifted young filmmakers submit their movies to u19 – CREATE YOUR WORLD (Austria), bugnplay (Switzerland), MB21 (Germany) and C3<19 (Hungary). The greatest hits will be featured in Young Animations.

*3D-Murmelbahn-Animation*, Anna Schneeberger

*GESTERN HEUTE MORGEN*, Lucas Goto, Cornelia Mairinger, Tina Naderer, Veronika Walter

*Watched*, Richard Forstmann (mb21)

*5D ARCHIVE DEPT.*, KATSUKI Kohichi

## Japan Media Arts Festival Selection

The Japan Media Arts Festival honors outstanding works from a wide range of media in four award categories: Art, Entertainment, Animation, and Manga. It also serves as a platform that celebrates the winners of awards and outstanding creative works of art.

*Man on the chair*, JEONG Dahee

*The Wound*, Anna BUDANOVA

*a reflection of one´s mind*, KOHEI Nakaya

*Brother*, wakuwa

## Campus Genius Award

The Campus Genius Award (Gakusei CG Contest) honors digital artworks created by students. The continuity of this contest, which is being held for the 21st time this year, underpins its important role in Japanese Media Arts. Incorporating expression forms of new media and technology that change with the times, the contest forms a gateway not only for computer graphic artworks, but a wide range of diverse genres. Many past award-winners have also won high acclaim at Ars Electronica, the Berlin International Film Festival Berlinale and the Japan Media Arts Festival and conduct their activities at the first line of several creative fields of society such as art, design and entertainment. In this year's Ars Electronica, a series of animated short films will be screened.

## ISCA–The International Students Creative Award

The International Students Creative Award is an international arts and information media competition sponsored by Knowledge Capital Association. It's for Japanese and international university, graduate school, and vocational school students.
*https://kc-i.jp/en/award/isca/about/*

*6:45 a.m. SUN 31 August 2014*, Eri Ando

*Rabbit and Deer*, Péter Vácz

*Treo Fiskur*, Noemie Cauvin

# Ars Electronica

In addition to annually producing and staging a major festival—its elaborate program is described in this volume—Ars Electronica is involved in a wide array of activities at the nexus of art, technology and society. They include the exhibitions and didactic programs offered by the Ars Electronica Center in fulfillment of its public educational mandate, as well as the Ars Electronica Futurelab's R&D work, product development by Ars Electronica Solutions, and the international exhibitions, workshops and events produced by Ars Electronica Export. The revenues generated by these activities make a substantial contribution to Ars Electronica's entire budget and thus support this organization in carrying out its public service mission in art and education. The following section gives an overview of the activities and projects conducted over the past year.

# Ars Electronica

Ars Electronica is always on the lookout for something new. However, the focus is never solely on art, technology or society, but on the complex relationships and interaction between them.

During the 36 years since it was founded, Ars Electronica has developed into a cultural center, educational institution and R&D facility with a diverse range of pursuits. The Ars Electronica Festival, Prix Ars Electronica, Ars Electronica Center, Ars Electronica Futurelab, Ars Electronica Solutions, and Ars Electronica Export are the divisions of this enterprise, which also maintains a huge archive. Including the management service staff, Ars Electronica employs about 190 men and women.

The watchwords—Art, Technology and Society—remain just as valid today as when they were used to describe the first Festival in 1979. Utilizing artistic means to understand the manifold impacts new technologies and scientific breakthroughs are making on our society and culture, and even going beyond that and striving to actively participate in these transformation processes—this is the core concept around which a sort of ecosystem has developed. Fostering creative thinking, nurturing and enabling artistic productions, hosting a wide array of educational offerings, carrying out R&D projects commissioned by private-sector clients—what has emerged is an organic chain that ultimately reconnects with its first link, in that the enormous possibilities engendered thereby yield investments right where it all began: in art and creativity.

Despite all these successful endeavors, the broad spectrum of educational and cultural offerings Ars Electronica stages would be impossible without a public-sector mandate and financing. We wish to express our gratitude, above all, to the City of Linz as proprietor, and to the Province of Upper Austria and the ministries of the Republic of Austria for the support they make available on an ongoing basis.

# Ars Electronica Center
## Museum of the Future

This is a time of transition for the institution known as a museum. Since its very inception in 1996, the Ars Electronica Center has been addressing the question of what a Museum of the Future ought to be like. Right from the start, the Ars Electronica Center has considered itself an experimental laboratory to learn how imparting educational material can function in an information-based society. Since its architectural makeover and reopening on January 1, 2009, more than a million people have visited the exhibitions and attended the events held in Linz's Ars Electronica Center. A key component of its success has been the concept of situating open labs amidst the exhibits, and of creating a museum that makes carrying on a dialog with human beings the core of its mission. Change is another essential element of the Museum of the Future, an institution that reinvents itself on an ongoing basis while remaining true to its basic principles of dealing with the interplay of art, technology and society, and establishing a public setting for participation, conversation, and fascinating discussions.

Leading protagonists in this interactive process are the Infotrainers, who regard the exhibitions as their instruments and use stimulating stories and flashes of inspiration to get visitors involved in what they're beholding and to link it up to their everyday lives, local surroundings and personal experiences. Infotrainers get into a conversation with the members of the tour groups they guide, help them to formulate questions related to our shared future and offer them potential answers to consider on their own. In going about this, Infotrainers can reference current trends and configure the interaction with laypeople as a form of give-and-take among peers—after all, the Infotrainers themselves come from a wide variety of backgrounds and have acquired their know-how from a broad spectrum of fields including biotechnology, sociology, art, design, teaching, and psychology. The Museum of the Future is one of the cornerstones of Linz's cultural landscape. It's a museum that's paying attention to what people are saying.

# Ars Electronica Center
## New Educational Formats

The International Council of Museums defines a museum as "a non-profit, permanent institution in the service of society and its development, open to the public, which acquires, conserves, researches, communicates and exhibits the tangible and intangible heritage of humanity and its environment for the purposes of education, study and enjoyment." The Ars Electronica Center has made a name for itself worldwide with a dialog-based concept for mediating visitors' encounters with content, and deploying Infotrainers to provide on-the-spot verbal guidance. Educational formats custom-tailored to age groups beginning with 4-year-olds is another instance of the Museum of the Future acting in accordance with the ICOM's internationally accepted definition as well as redefining what a museum is. More than 31,000 pupils took advantage of the extensive educational offerings of the Ars Electronica's well-established school program in 2014. The Center has developed into an extramural educational facility beloved throughout the region, and is constantly conceiving new formats designed to appeal to people interested in issues at the nexus of art, technology and society. For example, the *Kids' Research Laboratory* targets 4-8-year-olds, kindergarten & afterschool care groups as well as young families who want to enable their kids to take a playful approach to research, discovery, and understanding. Formats such as *My Future Workshop* and *Go Future! Apprentice Day* are designed for young people to discover their creative skills and establish potential career goals. *The Land of My Grandparents* is a pilot project that fosters both media competence and intergenerational dialog. Guided tours for people with impaired vision and hearing get frequently disadvantaged communities involved in the conversation, and the *Anatomy for All* series of talks is part of Ars Electronica's long-term commitment to the popularization of science. It's time to experiment with new educational formats!

Text: Martin Hieslmair

# Kids' Research Laboratory
## for kids aged 4 to 8
Start: January 27, 2015

"Play is the highest form of research."
Albert Einstein

The *Kids' Research Laboratory* at the Ars Electronica Center is a setting for experimentation with motor, mental and social skills. The principle on which this approach is based is the concept of *homo ludens*— investigating, discovering and comprehending via game playing.

There's no prescribed path through the exhibits; instead, kids move about the space freely, guided by their own interests. Hands-on encounters with unusual devices and fascinating experimental installations are the young explorers' gateways to discovery across Ars Electronica's entire thematic spectrum: the interplay of the virtual and the real world, the enchantment of light and shadow, what goes on inside high-tech gadgets, construction & programming, and the human-machine relationship. Naturally, there's lots of fun stuff to try out and play around with, but there's also much to observe, to consider and to discuss. After all, that's the whole point of a research lab—giving some thought to extraordinary phenomena, recognizing interrelationships, testing new possibilities and deriving insights that will be useful in the future. This also applies to the young researchers' activities in the Ars Electronica Center.

Text: Kathrin Meyer

**Exhibits:**

*Cubelets*, Modular Robotics
*Incident Light Microscope*, Firfly Global
*Otamatone*, Maywa Denki
*MagicShifter*, Florian Bittner / Hackerspace Wien
*BeeBot*, Terrapin Software
*OTOTO*, Dentaku
*Sticker Modeller*, Ars Electronica
*Disassembly Station*, Otelo
*Makey Makey*, JoyLabz LLC
*la Pâte à Son*, lecielestbleu
*Freqtic Drum*, Tetsuaki Baba

AEC, Martin Hieslmair

# My Future Workshop

Endowing future prospects, demonstrating possi-
bilities, taking a hands-on approach to discovering
one's own talents–*My Future Workshop*, initiated
by Regional Minister Michael Strugl in cooperation
with the Province of Upper Austria and set in the
Ars Electronica Center, is a project that focuses
on unemployed young people in training projects.
In May 2015, the first 20 young people spent a
week touring the Museum of the Future. In the
Ars Electronica Center's labs, they got acquainted
with various promising new areas of employment
and the tools of those trades. Plus, these young-
sters met interesting people, some of whose CVs

were anything but conventional. 3D printing in
FabLab, sound design in SoundLab, programming
in RoboLab and producing your own films–there
was a pretty fair chance of identifying undiscov-
ered talents and enjoying being creative. Teamwork
was called for in the *My Future Workshop*; so were
independently coming up with strategies to solve
problems, and public speaking in front of a small
audience. Provided with tablets, youngsters had the
opportunity to record their experiences on a blog
and thus refer to them later in preparation for future
job interviews.

Text: Martin Hieslmair

AEC, Florian Voggeneder

## The Land of my Grandparents

Where do I come from? Where am I at home, and what does the term "homeland" even mean, for that matter? These are the key questions young people confront when they look back at their own family history. In cooperation with class 3c of Linz's Kollegium Aloisianum college preparatory school and with funding from the Culture Connected initiative, the Ars Electronica Center organized *The Land of my Grandparents* to give 12-14-year-old students the opportunity to spend a semester dealing in a very personal way with the subjects of homeland and migration. Here, the accent was on tracing one's roots, asking questions, acquiring media skills and doing creative work as independently as possible.

First, the class members decided on their theme and on publishing their results as a virtual diary. Then, the Ars Electronica Center brought in its expertise in art, technology and society. The agenda included discussions about online security and privacy on the Web, as well as video workshops that dealt with technical aspects such as shooting and editing video, interviewing techniques and various lighting options. The students also got access to the Fab-Lab's infrastructure including a laser cutter and 3D printer. This successful pilot project is now ready to proceed to the next level as an ongoing format that the Ars Electronica Center can offer to other schools.
Text: Martin Hieslmair

# Guided Tours for People with Hearing or Vision Impairment

Technology is essential to our communication, our medical care, our workplace and much more. Since 2015, the Ars Electronica Center has offered guided tours for people with vision or hearing impairment in order to enable men and women with special needs to take part in the discussion about these various technological developments and their manifold consequences in everyday life, and to consider them through the lens of art. This is especially evident in medical technology and the development of increasingly effective devices to benefit the deaf.

All of these one-hour tours were developed in cooperation with people with sensory impairments. Moreover, tours for the deaf are conducted in Austrian sign language by specially trained deaf people. In addition to imparting to these deaf guides the same substantive knowledge that the Infotrainers working at the Ars Electronica Center get, the training focused above all on the development of didactic methods suited to deaf visitors. We received plenty of suggestions and feedback from the deaf community.

Text: Martin Hieslmair

AEC, Florian Voggeneder

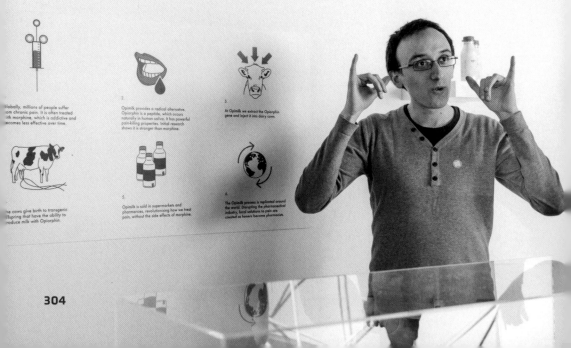

304

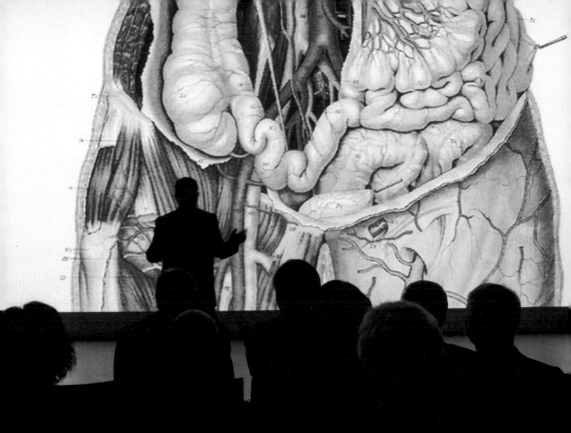

# Anatomy for All

Modern imaging procedures like ultrasound, computer tomography and magnetic resonance imaging are constantly improving—delivering deeper, more detailed and more fascinating insights into what goes on inside the human body. And the field of virtual anatomy is becoming increasingly important in physicians' training & continuing professional education as a means of speedily comprehending and learning human anatomy and coming up with innovative treatment methods. This was acknowledged by the faculty of the University of Linz's medical school that was founded in autumn 2014. In conjunction with their grand opening celebration, they took advantage of the competence and infrastructure available at Ars Electronica and invited the first students in the school's Human Medicine program to convene in Deep Space for a look at the future of the study of medicine. *New Views of Humankind*, the permanent exhibition in the Ars Electronica Center's Main Gallery, has showcased these new imaging procedures and the insights they yield since 2009. And even before *The Universe Within*, the new program for *Deep Space 8K*, was even conceived, the Ars Electronica Futurelab's transdisciplinary staff had already been collaborating with Dr. Franz Fellner, director of the Department of Radiology at Linz General Hospital and president of the Upper Austrian Medical Society. *Deep Space LIVE: Anatomy for All* is an ongoing series of talks that has provided the ideal platform to make available to the general public visualizations of the human body created through the post-processing of previously made 3-D cross-sectional images.

Text: Martin Hieslmair

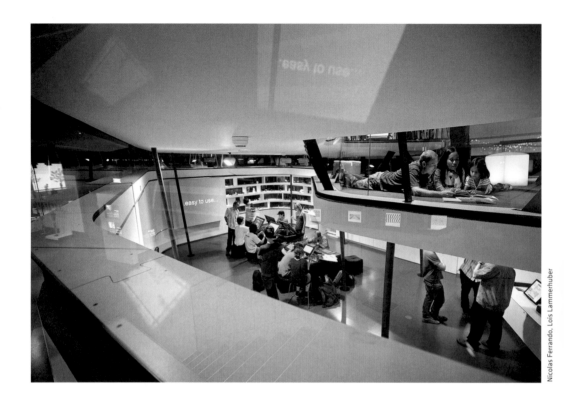

Nicolas Ferrando, Lois Lammerhuber

# Ars Electronica Center
## Exhibitions

With its colorful mix of permanent and temporary exhibitions, the Ars Electronica Center continually responds to highly topical technological issues and their impact on art, society, and each and every one of us. Here, the themes of the future are the exhibitions of today. Dialogue and the exchange of ideas have top priority at the Museum of the Future. The exhibits morph into narratives about current social developments, which the Infotrainers relate and draw people's attention to. The exhibitions are a stage on which fascinating comparisons, links, food for thought, and insights meet and, above all, questions emerge. Traditional educational institutions are welcome at this extracurricular place of learning with its exceptional infrastructure.

**Long Term exhibits**

*New Views of Humankind*
*Out of Control—What the Web Knows about You*
*GeoPulse*

# TIME OUT
## Time-based and Interactive Media meets Ars Electronica

*TIME OUT–Time-based and Interactive Media Meets Ars Electronica* has been produced jointly by Ars Electronica and Linz Art University's Time-based and Interactive Media bachelor's degree program for two years now. The TIME OUT exhibition series gives outstanding students the opportunity to display works of interactive media art at the Ars Electronica Center and thus present them to museum visitors as well as international audiences.

Now that four exhibitions have been staged, it certainly is fair to talk about TIME OUT in terms of a success story and a win-win-win situation for the students, the Ars Electronica Center, and the City of Linz. For up-and-coming media artists, it is, of course, a great experience being showcased in a venue with a worldwide reputation. The prospect of displaying their work at the Ars Electronica Center motivates students as they go about producing their projects. For those whose works are selected, the next assignment is to transform functioning prototypes into exhibition objects capable of withstanding several months of intensive use by visitors. For the young artists, these are important experiences that you can only get in real-world situations.

The fourth exhibition included a presentation in Deep Space of interactive, spatially oriented works that were produced in conjunction with a course held in cooperation with the Futurelab.

The TIME OUT series organized by the Ars Electronica Center and the City of Linz demonstrates that the local scene can give rise to exciting projects capable of holding their own in an international context. At the end of the current show's run, several of the works will be integrated into the Center's ongoing themed exhibitions or the Ars Electronica Festival's lineup, or become part of traveling exhibitions.

Text: Gerhard Funk

## TIME OUT .03
March 14, 2015 – June 14, 2015

Martin Hieslmair

### Julian Reil
## Bottleneck

Like a conventional message-in-a-bottle, *Bottleneck* has a communiqué securely sealed inside. It floats along in the hope of being washed up on land somewhere and then being found and read by someone. The big difference: The digital message inside this bottle can be composed in retrospect. To do it, simply send an SMS to a cell phone number. All the requisite technology including Arduino microcontroller and GSM module is built into the custom-designed, hand-blown, watertight bottle. *Bottleneck* is thus the confluence of two communication channels from two different epochs. All the same, just like in bygone days, the messages reach only those persons who happen to be in the vicinity of the bottle transporting them.

*julianreil.at*

**307**

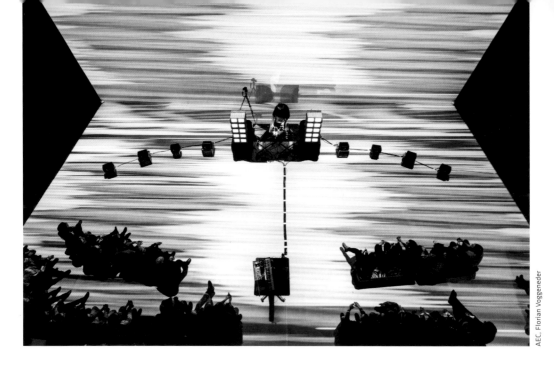

## Stefan Tiefengraber
## WM_EX10 WM_A28 TCM_200DV BK26

In this sound performance, conventional and fully functional electronic devices such as a Walkman, a Dictaphone, and a keyboard are transformed into novel instruments. Using his moistened fingers, artist Stefan Tiefengraber strokes the devices' exposed circuit boards to play them. The skin's characteristics and the conductivity of the human body com-bine with the switches' electronic components to produce the various sounds. Cathode-ray screens simultaneously visualize the signal as a flickering pattern of abstract forms and lines. The title of this work consists of the model numbers of the devices employed.

*stefantiefengraber.com*

AEC, Martin Hieslmair

## Verena Mayrhofer
## Draw:er

What images come to mind when a person who's never been to Austria thinks about this country? This cabinet, designed to conveniently store food staples, categorizes answers given by people from different regions of the world—as recited by speakers of various Austrian dialects. Where do these images come from? Are stereotypes in constant transition or are they quite difficult to modify? And how much room for individuality is there in compartments like these? Open as many drawers as you like and decide for yourself which preconceptions of Austria you prefer to hear.

*verenamayrhofer.at*

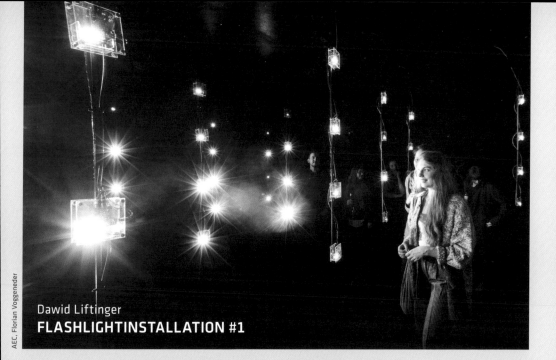

Dawid Liftinger
## FLASHLIGHTINSTALLATION #1

How do flashes of light affect our perception? This installation space equipped with 64 electronic flash units from disposable cameras invites visitors to experience the effects of randomly flashing light impulses on their own bodies. Step inside, and decide for yourself how long you wish to remain. These visual stimuli aren't the only sensory inputs inside the installation space. The noise the capacitors make while the units are charging—steadily higher-pitched and softer—and the popping sound that each one makes when a flash is triggered are integral elements of the overall experience. *dawidliftinger.com*

June 17, 2015 – September 30, 2015

Christina Dellemeschnig
## T-TWEE

The more internet companies like Facebook and Twitter gather, analyze and sell their users' data, the more money they earn. *T-TWEE* deals with precisely this interrelationship characterized by reciprocal dependence, one involving personal data and global financial flows. In doing so, *T-TWEE* also builds a bridge between a digital and an analog medium. Randomly selected tweets—short messages published at *www.twitter.com*—are punched, character for character, into a paper tape and then made audible by feeding the tape through an analog music box. Depending on the current price of Twitter Inc.'s stock (which is visible on the small display), the music box's motor is set in motion. *christina-dellemeschnig.com*

AEC, Florian Voggeneder

**309**

Lukas Jakob Löcker
## Tape Delay

This is a matter of interacting with the installation, with the architecture of the space, and ultimately with yourself. *Tape Delay* is an analog setup that invites you to experiment with sounds, noise and your own voice. Since the 1950s, the sound effect of the same name as this work by Lukas Jakob Löcker has been an essential element in many musical genres. To achieve it, audio signals are recorded to an audiotape and played back after a specified time delay. Since both ends of the audio tape are spliced to each other, the tape forms a loop so that the sounds audible in the installation space are played back again by the same audiotape. This analog technology thus enables users to listen in to the past and to leave behind temporary tonal traces.
*http://www.backlab.at/artist/eliot*

Andreas Trixl
## Siblings of Frank

Do you feel like you're being observed? Evidently, we've already gotten used to the fact that surveillance cameras are constantly monitoring what's going on in public places from a variety of perspectives and capturing people's actions for analysis at a later time. On the other hand, direct eye contact with the lenses that are keeping an eye on us evokes a rather uneasy feeling. With the help of a Kinect camera and OpenTSPS software, *Siblings of Frank* recognizes persons and objects in the installation space and reports their position to a program that controls the projections of the artificial eyes. Which eye focuses on which objective is allocated at random. If they don't recognize anything, they close their eyelids.

Peter Karrer
## Selbsttonfilm

The sound doesn't make the music; the film does! *Selbsttonfilm* analyzes existing video material according to a prescribed set of rules and generates a soundtrack on that basis. The film sets itself to music, so to speak, and the synchronized playback of the appropriately matched up images and sounds provides a fascinating audiovisual experience. In this modern-day take on the live accompaniment of silent films that was commonplace in theaters and the first movie houses beginning in the late 19th century, the piano once again plays the starring role. But this musical interpretation of the on-screen action isn't a live pianist's artistry; it's the output of software reacting to the visual content.

## Works presented in or created for Deep Space

TIME OUT .04, the fourth showcase of works by young Linz-based media, is also featuring the first applications to come out of the course "Ars Electronica Center Deep Space." Under the guidance of Ars Electronica Futurelab staff experts the students got to use Deep Space as their own personal workshop of sorts and to take advantage of its marvelous technical possibilities specifically for their own artistic works.

*movie puzzle*, Katharina Gruber
*Sinus*, Simon Krenn
*Untitled (Geometric Soundscape)*, Clemens Niel
*solar system*, Moritz Rathke
*TS19* (Video), Ferenc Hirt

Texts: Martin Hieslmair

*movie puzzle*, Katharina Gruber

*Untitled (Geometric Soundscape)*, Clemens Niel

# technē – The Interplay of Art and Technology
January 17, 2015 – September 30, 2015

The *technē–The Interplay of Art and Technology* exhibition on display throughout several levels of the Museum starting at the lobby consists of works that shed light in a particularly incisive way on an overarching theme of Ars Electronica: The interplay and reciprocal effects of art and technology.

The Ancient Greek concept of *technē* has had a formative influence on Western philosophers' understanding of art, science and technology right up to this day. *Technē* does not differentiate between art and technology. It can be approximately rendered as skill, craftsmanship, artisanal ability, and technique. Art and technology were inseparably connected in antiquity, but in subsequent centuries the effort was made to isolate them from one another as much as possible. In the meantime, however, interdisciplinary thinking and working are once again taken completely for granted. And with technology progressively pervading our world, they have even become a necessity.

The artists whose works have been gathered together in this exhibition not only reflect upon technological developments and their impact; they also use technology as a tool. The artists themselves acquire the technical competence they need, and they also work in teams whose members bring various qualifications and specialties to the table.

The ways and means they employ thereby are the same as those used in technical and scientific developments, but they deal with other ideas and issues, and do so from their own artistic perspective. *technē–The Interplay of Art and Technology,*

## Works

*A Million Seasons*, Shinseungback Kimyonghun (KR)
*CAPTCHA Tweet*, Shinseungback Kimyonghun (KR)
*Captives*, Quayola (IT/UK)
*Cat or Human*, Shinseungback Kimyonghun (KR)
*Cloud Face*, Shinseungback Kimyonghun (KR)
*Face to Facebook*, Paolo Cirio, Alessandro Ludovico (IT)
*FADTCHA*, Shinseungback Kimyonghun (KR)
*Iris*, Chloe Cheuk, Kenny Wong (HK)
*Landscape Abbreviated*, Nova Jiang (NZ)
*Lapillus Bug*, Kono Michinari, Takayuki Hoshi, Yasuaki Kakehi (JP)
*Looks Like Music*, Yuri Suzuki (JP)
*Loophole for All*, Paolo Cirio (IT/US)
*Nonfacial Mirror*, Shinseungback Kimyonghun (KR)
*Portrait*, Shinseungback Kimyonghun (KR)
*Real Imaginary Objects*, Daniel Crooks (AU)
*Street Ghosts*, Paolo Cirio (IT/US)
*The God's Script*, Shinseungback Kimyonghun (KR)
Text: Kathrin Meyer

# 35 Years ORF TELETEXT
January 17, 2015 – April 15, 2015

On January 21, 1980, Austria's ORF became the third public broadcasting company in Europe to provide teletext. Ars Electronica marked this anniversary with an exhibition in the Center's Lobby: *35 Years of ORF TELETEXT*. Simultaneously, the glowing media facade of the museum of the future turned into an ORF TELETEXT sculpture consisting of animated patterns and colors of the ORF TELETEXT.

Despite the many prophesies that the proliferation of the internet would mean the death of teletext, this medium is still going strong. The ORF has more than a two-thirds share of all teletext usage time in Austria. On a weekly basis, 1.9 million users take advantage of the ORF's teletext offerings, which constitutes a reach of 25.7% (Austrian TV viewers over age 12). TV viewers access an average of 18.4 million ORF TELETEXT pages daily.

In addition to a review of this medium's highlights over the past 35 years, the show at the Ars Electron-ica Center featured selected works from two International Teletext Art Festivals: ITAF 2013 and 2014. It was launched by Finnish art cooperative FixC. The works have been featured on ORF TELETEXT, ARD Text (Germany), Schweizer TELETEXT (Switzerland), and arte Teletext (Europe). Minimalism as a challenge; reduction as an incentive—in the teletext format, creative artists have a mere 24 lines of 39 characters each at their disposal. Moreover, there are only six colors available in addition to black and white. But it's precisely this retro aspect—teletext's concentration on individual pixels and limited technical possibilities—which, amidst today's high-definition world of viewing, exerts a particularly strong visual appeal. Thus, elements of the teletext aesthetic can be found in many other settings, such as building walls and graffiti, in videos and animated films, and on the internet.

Text: Martin Hieslmair

AEC, Martin Hieslmair

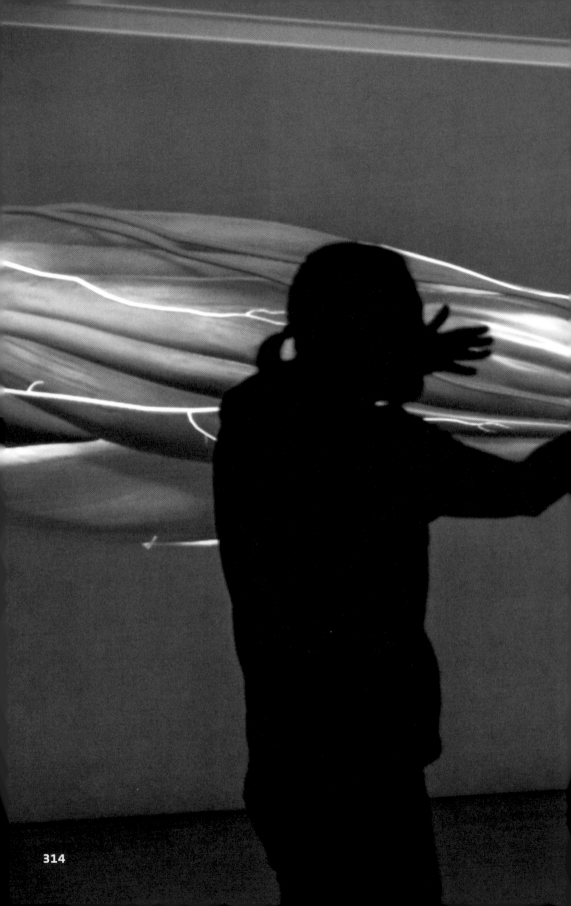

# Deep Space 8K
The Next Generation of Visualization Technology

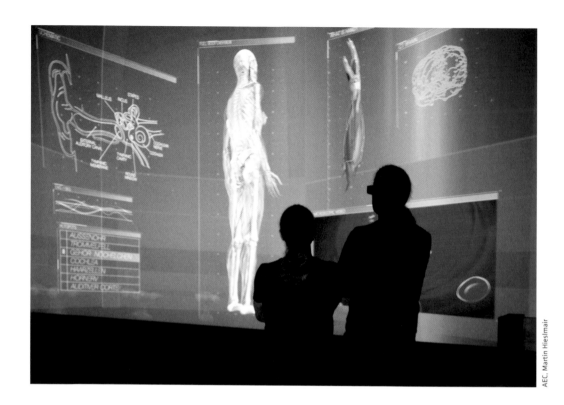

AEC, Martin Hieslmair

Ever since the first Ars Electronica Center opened in 1996, virtual reality has been a core component of its infrastructure. Back then, a 3x3x3-meter CAVE—developed at the Electronic Visualization Lab in Chicago—provided Ars Electronica with a technology that was being made available to the public in Europe for the first time. It made it possible to show Ars Electronica Center visitors three-dimensional visualizations—especially of artistic works—that gave them the feeling of not just viewing an art installation but immersing themselves into a work and interacting with it.

The technology was taken to the next level in 2009, when the Ars Electronica Futurelab developed Deep Space for the new, expanded Ars Electronica Center. Eight 1080p HD and active stereo capable projectors could generate crystal-clear, 4K images on 16x9-meter projection surfaces on both the wall and floor. With content that included Leonardo da Vinci's *The Last Supper*, Ryoichi Ikeda's digital worlds of imag-

ery, a journey through outer space and a downhill run on *Die Streif*, the world's most famous ski slope, Deep Space was capable of totally blowing audiences away with visuals the likes of which they'd never seen before—impressions of objects and worlds both past and present. This was a setting for assorted media formats. High-definition photographs, stereoscopic videos, 3D visualizations, and interactive games took the projection technology, the graphic output and the data processing capacity to the very limits of doability.

Now, six years after Deep Space premiered in Linz, and now that 4K resolution has established itself throughout the professional technology segment, it's time for the next quantum leap. What we've named *Deep Space 8K* presents a new generation of visualization technology that, once again, sets the standard of technical feasibility.

It took some renovation work to install the eight 4K projectors—four for the wall and four for the floor.

AEC, Martin Hieslmair, Florian Voggeneder, Andreas Bauer

The data is delivered to each one by four parallel signal channels, since such a gargantuan quantity of visual data simply cannot yet be transported via a single channel. The 4,096 x 2,160 pixels, each one computed 120 times per second and then fed to one of the projectors via four separate channels, combine to generate each image. A pixel streams through these cables over 4.2 billion times per second. And that's only for one projection surface. To screen content on both the floor and the wall of Deep Space, you need to double that output and synchronize the two systems! The transport performance alone of a little over 23 gigabytes/second is impressive—just to put it in perspective, the content of almost an entire BluRay disc moves through the system every second. And when you consider the fact that, in certain applications, this stream of data is also computed in real time, then you can begin to grasp how close we are here to the outer limits of technical feasibility.

The graphic output is produced by two quartets of NVIDIA Quadro M6000 graphic cards. The ability to drive four of these cards with only a single motherboard was the outcome of a long, intensive search; what we came up with was a high-performance processor manufactured by XI-MACHINES. And the picture resolution wasn't all that took some doing; the color space, contrast and brightness also call for a state-of-the-art technical ensemble. The old projectors brought 12,000 ANSI lumens to bear; their replacements, 4K30s by Christie, jack that number up to 30,000 each. The improved technical specifications now in place in Deep Space make it possible to project a number of pixels that corresponds to twice that of 8K resolution. Thus, the content screened here has even higher resolution and the visualization capabilities are multiplied. These new technical possibilities were a particular challenge for the Ars Electronica Futurelab, since there hardly existed any content for the resolution that Deep

Space is now capable of. New depiction formats like 8K videos were exceedingly rare. A few of the very first ultra-high-resolution time-lapse videos can now be viewed in Deep Space for the first time in the quality they were meant to be seen in. Screening content at this extraordinarily high degree of detail opens up new depiction possibilities—above all with respect to graphic surfaces and their visual information economy. Accordingly, this also calls for the development of a sort of graphic language that do justice to these changed conditions. The artists and researchers on the staff of the Ars Electronica Futurelab will be dealing with these issues for some time to come. Thus, Deep Space will also be serving as a laboratory and proving ground for new visualization concepts. The implementation of *Deep Space 8K* was made possible by intensive collaboration among experts from all of Ars Electronica's divisions. The result of this collaboration is a truly outstanding ensemble of components.

First of all, a new content management system was developed. Since, in the meantime, the number of works produced or adapted especially for Deep Space far exceeds 500, a simple, intuitively comprehensible tool had to be developed to make it possible to quickly and conveniently play back complex content.

Secondly, a tracking system custom-tailored to Deep Space had to be installed. This system enables visitors to actively deal with the screened content and to interact among themselves. This equipment registers audience members' gestures as well as their footprints on the floor and translates it into movements on the projection. Plus, technicians developed presentation formats that reorder the relationship between the moderator and the audience to provide an innovative way to get content across. Thus, *Deep Space 8K* isn't just a room in which breathtaking pictures and videos can be screened in 3D and at an unprecedented degree of sharpness; it's also a setting in which viewers can interact with what's being screened in a wide variety of ways.

Thirdly, and most importantly: a lot of effort is going into the content. We're constantly making every effort to acquire new material that takes full advantage of the technical possibilities available in the reloaded Deep Space—footage created in house at the Ars Electronica Futurelab as well as films produced jointly with partner institutions.

Text: Horst Hörtner, Roland Haring, Christoph Kremer

**Deep Space 8K Team**

| | |
|---|---|
| Roland Aigner | Christoph Kremer |
| Andreas Bauer | Juliane Leitner |
| Florian Berger | Benjamin Mayr |
| Barbara Erlinger | Michael Mayr |
| Maria Eschlböck | Patrick Müller |
| Martin Gösweiner | Otto Naderer |
| Roland Haring | Clemens Francis Scharfen |
| Horst Hörtner | Gerfried Stocker |
| Gerold Hofstadler | Marianne Ternek |
| Peter Holzkorn | Florian Wanninger |
| Andreas Jalsovec | Special thanks to: |
| Thomas Kollmann | Maria Pfeifer |

**With support from:**

Fraunhofer MEVIS Institute for
Medical Image Computing
The Centre for Digital Documentation
and Visualisation LLP (CDDV)
CyArk
Upper Austria University
of Applied Sciences' Hagenberg Campus
Linz Art University
Red Bull Media House
XI-MACHINES
Ton & Bild

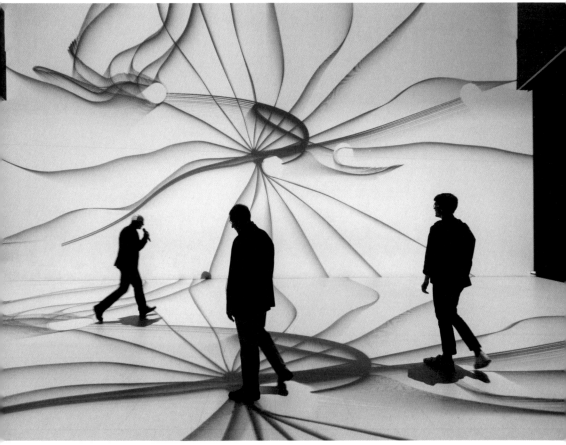

*Sinus*, Simon Krenn

## Deep Space 8K

8K is the standard set by the latest all-out upgrade of the Deep Space technical infrastructure at the Ars Electronica Center. Now, audiences can enjoy projections at 8K resolution and thus worlds of imagery at a never-before-achieved level of quality!

# The Universe Within
## In the Virtual Anatomy Theater of the Future

*Human Bodies: The Universe Within* is an application especially developed by the Ars Electronica Futurelab to exploit the full potential of this virtual three-dimensional space and make exploration of the human body an impressive experience. Organs, muscles, bones, the cardiovascular system and the body's network of nerves—layer by layer, extraordinarily detailed and breathtakingly beautiful 3D visualizations deliver ultra-close-up views inside the human body.

The vastly improved resolution offered by *Deep Space 8K* makes it possible to simultaneously augment the three-dimensional models on screen with other media elements such as detailed graphics, high-resolution videos and additional information.

The Infotrainers who moderate the live presentations in *Deep Space 8K* have an extensive selection of material at their disposal to comply with audience's requests and go into detail when it's called for. Now, only a few months after the founding of the University of Linz's School of Medicine, *Human Bodies: The Universe Within* provides an extraordinary platform to get medical education away from the conventional anatomy atlas in book form and shift it in the direction of three-dimensional learning and visual understanding of the interrelationships in the human body. And that applies just as much to future physicians as it does to interested members of the general public—from little kids to seniors.

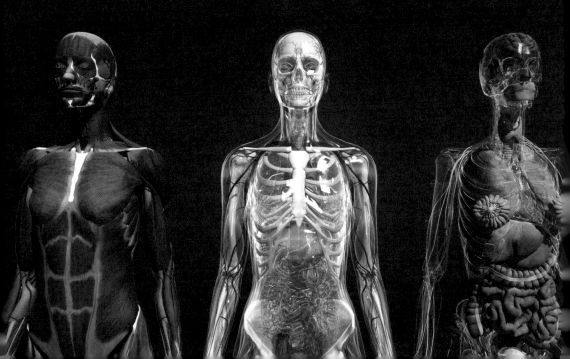

## Collaboration with Renowned Institutions

The Ars Electronica Futurelab has woven several narrative strands into the program. They elaborate on the workings of the human body's various systems, and use facts, images and narratives to facilitate understanding how these processes work. The point of departure of *Human Bodies: The Universe Within* is a corpus of 3D data provided by Zygote Media Group Inc., a company that specializes in anatomically exacting three-dimensional representations of the human body. We also worked together with the Fraunhofer Institute for Medical Image Computing (MEVIS) to get a detailed and comprehensive look at the heart. New procedures such as magnetic resonance imaging make it possible to investigate how blood flows through the heart's chambers so that physicians can reconfigure pressure distribution without having to resort to a drastic measure like surgery.

A close-up examination of the immune system shows that not only oxygen but also dust, pollen, bacteria and viruses enter the human body through the respiratory tract. What actually happens when someone gets sick? Another focal-point topic in *Human Bodies: The Universe Within* is the brain and the five senses, with particular emphasis on sight and hearing. For example, an interactive virtual ear originally developed by Ars Electronica Solutions for the MED-EL medical technology company's *Audioversum* exhibit shows how sound travels from the auditory canal to the brain. The human body's locomotion apparatus, its system of muscles and bones, is also part of the presentation in *Deep Space 8K*–after all, we're programmed to get up and go! And last but not least, *Human Bodies: The Universe Within* takes an intimate look at one of humankind's greatest triumphs: our reproductive prowess.

Text: Martin Hieslmair

# Time-lapse

Ever since time-lapse photography was first used in the late 19th century, viewers have been enthralled by this filmmaking technique and the amazing way its highly accelerated tempo sheds new light on things that occur in our world. Cameras that can be set to take shots at intervals ranging from a few minutes to several days capture visual phenomena played out far beyond our conventional time horizon. Combining these highly detailed, fast-forward motion pictures with the extraordinarily high degree of resolution in *Deep Space 8K* opens our eyes to everyday events that we've never seen in this form before.

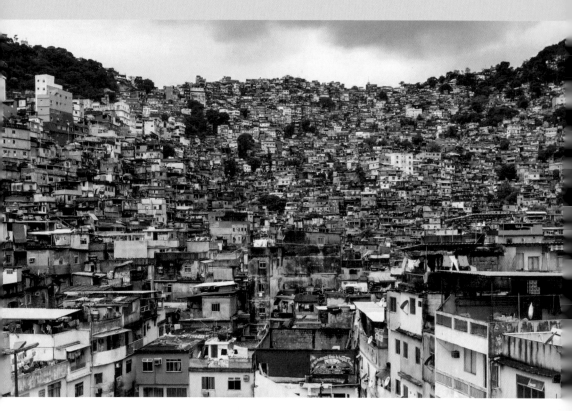

## Rio 10K
### Joe Capra (aka Scientifantastic)

American photographer Joe Capra (aka Scientifantastic) specializes in time-lapse photography in the ultra-high-resolution range of 4K to 10K. For an assignment commissioned by a major client in Rio de Janeiro, he captured the vibrant life in that Brazilian megalopolis with a Phase One IQ180 camera. Each individual image that makes up this 10K video measures 10,328 by 7,760 pixels, which affords very high flexibility in post-processing. A single 10K sequence ultimately yields up to six different 4K motifs. The images worked up by the Ars Electronica Futurelab for *Deep Space 8K* offer an extraordinary opportunity to enjoy Joe Capra's world-class time-lapse photography on 16x9-meter projection surfaces.

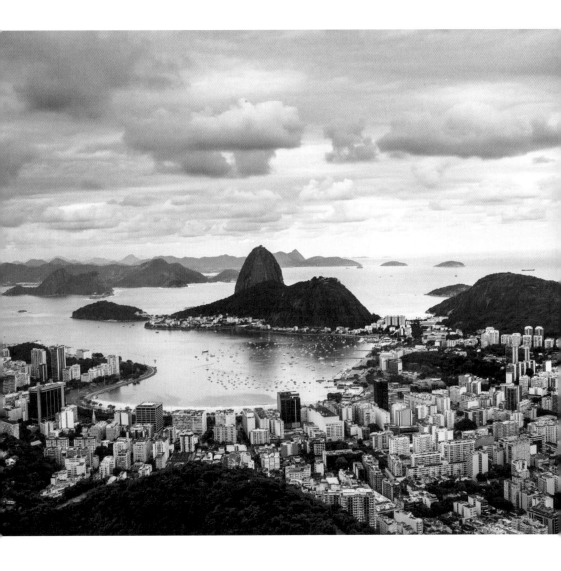

# Sun
## Michael König

The star at the center of our solar system delivers the light and warmth that make life on Earth possible. *Sun* enables viewers in *Deep Space 8K* to behold that star's enormous power. The audiovisual wall & floor projection by Michael König is an enhanced version of his time-lapse project of the same name created with footage furnished by the Solar Dynamics Observatory of the NASA Goddard Space Flight Center. This project developed especially for *Deep Space 8K* features impressively detailed images of solar activity from 2011 to 2015. There's a walk-though full view of the gigantic gas ball projected onto the floor; condensed commentary accompanies the images on the wall; and the soundtrack is the work of Mexican musician Murcof-Una (album *Utopia*, 2004).

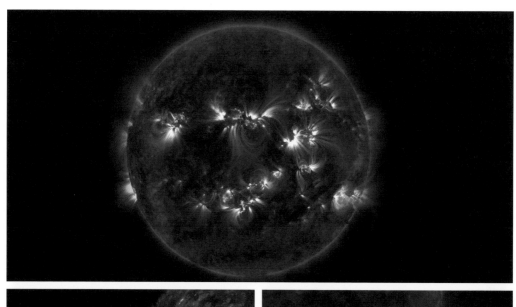

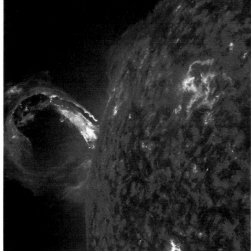
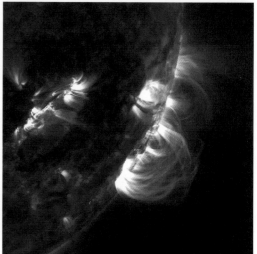

Solar Dynamics Observatory (SDO) / NASA Goddard Space Flight Center

## Urfixed Light Animation
Thomas Schwarz

With its colorful mix of carousels, Ferris wheels, roller coasters and fireworks, the *Urfahranermarkt*, a twice-annual (spring and autumn) event staged on a fairground adjacent to the Ars Electronica Center Linz, attracts over a million visitors a year. In artist Thomas Schwarz's time-lapse video entitled *Urfixed Light Animation*, the Linz native has succeeded in capturing and documenting the colorful hustle and bustle at this very popular carnival along with its transient luminous structures and tonal fragments.

# Cultural Heritage

The wanton destruction of significant cultural sites in the Near East by ISIS terrorists remind us how important it is to preserve—at least digitally—these symbols of cultural consciousness for future generations and to make them accessible to the general public. There are several crews equipped with 3D laser technology traveling the world to scan in statues, buildings or entire architectural ensembles and thus preserve these priceless cultural treasures for posterity. The results of these efforts are huge quantities of points—so-called point clouds—that can be displayed as three-dimensional visualizations. *Deep Space 8K* now lets visitors behold virtual reconstructions of historical sites in 3D and walk through them in the truest sense of the word. This is made possible by a point cloud renderer & viewer that the Ars Electronica Futurelab specially enhanced for 8K image resolution.

## CyArk

Along with the technological upgrading of *Deep Space* to *Deep Space 8K*, Ars Electronica is intensifying its collaboration with CyArk, a nonprofit organization we've been working together with since 2009. CyArk works to document cultural heritage sites around the world using 3D technology. Their archive currently houses over 180 international sites freely available to the public. The high-resolution technology at *Deep Space 8K* has the enhanced capacity to screen 3D images generated by even finer and more precise point clouds. The colorful spectrum includes the ancient Maya city of Tikal in Guatemala, the cathedral of Beauvais, France, the cliff dwellings of Mesa Verde National Park in the U.S., and St. Sebald, a medieval church in Nuremberg, Germany. What they make clear is that human destructiveness isn't the only thing responsible for the dilapidation of important cultural treasures; natural catastrophes or simply the ravages of time necessitate measures to preserve humankind's precious cultural heritage.

Centre for Digital Documentation and Visualisation LLP (a partnership between Historic Scotland and the Digital Design Studio at The Glasgow School of Art)

## The Scottish Ten
### Centre for Digital Documentation and Visualisation LLP

3D laser scans can not only document the extent of an object's deterioration; the resulting cloud of points also provides a valuable data-based point of departure for the reconstruction of the object's original state. *The Scottish Ten* is a five-year project that aims to create extraordinarily precise digital models of the five UNESCO World Cultural Heritage sites located in Scotland and five heritage sites in other countries. To accomplish this, Historic Scotland, the nation's heritage agency, and the Glasgow School of Art's Digital Design Studio established the Centre for Digital Documentation and Visualisation LLP (CDDV). In *Deep Space 8K*, visitors can behold Scotland's cultural treasures: Skara Brae pre-historic village was inhabited before the Egyptian pyramids were built, and flourished for centuries before construction began at Stonehenge. The monumental chambered tomb of Maeshowe is simply the finest Neolithic building in North West Europe. Built around 5,000 years ago, it is a masterpiece of Neolithic design and stonework construction. New Lanark was at one time the cornerstone of the Scottish cotton spinning industry and is regarded as an exemplar of enlightened management, proving that productivity increased with the improved treatment of the workforce. CDDV is working on it together with CyArk, another goldmine of digital 3D data. *www.scottishten.org*

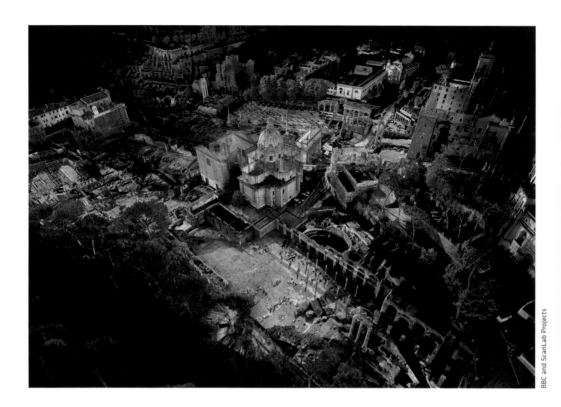

BBC and ScanLab Projects

## Rome's Invisible City
BBC and ScanLab Projects

In *Rome's Invisible City*, with the help of cutting-edge 3D laser scanners, a team of experts explore the hidden underground treasures that made Rome the powerhouse of the ancient world. We uncover a subterranean world that helped build and run the world's first Metropolis and its Empire. From the quarries that helped build the Pantheon's magnificent dome to the aqueducts and sewers that supplied and cleansed the city, from the mysterious cults that sustained it spiritually to the final resting places of Rome's dead, they reveal the underground marvels that serviced the greatest city of the classical world. This short compilation from the film, by BBC and ScanLab Projects, foregrounds the extraordinary 3D scans of Rome's invisible underground treasures.

328

# Artistic Explorations

With its jumbo-format wall & floor projections and built-in laser tracking system, Deep Space 8K presents a creative challenge to media artists. Adapting existing works and designing installations custom-made for this space is like entering artistic terra incognita. The audience is within the bounds of the projection surface, so audience participation calls for a well-thought-out aesthetic composition and concepts for the resulting dynamics. The outcome should be a cooperative aesthetic that the audience not only views but co-determines.

## Cooperative Aesthetic
University of Art and Design Linz

In *Sinus*, a work by Simon Krenn, a student in the Time-based and Interactive Media program, visitors walk across the projection surface and—individually or as a group—impart vibrations to sine waves several meters in length. During the academic year 2014–15, university professor Gerhard Funk conducted a course in conjunction with AEC Deep Space. Linz Art University undergrads worked together with experts on the Ars Electronica Futurelab's staff to program interactive works designed especially for Deep Space. They debuted in the TIME OUT .04 exhibition.

AEC, Martin Hieslmair

*Sinus*, Simon Krenn

## Colour Bars
### Gerhard Funk, Christoph Frey (sound)

*Colour Bars* is an interactive work by Gerhard Funk, director of Linz Art University's Time-based and Interactive Media program. Visitors to this installation jointly endeavor to define a particular shade of color.

## WHITE POINT
Arotin & Serghei

The vanishing point is an imaginary point—or one in a perspective drawing—at which parallel lines receding from the observer seem to converge and vanish. The closer the observer gets to the vanishing point, the further it seems to recede. In the Ars Electronica Center's new Deep Space featuring projections with 8 x 4K resolution and composed of more than 66 million pixels, the dimensions of the smallest possible vanishing point—assuming it were illuminated to make it visible—would be approximately 1 mm and thus the size of a single pixel. *WHITE POINT* is based on the premise that the observer is situated in the vanishing point. Visitors thus seem to move into the center of the light inside this single pixel, and are within an imaginary cube made up of six picture membranes. The initial image is reflected and rotated on three different axes. The resulting impression on the part of visitors is to be amidst a perspective that extends in all six directions.

Mother and Child near Al Zaatari Refugee Camp, Jordan, 2014

## Post Refugee City
Lukas Maximilian Hüller, Hannes Seebacher, Kilian Kleinschmidt, Robert Pöcksteiner

There's fear of refugees and asylum seekers, of a modern-day mass migration that threatens our habitat. These are scenarios that many of us find alarming. How are we to encounter those who have lost all hope of living a life fit for a human being in their own homeland? In the future, will we still be able to afford humanism? Producer/director Robert Pöcksteiner embarked on a search for answers. In 2014, he traveled to the Al Zaatari refugee camp in Jordan in conjunction with artist Lukas Maximilian Hüller's photography project which he did in cooperation with Hannes Seebacher. What he saw defied all his expectations. The people who live here have made arrangements with their fate without losing hope. But for them, hope doesn't entail moving to Europe; it's returning to their homeland.

Pöcksteiner shoots footage and conducts interviews. He meets young mothers who live in the camp with their children, as well as children who arrived alone and have to get by on their own. He realizes that it's up to him to tell the story of those living in Al Zaatari. To give an account of people whose most fervent desire is to live in peace, people who yearn for their homeland. Zaatari is the world's third-largest refugee camp. The civil war rages only 10 kilometers away. The explosions of artillery shells

can be felt in the container city. Right now in this rocky desert, there are 100,000 Syrians living apart from their families; 60,000 of them are children. In this situation, it's virtually impossible to deal with the trauma of war and fleeing from it. But Robert Pöcksteiner meets people who are trying to do just that, nevertheless. This documentary is planned to be completed in October 2015. In the meantime, selected film sequences and gigapixel images have been compiled into a visually stunning and, above all, deeply touching preview to be screened in Deep Space 8K.

*Let the Children Play* project, realized at Zaatari Refugee Camp, Jordan, by Hüller / Seebacher, 2014 / produced by *playfoundation.org*. Featured in Robert Pöcksteiner's documentary film project *Snapshots in Time,* Zaatari Camp. Project and photo compositions realized with the substantial support of Kilian Kleinschmidt, former camp manager Zaatari Refugee Camp.

*http://www.letthechildrenplay.info*
*http://www.dontpanicproduction.com*

## In2white
### Mont Blanc largest panoramic image

This 365-gigapixel panoramic shot immerses spectators into the white world of Mont Blanc. Filippo Blengini's *in2white* project focuses with unprecedented clarity on Europe's highest mountain in the Alps.

**Facts:**

3,500 m altitude
365 gigapixel
70.000 images
-10° temperature

Red Bull Media House

Rocky Mountains

Sebastian Marko/Red Bull Content Pool

Ryan Doyle Brazil

Christian Pondella/Red Bull Content Pool

Red Bull Rampage

# Action Pack

For years now, Ars Electronica has been partnering with Red Bull Media House, a constant source of action-packed sports videos and breathtaking tracking shots. From their wealth of new content in 4K quality, the Austria-based media enterprise will continue to provide Deep Space with leading-edge worlds of imagery. For instance, their *Red Bull Rampage* video gives a spectacular overview of the freeride mountain biking competition of the same name held annually in the U.S. State of Utah. *Rocky Mountains* accompanied daredevils Will Gadd and Gavin McClurg on their paraglider flight over what is quite possibly North America's most imposing mountain range. *Ryan Doyle Brazil* follows British freerunner Ryan Doyle as he traverses Brazil's multi-faceted megacity Rio de Janeiro.

# Play Spaces

Deep Space reloaded opens up a whole series of portals to new content. Two 16x9-meter projection surfaces on the wall and floor of a space equipped with sophisticated tracking technology makes *Deep Space 8K* an extraordinary setting for realistic three-dimensional experiences. Pharus, the laser tracking system Ars Electronica Futurelab staffer Otto Naderer developed as his master's degree project, has been continuously enhanced since its inception. Students at the Upper Austria University of Applied Sciences' Hagenberg Campus and Linz Art University were so fascinated by it that they created their own applications for Deep Space. Six laser sensors installed at ankle height around the periphery of the floor detect the positions of the individuals moving about the space. Simultaneous evaluation of the captured data in combination with intelligent tracking makes it possible for this setup to register up to 30 individuals in *Deep Space 8K*.

## Game Changer Suite
### University of Applied Sciences' Hagenberg

*Game Changer Suite* is a collection of multiplayer games that were developed as prototypes by students at the Upper Austria University of Applied Sciences' Hagenberg Campus. The accent in *Game Changer* is on exploring cooperative and competitive game playing. The gamers moving about in *Deep Space 8K* are registered by means of laser tracking, which enables them to control their virtual avatars projected onto the space's wall and floor. Getting their whole body into the swing of things, they can play out a variety of scenarios—either collaboratively or every man for himself. Originally developed as a temporary installation for the 2014 Ars Electronica Festival, *Game Changer Suite* is now a mainstay of the lineup in *Deep Space 8K* at the Ars Electronica Center.

All texts: Martin Hieslmair

# ITAF 2015

During this year's Ars Electronica Festival, the International Teletext Art Festival 2015, will be presented in Deep Space. Artworks specifically created for the Teletext medium will be shown on the 16x9 meter screen.

## International Teletext Art Festival

Since it was launched by the Helsinki-based FixC cooperative in 2012, the International Teletext Art Festival ITAF has been enjoyed by over 2 million people in Germany, France, Switzerland, Austria, and Finland. The idea of the festival is to explore the creative aspects of teletext by inviting artists to create art works in teletext format and to broadcast the results to the public.

Before ITAF made Teletext Art known to a wider audience, there were some serious efforts to open up teletext for art: for example, Edwin van der Heide's *Teletext Art Project* broadcasted in Dutch National Television in 2000 with JODI, Joost Rekveld, Maki Ueda and Wlfr. Another ambitious project was Microtel by *Lektrolab,* which was created in association with the Witte de With Center for Contemporary Art during the International Rotterdam Film Festival in 2006. Teletext was originally launched by the BBC in 1974 (known as Ceefax) and is a means of sending text and simple geometric shapes to a properly equipped television screen by use of one of the "vertical blanking interval" lines that together form the dark band dividing pictures horizontally on the television screen. A teletext page can be perceived as a grid of 24 rows and 40 columns. To change the colors of the graphics, text and background or to add a blink effect, a control character needs to be inserted. Each time a control character is placed it uses up one space in the grid, which then appears black. And you only have 6 colors + black and white. Teletext is a basic and a very economical way of broadcasting information, and though it ceased to exist in UK, it has survived in many countries and is still used by millions of people daily.

The 15 artists/artist groups featured in the 2015 festival who are also competing for the Teletext Art Prize are: Bakketun & Norum (NO), Christina Kramer (DE), Emilie Gervais (FR), Holger Lippmann (DE), Ian Gouldstone (US), Karin Ferrari (AT), MadAsHell (US), Maria Lavman Vetö (SE), Matthias Moos (CH), Max Capacity (US), Paula Lehtonen (FI), Ryo Ikeshiro (JP), Bernhard Garnicnig & Lukas Heistinger (AT), Rich Oglesby (GB), and Rainer Kohlberger (AT). The 2015 Teletext Art Prize jury members are: last year's winner Dan Farrimond (GB), artist Raquel Meyers (ES), and curator and art historian Pontus Kyander (SE).

The 2015 festival is curated by Juha van Ingen from FixC cooperative. ITAF starts on August 13th and is broadcasted for one month in ARD Text, ORF Teletext, SWISS Teletext and arte Teletext. The teletext page numbers, information on participating artists and an archive of past festivals are available on line: *www.teletextart.com.*

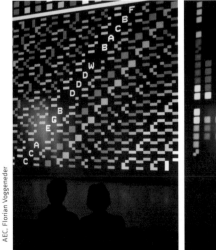

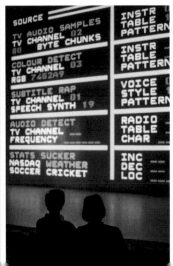

AEC, Florian Voggeneder

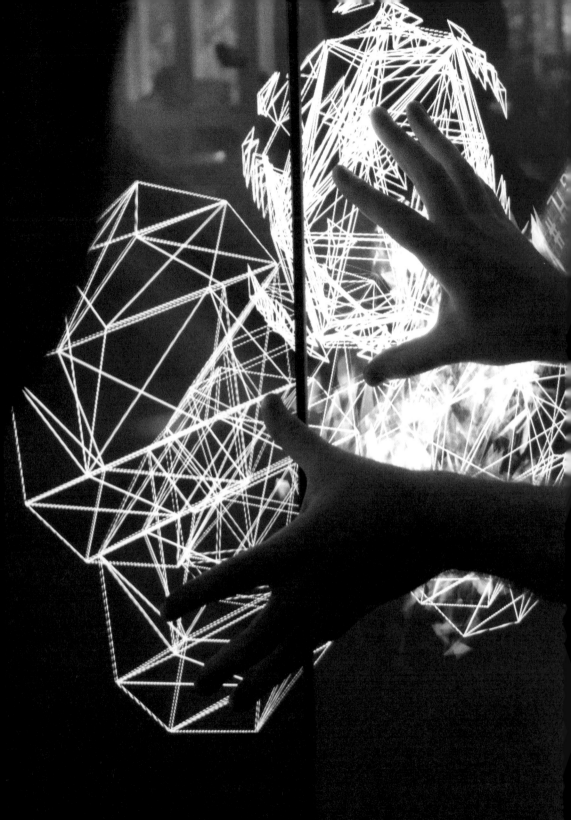

# Ars Electronica Futurelab
## Future Prospects for Linz and the World

The Ars Electronica Futurelab has been working at the nexus of art, technology and society since 1996. Transdisciplinarity, artistic practices and applied research characterize this laboratory/atelier's approach to assignments. The focus of its activities is on manifesting great future promise as well as social relevance in the projects it implements. In this sense, the Ars Electronica Futurelab's work can be understood as generating sketches of potential future scenarios that offer new prospects for the participating project partners in art, science, and commerce as well as for society as a whole. Confirmation that this way of going about things has been crowned with success is delivered by the lab's international orientation. Over the course of its 19-year career, the Ars Electronica Futurelab has advanced to the status of global player and made a name for itself in such hot spots as Berlin, Dubai, Hong Kong, London, Osaka, and San Francisco.

Nevertheless, ever since it was founded, the Ars Electronica Futurelab has also had a close bond with the City of Linz. Dealing with issues such as demographic & urban development, interactive technologies that get Linzers involved in public extravaganzas like the *Linzer Klangwolke* (Linz Sound Cloud), and impressive visualizations of the activities of the Unternehmensgruppe Linz network of public service enterprises are just a few of the Ars Electronica Futurelab's many, multifarious installations and projects that have added fascinating facets to life in Linz. Individual projects implemented in cooperation with institutions such as the University of Linz, Linz Art University, the Upper Austria University of Applied Sciences' Hagenberg Campus, and voestalpine have developed into a full-blown network of exchange with a wide variety of organizations located in and around Linz. This dovetailing of global and local activities has made the Ars Electronica Futurelab an agent of change that not only combines approaches from many different disciplines but also blends diverse geographic influences. To provide a glimpse at the Ars Electronica Futurelab's current activities, a selection of projects that either took place or are underway between September 2014 and September 2015 will be described. First, there's a brief overview of the lab/atelier's activities, followed by a more detailed look at a few projects that are closely connected to this year's festival or are especially relevant at this time.

The Ars Electronica Residency Network invites artists from all over the world to develop projects jointly with staff members of the Ars Electronica Futurelab and/or a partner institution, or to further develop extant works. The following residencies were staged over the past year:

In early 2015, four artistic research residencies under the aegis of the EU's *Connecting Cities* project were hosted by the Ars Electronica Futurelab (see p. 154). Their theme was public media infrastructure and participation.

Chilean artist María Ignacia Edwards won the first European Digital Art and Science Network's residency and, in cooperation with ESO (the European Southern Observatory), spent time at the La Silla and ALMA observatories (see p. 177). Semiconductor won the 2015 *Collide@CERN* residency within this framework (see p. 180).

At the outset of this year, Japanese artist Ryoji Ikeda, winner of the 2014 Prix Ars Electronica Collide@CERN Residency, spent about two weeks at close quarters with the European Center for Nuclear Research's Large Hadron Collider.

*Sorting out Cities*, Dietmar Offenhuber, National Museum of Emerging Science and Innovation (Miraikan) and Ars Electronica Futurelab

Futurelab's Spaxels at the Eurovision Song Contest 2015

*Soul of the Cube*, Ars Electronica Futurelab, Queensland University of Technology, Brisbane, Australia

TRANSMIT³, the Queensland University of Technology's residency program, is now in its second year. The current recipient is Friedrich Kirschner, a German filmmaker, software developer, and visual artist.

CAT@Ars Electronica, a program supported by the Chungnam Culture Technology Industry Agency, is likewise being reprised. This year, Hyungjoong Kim, a young media artist from MAC Lab at the KAIST Institute in South Korea, is getting the opportunity to implement his Jangdan project at the Ars Electronica Futurelab.

And Indonesia-based XXLab, recipient of Prix Ars Electronica [the next idea] voestalpine Art and Technology Grant, will once again be taking up residency at the Ars Electronica Futurelab to further develop their project and take their idea to the next level.

In the Futurelab Academy, Ars Electronica's academic program, students from all over the world come to Linz from to learn from Futurelab staffers. And this works reciprocally too—researchers from Linz are invited to participating universities to hold workshops for their students on site. In 2014-15, the partner institutions were FH Joanneum Graz, the Hong Kong Design Institute, and the University of Tsukuba.

The Connecting Cities project financed by the EU Culture Programme entered its final phase in 2015. The project's aim is to set up infrastructure at interlinked media façades, jumbo screens and urban projection surfaces that can be used by the general public for the purpose of creative exchange. In 2014-15, four artists have produced works at the Ars Electronica Futurelab under the aegis of the project's artist-in-residence program. Plus, this year's Ars Electronica Festival will be spotlighting the Connecting Cities network.

Creative Cloud Osaka is a project the Ars Electronica Futurelab has produced in cooperation with Knowledge Capital in Osaka, Japan. It brings together artists, innovators and Osaka city dwellers for workshops, speeches and exhibitions designed to engender new ways of looking at a broad spectrum of current issues and thereby contribute to innovation and positive social change (see p. 164).

The Ars Electronica Futurelab has been working together with carmakers once again. For Audi, experts in the field of 3D simulation & interaction are developing improved ways to depict and test vehicle driving characteristics. And the Futurelab has teamed up with Mercedes-Benz (see p. 86) to perform collaborative research on self-driving cars. 2014-15 has also been a busy year for the Spaxels (space pixels), the Ars Electronica Futurelab's choreographed swarm of LED-equipped quadcopters. Among their high-profile aerial shows were appearances at the Day of German Unity in Hannover, the national celebration in the United Arab Emirates, and at this year's Eurovision Song Contest. They also displayed their precision maneuvers indoors at two conferences held by Intel Corporation.

Soul of the Cube was a project produced jointly with Queensland University of Technology in Australia. The Cube, a large-scale interaction environment on the QUT's campus, displayed visualizations of activities at the school and thus put in place an application designed to give the people on site a new way of relating to their everyday surroundings.

The Sorting out Cities project was a collaborative effort with Dietmar Offenhuber of Northeastern University in Boston and the Miraikan, Japan's National Museum of Emerging Science and Innovation. This work is an extraordinary visualization of the central role of cities and the changing interrelationship between urban and rural areas.

A project entitled FOCUS was produced right here in Linz in cooperation with Schlossmuseum Linz. It's a smartphone app that enables visitors to the Schlossmuseum to take an active approach to the exhibits and zoom in on what they like best. At the end of their museum tour, visitors are invited to upload their favorite motif to the FOCUS terminal and create a button they can take home. This Futurelab project will also be found at the AEC and this year's festival (see p. 116).

Another Linz-based project was produced in-house at the Ars Electronica Center, where the world's highest-definition projection space just took a technological quantum leap. Deep Space 8K–The Next Generation of Visualization Technology features state-of-the-art 8K projectors (see p. 314). The Ars Electronica Futurelab has made a major contribution to meeting the challenges posed by the conception and depiction of content that lives up to the demands of this awesome equipment.

Text: Bernhard Böhm

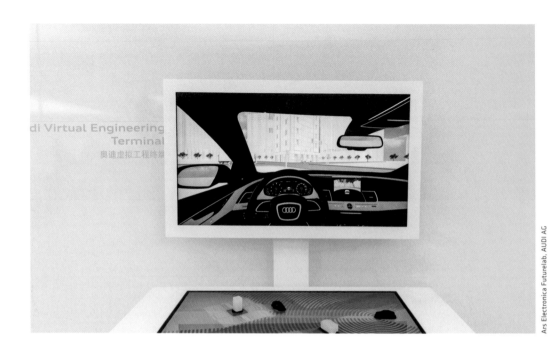

Ars Electronica Futurelab, AUDI AG

AUDI AG + Ars Electronica Futurelab

# Audi Virtual Engineering Terminal

Virtualization is becoming increasingly important in the auto industry—in both the cost-saving product development and the public relations fields. The Audi Virtual Engineering Terminal (VET), developed by AUDI AG and the Ars Electronica Futurelab, facilitates mediation and decision-making in terms of design and the customer's experience of performance features and characteristics, but also in technical development of assistance systems. The interactive installation makes it possible to gain first insights and to experience technical innovations that may still be in an early stage of development. To design and configure this novel terminal, AUDI AG and the Ars Electronica Futurelab engaged in an intensive process of exchange, whereby AUDI AG staffers elaborated on various problems that were then subjected to precise analysis by the Ars Electronica Futurelab. Reliance on the Ars Electronica Futurelab's expertise in the fields of human-computer interaction, real-time graphics, and virtual

reality, yielded new modes of identifying mediation issues and thus limning approaches to solving them in totally unprecedented ways. On the basis of this analysis, we developed several prototypes; one of them—the Audi VET—proved to be the optimal solution, and was subsequently produced by the Ars Electronica Futurelab. The terminal features Tangible User Interfaces (TUIs) providing a very intuitive way to juxtapose and compare respective variants of various vehicle features, and to take a comprehensible, hands-on approach to experiencing the benefits of novel developments. One or more Audi models can be positioned and configured on an interactive tabletop display in order to simulate their performance in diverse traffic scenarios and under various conditions. Parallel to the op view on the tabletop, the same simulation is screened either from the driver's perspective or a bird's-eye view on a frontally positioned vertical display. The Audi VET depicts the physically correct driving simulation data generated

by AUDI AG and can, at the same time, be operated within the context of any definable traffic situation. The VET has already been utilized worldwide at numerous public events to introduce new vehicle functions such as Audi's novel LED Matrix Headlight and Intersection Assistant. It elicited enthusiastic responses from tradeshow visitors at CES 2015 in Las Vegas and CES Asia 2015 in Shanghai, and thus impressively underscored Audi's long-term commitment to achieving *Vorsprung durch Technik* (Prog-

ress through Technology) not only in its products but also in its tools for development. In addition to its use for presentation purposes, the VET is deployed in-house to develop new features by offering the possibility of virtually testing several variants of new features even before the first prototypes are developed—for instance, illumination performance of new headlight designs or innovative assistant functions that, as marketable products, are still a few years down the road.

Text: Roland Aigner, Wolfram Remlinger

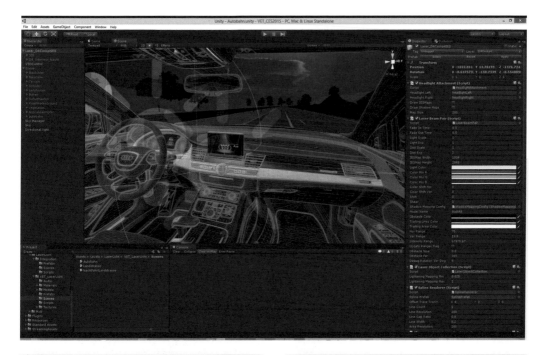

Ars Electronica Futurelab, AUDI AG

## SAP + Ars Electronica Futurelab
# Innovative Media Art Strategies in Corporate Space

For more than a decade Ars Electronica Futurelab has been enjoying fruitful and inspiring collaboration with the German Software producer SAP, creating innovative and experimental prototypes that generate new perspectives in corporate settings, through artistic approaches. Special importance is placed on projects focusing on the built environment. Ars Electronica Futurelab has integrated SAP's data processing into their media-art architecture concepts and created unique architectural installations in several SAP buildings. SAP's culture, the actual environment as well as artistic considerations are integrated in these installations, which both reflect and shape the local architecture. Just recently, two projects were concluded: *Building Bridges* and *Monolith.*

### Building Bridges

*The Bridge* is one of the main passageways connecting two building complexes on the Walldorf campus and it is host to the interactive music piece *Building Bridges*, jointly composed with Vienna-based composer Rupert Huber. Translating the movements of the pedestrians through a compositional algorithm, *The Bridge* serves as stage and instrument at the same time. Every person is tracked by Ars Electronica Futurelab's custom Pharus laser tracking system. This system can read people's movements and consecutively triggers the playback of tones. Each of the 48 individual tones is assigned to one of the speakers that are evenly distributed in the ceiling of the 60 meter long passageway, summing up to 96 tones for both walking directions. This linear arrangement of evenly distributed sound sources in the space renders an always-unique composition created by the madding crowd. 48 meeting sounds, which become audible when people meet and pass each other by, additionally reinforce activities on *The Bridge.* The sounds are based on recordings of classic instruments such as piano, horn, flute, viola and contrabass—played by SAP employees, who are members of the unofficial SAP Orchestra. To achieve optimal architectural sonification Rupert Huber uses sounds of the overtone series, and sorts them according to their frequency intervals to achieve harmonic, proportional music. *Building Bridges* was initiated to underline a statement by SAP CEO Bill McDermott and former co-CEO Jim Hagemann Snabe about "[...] *building bridges rather than silos.*" Like the company's products, the installation's unique momentous composition is the outcome of each and everybody's contribution

Ars Electronica Futurelab, Peter Freudling

to a bigger whole. *Building Bridges* accompanies walkers through the highly frequented passageway, providing subtle, continuous interaction with the instrument. Located in the bridgeheads, a live visualization of the crowd and the current composition's score serves as informative conclusion and uncovers the magic behind it. Additionally, a room in one of the break-time areas hosts a visualization screen as well as a down mix of the 48 channels on five speakers. Due to its success and SAP's global operations, there are plans to develop *Building Bridges* with new sound sets from all over the world and plans for a CD and a stereo audio stream.

## Vedaport / Monolith

A huge three-dimensional sound sculpture—the *Vedaport*—is situated in front of the main entrance of the International Training Center on the Walldorf campus. This port is a landmark for trainees and reacts to movement, uttering quotes on matters such as knowledge and education. In the Lobby, the *Vedaport's* geometric and sensual counterpart is an interactive installation called *Monolith*, completed in spring 2014.

The six meter tall *Monolith* consists of 24 frameless screens, wrapped in translucent mirror panels. These panels render the *Monolith* almost invisible at first glance and enhance it. Displaying the time of the day, the Monolith also fulfils the function of a central clock tower. *Monolith* is part of the overall concept of *Vedaport*, also focusing on the core topics knowledge and education, which are communicated via handwritten historically important quotes. The chalk and board aesthetics of this visual language contrasts with the *Monolith's* architectural and geometric cleanliness. Frequency, creation-speed and variety of the content shown are based on the movement of the crowd within the lobby, cumulating in an abstract live visualization of tracking data. Construction of the *Vedaport* is currently underway and due for completion by the Ars Electronica Futurelab late 2015.

Text: Peter Freudling

# Creative Catalysts

As a non-university research and development institution, the Ars Electronica Futurelab considers its everyday practice of connecting a variety of disciplines a as fundamental, important innovation battery. For years, interaction designers, media artists, software and hardware developers as well as social scientists and cultural theorists have been working together in flexibly arranged teams. Based upon the concept of "shared creativity," an ideal breeding ground evolves for the research, development and evaluation of technological innovations. The term creativity has become a common denominator of considerations with respect to a new European economy. What is called for now at the outset of the 21st century are inventiveness and innovation. Emerging technologies have the potential to play a dual role in the "Creative Society" of the future. Whereas they are quickening the need for change in all aspects of people's lives on the one hand, technology—if properly designed—can on the other hand also help its users to develop as creative thinkers. One doesn't have to be an artist to become an innovative creator. We therefore examine the impact of digital technologies on creative processes; we conceptualize technology-based creativity support tools and also provide access to such tools for children and adolescents.

Projects realized within our research program include *Switch* (2010), an edutainment kit from Futurelab in collaboration with Elekit, with which users can design comfortable communication depending on their environment and context; *Shadowgram* (2010), an installation in which your silhouette can be integrated. By writing comments in a speech balloon next to your silhouette, you can display your thoughts on a large wall within the installation. These stickers with their individual messages on a certain theme constitute an artwork in their own right. *Klangwolke ABC* (2012) is a social participation project using an LED kit to create alphabetical characters, in which the light is controlled by a radio receiver.

Following the big success of *Switch*, Futurelab is working with Elekit for the second time this year. After the so-called 3/11 in Japan, the requests for educational kits especially addressing the topic of energy have increased. Focused on this demand, Elekit has already been a provider for ecological products dealing with solar and new energies. Futurelab's collaboration with Elekit, has produced *CandleScape*, a solar energy based creative kit where people can construct their own worlds inside this magical candle. *Switch* explores experience design, using the simple metaphor of "on" and "off". *CandleScape* follows a similar fashion by providing two layers of canvas, to which the participants in the workshop can bring their own worlds. Creative Catalyst is a new kind of research and innovation that creates unforeseen forms of expression, transforms our minds and society, and enhances further discussion on creativity.

Text: Hideaki Ogawa

*Switch*, Ars Electronica Futurelab, ELEKIT

*CandleScape*, Ars Electronica Futurelab, ELEKIT

Chihiro Masuda

University of Tsukuba + Ars Electronica Futurelab
# Ars Electronica Futurelab Academy "LabX"
# Post City Kits from the University of Tsukuba

The Ars Electronica Futurelab Academy comprises a range of activities that share the goal of knowledge transfer and exchange with educational institutions and organizations acting at the nexus of art, design and technology.

In one of the Futurelab Academy's most successful program formats, Ars Electronica Futurelab experts act as external mentors for university students in a range of fields from human-computer interaction to media art; this co-supervision of projects results in an exhibition at the Ars Electronica Festival. This year, the Ars Electronica Futurelab partnered up with Japan's University of Tsukuba, where a new PhD program in *Empowerment Informatics* has been founded. From Hiroo Iwata, head of the program:

The PhD program *Empowerment Informatics* (EMP), is a five-year program supported by the Ministry of Education, Culture, Sports, Science and Technology. It consists of the following three areas that are core strengths of the University of Tsukuba, and highly important in the related industries.

1. Supplementation: To supplement the reduced physical and sensory functions of elderly people or people with disabilities.

2. Harmony: To harmonize the engineered systems that people encounter in daily life (advanced mobility, etc.) so that they integrate with people.

3. Extension: To draw out and extend people's latent creative functions.

EMP has established a specialized place for students named Empowerment Studio, a combination of laboratory and exhibition space. Prototypes developed by the students are exhibited in the Grand Gallery of the studio and evaluated by the public. As an extension of this, the collaboration in the Ars Electronica Futurelab Academy framework has been dubbed *LabX:* Over the course of a few months, Ars Electronica Futurelab mentors visit the Empowerment Studio to conduct workshops and discuss the projects with the students via video conferences.

In this first iteration of *LabX*, two student teams exhibit their work at the Ars Electronica Festival, reflecting the theme of the *Post City Kit* (see p. 117).

Text: Hiroo Iwata, University of Tsukuba; Peter Holzkorn, Ars Electronica Futurelab

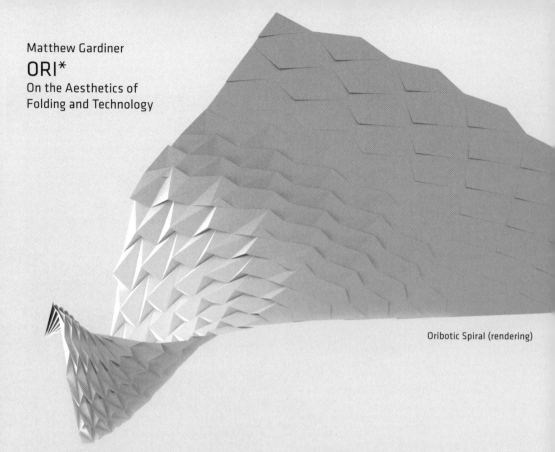

Matthew Gardiner

# ORI*
## On the Aesthetics of Folding and Technology

Oribotic Spiral (rendering)

This research examines how new design approaches that utilise advances in scientific origami, computation, robotics, and material experimentation, can influence the functional aesthetic of the art of oribotics. Situated in the context of contemporary electro/mechanical artworks and objects, and joining the fields of origami and robotics, oribotics is influenced by notions of folding scientifically and philosophically. Oribotics breathes movement into the static domain of origami through responsive robotic technology, and it brings to the viewer of oribotic works, a consideration of the folds found in nature, through the evocation of a state of reflection. Scientific fields like Soft Matter share similar material and design/engineering concerns, utilising the function of folded surfaces. Origami artists craft works by folding paper, expressing the aesthetic of the fold. The signficance of oribotics is that both the function and aesthetic of folding are expressed by the oriboticist. New design methods for oribotics unfold expressive potential in the research field. Research is focused on the artistic thinking, design and material processes that contribute to the fabrication of robotics from folded surfaces. The pro-cesses can be understood as an extension of past oribotic research wherein related concerns are folding pattern design, fabrication technologies, and actuation specific to folding. Cultural and historical perspectives inform the research question, as the group works towards a new theoretical model of Folding as a Language of Structure, expressed as "Folding = Coding for Matter". The additional influences of scientific developments in soft matter, computation, genetics and synthetic biology inform the creative process. Folding is a language of nature: as a higher-level expression of genetic code it defines the sculpture of genetic expression. This analogy to genetics does not translate in a formal sense directly to sheet folding like origami, as genes are not made from paper or planar forms. However the mechanisms and the notions of programming form and function into nature is a strong metaphor that connects artistic and scientific domains.
http://www.matthewgardiner.net/ori

Text: Matthew Gardiner

Lead Researcher: Matthew Gardiner
Researchers: Hideaki Ogawa, Erwin Reitböck, Rachel Hanlon; Funded by FWF PEEK Program, http://fwf.ac.at

Hyungjoong Kim
# Jangdan

With *Jangdan* the South Korean artist Hyungjoong Kim creates an interface to experience, see and evolve rhythms that are used in nongak. Nongak is a kind of traditional Korean farmer's music played by five instruments, each of which represents one of the five elements of nature: kkwaenggwari (a small brass gong), jing (a large gong), buk (a drum), janggu (a double-headed drum), and taepyeongso (a double reed wind instrument). He analyzed and visualized the interplay of the four main instruments and the resulting rhythms of such traditional songs. Through voice input, each visitor of the installation is able to change the musical DNA of the jangdan and thus see and hear the resulting evolvement of the rhythm.

Jangdan, traditional Korean set rhythm patterns of varying length, are treated like DNA and expressed as binary strings on the time sequence. By calcu-

lating the distance between these, the fundamental rhythm of Korea can be found. Jangdan rhythm patterns from nongak songs are combined with other kinds of rhythm DNA. To extract this DNA from a human, the individual's prosodic structure of language is converted into a musical rhythm. The combination of the previously existing jangdan in nongak music is altered by adding the new information about the interface user's rhythm of spoken language. In other words, the audience's spoken language will be converted into DNA sequences and combined with Korean rhythms, thus changing the fundamentals of traditional music into future visions of how it may evolve.

This project has been realized within the framework of CAT@Ars Electronica, a program within the Ars Electronica Residency Network in collaboration with CTIA Chungnam Culture Technology Industry Agency.

# Ars Electronica
# Solutions

Ars Electronica Linz GmbH is multifaceted: a Museum of the Future that attracts 190,000 visitors per year, a festival with attendance of 80,000, an internationally renowned prize competition in the digital media arts, and a state-of-the-art R&D lab. The newest addition is Ars Electronica Solutions offering a comprehensive portfolio of services to private sector clients and government agencies. The 34-member staff of Ars Electronica Solutions specializes in brilliantly conceiving and skillfully implementing a diverse array of interactive installations and new modes of imparting information. Ars Electronica Solutions provides projects and services in four segments: Brandlands & Exhibitions, Event & Show Design, Urban Media Development, and Shop Experience.

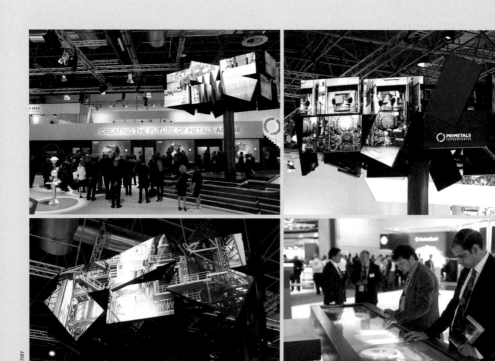

Stephan Pointner

QUPIK Creative Technologies

## Primetals Technologies–METEC 2015
A New Way to Experience Metals

In June 2015, METEC, the world's foremost metallurgical trade fair, took place in Düsseldorf. Ars Electronica Solutions played a key role in the show alongside the industry's newest global player, Primetals Technologies. For this joint venture of VAI Siemens Metals Technologies and Mitsubishi-Hitachi Metals Machinery, Ars Electronica Solutions conceptualized, designed, and developed an 800 m² interactive booth that provides visitors with an enjoyable, efficient way to get informed about the products and services offered by Primetals Technologies. This tradeshow booth makes it possible to interactively experience newly established Primetals Technologies' entire portfolio, and also spotlights the global interaction among the company's individual divisions. The booth architecture and furnishings developed together with any:time architects are references to mining and metallurgy– the seating alludes to the topography of an openpit mining region and the interactive Touch-Table resembles casually stacked cast steel slabs. This eye-catching experience also includes the spectacular centerpiece featuring an artistic interpretation of the metallurgical process in the form of a sophisticated choreography of animation and rotating screens. This innovative, artistic concept of launching the new company name and corporate design mirrors the unique global standing of Primetals Technologies.

# STYRIA–Styriaversum
Interactive lobby at the corporate headquarters

The Styria Media Group is one of the leading media conglomerates in Austria, Croatia and Slovenia. Ars Electronica Solutions' "Styriaversum" concept outshone a field of international competitors and was selected for the design of the Lobby at the company's new headquarters in Graz. The 390 m² Lobby is morphing into the Styriaversum brandland. Beginning in June 2015, visitors will be greeted by interactive exhibits designed to acquaint them with Styria's diversified product line. Ars Electronica Solutions is proud of the media art installations implemented at Styria's corporate headquarters. On the substantive level, they're fed with content from various sources within the Styria Media Group. To achieve this, information is automatically gathered or, if the need arises, input by staff members into a flexible content management system (CMS). By approaching the Media Wall, visitors trigger its active mode, in which they're offered a stylish presentation of digital content that, in a variety of configurations, provides a comprehensive look at the Styria Media Group's corporate world. At the Media Table, visitors can explore the Styria Media Group's digital content, while the interactive History Book lets viewers take a fascinating look at the history of the company and puts it in the context of larger global developments. Last, but not least, the Styria Pillar provides up-to-the-minute looks at Styria Media Group products and serves as a source of information for staff members as well as visitors.

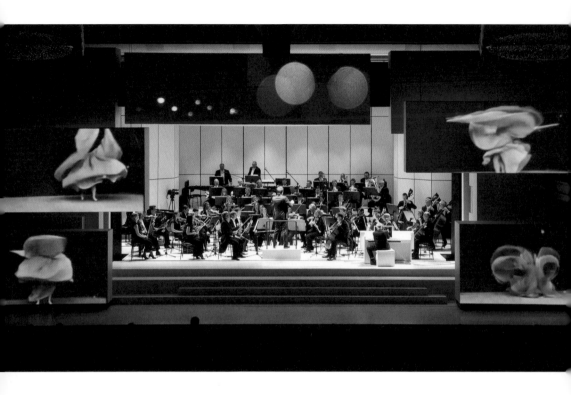

## BASF's Sesquicentennial Celebration
Media Performance with Michael Nyman

Ars Electronica Solutions developed the media infrastructure to display visuals accompanying a live musical performance that was the world premiere of Michael Nyman's Symphony No. 8, *Water Dances*. BASF had commissioned Nyman to compose a work to mark the 150th anniversary of the company's founding. He then collaborated with Ars Electronica Solutions, Hans Reitz and filmmaker Max Pugh to work out a novel approach to accompanying this piece of music with video material from his extensive archive of images. The outcome was media infrastructure on which 132 different video loops were displayed on each of six projection screens arrayed about the band shell. The arrangement of the controls on pianist Nyman's keyboard provided him with an intuitive approach to activating the computer-controlled elements.

AEC

# Spy Museum Berlin
Welt der Spione GmbH

In Europe's capital of espionage, Ars Electronica Solutions conceived and created an interactive museum that presents the cultural and historical development of spying chronologically from antiquity to the present. In collaboration with the *Welt der Spione GmbH,* we developed a spectacular 3,000 m² parcours of interactive exhibits that pass along valuable intelligence about the clandestine world of secret agents. The exchange of information gets started with a 10-meter digital timeline providing a historical survey of espionage from the first known instances until World War I. From then on, each era up to the current day is treated individually, with special emphasis on the Cold War. The cryptology section—including an ENIGMA cipher machine—offers a fascinating look at data encryption. Plus, a *SpyMap* makes available current and historical maps of the city so visitors can trace agents' steps during their stay in Germany's capital. The museum's highlights include an action-packed laser parcours in which

spychasers compete to record the best time through a labyrinth, original James Bond movie props, and a walk-through installation in the form of Teufelsberg (site of an NSA listening station) that deals with Big Data and shows how this matter is everybody's business. Thus, in addition to the Cold War, the museum's substantive focus is on data gathering in the Internet Age. One enlightening feature is a *Password Hacker* that tests the strength of visitors' passwords, and there's *SpyWatch,* an installation that provides access to images from webcams and surveillance cameras. The section entitled Present & Future includes a display of real-time data on air & sea traffic, and elaborates on current espionage-related issues. The Spy Museum Berlin assignment ran the competence gamut: once again, Ars Electronica Solutions was responsible for the installations' content, the exhibition architecture, and the technical planning & implementation of the whole museum. Additional exhibits and areas will be set up in a second phase.

# SAP–Inspiration Pavilion Beijing
Interactive exhibits & Big Data

On January 29, 2015, the Inspiration Pavilion Beijing opened at the new SAP offices in Beijing. Several interactive exhibits invite visitors to explore the world of Big Data. The exhibition's thematic background consists of the global interconnectedness and the related increase in the amount of data we are sending around the world every day. The exhibition is an adaptation of the SAP Pavilion in Walldorf, Germany, which was realized by the Ars Electronica Futurelab in 2014. The Pavilion's highlight exhibits include the Big Data Panorama featuring gigapixel images of Shanghai and the Magic Mirror, a large-format glassy surface that displays the reflection of the person in front of it and lavishly enhances that image with data particles and information.

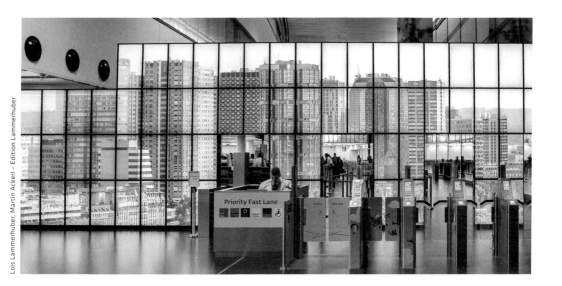

Lois Lammerhuber, Martin Ackerl – Edition Lammerhuber

## Vienna Airport–From Austria to the World: Paris
Unique gigapixel image of Paris at Vienna International Airport

In partnership with Ars Electronica Linz, the multi-award winning Austrian photographer Lois Lammerhuber is once more setting new international standards with *From Austria to the World*–on the initiative of Austrian Airlines. As of 14 February 2015, the Austrian Star Alliance Terminal Check-in 3 at Vienna International Airport is presenting a unique 180-degree photograph of Paris with an extreme resolution of 27 gigapixels. Ars Electronica implemented the hardware and software concept.

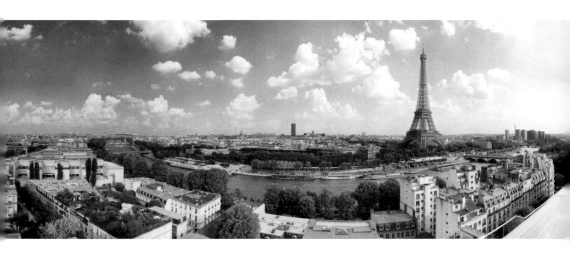

# Other Projects

Jefta Hoekendijk

*BeeHive*, Café Europa, European Capital of Culture, Mons

Umdasch Shopfitting

Umdasch Shopfitting: viPOS Wall at the EuroCIS, Düsseldorf

Johanna Mathauer

Provincial Government of Lower Austria: N[OE]CLEUS

Ars Electronica Solutions

Morphing Station at Schlossmuseum Linz:
Exhibition *Mythos Schönheit*

Guillaume Ohl

GeoPark Karawanken: GeoApp, GeoGame, GeoPulse Mobil

Bernd Albl

BMEIA: Touchwall

Daniel Auer

TEDxVIENNA: City 2.0

K. Umrikhin

Circle of Light, Moscow International Festival

3rd Dialogue for Global Innovation

K. Umrikhin

Circle of Light, Moscow International Festival

## Ars Electronica Solutions—Talks & Lectures

Ars Electronica Solutions' experts have been at festivals and conferences worldwide to give talks about topics related to the area of Urban Media Development. Main subjects include the consequences of continuing urbanization and the way Big Data and Open Data are used to forge a better understanding of cities as a living space. In addition, the talks examine the future perspectives—for instance, in the context of smart cities.

Our experts' talks have been heard at the Smart City EXPO in Beijing, the Moscow Circle of Light Festival, the Smart City symposium in Vienna, the Moscow Urban Forum, and at many other prestigious conferences.

## Ars Electronica Solutions—Urban Media Development

Ars Electronica Solutions' Urban Media Development department examines the interrelationship between media and a particular urban space. One of our primary aims is to create media environments that enable users to comprehend the complexity of medial processes and to actively intervene in them.

# Ars Electronica Export

In 2004 Ars Electronica created Ars Electronica Export, a program dedicated to the production of exhibitions, workshops and education programs for and together with partners from all over the world. The partners are institutions involved in art and culture, science, and education as well as private sector companies. Since then, several dozen of such projects have been realized, and each one has been specially configured together with the hosting partner with the aim to involve local as well as international artists. The activities of Ars Electronica Export play an important role in maintaining and extending the range of our vital network of artists and creative collaborators.

## ITU Telecom World 2014
Doha, Katar, 07.12.–10.12.2014

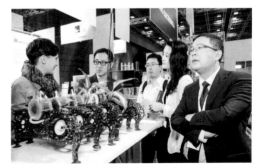

For the second time Ars Electronica is staging a presentation at ITU Telecom World, held at a different venue every year. ITU Telecom provides a global platform for debate and scientific exchange at the highest level in the field of information and communications technology. Ars Electronica was invited to stage an exhibition at ITU's conclave. In an approximately 200 m² exhibition space, *The Lab* showcased a selection of innovative projects at the interface of art, technology and society that were grouped into four thematic clusters: better and fairer coexistence; thinking about and striving to come up with alternatives; design with a (social) message; and the arbitrariness of systems. What all these project had in common was the attitude to regard technology, basically, as a chance.

### Projects presented:

CORD, Mohammed A. ElRaffie (EG)
Parametric Hybrid Wall, Cecilia Lalatta Costerbosa (IT)
BlindMaps, Markus Schmeiduch (AT), Andrew Spitz (FR), Ruben van der Vleuten (NL)
Energy Parasites, Eric Paulos (US)
LillyBot 2.0, Cesare Griffa (IT)
Mine Kafon, Massoud Hassani (AF)
Moony, Takehisa Mashimo (JP),
Akio Kamisato (JP), Satoshi Shibata (JP)
Bhoreal, MID / Alex Posada (ES)
Mycotecture Brick Corner, Phil Ross (US)
Nomadic Plants, Gilberto Esparza (MX)
Perpetual Plastic Project, Better Future Factory (NL)
Prototype for a new BioMachine,
Ivan Henriques (BR)
Rotor / mobile hydro, Markus Heinsdorff (DE), Andreas Zeiselmair (DE), Christoph Helf (DE),
Project Fumbaro Eastern Japan, Takeo Saijo (JP)
Protei, Cesar Harada (FR)
Roboy, Rolf Pfeifer (CH)

AEC, Florian Voggeneder

## Café Europa
## The Austrian Week
Mons 2015 European Capital of Culture

The Austrian Week being staged by Mons 2015 European Capital of Culture showcases cultural exchange with Ars Electronica. The focus is on the Digital Revolution and its consequences in everyday life. The objective is to shed light on three important issues:
· What impact will digitization and new cultural techniques have on our educational systems & programs?
· How will digitization and network-linkage affect conventional production processes?
· What potential can emerge from combining new technologies with traditional—above all, stage-based—artistic forms?
Ars Electronica will provide a wide array of insightful contributions that elaborate on these issues. The ideal venue in which to encounter them is *Café Europa*, a network interconnecting 10 European cities. *Café Europa* combines a 21$^{st}$ century café, a training center, a Fablab and a wall of screens connected to ten European cities.

### Education City with Café Europa

The speed of media evolution makes it more and more challenging to integrate these topics into existing education programs. Information a student teacher learns at university may already be outdated by the time they are actually teaching in the classroom. What can we do to bring new technologies, art projects and digital "musts" more easily and quickly into an educational setting?
The Ars Electronica CREATE YOUR WORLD TOUR aims to take us a huge step closer to a possible answer to this question. What are the educational places, methods, and contents in my city besides the traditional institutions of school and university (e.g.Fablabs, Hackspaces, Repair Cafés...)? The exchange between the *Café Europa* network with Hans Christian Merten and the CREATE YOUR WORLD Team will focus precisely on these questions, addressing the educational objectives and methods.

## Performance and Media

The Ars Electronica Futurelab and two Austrian art-
ists working in the field of performance will present
their work and invite *Café Europa* visitors to partici-
pate in unique insights while elaborating the inter-
sections between traditional, stage-based perfor-
mances and new technologies. A video selection of
performance-based projects developed from the Ars
Electronica Futurelab will showcase an exceptional
selection of productions on the interface to media.
Austrian composer and artist Mia Zabelka will speak
about her electroacoustic interdisciplinary work,
rounded off by a live electronic music performance.
Additionally, the Austrian dancer and choreogra-
pher Dagmar Dachauer will present her video work
in *Café Europa*.

A collaboration of Ars Electronica Linz with Mons Capital
Culture 2015, supported by Österreichisches Kulturforum
Brüssel and the Bundeskanzleramt – Kultur.

Jelena Popic

## Project Beehive
Mons 2015 European Capital of Culture

Mons (BE) and Pilsen (CZ) are the 2015 European
Capitals of Culture. Mons invited Ars Electronica
to stage *Project Beehive* (a crowdsourced video
documentation tool developed by Ars Electronica)
in conjunction with its art & culture program. The
aim is to enable user-generated videos of diverse
cultural events to be conveniently uploaded to a
platform, linked with geodata, and then displayed
on a specially constructed wall of screens. *Beehive* is
set up in Mons' *Café Europa*, which integrates a 21$^{st}$
century café, a training center, a fab lab and a wall
of screens connected to ten European cities. During
the Ars Electronica Festival in September, there'll
also be a live remote hookup from Café Europa to
Linz as part of the Austrian Week in Mons.

## Ars Electronica Creative Cloud and Ars Electronica in the Knowledge Capital
Osaka, ongoing since June 2013

Ars Electronica *Creative Cloud* and *Ars Electronica in the Knowledge Capital* is a workshop series held in the Knowledge Capital of Osaka in a brand-new creative hub for innovation through a fusion of human creativity and technology. Fourteen workshops were conducted in this cultural program curated by Ars Electronica, including cutting-edge talk sessions with international artists and Ars Electronica members. This event was held under the auspices of Knowledge Capital and Kansai Telecasting Corporation (2013–2014). The venue is located in the center of Osaka, and is a complex facility and incubation center for advanced technology and innovation. *The Lab* in the Knowledge Capital consists of open experimental laboratories used by industries and universities, and the venue functions as a unique intersection where general visitors, industries, universities, and creators meet. During the Ars Electronica *Creative Cloud*, three days are filled with talks and workshops. On the first day an artist and an Ars Electronica member hold the *Cloud Talk*. The talks provide in-depth insight into many interesting topics on the cutting-edge of art, technology and society. Since 2014 the talks were accompanied by exhibitions and artwork presentations and this program altogether aimed to stimulate social discussion and action for new creativity based in the Knowledge Capital Osaka during the whole year as *Ars Electronica in the Knowledge Capital*.

### Ars Electronica Creative Cloud 2013 to 2014

June 2013: Zach Lieberman and Gerfried Stocker, Drawing++ / Creative platform
July 2013: Sam Auinger and Horst Hörtner, Thinking with your ears / Future of Lab
August 2013: Greg Saul and Christoph Kremer, SketchChair / Future of Education
October 2013: Ursula Damm and Martin Honzik, Grow your city / Art and Society
November 2013: Michael Doser and Gerfried Stocker, Seeing the invisible / Art and Science
December 2013: Christopher Lindinger and Hideaki Ogawa, Digital Creativity / Art and Innovation
February 2014: Juliane Leitner and Emiko Ogawa, Klangwolke ABC: Parade of Letters / Art and Culture

March 2014: Matthew Gardiner and Hideaki Ogawa, Ori / Art and Making
April 2014: Nova Jiang, Hannes Leopoldseder and Christine Schöpf, The Adventures of You / Art and Expressing
May 2014: Manuel Selg, Horst Hörtner and Hideaki Ogawa, Project Genesis / Art and Thinking

### Ars Electronica in the Knowledge Capital 2014 to 2015

November 6, 2014 – January 25, 2015: Golan Levin, exonemo, Gerfried Stocker and Hideaki Ogawa, CODE–The Language of Our Time
January 29, 2015 – April 19, 2015: Oron Catts, BCL and Hideaki Ogawa, Hybrid–Living in Paradox
May 21, 2015 – July 26, 2015: Carlo Ratti, plaplax, Gerfried Stocker and Emiko Ogawa, Simplicity–The Art of Complexity
July 30, 2015 – October 4, 2015: Electric Circus, PLEN Project Committee, KURUMA-IKU Lab and Ars Electronica Futurelab, Robotinity

## INTERPLAY
Singapore Science Centre
29.05.–16.08.2015

Ars Electronica made its second guest appearance at Science Centre Singapore with *INTERPLAY–where science meets art*. A mobile version of the Deep Space, a multidimensional projection and experience domain and seven art projects were presented to the audience. The fact that both play and art can entail an abstraction of reality is alluded to by the title *INTERPLAY* and demonstrated by the artistic works presented in it. On the exhibition's opening weekend an *Ars Electronica Academy* was held. During this two-day conclave, attendees joined the participating artists in scrutinizing and questioning playful approaches in artistic practice today.

Game Border, Jun Fujiki (JP)
ArsRecollected, Marek Straszak (PL)
Ideogenetic Machine, Nova Jiang (CN)
o.lhar (look), Raquel Kogan (BR)
Digital Puppetry, Tine Papendick (DE)
A Matter of Factory, Softstories (Isobel Knowles and Cat Rabbit) (AU)
Shadowgram, Ars Electronica Futurelab (AT)
Deep Space–mobile version, Ars Electronica Futurelab (AT), Ars Electronica Solutions (AT)
Kinetic light sculpture, Paul Friedlander (UK)
Recollections Six and Temporal Distortions, Ed Tannenbaum (US)

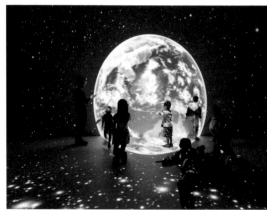

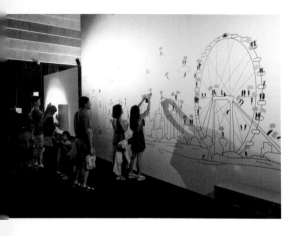

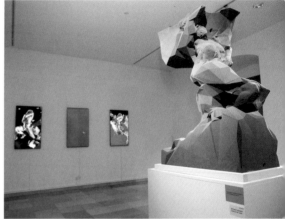

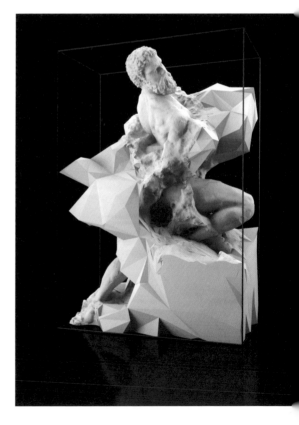

## Captives
## Quayola
Vienna, 29.07. – 07.09.2015

Ars Electronica Linz and Bildraum 07 are hosting an exhibition of works by Quayola, the London-based artist and Golden Nica prizewinner. Bildraum 07 is a cultural facility in Vienna operated by Bildrecht GmbH. In his current digital works as well as in *Forms*, a several-meter-high sculpture from the *Captives* series that the Prix Ars Electronica honored with a Golden Nica in 2013, the artist interprets Michel-angelo's uncompleted *Prigioni* series and updates his renowned *non finito* technique. The exhibition explores the tension and balance between form and content, as well as between human striving for per-fection and the complex, chaotic forms of nature.

## Ars Electronica Animation Festival

The Ars Electronica Animation Festival, which debuts every year in September at the Ars Electronica Festival in Linz, has been garnering rave reviews from moviegoers ever since its premiere. Every year Ars Electronica is working together with the Austrian Federal Ministry for Europe, Integration and Foreign Affairs to make a selection of outstanding submissions for Prix Ars Electronica prize consideration available to educational institutions, film festivals and cultural organizations. The Blu-rays are provided free of charge at the Austrian Embassy and Cultural Forum in every country.

*Ghost Are Dancing*, Maxime Causeret, Gilles-Alexandre Deschaud

*Hollow land*, Michelle and Uri Kranot

*ESCAPE*, Laszlo Zsolt Bordos

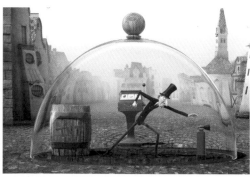

*Plot-O-Mat*, Iring Freytag, Florian Werzinski (Filmakademie Baden-Württemberg)

*y2o {distillé}*, dominique T Skoltz (SKOLTZ inc)

*Portrait*, Donato Sansone

The Ars Electronica Animation Festival
has been screened at the following locations:

| | |
|---|---|
| 24.10.-27.10.2013 | Augsburg, Germany, LAB.30 |
| 28.10.-29.10.2013 | Kaliningrad, Russia, Ars Electronica in Kaliningrad |
| 31.10.2013 | Moscow, Russia, Media Art Lab |
| 06.11.-08.11.2013 | Ankara, Turkey, CerModern Arts Centre |
| 08.11.-11.11.2013 | Brussels, Belgium, ICT ART CONNECT |
| 12.11.2013 | Budapest, Hungary, Grand Café Szeged |
| 22.11.-26.11.2013 | Kraków, Poland, International Film Festival Etiuda & Anima |
| 26.11.-30.11.2013 | Copenhagen, Denmark, Innovation Festival Afsnit I |
| 09.12.2013-17.01.2014 | Munich, Germany, Gasteig Kulturzentrum |
| 11.12.2013 | Hagenberg, Austria, University of Applied Sciences Upper Austria |
| 21.01.2014 | Strasbourg, France, Musée d'Art moderne et contemporain |
| 30.01.2014 | London, UK, Austrian Cultural Forum London |
| 07.03.2014 | Bucharest, Romania, National Museum for Contemporary Art |
| 21.03.-18.04.2014 | Szczecin, Poland, 13 MUZ |
| 26.03.2014 | Rio de Janeiro, Brazil, Cidade das Artes |
| 27.04.2014 | Stuttgart, Germany, Internationales Trickfilm-Festival |
| 20.04.2014 | Trier, Germany, AUSTRIAR |
| 22.04.-25.04.2014 | Ludwigsburg, Germany, FMX 2014 |
| 27.04.2014 | Kiev, Ukraine, Austrian Film Week – Austrian Cultural Forum |
| 07.05.2014 | Lublin, Poland, Chatka Zaka: |
| 14.05.2014 | Tokyo, Japan, European Animation Film Evening, Austrian Embassy: |
| 17.05.2014 | Trnava, Slovakia, Jan Koniarek Gallery |
| 23.05.2014 | Gliwice, Poland, Technopark Gliwice |
| 18.06.-16.08.2014 | Riga, Latvia, International Contemporary and Video Art Festival Waterpieces |
| 18.06.-21.06.2014 | Kosice, Slovakia, OZ Publikum |
| 18.07.-28.09.2014 | Sapporo, Japan, Sapporo International Art Festival |
| 04.09.-06.09.2014 | Trieste, Italy, Wiener Kunstsalon |
| 04.09.-17.09.2014 | Nagoya, Japan, Theater Cafe |
| 12.09.2014 | Istanbul, Turkey, Österreichisches Kulturforum Istanbul |
| 19.09.2014 | Gliwice, Poland, Media Tent |
| 25.09.-27.09.2014 | Maribor, Slovenia, The International Festival for Computer Arts |
| 09.11.2014 | Wien, Austria, Stadtkino Wien |
| 20.11.2014 | Katowice, Poland, Muzeum Śląskie |
| 05.12.-07.12.2014 | Santa Cruz de Tenerife, Spain, Espacio Enter Canaris |
| 11.12.2014 | Hagenberg, Austria, University for Applied Sciences Upper Austria |
| 19.12.2014-31.01.2015 | Munich, Germany, Gasteig Open Video |
| 10.02.-11.02.2015 | Bytom, Poland, Centre for Contemporary Art Kronika |
| 07.03.2015 | Katowice, Poland, Muzeum Śląskie |
| 21.03.2015 | Katowice, Poland, Muzeum Śląskie |
| 17.04.2015 | Gliwice, Poland, Halo!gen Festival |
| 01.05.-31.08.2015 | Hong Kong, Comix Home Base |
| 10.05.2015 | Stuttgart, Germany, Metropol Kino |
| 12.05.2015 | Lublin, Poland, UMCS – Faculty of Political Science |
| 14.05.-17.05.2015 | Helsingor, Denmark, CLICK Festival |
| 18.05.-16.08.2015 | Helsingor, Denmark, Kulturværftet |
| 27.05-03.06.2015 | Riga, Latvia, Art Gallery NOASS |
| 01.07.-30.11.2015 | Hong Kong, Hong Kong Arts Centre |

# Biographies

**Roel Roscam Abbing** (NL) is an artist and researcher dealing with the cultures and issues surrounding networked computation. Currently his topics of interest include the Internet's infrastructure, wireless community networks, and DIY techniques. His recent work *Border Check,* a browser extension that maps how your data moves across the Internet's infrastructure while you surf the web, was realized during a Summer Sessions artist in residency at LABoral in Gijón.

**Búi Bjarmar Aðalsteinsson** (IC) studied Psychology and Applied Studies in Culture and Communication at the University of Iceland, and Product Design at the Icelandic Academy of the Arts. He has worked for Brynjar Sigurðarson.

**alien productions** (AT) was founded in 1997 by Andrea Sodomka, Martin Breindl, Norbert Math, and August Black as a network of artists working with new technologies and media. They have all been working in crossover fields since 1985, working with other artists, technicians, theorists, and scientists from the most diverse fields in an interdisciplinary way. Their works include performances, installations, electronic music, net art, radio art, sound art, interactive art, video, visual art, and artistic photography. alien productions are regularly involved in pioneering collaborative radio and Internet projects. *http://alien.mur.at*

**Anarchy Dance Theatre** (TW) breaks free from the traditional restraints of theater, producing an entirely new performance space with the dancers, audience, interactivity, theater, and environment as its main elements. It explores the intricate power structures and personal relationships in today's powerful social structures and the relationships between time, space, objects and people.

**Peter Androsch** (AT) is a composer, musician, artist, researcher, writer, and lecturer. Intensive compositional activity in the fields of musical theater, multimedia, orchestra, chamber music, choir, electroacoustics, and stage and film music. 2012 nomination for the German "Faust" Stage Art Award. Lecturer at the University of Arts and Design Linz since 2003. Musical director of Linz 2009 European Capital of Culture from 2006 to 2010, as well as the founder and head of *Hörstadt.*

**Norbert Artner** (AT) is a visual artist from Linz. He studied Metal Sculpturing at the University of Art and Design Linz and became a member of the academic staff there in 1995. He has participated in many exhibitions and his work has been shown internationally. Works from his series *Studios* have been shown at Ars Electronica 2011. *www.norbertartner.com*

**Tamer Aslan** (TR) is an independent creative technologist based in Vienna. He studied Electronics Engineering at Sabancı University, Istanbul, and Interaction Design at Domus Academy, Milan. He has worked as a creative engineer, designer and researcher in Ars Electronica Futurelab and his current interests focus on Enchanted Products and Playful City. *http://www.tameraslan.net/*

**Herwig Bachmann** (AT) was for many years in charge of visual communication for the Poolbar Festival in Feldkirch, Austria—a retrospective is now being shown at the Vorarlberg Museum in Bregenz.

**Michael Badics** (AT) is senior director of AE Solutions, a new division of Ars Electronica, and is responsible for developing the most promising prototypes and research results of the Ars Electronica context into products ready for real-world implementation, especially in the fields of Urban Development and Brandlands & Exhibitions. He studied Computer Science at Johannes Kepler University in Linz and was founder and managing director of Memetics GmbH in Berlin. After 15 years working as software engineer and manager in the multinational software company Fabasoft AG, he co-managed the Ars Electronica Futurelab for about 8 years. *http://www.aec.at/solutions*

**Ian Banerjee** (IN/AT) is an architect, urban planner and educational researcher living in Vienna. He studied architecture and wrote his Masters thesis on the planning principles of Curitiba—the "ecological capital" of Brazil. He then worked for several years at the Austrian Broadcasting Corporation (ORF) and the German Satellite TV (3Sat) as a consultant for documentaries on urban innovations. He joined the Centre of Sociology (ISRA) at Vienna University of Technology as assistant professor in 2008, where he started researching the interrelations between strategic spatial planning and educational planning. His main interest today is to study the global trends in urbanism and the dynamics of learning in the city.

**Cédric Brandily** (FR) is an artist and performer. He studied archaeology, arts and architecture at the Reina Sofia National Art Museum's university department in Madrid, and quickly turned to a career in visual arts and performance. His work draws both on Canadian and French situationist performance practices and on the Fluxus movement.

**Mónica Bello** (ES) is an independent curator and art critic with expertise in art and science. Since March 2015 she is the new head of Arts@CERN in Geneva—the artistic program with the mission to establish links between the worlds of science, art, and technology.

**Anatol Bogendorfer** (AT), born in 1979, lives as a freelance artist in Linz. He studied audiovisual media design at the University of Art and Design Linz and his fields of activity include music, film, and acoustics. Longtime involvement in the independent art and cultural scene. Various film works: experimental videos, video installations, debut film *Innere Blutungen* (2013). As a member of the Linz-based Acoustic City laboratory since its founding in 2007, Bogendorfer has been intensively dealing with acoustic environments as socio-political and artistically designable spaces.

**Florian Born** (DE) is an interaction designer, who works between media arts and media design. His projects focus on connecting the virtual with the physical world. He works with new technologies, the field of creative coding, and crafting things. He currently lives in Berlin, where he studies new media in a master program at the University of the Arts Berlin. He also works for the German research agency Fraunhofer-Gesellschaft. *http://florianborn.com/*

**Bernhard Böhm** (AT) is a researcher and cultural worker, currently working on his PhD in architecture at the ETH Zürich. His research involves a comparison of different knowledge production cultures in architecture, in the USA, Germany and Great Britain. He studied Sociology (BA) and Science–Technology–Society (STS) (MA) at the University of Vienna and worked for 8 years for Ars Electronica as a producer, content manager, and researcher. He was also involved in the project *www. transformingfreedome.org*, an open online archive for digital culture and politics.

**Anita Brunnauer aka nita.** (AT) is a Vienna-based graphic designer who studied Multimedia Arts at the University of Applied Sciences in Salzburg. In 2014 nita. founded her own multidisciplinary studio for visual arts. She is also a member of sound:frame's AV label and Duzz Down San Records. The visual style can be understood as constant interplay between daydream & night watch, surface & depth of flotation. *http://www.studionita.at/*

**Michael Burk** (DE) is an interaction designer and media artist based in Berlin. Focusing on the design of spatial media environments and physical interfaces, he pursues the creation of enriching experiences that establish a meaningful relation with the user or spectator, and covers a wide range from thought-provoking critical design to immersive interactive environments that blend the boundaries between the virtual and the physical. Recent projects were realized for public spaces and museums, reaching a broad and diverse audience.

**Aisen Caro Chacin** (US), MA, received an MFA in Design and Technology from Parsons in NYC, where she taught Physical and Creative Computing. Her radar is on Human-Computer Interaction (HCI), designing new perceptual interfaces, and discovering the limits of digital media. She is currently designing assistive devices as Ph.D. candidate for the Empowerment Informatics program at University of Tsukuba, Japan.

**Hui CHENG** (CN) is currently working at the Planning Information Center of Beijing Municipal Institute of City Planning & Design, focusing on research and development of GIS technology. CHENG aims to build urban planning support systems and planning platforms by applying advanced technology.

**Fernando Comerón** (ES) has carried out research in astrophysics at the University of Barcelona (Spain), the Observatory of Paris Meudon (France), the University of Arizona (USA) and, since 1995, at the European Southern Observatory (ESO). He was involved in observatory operations for over 15 years and was head of the ESO Data Management and Operations Division, Germany, before moving to Chile, where he became head of the ESO Representation in Chile in 2013. His research interests are star formation, galactic structure, and young stellar objects at both high and low masses, and he has published over 80 papers in these fields in international journals.

**Şirin Bahar Demirel** (TR) graduated from the cinema department at Galatasaray University, Istanbul in 2010 and finished her MA in Artistic Direction of Cultural Projects at Université Paul Valéry, France. She has worked as assistant director in feature documentaries. She continues to work on her photography, video, and street art projects in Istanbul.

**Klaus Dieterstorfer** (AT) is an energy and environmental engineer with a specific focus on development cooperation. He has been working in this field since 2006, starting with building an orphanage in Kathmandu (Nepal), followed by a series of technical aid projects in Nepal, Kenya, Sudan, and Uganda. In 2013 he joined Engineers without Borders Austria. Since 2014 he has been on the executive board of Engineers without Borders Austria.

**Wolfgang "Fadi" Dorninger** (AT). Sound stands at the center of Wolfgang Dorninger's artistic work, as the operator of the experimental music label *base*, performer, composer of theater and film music, sound designer, sound artist or lecturer at the University of Art and Design Linz. Two diametrically opposed sound worlds dominate the work, which is located between digital sound generation and concrete ambient noises. The arrays range from concertante space-sound-installations, multimedia performances and acoustic presentations to theater music and techno. *http://dorninger.servus.at*

**Eddea Arquitectura y Urbanismo** (ES/AT) is a leading international firm in Strategic Economic and Urban Design, Urban Planning, Architecture, Construction and Project Management, moving between Design, Technology, and Business and working to create the conditions for a new dialog between Society, Nature, and Economy. Working globally, and with more than 25 years of experience, the right combination of strategic thinking and innovation, quality design and accuracy, serves to meet the expectations of each individual client.

**Floris Erich** (NL), studied Computer Science and Business Information Technology at the University of Twente, NL and is currently Special Fellow at University of Tsukuba, Japan, where he is working on his doctoral thesis in Empowerment Informatics. He is studying Software Engineering in Robotics, and how interdisciplinary teams can efficiently and effectively create innovative new technologies.

**Nick Ervinck** (BE) explores the boundaries between various media, fostering a cross-pollination between the digital and the physical. Studio Nick Ervinck applies tools and techniques from new media, in order to explore the aesthetic potential of sculpture, 3D prints, animation, installation, architecture and design. Ervinck's work, in short, oscillates between the static and the dynamic, prospecting new virtual or utopian territories.

**exonemo** (JP) is an artist duo, formed in 1996 by Yae Akaiwa and Kensuke Sembo. Their experimental projects are typically humorous and innovative explorations of the paradoxes of digital and analog computer networked and actual environments in our lives. Their *The Road Movie* won the Golden Nica for Net Vision category at Prix Ars Electronica 2006. They have been organizing the IDPW gatherings and *Internet Yami-Ichi* since 2012. *http://exonemo.com*

**Ursula Feuersinger** (AT) is a graphic and video designer based in Vienna, Austria. After studying Information Design with a focus on media and interaction, she worked in Berlin as a video designer and produced stage projections for theatrical works. In 2007 she moved to Vienna, where she has been active as a video artist, visual performer, and as exhibition, brand, web, and print designer. In 2013 she founded her own graphic and motion design studio. *http://ursulafeuersinger.com/*

**FIELD** (UK) is a London based studio, creating expressive and dynamic artworks such as audio-visual installations, experiences for web and mobile, and shareable digital artifacts for digital platforms. Led by co-founders Marcus Wendt and Vera-Maria Glahn, the studio explores Colour, Life, and Infinity through new technology and a research-led approach—hi-tech experiences with a human touch.

**Ingrid Fischer-Schreiber** (AT) is a translator, editor, and project manager. Since the 1980s she has been a freelance translator, working for major German publishers, focusing on Chinese philosophy, digital culture, and societal questions. Since the mid 90s, she has been working on projects for Ars Electronica as editor and curator. Most recently, she is engaged in cultural exchange projects related to China. *http://yingeli.net*

**Christoph Fraundorfer** (AT) is architect, designer and founder of the bicycle-startup *myESEL* located in Linz. During his architecture studies in Vienna he focused on product and furniture design and realized various projects with THUM architects, Atelier Löwy and Querkraft architects. Since 2012 he has his own company *Von Johann*—design and prototype production (carbon & fiberglass composites).
*http://www.my-esel.com/, http://www.vonjohann.com/*

**Wolfgang Fuchs** (AT) lives in Linz and has been producing projects in a wide array of genres—noise, free improvisation, new music, dance and radio—as well as numerous works in the visual arts since the late 1990s.

**Shiho Fukuhara** (JP) is part of the artist duo BCL, collaborating with Georg Tremmel on art projects that explore the impact of biotechnologies on society—and human perception of these coming changes—at the Institute of Medical Science, University of Tokyo.

**Gerhard Funk** (AT) studied mathematics and art education in Linz and received his PhD in theoretical computer science. As a high-school teacher he taught art education, mathematics, and informatics, and worked in parallel as an assistant and researcher at RISC Linz. In 1993 he transferred to the University of Art and Design Linz, where he established an education program for digital media and developed the e-learning platform Digital Media for Artists (DMA). Since 2004 he has been a full professor at the Institute of Media and the head of the bachelor's degree program Time-based and Interactive Media, which he conceived.

**Takayuki Furuta** (JP) is group leader of the robot development project at Japan Science and Technology Agency and founder (2003) and general manager of the Future Robotics Technology Center at Chiba Institute of Technology. He has created many state-of-the-art robots, including *Halluc II* (2007) and *ILY-A* (2015), and developed various robots that are deployed in severe disaster areas, such as the Fukushima nuclear disaster site.

**Matthew Gardiner** (AU/AT) is an artist most well known for his work with origami and robotics. He coined the term Oribot 折りボト and then created the field of art / science research called Oribotics. Oribotics is a field of research that thrives on the aesthetic, biomechanic, and morphological connections between nature, origami, and robotics.

Rosi Grillmair (AT) is an artistic researcher and cultural worker interested in the institutional art world and digital art within its virtual habitat. She studied interactive media in Linz and Milan and works mainly with real-time processing and data visualization. She has been involved in the organization of digital art events like Ars Electronica Festival and NODE Forum for Digital Arts/Frankfurt and belonged to the group of students who won the Golden Nica in the u19 – CREATE YOUR WORLD, Prix Ars Electronica in 2011.

Jürgen Hagler (AT) is an associate professor in the Digital Media department at the Upper Austria University of Applied Sciences (Hagenberg, Austria) and is in charge of computer animation and animation studies. He became the program coordinator for the Digital Arts master's degree in 2009. Since 2008 he has been actively involved in Prix Ars Electronica and in 2009 he became curator of Ars Electronica Animation Festival.

Johann Hammerschmid (AT) used to build manufacturing facilities until he decided to found the startup Johammer e-mobility GmbH, developing a futuristic electric cruiser with innovative energy technology based on lithium-ion-batteries.

Brian Harms (US) is a Research Engineer within the Think Tank Team at Samsung Research America, Silicon Valley. With an academic background in Architectural Design and Robotics, his work focuses on rethinking and improving the ever-changing relationship between digital tools and processes of design and fabrication.

Daniela Herold (AT) is an architect based in Linz and Vienna. From 2005 till 2009 she taught at the Institute of Space and Design Strategies at the University of Art and Design Linz, and has been an assistant professor at the Institute for Art and Architecture at the Academy of Fine Arts Vienna since 2009. She runs her own business together with Rolf Touzimsky and Wolfram Mehlem.

Carina Hesper (NL) is an artist who predominantly works with photography, often within the realm of fashion. She is fascinated by the passing of time and many of her works capture the traces time leaves on people, objects, and environments. She developed her work Portrait Series as part of a Summer Sessions artist in residency at V2_Institute for the Unstable Media in Rotterdam.

Rolf-Dieter Heuer (DE) is a particle physicist and Director-General of CERN since 2009.

Martin Hieslmair (AT) has been the Ars Electronica Center's editor and press photographer since 2012. He's also on the staff of Ars Electronica's press department, where his responsibilities including website content and blogging. Before that, he was website photo editor at the ORF – Austrian Broadcasting Company's Vienna headquarters. He studied political science, majoring in visual communication.

Andreas J. Hirsch (AT) is a photographer, writer and curator based in Vienna, Austria. He recently exhibited his series on Vienna The Nocturnes of Day (2014) and the photographic investigation BLOW ME UP NOW (2014). He curated exhibitions of photographers including Tina Modotti, René Burri, Henri Cartier-Bresson, Elliott Erwitt, and Linda McCartney. www.andreas-hirsch.net

Andreas Hofer (AT) studied architecture in Vienna and Bogotá. He is currently Assistant Professor at the Institute for Urban Design and Landscape Architecture at Vienna University of Technology, and has worked on his PhD in Urbanism (2000), cooperation projects, and teaching and research on international and informal urban development. He undertook further teaching and research assignments at RWTH Aachen, Universidad Nacional de Colombia, and Lviv Polytechnic National University (Ukraine).

Peter Holzkorn (AT) is an artist and researcher at the Ars Electronica Futurelab, and coordinates programs for the Futurelab Academy.

Horst Hörtner (AT) is a media artist and researcher. He is an expert in the design of human-computer interaction and holds several patents in this field. Hörtner was a founding member of the Ars Electronica Futurelab in 1996 and since then he has been the director of this atelier/laboratory. He started work in the field of media art in the 1980s and co-founded the media-art group x-space in Graz, Austria, in 1990. Horst Hörtner works at the nexus of art and science and gives lectures and talks at numerous international conferences and universities.

Lukas Maximilian Hüller (AT) studied photography at La Cambre in Brussels. He follows a multidisciplinary approach in his work, focusing on the phenomenon "time" in staged, narrative photography and installation projects with real people, and his works question cultural and human values by using photography to create moments of illusion. His engagement with historical painting and collaboration with other artists play a decisive role in Hüller's work.

Salvatore Iaconesi aka xdxd.vs.xdxd (IT) is an interaction designer, robotics engineer, artist, and hacker, and teaches Near Future Design at the Faculty of Architecture at Sapienza University of Rome and ISIA Design Florence. TED Fellow 2012, Eisenhower Fellow since 2013, and Yale World Fellow 2014. Iaconesi is the founder of Art is Open Source and Human Ecosystems, and Principal Investigator at Ubiquitous Commons.

**IDPW** (JP) is a community meeting place connecting the real site and the website which was created by exonemo duo Kensuke Sembo and Yae Akaiwa. It is a loose artists' collective that meets on a monthly basis and has approx. 10 members who operate as "a secret society on the internet that goes back more than 100 years", and descend on various internet scenes. Projects include *Internet Black Market, Whatever Button* ("New Face" award at the 17th Japan Media Arts Festival 2012), and *Text Party*.

**Hiroo Iwata** (JP) is a professor at the University of Tsukuba, where he leads research projects on virtual reality and Device Art. His research interests include haptic interfaces, locomotion interfaces and spatially immersive display. He received a PhD in engineering from the University of Tokyo in 1986 and won honorary mentions at Prix Ars Electronica 1996 and 2001. In 2004 he launched the Device Art Project. He is now head of the PhD program in Empowerment Informatics.

**Werner Jauk** (AT) is a musicologist/psychologist and scientific media artist, and Professor of Musicology at the University of Graz (KFU), working on music + media/art, with the focus on music as a role model for media arts. Studies in perception, cybernetics, and experimental aesthetics led him to try and bridge the gap between science and arts. He has published many scientific papers and exhibited installations as a scientific artist at international festivals such as Ars Electronica, Cynetart, liquid music, and Biennale di Venezia.

**Maša Jazbec** (SL) studied Fine Arts in Maribor and Interface Culture in Linz. She works mainly in the field of video and interactive installations, and is a founding member of the art group V.A.T. (Visual Alternative Trbovlje).

**Yasuaki KAKEHI** (JP) is an interactive media designer & researcher. He is associate professor of Keio University, Co-founder and director of plaplax ltd. Presently he is Visiting Associate Professor at MIT Medialab.

**Jonathan Keep** (ZA) is an artist potter and a leading exponent of studio-based ceramic 3D printing. The shapes of his pots are written in computer code, which is passed to his self-designed 3D printer that prints out the pots in clay, layer by layer. He has won various awards, undertaken artist residencies, lectured, held workshops, and exhibited widely in the UK and abroad. *http://www.keep-art.co.uk/*

**Derrick de Kerckhove** (CA/IT) is a guru of the digital age, who, as a student of the great master Marshall McLuhan, directed the McLuhan Program in Culture & Technology of Toronto between 1983 and 2008. He is Scientific Advisor of the association Osservatorio TuttiMedia, scientific director of the digital culture magazine Media Duemila, research supervisor of the Planetary Collegium T-Node in Trento, and creator along with Maria Pia Rossignaud of the Atelier of Connective Intelligence. Digital Champion of the City of Rome.

**Hyungjoong Kim** (KR) is a media artist whose artistic research focuses on the field of audio-visual interaction where he explores the visualization of sound and music in order to let the audience experience the convergence of technology and humans. He works as Research Assistant at KAIST University, South Korea, in the Information Based Design Research Group and at the Music and Audio Computing Lab.

**Simon Klose** (SE) holds a law degree from Stockholm University. He has produced and directed a number of music videos and music documentaries. In 2013 he released the documentary *TPB AFK: The Pirate Bay Away From Keyboard*. Simon Klose is also the founder of the startup Linklib.org, that lets film lovers connect their phones to extra information about documentaries.

**Roland Krebs** (AT) is an Austrian urban planning specialist with experience in strategy planning, project development and management and urban design. He holds a Master in Urban and Regional Planning from Vienna University of Technology, 2001, and a Master of Business Administration from Universidad de Belgrano, Buenos Aires, 2007, and is working as planner, designer and researcher at the University of Technology in Vienna and the Inter-American Development Bank in Washington, DC.

**Ann-Katrin Krenz** (DE) is an interaction designer and media artist based in Berlin. Her work ranges from rich interactive installations and environments to generative design and visual explorations with pixels, pen, and paper. She is currently working on her master thesis in the Digitale Klasse held by Joachim Sauter and Jussi Ängeslevä at the University of the Arts Berlin.

**Jurij V. Krpan** (SI) At the initiative of the student organization of the University of Ljubljana he conceived the Kapelica Gallery—Gallery for Contemporary Investigative Arts in 1995, which he has been running since then. As curator and selector he has contributed to domestic and international festivals. In 2014 he co-curated the Designing Life section for the Product Design Biennale in Ljubljana and curated the Slovenian pavilion at the Venice Architecture Biennale. He started 2015 as curator of the Freies Museum Berlin. Jurij Krpan lectures on the artistic profile of the Kapelica Gallery in Slovenia as well as abroad.

**Wolfgang C. Kuthan** (AT/FR) originally from Austria, is a French multi-talent—director, author and photographer—who worked as an art director in the Paris fashion scene for twenty years. He has been working on Sound-Ritual (concept, direction, and production) since 2011.

**Lois Lammerhuber** (AT) is a self-taught artist who, since 1984, has worked closely together with GEO magazine. His pictures have been published in hundreds of books and magazines and earned him international awards, including three times the Graphis Photo Awards for the world's best photo report of the year. He joined the Art Directors Club New York in 1994. In 1996 he set up Edition Lammerhuber publishing house. In 2013 and in 2015 Lois Lammerhuber was judged Best Editor at the FEP European Photo Book of the Year Awards. In 2014 he received the Republic of Austria's Cross of Honour, First Class, for Science and Art.

**Johannes Langeder** (AT) studied Experimental Art at the University of Art and Design Linz. His current projects are Vienna Biennale 2015—*Ideas for change; Linz Bicycle Happening*, Lentos Art Museum, Linz. www.han-lan.com

**Johannes Langkamp** (DE/NL) experiments with the features and limitations of digital media. Inspired by the everyday, he turns straightforward observations into presentations of unusual takes on reality. In a recent series of works, which Langkamp initiated as a Summer Sessions artist in residence at Chronus Art Center in Shanghai, he highlighted the camera's relationship to the space it captures.

**Jess Ching-wa LAU** (HK) is a media and illustration artist from Hong Kong. She often focuses on the relations between animation and contemporary arts in general in her works.

**Lawine Torrèn** (AT), founded by Hubert Lepka, is an artists' network working in the fields of art, economy and science. Since 1992 the group of dancers, actors, media artists, and technicians turns existing places into stages for its dramatic art which lies outside traditional formal categories. Dance, theatre, media art, and music merge with machines and techniques, and thus create sensitive yet breathtaking performances.

**Christopher Lindinger** (AT) is co-director of the Ars Electronica Futurelab and is responsible for the areas of research and innovations. His work is characterized by cooperations with international partners with whom he develops entrepreneurial innovation strategies or shifts concepts and trends of radical innovations for social future scenarios. Lindinger has worked together with large companies like Daimler, Toshiba, Vodafone, Honda Robotics, and Nokia in the past few years. Beyond that, he advises local authorities and government institutions on the formation and development of a creative industry and lectures at several European universities.

**Robert Lippok** (DE) lives in Berlin, where he's a musician, visual artist, and set designer. Among the countless musical projects he's been involved in are *Ornament und Verbrechen* and the band To Rococo Rot.

**Nestor Lizalde** (ES) is an artist whose work focuses on the creation of electronic devices, audiovisual systems and interactive installations that explore the possibilities of art through the so-called New Media. With a broad educational background: BA in Fine Arts, Master in Visual Arts and Multimedia, Higher Education in Design & Electronics, the artist creates a dialogue between technological experimentation and artistic tradition, exploring the possibilities to develop new approaches. Winner of multiple awards, lecturer in specialized forums, and regular contributor to art and technology centers.

**Félix Luque and Iñigo Bilbao** (ES), create audiovisual and sculptural artworks, for which they experiment with different 3D scanning-animation techniques, develop software / hardware, and use digital fabrication technologies. They have exhibited their works at Transmediale (Berlin), Ars Electronica (Linz), iMAL (Brussels), LABoral (Gijón), Bozar (Fine Arts Museum Brussels), and BIAN (Musée d'art contemporain de Montréal), among others.

**SAINT MACHINE aka Marilena Oprescu Singer** (RO) is a multimedia artist with curatorial background. She studied literature as well as communication and art history before starting experimenting with juxtaposition of real and virtual space and playing with form and ideas. Her main projects are *Cannibal* (2015), *Feed Me* (2014), *Authentic Romanian* (2011), *Playground for Animation* (2009), *Urban Art Festival* (2007, 2008, 2009), and *Artmix / Mousetrap* (2005).

**Thomas Macho** (AT/DE) has been professor of Cultural History at Humboldt University of Berlin since 1993. He was co-founder of the Hermann von Helmholtz-Zentrum für Kulturtechnik and Dean of the Faculty of Philosophy III (2006–2008); Fellow at the Internationales Kolleg für Kulturtechnikforschung und Medienphilosophie (IKKM) at the Bauhaus-Universität Weimar (2008–2009); Head of the Institute of Cultural Theory and History (2009–2011); and Fellow of the Internationales Kolleg Morphomata at the University of Cologne from 2013/14.

**Alexander Mankowsky** (DE) studied philosophy, psychology and sociology at the Free University of Berlin and worked for four years in social services helping troubled children, before starting postgraduate studies with a focus on the then new field of Artificial Intelligence and becoming a Knowledge Engineer. Since 1989 he has been working in the research unit at Daimler AG, initially focusing on societal trends in mobility, which led him in 2001 to his current field of work—Futures Studies & Ideation.

**Mingrui MAO** (CN) is Associate Director of the Planning Information Center of Beijing Municipal Institute Of City Planning & Design BICP; Director of the Urban Planning Society of Beijing (UPSB); Associate Director of Beijing City Lab; and Director of CITYIF Urban Planning Cloud Platform.

**Julian Melchiorri** (UK/IT) is a designer engineer and innovator based in London. His works, located between art and science, explore new scenarios and experiences through innovative experimentations of materials, functions and interactions between people, objects, and the built environment. After studying industrial design in Rome and Australia, Julian designed and engineered for the Italian Lighting company Catellani & Smith where he explored light as a tool for space and material perception.

**Martina Mara** (AT) obtained her doctorate in media psychology from the University of Koblenz-Landau. As a Key Researcher at the Ars Electronica Futurelab, she is responsible for the research field of RoboPsychology. Together with international partners from academia and industry, she particularly addresses how robots should look, behave, and communicate in order to establish high user acceptance and comfortable interaction experiences. Martina also lectures at several universities and has been giving talks at leading conferences. Due not least to her professional background in journalism, she considers herself as a communicator between basic social research, emerging technologies, and the public.

**Marie Masson** (DK) graduated from McGill University, Quebec, in Political Science & Economic Development, and interned for the UN Youth Envoy as Communications Coordinator for a youth campaign. She is co-founder of SOCENT, a network of social entrepreneurs in Quebec, and a board member of MyVision—a global movement of young social entrepreneurs. Since April 2015, she is the International Assistant of Hans Reitz at the Grameen Creative Lab.

**Hannes Mayer** (EU), born 1981 in Stuttgart, is an architect, writer, educator, curator, lichenologist, and musician. Before joining the Academy of Fine Arts as the Roland Rainer Chair 2014/15, he was the director and editor-in-chief of *archithese*. Parallel to his work as an editor, he was a studio master (unit 20) and thesis supervisor at the Bartlett School of Architecture, University College London. In 2007 he established his own office—M-A-O/architecture and optimism—in London.

**Geeta Mehta** (IN/US) is an adjunct professor of architecture and urban design at Columbia University in New York. She is the founder of Asia Initiatives *(www.asia-initiatives.org)*, where she developed Social Capital Credits (SoCCs). This breakthrough virtual currency for social good is currently in use in projects in USA, India, Ghana, Kenya, and Costa Rica. Geeta is also the co-founder of a think-tank—URBZ: User Generated Cities, located in Mumbai. *www.urbz.net*

**Laurent Mignonneau** and **Christa Sommerer** (AT) are internationally renowned media artists, researchers, and pioneers in the field of interactive art. For 25 years now they have been exhibiting their works worldwide, and they have won numerous awards such as the 2012 Wu Guanzhong Art and Science Innovation Prize of the Ministry of Culture of the PRC and the Golden Nica of the 1994 Prix Ars Electronica. They are professors and heads of the Interface Cultures Department at the University of Art and Design Linz, and guest professors at Aalborg University in Denmark and the Université Paris 8.

**Soichiro Mihara** (JP) questions the relationship between technology and society in his works. In 2011, in the aftermath of the eastern Japan earthquake, he started the *blank* project. He has exhibited his award-winning projects internationally. *The world filled with blank* (2013, Kunstquartier Kreuzberg/Bethanien) and Sapporo International Art Festival (2014, Sapporo Art Park); *Soundart—sound is a medium of art* (2012, ZKM); *Open Space* (2012, NTTICC); *Simple Interaction—soundart from Japan* (2011, Museum of Contemporary Art Roskilde); *ISEA 2010 Ruhr* (2010, Kunstverein Dortmund), and many more.

**Peter Moosgaard** (AT) studied philosophy and digital art at the University of Applied Arts Vienna. He is the co-founder of TRAUMAWIEN publishing and specializes in Cargo Cults and Shanzhai as global post-digital techniques. *http://www.cargoclub.tumblr.com*

**Ou Ning** (CN) has been living and working in the Bishan Commune, a group devoted to the rural reconstruction movement in China, since 2011. He works as a publisher *(New Sound of Beijing*, 1997; *Liu Xiaodong's Hotan Project and Xinjiang Research*, 2014; and the literary bimonthly journal *Chutzpah!* 2011–2014). As a curator, he initiated the biennial art and design exhibition *Get It Louder* (2005, 2007, 2010), among others. He was the chief curator of the 2009 Shenzhen & Hong Kong Bi-city Biennale of Urbanism and Architecture. As a filmmaker, he is known for urban research and documentary projects.

**Naoki NISHIMURA** (JP) is a designer at design studio THA. *http://please.bouze.me/*

**NOPER aka Radu Pop** (RU) is an illustrator and animator artist. He graduated the National University of Arts in Bucharest where he experimented with and developed his inner visual world. His fresh weird artworks were featured in albums such as Luerzer's *200 Best Illustrators Worldwide 2009–2010* and opened doors to collaborations with international galleries for projects such as *Feed Me* (2014), *Cranium* (2012), *Bold* (2010), *As if by Magic* (2010), and *Urban Art Festival* (2007, 2008, 2009).

**Madeleine O'Dea** (AU) is a writer and journalist who has been covering the political, economic, and cultural life of China for the past three decades. She first reported from China as the Beijing correspondent for *The Australian Financial Review* newspaper in the late 1980s, and subsequently covered the country throughout the '90s as a producer with Australia's ABC Television. In the 2000s she took up a position as a presenter and editor with China Radio International and later served as the Arts Editor for the *Beijinger* magazine. In 2010 she joined Blouin Media as the founding Editor-in-Chief of *ARTINFO China* and the Asia Editor of *Art+Auction* and *Modern Painters* magazines. She is currently completing an intimate history of contemporary China—*The Phoenix Years*—which will be published by Allen & Unwin in September 2016.

**Dietmar Offenhuber** (AT) is assistant professor at Northeastern University, Boston, in the departments of Art + Design and Public Policy. He holds a PhD in Urban Planning from MIT, and studied at the MIT Media Lab and TU Vienna. Dietmar investigates urban infrastructure such as formal and informal waste systems and has published books on the subjects of Urban Data, Accountability Technologies, and Urban Informatics.

**Hideaki Ogawa** (JP) is an artist, curator and researcher in the field of art, technology, and society. He is a representative and artistic director of the media artist group "h.o", *www.howeb.org*. Currently he also works in the Ars Electronica Futurelab and has realized many projects for research, festivals, and the Ars Electronica Center.

**Julian Oliver** (NZ) is a Critical Engineer and artist based in Berlin. His work and lectures have been presented at many museums, galleries, international electronic art events and conferences, including the Tate Modern, the Chaos Computer Congress, FILE, and the Japan Media Arts Festival. Julian has received several awards, most notably the Golden Nica at Prix Ars Electronica 2011 for the project *Newstweek* (with Daniil Vasiliev). *http://julianoliver.com*

**Máté Pacsika** (HU/NL) develops theatrical interactive installations inspired by cinematic techniques. In his recent work *Vertigo System* for example, which he developed at Chronus Art Center in Shanghai during a Summer Sessions artist in residency, he translates the well-known cinematic techniques known as the "vertigo effect" into a physical interactive experience.

**Veronika Pauser** (AT) works as producer, artist, and researcher at the Ars Electronica Futurelab. In addition to her master studies in Interface Culture at the University of Art and Design Linz, she did a Master of Science in Digital Media at the University of Applied Sciences in Hagenberg. Her main focus of interest is the design of interactive installations and performances at the borderline of art and technology.

**Hannah Perner-Wilson** (AT) is a designer who combines conductive materials and craft techniques, developing new styles of building electronics that emphasize materiality and process. She has a BA in Industrial Design from the University of Art and Design Linz and an MA in Media Arts and Sciences from the MIT Media Lab. Since 2006 Hannah has collaborated with Mika Satomi, forming the collective KOBAKANT.

**Oriana Persico aka penelope.di.pixel** (IT) is an artist, cyber-ecologist, and an expert in participatory policies and digital inclusion. She has worked with national governments and the European Union on best practice and research in the areas of digital rights, social and technological innovation, practices for participation, and knowledge sharing. She teaches Near Future Design at ISIA Design Florence, and is co-founder of Art is Open Source and the *Human Ecosystems* event, and is Investigator and Partnerships Manager at Ubiquitous Commons.

**Robert Pöcksteiner** (AT) is a film producer and director, founder of Don't Panic Production. Collaboration with Lukas Maximilian Hüller on the documentary film project *Snapshots in Time: The Children of Zaatari* about children in the Zaatari refugee camp in Jordan (2014).

**Susa Pop** (DE) is an urban media curator and producer based in Berlin. In 2003 she founded Public Art Lab (PAL) as a network of experts from the fields of urban planning, new media arts and IT to develop urban media art projects for participatory place-making and co-creation of our cities—like the Media Facades Festivals (together with Mirjam Struppek) and the EU funded artistic research project *Connecting Cities Network*.

**Robert Pravda** (NL/RS) is a sound artist, composer, and performer. He studied interdisciplinary art in the Image and Sound department at the Academy of Fine Arts, Music and Dance in the Hague. During and after his studies he concentrated on building instruments for multimedia performances, performing and composing for spatial sound and light installations. From 2002 'till present, he has been teaching sound related courses and developing research projects as a member of the teaching team at the ArtScience department of the Royal Academy of Art and the Royal Conservatoire in the Hague.

**Julian Pröll** (AT) is an artist and a designer who studied Industrial Design at FH Joanneum, Graz, and started at the formquadrat graphic design agency in Linz in 2010. His projects have won several awards, including the Red Dot Award, iF design award, Plus X Award, and the Austrian State Prize for Design.

**Ianina Prudenko** (UA) is a freelance curator and assistant professor at the National Pedagogical Dragomanov University, Kiev, Ukraine. She is curator of the Open Archive of Ukrainian Media Art and curator of the Kiev Art School.

**Andrew Quitmeyer** (US) is a Polymath Adventurer. His PhD research in Digital Naturalism at Georgia Tech blends biological fieldwork and DIY digital crafting. This work has taken him through the wilds of Panama and Madagascar and the US where he's run workshops with diverse groups of scientists, artists, designers, and engineers. He's also adapted some of the research to exploring human sexuality with his Open Source Sex Technology startup *Comingle*. His transdisciplinary, multimedia projects have been featured in many international magazines, and various internet blogs and local news sources.

**Carlo Ratti** (IT/US) is director of MIT Senseable City Lab and founding partner of Carlo Ratti Associati. An architect and engineer by training, Carlo Ratti practises in Italy and teaches at the MIT, where he directs the Senseable City Lab. Ratti has co-authored over 250 publications and holds several patents. His work has been exhibited in several venues worldwide, including the Venice Biennale, MoMA in New York City, and MAXXI in Rome. At the 2008 World Expo, his *Digital Water Pavilion* was hailed by *Time Magazine* as one of the "Best Inventions of the Year." He has been included in *Blueprint Magazine's* "25 People who will Change the World of Design" and in *Wired* magazine's "Smart List 2012: 50 people who will change the world." He is curator of the *Future Food District* at Expo Milano 2015.

**Hans Reitz** (DE) spent 7 years living a simple life in Southern India and can relate to problems of poverty. In 1994, he founded the event and creative communication agency *circ* and in 2004, the café chain Perfect Day, a social business. H. Reitz became the Creative Advisor to Nobel Laureate Muhammad Yunus, and together they founded The Grameen Creative Lab to spread Yunus' concept of social business all over the world.

**Markus Riebe** (AT) studied at the University of Art and Design Linz and has had a studio for Digital Art and Media in Gallneukirchen since 1986. He has been involved in many exhibitions, including Chicago Siggraph; Third International Symposium on Electronic Art, Sydney; Computer Art, Gladbeck; Künstlerhaus Vienna; OÖ Landesgalerie; OK, Linz; and OÖ Kunstverein.

**Kristien Ring** (DE) is an architect, curator, and publicist, and founder of AA PROJECTS I Interdisciplinary Studio, engaged in the production of interdisciplinary projects on future-oriented themes in the realm of architecture and urban planning. She is author of *SELF MADE CITY Berlin, Self-initiated Urban Living and Architectural Interventions* 2013, and *URBAN LIVING Strategies for the Future* 2015. She is a professor at the University of South Florida for Architecture and Community Design (2015) and visiting professor at the University of Sheffield (2014–17). Founding director of the DAZ German Center for Architecture in Berlin (2004–11) and co-founder of the gallery Suitcase Architecture (2001–2005). *www.aa-projects.eu,* Blog: *www.urbanlivingberlin.de*

**Karl Ritter** (AT) was a guitarist with Kurt Ostbahn until 2003, before pursuing his solo career that includes the solo album *Atmen* and the *Weisse Wände* project.

**Maria Pia Rossignaud** (IT) is editor of digital culture magazine *Media Duemila* and vice president of the Osservatorio TuttiMedia. With Derrick de Kerckhove she created the Atelier of Connective Intelligence. She organizes the prize *Nostalgia di Futuro* and meetings on burning issues, is involved in the Wister (Women for Intelligent and Smart TERritories) network, is on the board of Stati Generali Innovazione, and is Digital Champion of the municipality of Vico Equense.

**Dennis Russell Davies** (US) studied piano and conducting at the Juilliard School in New York. His activities as opera and concert conductor, pianist, and chamber musician are characterized by an extensive repertoire ranging from Baroque to contemporary modern works, by fascinating and brilliantly conceived programs, and by close collaboration with such prominent composers as Luciano Berio, William Bolcom, John Cage, Manfred Trojahn, Philip Glass, Heinz Winbeck, Laurie Anderson, Philippe Manoury, Aaron Copland, Hans Werner Henze, Michael Nyman, and Kurt Schwertsik. Since 2002, Dennis Russell Davies has been chief conductor of the Bruckner Orchestra Linz and opera director at Landestheater Linz.

**Dorota Sadovská** (SK) lives in Bratislava. She received a Masters in Painting from the Academy of Fine Arts and Design in Bratislava in 1997 and works in a variety of media including photography, installation and video. Sadovská focuses on the body—not in the traditional depiction of a nude sense, but in a spiritual sense.

**Katja Schechtner** (AT) holds a dual appointment with MIT Media Lab and the Asian Development Bank to create and implement large-scale urban technology investment programs by integrating new data technologies with best practices in urban planning and management. She has a background in architecture, urban studies, management and technology assessment from Columbia University, NY, Danube University Krems, and Vienna University of Technology. Most recently she has been selected as a Rockefeller Global Social Innovation Fellow.

**Claudia Schnugg** (AT) is senior curator of the Ars Electronica Residency Network and is carrying out research in the field of art and science collaborations at Ars Electronica Futurelab, with a focus on aesthetic and embodied knowing and understanding and its influence on creating, work and organization. She holds a PhD in social and economic sciences from the University of Linz.

**Christine Schöpf** (AT), PhD, studied German and Romance Languages. She has worked as a radio and television journalist and was the head of the art and science department at ORF Upper Austria (1981-2008). She was appointed Honorary Professor at the University of Art and Industrial Design in Linz (2009). Since 1979, she has held a number of positions in which she has been able to contribute considerably to the development of Ars Electronica. She was responsible for conceiving and organizing the Prix Ars Electronica from 1987–2003. Together with Gerfried Stocker, she has been the artistic co-director of Ars Electronica since 1996.

**Heribert Schröder** (DE/AT) trained as a violinist, pianist and vocalist before studying music, ethnology, and Catholic theology at Bonn University. He worked at and taught at the Department for Sound Studies, Bonn University. Since 1999, he has taught orchestra & opera management in the Department of Cultural and Media Management at Hamburg University of Music and Theater. Since 2001, he has been artistic director of the Bruckner Orchestra Linz, responsible for the administrative agenda of Chief Conductor Dennis Russell Davies.

**Meinhard Schwaiger** (AT) is an inventor. He studied mechanical engineering and has been working in R&D and technical management since 1982. He is the founder / co-founder and CEO of three companies. His many awards include the Gold Solvin Innovation Award in 2007; the 2011 Green Dot Awards; nominations for the State Award Consulting in 2009 and 2013; the Upper Austria Innovation Award; the Austrian Patent Office Inventum Award in 2012; and the Linzer Company of the Year Award in 2013.

**Hannes Seebacher** (AT) is a self-taught artist who works in multidisciplinary fields. He shares a creative partnership with Lukas Hüller and together they founded the Austrian organization *KulturSpiel* and the London *Play Foundation*—in collaboration with other social and humanitarian networks and partners—in order to develop and realize art projects that question values and use (visual) art to provoke sociopolitical engagement.

**Mark Shepard** (US) is an artist and architect whose work addresses contemporary entanglements of technology and urban life. Recent work includes the *Sentient City Survival Kit*, a collection of artifacts, spaces and media for survival in the near-future "sentient" city. It has been exhibited at the 13th Venice International Architecture Biennial; Ars Electronica, Linz, Austria; and Transmediale, Berlin Germany, among other venues. *http://www.andinc.org/*

**Rintaro SHIMOHAMA** (JP), born in Tokyo, is a graphic designer and artist. *http://rin-shimohama.tumblr.com*

**Onur Sönmez** (TR) is a designer, whose special focus is interaction design and interface design research. After his BA Visual Communication Design from Istanbul Bilgi University, he completed his Masters degree in Interface Cultures at the University of Art and Design Linz and worked for Ars Electronica Futurelab and Bosch Design Studio Munich. *http://www.onursonmez.com/*

**Maja Smrekar** (SI) is an intermedia artist who connects humanistic and natural sciences in transdisciplinary projects. She received 1st Prize at the Cynetart festival from the European Centre for Arts Hellerau (Dresden), an Honorary mention at the Ars Electronica Festival Linz, Austria, and the Golden Bird Award—a national award for special achievements in visual art, Ljubljana, Slovenia.

**Stadtwerkstatt** (AT), based in Linz, is an innovative cultural space founded in 1979 by a group of socially engaged art students. In advocating open source software and free spaces, they add a political dimension in confronting contemporary issues across borders, creating and presenting interdisciplinary projects in public space, radio, and the Net.

**Moritz Stefaner** (DE) works as a "truth and beauty operator" on the crossroads of data visualization, information aesthetics, and user interface design. He consults with clients like OECD, World Economic Forum, Skype, dpa, and Max Planck Research Society, to find insights and beauty in large data sets. His work has been exhibited at Venice Biennale of Architecture, SIGGRAPH, Ars Electronica, and the Max Planck Science Gallery.
*http://truth-and-beauty.net/*

**Gerfried Stocker** (AT) is a media artist and electronic engineer. In 1991, he founded x-space, a team for the realization of interdisciplinary projects. In this framework numerous installations and performance projects have been carried out in the field of interaction, robotics, and telecommunication. Since 1995 Gerfried Stocker has been a Managing and Artistic Director of Ars Electronica. 1995/1996 he developed the groundbreaking exhibition strategies of the Ars Electronica Center with a small team of artists and technicians and was responsible for the set-up (and establishment) of Ars Electronica's own R&D facility, the Ars Electronica Futurelab. Since 2004 he has been in charge of developing Ars Electronica's program of international exhibition tours. Since 2005 he has planned the expansion of the Ars Electronica Center and implemented the total substantive makeover of its exhibits.

**[tp3] architekten aka Henter, Rabengruber and Schullerer-Seimayr** (AT) is an architectural office located in Linz. Their design is characterized by a contextual approach, the environment, topography, urban realities, and the functions of the respective architecture. As an interdisciplinary project team they have been working for years with urban development methods and strategies, housing estate and urban designs, and form-finding processes of urban construction.

**Georg Tremmel** (AT) is an Austrian artist who currently lives in Japan, working in a DNA analysis laboratory at the Institute of Medical Science, University of Tokyo. Together with Japanese artist Shiho Fukuhara he forms the art duo BCL, which explores the relationships between biological and cultural codes by means of artistic interventions and social research. They have created various works revolving around art and modification, including *Biopresence*.

**The Trinity Session** (ZA), directed by Stephen Hobbs and Marcus Neustetter, has been implementing public projects for the past 15 years—both as commissioning agents and as artists. Their experience of working in the public arena has evolved their artistic and socially engaged processes towards symbolic translations of radical changes in society. Practicing in Southern and Western Africa, Europe and North America to date, the acts become a reflection on their own understanding of their local conditions in Johannesburg, South Africa. *www.thetrinitysession.com*

**UltraCombos** (TW) is an interactive and new media design studio founded in 2010, professionals in crossover integration execution services such as all kinds of interactive programs, visual art designs, and hardware devices, who provide clients with various creative proposals, and work them out in accordance with the clients' needs. The team also participated in many local and international art events including Taipei Digital Art Festival, SIGGRAPH; FILE—Electronic Language International Festival, Brazil; and many more.

**Pablo Valbuena** (ES) focuses on space, time, and perception in his art projects and research, dealing with concepts such as the physical and the virtual, the generation of mental spaces by the observer, boundaries between the real and the perceived, space and time links, communication, and light. Most works are developed for a specific location or space and have been presented at numerous venues throughout Europe, Asia, and America.

**Victoria Vesna** (US) is a media artist and professor at the UCLA Department of Design | Media Arts and Director of the Art|Sci center at the School of the Arts and California Nanosystems Institute (CNSI). With her installations she investigates how communication technologies affect collective behavior and perceptions of identity shift in relation to scientific innovation (PhD, University of Wales, 2000). Her work involves long-term collaborations with composers, nano-scientists, neuroscientists, and evolutionary biologists, and she brings this experience to her students. She is editor of *AI & Society* (2006), *Database Aesthetics: Art in the Age of Information Overflow* (2007), and *Context Providers: Conditions of Meaning in Media Arts* (2011).

**Addie Wagenknecht** (US/AT) is the founder of deep lab *(www.deeplab.net)*, an all-female collaborative, working within the topics of surveillance and data aggregation. She is an artist with F.A.T. lab and a conceptual hacker who work plays with new technologies and challenges the status quo. *http://placesiveneverbeen.com/*

**Shinya WAKAOKA** (JP) studied visual design at Kanazawa College of Art, Ishikawa, Japan, and is a freelance graphic designer in Yamanashi Prefecture.

**Jürgen Weissinger** (DE) began his career in 1985 at the old Daimler-Benz AG as test engineer in pre-production development, where, three years later, he became head of vehicle testing. In 1995, he assumed responsibility for vehicle studies and special vehicle construction and became director of Maybach testing as well as, in 2005, the development of the Maybach and the SLR. 2007-14 in Mercedes-Benz Development, he was chief engineer responsible for the SL, SLK, and SLR series, as well as the Maybach and special vehicles. Since January 2014, Jürgen Weissinger has been head of Daimler AG's research center for vehicle concepts and future trends.

**Shunji Yamanaka** (JP) is a design engineer and professor at the University of Tokyo, where he graduated from the Faculty of Engineering in 1982. He joined Nissan Motors Design Center the same year, and became an independent industrial designer in 1987. Assistant professor at the Faculty of Engineering, University of Tokyo, 1991-94; founder (1994) and president of LEADING EDGE DESIGN; professor at the Graduate School of Media and Governance, Keio University, 2008-12; Professor at the Institute of Industrial Science (2013) and the Interfaculty Initiative in Information Studies, University of Tokyo (2015).

**Lei YANG** (CN) is the Deputy Director in CBC Academy. Curator and researcher on urban future with deep interaction amongst digital art & design, information and technology. Previously, he was the chief curator at CMoDA (China Millennium Monument Museum of Digital Arts), Beijing, and founded CMoDA CoINNO Lab on collaborative innovation on digital art and design in 2012. He is founder, curator, and producer of NOTCH Festival on live media and social innovation. Before that, he founded Radio Take10, a collective internet radio co-curation project on net label and demo culture.

**Dana Zelig** (IL) is a designer, based in Tel-Aviv. Her work focuses on the interrelationships between natural processes, computational systems, and procedural-based art practice.

**Leart Zogjani** (KO) has an MA in graphic design from Kosovo and is the founder of Kokrra.tv design and motion studio. He has exhibited in France, Kosovo, and Albania and has been featured in *PC World, Mac World* in Italy, MAXON web gallery etc. His work with Kokrra.tv has recently been featured on *Motionserved.com*, and he received a Behance Portfolio Review Award and a Certificate of Appreciation by TED.